Canadian Aboriginal Art and Spirituality: A Vital Link

John W. Friesen, Ph.D., D.Min., D.R.S.
and
Virginia Lyons Friesen, Ph.D.

Artwork by David J Friesen, B.Ed.

DETSELIG
ENTERPRISES LTD

Canadian Aboriginal Art and Spirituality

National Library of Canada Cataloguing in Publication

Friesen, John W.
 Canadian Aboriginal art and spirituality: a vital link / John W. Friesen and Virginia Lyons Friesen ; artwork by David J Friesen.

ISBN 1-55059-304-8

 1. Native art--Canada. 2. Spirituality in art. I. Friesen, Virginia Agnes Lyons, date- II. Title.

N6549.5.A54F74 2006 704.03'97071 C2005-906353-X

Detselig Enterprises Ltd.
210, 1220 Kensington Road NW
Calgary, Alberta
T2N 3P5

www.temerondetselig.com
Email: temeron@telusplanet.net
Phone: (403) 283-0900
Fax: (403) 283-6947

We acknowledge the support of the Government of Canada through the Book Publishing Industry Development Program (BPIDP) for our publishing program.

We also acknowledge the support of the Alberta Foundation for the Arts for our publishing program.

SAN 113-0234
ISBN 1-55059-304-8
Printed in Canada

Cover art by David J Friesen
Cover design by Alvin Choong

Table of Contents

To the students of Old Sun College

Siksika First Nation

Preface

Native North American art, after five centuries of contact and colonialism, is extraordinarily rich and diverse. Today, Native artists. . . work in a broad range of media, conceptual modes and expressive styles.

Berlo and Phillips, 1998: 1.

During the late nineteenth century and most of the twentieth century, Aboriginal art, like virtually every other component of the First Nations lifestyle, received short shrift in Canadian historical literature. Aboriginal philosophy was mislabelled, Native culture was mis-understood, and Indigenous art was misinterpreted and called craft. Even the spiritual bases of Aboriginal art were discounted or ignored.

Today the scene is changing, thanks to the availability of more thoroughly researched accounts provided by anthropologists, artists, archaeologists, educators, and historians, but most of all, due to the efforts of Indigenous researchers. Their historians, poets, artists, and elders have worked hard to set the record straight by describing historical events and cultural practices from their perspective. They have been tireless in their efforts which are slowly bearing fruit. Aboriginal art is finally being regarded as art in its own right, in the best sense of the word.

Proof of this advance is the fact that over one hundred Native artists from across Canada are being formally recognized through a multiplicity of avenues. Their biographies are readily available on the web (for example, see http://collections.ie.gc.ca/artists/artists.html) and in such sourcebooks as *St. James Guide to Native North American Artists*. Most cited Canadian Aboriginal artists are internationally known, and their careers represent a wide variety of artistic undertakings including architecture, carving, ceramics, drama, film, graphic arts, jewelery-making, mask-making, media, painting, photography, print-making, and sculpture. Their cultural affiliations range from the Beothuk and Mi'kmaq of the east coast across the nation to the Haida, Kwakwaka'wakw, and Tlinget communities on the northwest coast. The artistic works of more than two dozen Inuit artists in the Northwest Territories are easily identified in publications readily available to the public. It is a good day for Aboriginal art in Canada.

The first three chapters of this book are introductory and deal with definitions of art, Native art, and Aboriginal spirituality. After that, readers are invited to participate in a literary journey to reflect on the Indigenous cultures and art of the six major cultural areas of Canada. These include the eastern Maritime coast, the Woodland region, the Plains, the Plateau and Northwest coast regions, and the North. Beginning with chapter four we have included brief biographies of selected Aboriginal artists representative of each area. The work of these artists is summarized at the end of each chapter. It was difficult to choose which artists to introduce since the number of them is increasing every year. Our decision was to portray a few of the best-known artists as well as those whose reputations are less well-known. We also wanted to give space to the various genre in which these artists work. It is perhaps best to acknowledge that our methodology was somewhat eclectic, even random. If we have erred on the side of "discaution" (new word), we apologize to anyone who feels left out. Perhaps such omissions can be remedied in a second edition of this book.

Like other artists, many contemporary Aboriginal painters, printmakers, and sculptors have purpose to their art. Some take up political themes, trying to inform viewers about the unfortunate and dismal happenings that have been inflicted on their home communities through the last few centuries. Others, like Woodland artist, Norval Morrisseau, who portrayed Indian legends in his works, have a more pedagogical objective in mind and try to teach traditional ways to those who view their art. Still others simply have a personal story to tell when they draw, sing, or perform, and they want to share it with the world around them. Whatever the motive or message, it is certain that Aboriginal art is a valid form in its own right and there is a great dal to be learned from the various genre assumed by these artists.

A Note on Terminology

There are a variety of descriptive terms to choose from in writing about the original occupants of this continent, and there seems to be no front runner. One can choose from a long list of descriptors – Aboriginal Peoples, AmerIndians, First Nations, First Peoples, Indians, Indigenous Peoples, Native Peoples, and North American Indians. Recently a colleague suggested that the First Peoples in Canada be called "PreCanadians!" There are writers, Native and non-Native, who prefer a particular usage to the exclusion of all others. Currently the Government of the United States, and writers in that country, use the term Indian, or Native American while Canadians are opting for First Nations, Indigenous People, or Aboriginals. The Government of Canada still operates a Department of *Indian* and Northern Affairs. Despite arguments to the contrary, a variety of these usages will be employed in the ensuing pages, partly to relieve monotony in delivery, and partially because it is difficult to know which usage might be appropriate in any given context. It seems that the political correctness movement has

temporarily stalled efforts at meaningful literary communication. As historian J. R. Miller (2004: 62) has observed, "[p]olitical correctness confines or even closes off completely the scope of investigation, ensuring that whatever 'truth' emerges will be partial at best." It should be noted that in this volume, words to describe the First Peoples will be capitalized as a means of emphasizing the literary legitimacy of writing about the AmerIndians, in the same way that identities of other nationalities are capitalized.

On September 19, 2003, the Supreme Court of Canada awarded Aboriginal Status to the Métis people of Canada. Long neglected in the annals of Canadian history, the Métis people can at last lay claim to formal relations with the Government of Canada. What they need now is to be recognized by their fellow Canadians as a distinct and unique people. In order to emphasize this important legal happening, chapter ten highlights the distinctive forms and styles of Métis art and documents their cultural contributions to Canadian society.

We want to thank our publisher, Dr. Ted Giles, President of Detselig Enterprises Ltd., and the staff, for their support of our work. We owe a special thanks to Kim-Marie Ward for her very capable editorial work. Without this kind of encouragement and dedication, *Canadian Aboriginal Art and Spirituality* would probably have taken a much longer time to come to fruition, and we offer them our heartfelt thanks. We would also like to acknowledge the students at Old Sun College on the Blackfoot (Siksika) Reserve who sat through our first rendition of this course a few years ago. They were polite, attentive, enthusiastic, and encouraging. It was that experience which motivated the birth of this book, and we are grateful to them.

<div align="right">

John W. Friesen
Virginia Lyons Friesen
Calgary, AB

</div>

Chapter One
What is Art?

Only part of art can be taught, but the artist needs the whole.
> – Johann Wolfgang von Goethe (1749-1832).

We are quite convinced that our son, David, could take a coil of rusty barbed-wire, and with a few technological incantations, make a coffee table or a set of drapes out of it. Alternately, we could probably also use whatever he fashioned with the barbed wire to cook a gourmet meal. David is innately an artist. He is an expert blacksmith, a painter, designer, and architect, and whatever material he encounters is bound to become something much better or unique through the magic of his hands. The whole process will be accomplished without recipe or blueprint, and the end result will undoubtedly amaze every onlooker.

Obviously, David inherited his artistic bent from his mother. His father's own artistic side is a bit more limited. He did once fashion a lawnmower out of an electric washing machine motor and an obsolete baby carriage, but that was of necessity. At that time, he was a poor part-time worker, full-time student, and the lawn was getting taller by the minute. There was little choice in the matter for there were no funds with which to purchase or rent a commercially-made lawnmower. In the intervening years he has taken great satisfaction in relying on his commercially-manufactured Lawnboy lawnmower. He has also since decided that it is best to leave art to artists.

Definitions of Art

Art is anything that people do with distinction.
> – Louis Dudek, Canadian Poet (Colombo, 1987: 18).

Although the field of art has, for some time, been regarded as an academic discipline, it is still not an easy task to define exactly what we are talking about when we say "art." It is even more difficult to define the task when set within the parameters of

historical ethnology because many prehistoric societies that come under study never had a word for art, nor words for love or kinship, for that matter. Even though we may be closer to defining the term today, it is necessary to remember that definitions of art have changed through time. Plato and Aristotle, for example, have been credited with defining art as "the capacity to make or do something with a correct understanding of the principle involved" (Dissanayake, 1990: 35). This perspective has consistently been transmitted to succeeding generations in nonwestern societies. The arts continue to be judged and appraised for their level of technical virtuosity, their "correctness," of execution and their appropriateness. By contrast, definitions of art originating in the western world are all over the place. Sometimes art is defined as "skill," referring to the expertness of execution; sometimes art is defined in terms of the admiration, aesthetic appeal, and pleasure it stirs within the emotional domain of the viewer, and sometimes it is defined in terms of its ordering or harmonization of parts. Other criteria that frequently come into play in judging art include expression, communication, innovative tendencies, and artifice. As Richardson (1984: 21) states, "No simple definition is sufficient to describe everything that comes under the heading of art." After all, artists rarely worry about defining art; for them, art is simply what they do. If pressed, they may come up with elaborate verbal descriptions to justify their works, or they may not.

Richardson may be quite correct, about the difficulty of defining art, but there may still be benefit in investigating what more contemporary authorities have had to say on the matter. So what do scholars who study art say about art? Does a work of art necessarily provide the same aesthetic experience for people of different cultures? Probably not, so let us begin with Franz Boas (1955), who provided one of the earliest anthropological explanations. Boas differentiated between two kinds of art, both of which provide the observer with an aesthetic experience. The first kind of art is form. Certain forms of phenomena in certain localities provide their immediate audience with an aesthetic experience. All of us are familiar with what have been called beautiful automobiles, paintings, sculptures, and musical renditions, all of which evoke aesthetic feelings of appreciation. Emotion is naturally involved, often in the form of tears of joy, or appreciative bodily stances.

Boas (1955: 12) suggested that though aesthetic experiences can be produced by natural forms, they cannot logically be called art because they involve no human activity. Imagine if you can, a wondrous landscape, a magical cloud formation, or the majestic flight of an eagle. These are all natural forms that engender aesthetic appreciation, and most North Americans would probably agree that these are phenomena to be appreciated. Undoubtedly, all Canadians have a special affinity for colorful landscapes after the winter cold has finally subsided. To fit Boas' criterion, however, art forms are those created by human effort, be the end result a melody, a carving, a dance, or a pantomime; all are aesthetic expressions created by human effort. Therefore, they qualify as art.

If we can agree that certain humanly-concocted forms of themselves produce human appreciation, it should be easier to accept Boas' second notion that artistic effect can be produced by ideas associated with specific art forms. It may well be a universal truth that no work of art was ever produced without the creator having in mind a particular message that the art form was supposed to portray. Few painters ever sit before a canvas and randomly produce a work that has no inner message. Why would a sculptor take the effort of chiselling and shaping a piece of raw material just for its own sake? The end result of such a pointless activity (if it turned out somewhat spectacular), might well be, "My, my, look at what I have created. I wonder what it is supposed to mean?"

Some of the world's most magnificent architecture is situated in central Europe, particularly in England, France, Germany, Italy, and Switzerland. Clearly these beautiful buildings were envisaged, planned, and completed in response to fulfilling someone's concept of a functional, yet aesthetic structure. By contrast, much of North America's quickly put-together rows of housing constructed mainly of chipboard, glass, and plastic, are almost an embarrassment. Of course the latter were never planned to be works of art in any sense. They were merely intended as temporary shelters for needy folk who could not otherwise be able to say that they owned a home of their own. Unlike their more affluent neighbors, they could not afford a more permanent form of dwelling that might even have a shred of artistic conveyance about it. Those might qualify as significant works of art. As Sedgewick (1959: 23) suggests;

> A work of art . . . means a work embodying values that reflect its time and place of origin, the society and the [person] that produced it, and beyond that a view of the world that is somehow essential, that tells us something we could not learn otherwise of reality and truth. . . . [W]hat we mean by art is not something merely artful, but something of weight and significance to mankind.

Layton (1981: 10-11) makes the important point that the investigation of an artist's intent can only be validated if the viewer can understand the means that the artist used to communicate his or her values. A work of art may exhibit the artist's thoughts and expressions, but never directly. If that were the case, the production of works of art would be superfluous. A Russian dancer once performed an intricate dance before an appreciative audience. When she completed her performance, members of the audience approached her with expected compliments. One particularly impressed observer offered what he perceived to be a burning question. "Tell me, madam," he queried, "What was the meaning of the dance? What were you trying to tell your audience?" The dancer was appropriately chagrined and responded sharply. "Sir, if I could tell you what the dance was supposed to mean, there would be no purpose in performing the dance." Art, it appears, often portrays its own message. It does not require a complementary form of explanation. In short, it speaks for itself.

Cultures vary, of course, and that which inspires emotion and appreciation in one cultural setting will not do so in another. This is why many works of rock art, for example, produced by the First Nations of this continent centuries ago, were defaced and even destroyed by unappreciative incoming European explorers and fur traders. Sadly, contemporary attempts to salvage these unusual spiritual testaments to bygone days are accompanied with the realization that art appreciation is relative to specific time and place. It is only recently that social scientists have begun to appreciate that most art forms created by traditional Aboriginal artisans were portrayals of deeper meanings, usually spiritual in nature. Even items invented for daily sustenance were both utilitarian and spiritual in design (Vincent, 1975: 8). What appeared to incoming explorers to be simple geometric forms were indicative of hidden meanings, in the same sense that European forms of music, dance, and poetry might be. Unlike Aboriginal forms, the latter were not usually attached to, or indicative of, underlying spiritual belief systems. The results of this unfortunate cultural clash are still evident today. Most Canadians are still woefully ignorant of Aboriginal ways.

Schools of Modern Art

It would take a great deal of space to trace the history of artistic expression, but a few observations about the modern period might be in order, if only to indicate the contrasting features of the various "isms" with Aboriginal orientations. To begin with, art since the eighteenth century has tended to develop in a fad-like fashion. One school of style flourishes and then fades away, only to be followed by another. Only the experts know the true difference between realism and surrealism, or impressionism and postimpressionism. Add to this any attempt to differentiate between romanticism, cubism, expressionism, and futurism, and the stage is set for a great deal of frustration (Richardson, 1984: 228).

The middle class of Europe came to power in the latter part of the eighteenth century and effected dramatic change on many social institutions. With artistic influences out of the hands of the aristocrats, the revolution of the middle class opted for a reborn version of classic art as a means of expression. Seriousness of theme was the projected form. Then, as if to challenge this revivalist stance, the romanticist appeared on the scene offering a more comprehensive form of expression. Following the thinking of philosopher, Jean Jacques Rousseau (1712-1778), the romantics argued that life had visceral, tangible, and supernatural features to it that should be expressed in various art forms.

One of the corollary expressions of romanticism was realism, with its penchant for fostering friendship between the "real truth" and matter-of-fact expressions. Realists were challenged by impressionists who concentrated on "pretty things" like landscapes, dance scenes, ballet, and picnics. French impressionism was popularized by

Claude Monet (1840-1926), who rendered hues and shades as faithfully as classic painters did solid objects. After 1900, impressionist style art was suddenly depicted as postimpressionism. Then, again as though reacting to the new trend, artists who were disenchanted with the relative formlessness of impressionism, directed their talents toward a more rational bent. Pablo Picasso (1881-1973), for example, aided in the development of "cubism," a truly nonrepresentational or abstract movement whose works challenge the viewer to study the various forms depicted on canvas. By concentrating on any one form in what appears to be a jumbled mess, the viewer may perceive the painting in an entirely different light.

Vincent Van Gogh (1853-1890) is sometimes described as representative of a troubled group of subjective-expressionist artists whose personal lives were fraught with disappointment and tragedy. Artists of his persuasion tended to turn art into vehement forms of self-expression and projected a rather pessimistic view of humankind. This school was followed by what has been labelled "surrealism," a movement that drew upon Sigmund Freud's psychoanalytic theories by attributing most human activities to subconscious motives. Salvador Dali (1904-1989) has been depicted as representative of this orientation, because his works, like dreams, are subject to different interpretations. It is not unexpected that viewers would project their own experiences into their perceptions of works of art. Richardson (1984: 257) suggests that Dali "cribbed" most of his ideas from Baroque artists like Carravaggio and Vermeer, and basically attempted to mimic dreams in a literal way.

This brief summary only sketches the outline of the foundations of modern art, and the formation of new schools and trends has continued to the present time. It is difficult to fit traditional Aboriginal art into any of the above categories and it would probably not be wise to engage in such a pursuit. It is quite proper to speak of "classic" Indigenous art in the sense that it prevailed for thousands of years before European contact, but its metaphysical base is unique. For the most part, Aboriginal art has maintained its traditional ties. Northwest coast art, for example, (Gunther, 1966) classically includes totem poles, masks, and canoes, features very distinctive characteristics, and while making great changes, is still strongly tied to its past (Stewart, 1979: 95). Native North Americans view the universe as an ordered whole that gives birth to new art and often builds new institutional structures. The universe is not a static entity, but is dynamic, changing, and moving through time as ritual moves through space. Young Man (1992: 88) states;

> This is pure Native American philosophy which anthropology belatedly defines as theory, and which Native artists in turn reconstruct as art. It is also an important conceptual and cultural distinction that deserves more attention and exploration. For now, suffice it to say that Native cosmology is worthy of more of our time and understanding and should not be forgotten.

Theories of Art

Theories of art abound. Boas (1955) clearly supported the contention that art has two primary categories. The first is form itself and the second is in the form of the underlying presuppositions that motivated its creation. Other theorists are not as easily satisfied and insist that art forms must, themselves, express thought or emotion. In that sense art is something that speaks for itself; a work may not be considered art if it relies on what the observer brings to it. For example, one individual may view a photograph or painting of a landscape and admire the creative or expert style of the artist. Another individual may bring certain knowledge to the painting or photograph and use that knowledge in interpreting the art; this individual may even be acquainted with the portrayed scene. Perhaps he or she once lived in that locale. Obviously this experience would affect the individual's perception and, following Gestalt theory, interpret the scene in light of his or her accumulated experiences.

Painters and sculptors of the medieval period took great pains to incorporate hidden meanings in their works, and society is the richer for it. In fact, volumes have been written intended to ameliorate the masked messages of these masters. The messages of many works are obvious, and designed to supplement knowledge familiar to them. Others are more subtle, paralleled by more abstract works whose message is intended to be obscure, if decipherable at all. Surely there have been artists who created works whose underlying purpose was never intended to be discovered. Therein lies a strange joy within the artist. "Let them try to figure it out. I have made my statement."

The degree to which human artistic expressions affect the senses varies with the chosen medium. Massive bold strokes usually attract a great deal more attention than simple geometric forms. Loud percussion renditions at a rock festival usually affect the senses to a greater extent than soothing pipe organ renditions at a funeral. Some art forms are more dependent on sensual perception than others. A dramatic presentation, accompanied by music, verbal utterances, gestures, backdrop, and theatrics is more likely to feed the senses than a poetry reading, but both are inherently art forms. Depending on their underlying or attached meanings, both may also be indicative of projected ideals.

The answer to the question, "Is art always functional?" must be affirmative. Haselberger's definition is too restrictive when he notes that,

> [w]orks of art can be identified in objects produced with the intention that they be aesthetically pleasing, not strictly, pragmatically functional (Layton, 1981: 4).

Functionality, of course, has at least two meanings. In the first instance, function can mean utility in a practical sense, like that which an ornamented vase or a decorated table may convey. The table or vase may be elaborately painted, and still serve the function of a device for containing a beautiful flower arrangement or providing a place at

which to eat. Decorated tools are still tools in the sense that they can be used to pound, cut, saw, scrape, or chisel. Decorated windows still let in light; cheerfully painted cupboards may still contain dishes, and a braided saddle can provide respite from the abrupt movements of a trotting stallion.

A second dimension of function may be aesthetic or spiritual. A statue of an unknown Greek character, a wheelbarrow full of hand picked colored stones, or a bouquet of dried flowers may be admired for their own sake and yet have hidden meanings. Some people have an affinity for statues, others have special appreciation for wheelbarrows, while still others really like dried flowers. It may make no difference to the beholder that the Greek character represented by the statue was well-known to his peers. He or she may even have written a deeply philosophical book or penned significant rhymed lines. The statue is admired for itself. A similar case exists with respect to the wheelbarrow. The beholder in question may just like wheelbarrows. If he or she is told that the stones contained in the wheelbarrow came from a respected grandfather's farm, the meaning of the situation may change. Now the scenario can become a wheelbarrow containing historically significant stones. Surely those who admire any banquet of dried flowers will amend their perception of them when they discover that the flowers displayed were, years ago, part of his or her grandmother's wedding bouquet!

Art forms may be admired for themselves, and, in this context, may exhibit intrinsic value. Further informative embellishments will likely amend perceptions primarily in positive or negative directions. Using the example of the statue, it may be projected that negative perceptions of it could be fostered if the viewer is told that the statue once fell on the owner's toe and necessitated its amputation. However, since the statue was given to the owner by a revered grandparent, and cannot be discarded because it has been in the family for generations, the owner has to keep it on display. What would happen if a highly-regarded relative were to drop by unannounced, look for the statue, and notice it was not on display? If the statue were not in its usual location, the owner might risk suffering the family's scorn. An uninformed visiting viewer may admire the statue for its own sake, but once the story of the falling statue and the amputated toe has been shared, the viewer's perception will quite likely be altered. If the viewer has the propensity to quick sympathy for persons with amputated toes, the amended perception of the statue will likely be slanted in a more negative direction. If the viewer does not have a particularly positive bond with the owner of the statue, his or her perception may even be more positively inclined in the sense that "the owner probably got what he deserved when the statue fell."

Aesthetic Stages

Parsons (1987: 20) posits that there are five stages of aesthetic development. Each stage comprises a loosely knit structure in which a number of ideas are shaped by a dominant insight about art. Each stage brings about a more adequate understanding of

the art in question, for example, painting. Stage one may be thought of as a kind of theoretical zero: during this stage the physical appeal of art is more significant than the cognitive, social, or spiritual appeal. The main theme of stage one is favoritism and is reflected in the characteristic responses of young children: "This is my favorite color; I like it because it reminds me of my dog; It looks like a giant pickle coming down from the sky." The primary characteristic of stage one is intuitive delight, freewheeling association, or stimulus to pleasantness.

Stage two brings out feelings or expressions of beauty and realism. "It's gross; It's ugly; I could never have anything like that in my room." Stage two is centred on representation. A sculpture is considered more acceptable if it is attractive even if it is not meaningful in any other sense. Still, stage two represents psychological advancement because it enables the viewer to distinguish some aspects of experience as aesthetically appealing. A painting by a world famous artist may be praised simply because it contains an item with which the viewer is familiar – like a favorite doll, a dog, a house, or a tree.

Stage three goes a bit further and brings expressiveness into play. "I like that painting because it really grabs me; you can see that the artist felt sorry for himself." These statements indicate that the viewer is reading meanings into the painting that are not immediately obvious. This is essentially one of the purposes of art; it represents an attempt to have the work of art express the artist's experience. It is an added reward for the artist to witness elements of that experience perceived by a viewer. It may not be the "correct" perception, but at least some kind of meaningful insight is being experienced, adding to the value of the art. Psychologically, stage three is an advance because it brings into play an awareness of others' experiences and the ability to search for their expressed thoughts and feelings. It enables the viewer to see beyond the beauty of the painting, the realism of the style, and the skill of the artist.

Stage four concentrates on style and form. "Look at the way the paint is laid on here; it lets the background show through. Now the artist may be playing with the subject's eyes. Look at them; they look more like cups or boats – a visual metaphor!" The insight added in this stage is the examination of a painting as a social, rather than an individual, achievement. It places emphasis on the way the medium is handled, on texture, form, color, style, or space. All of the aspects of a work are public in the sense that they may be perceived or analyzed that way by all viewers. A work that has been interpreted differently by several analysts indicates that stage four has been realized.

Fifth, and finally, is the stage of autonomy. This means that the viewer must judge the concepts and values with which the traditional constructs affect the meanings behind works of art. The viewer's impression might be something like this; "It seems to me that it breaks out of the limitations of the style by emphasizing the flatness of the surface. It has a kind of tiredness to it; I can't be sure if it's because I think I am tired of seeing that kind of painting, or if its because he got tired of painting it."

Since values change with history, they must continually be readjusted to fit contemporary circumstances. This suggests that judgment is personal, yet fundamentally social. One's own experiences are, in the end, the only possible testing ground for judgment, and one can amend or change personal values only in light of understanding the self. "The result is an alert awareness of the character of one's own experience, a questioning of the influences upon it, a wondering if one really sees what one thinks one sees" (Parsons, 1987: 25). The social aspect of this experience is wondering if others see the same message in a work of art that one is seeing. While judgment is accepted as an individual responsibility, there is also a realization that discussion and dialogue are essential in the search for truth. When it comes to art, however, dialogue is probably more conducive to raising questions and engaging in reasonable arguments than arriving at some form of universally recognized truth.

Although considerable headway has been made in art appreciation, contemporary analysts of Aboriginal art have not yet reached Parsons' fifth stage. When the first portrayals of Native art by incoming Europeans appeared, they were basically descriptive. Vaillant (1973: 1) notes that Indian art in North America suffers from a "low ceiling"; its value has been seriously undermined. The nineteenth and twentieth centuries saw the development of conservationism and the rise of museums, but few bothered to include Native art in their collections. Some observers saw Indigenous art as a developing phenomenon. Ethnological collections of many kinds were sought, including that of other continents, but, for the most part, North American Aboriginal art was ignored. Duff (1974) notes that the shift from ethnology to art of the Indians of the northwest coast has been a circumspect accomplishment in the sculpture, painting, and related arts than that of Indigenous People in other lands. He suggests that this may be because of the relatively small and compact nature of the culture and its geographic isolation. In any event, as the generations passed, this attitude began to change. This was reflected in a number of ways, all part of the unprecedented explosion of interest in all facets of the Native American heritage (Brown, 1992: 47). It is especially significant that this intrigue was shared by both Native Americans and non-Natives alike. Formal recognition of the status of Aboriginal art was reflected in museum collections. Suddenly, nostalgia for the pure and noble Indian past fuelled the curio trade which reached its height in 1880-1930. Museum staff and private collectors amassed staggering quantities of Native American arts and artifacts including narrative images of myths and rituals, and examples of women's arts such as pottery, weaving, beadwork, and basketry (Cohodas, 1992: 89).

In 1925, the Denver Art Museum was one of the first in the United States to display Aboriginal art *as* art rather than as ethnographic material. In 1931, artist John Sloan travelled across the United States with an exhibition of American Indian art selected for its aesthetic value. A precedent setting exhibition, *Indian Art of the United States*, was

organized by Rene d'Harmoncourt and Frederic H. Douglas in 1941 at the Museum of Modern Art in New York City (Vincent, 1975: 10).

Appreciating Aboriginal Art

Observers have not always been quick to appreciate the nuances of different art forms, and this is particularly true when it comes to Aboriginal art. Highwater (1986) has identified six controversies that pertain to Aboriginal art including personal and cultural identity, imagery, history, modernism, success and recognition, and museums. Art and identity, for example, are closely linked. Art is not separate from other cultural components, and individuals tend to reflect their culture in their work. To understand Aboriginal art then, implies getting to know the person who created it.

The controversy surrounding imagery is even more complex, and all boils down to the question, "What is really Indigenous art? Must it always reflect traditional ways and is it necessarily contaminated when it changes to reflect modern beliefs and practices?" There are advocates who believe traditional arts have the power to preserve culture, and the same thing is often said about language. If paintings during the first half of the twentieth century basically reflected stereotypical images of First Nations, can we assume that the true essence of Aboriginal culture was recaptured in the second half of the century?

The third controversy has to do with history, namely, viewing the artist as an historian. Art that is founded in the European historical tradition commonly incorporates eight elements: landmark works; style categorization or style development; attribution or authentication; iconography; function; restoration; sociocultural interpretation; and provenance (Irwin and Farrell, 1996: 65). However, these concepts do not necessarily fit with the Indigenous way of doing art. To get closer to the goal of understanding Aboriginal art, it is necessary to engage in the appropriate level of analysis. Erwin Panofsky suggested three such levels, the first of which may be described as requiring practical experience on the part of the viewer. The second level demands knowledge of the culture under study, and the third calls for synthetic intuition which implies an understanding of the human spirit. This agenda certainly implies that the critic has enjoyed a long and meaningful familiarity with the Aboriginal community, and a full appreciation of the concept of cultural relativity is underway.

The fourth concept is modernism, a movement that greatly affected Indigenous art when the Europeans arrived. This was a time of crisis in First Nations communities, and the subjects and themes chosen by Aboriginal artists reflected it. Many artists branched out into new avenues of portrayal and performance, and challenged taken-for-granted images of Indian cultures. They began to address relevant issues in art form, for example, identity, pollution, land claims, residential school experiences, and the environment.

Success and recognition, a fifth concept, have plagued many Aboriginal artists for decades. Part of the challenge has been to seek acceptance in EuroCanadian society while at the same time maintaining a degree of respect in their home communities. There seems to be an underlying requirement in many Aboriginal communities that Native artists must remain spiritually and politically tied to the land. For many Indigenous artists it had been a tight-rope walk.

Sixth, and finally, is the role played by museums. Traditionally, museums have collected ethnocultural art as a means of preserving vanishing cultures. While laudable, this habit is fraught with additional controversies. In the first place, the display of traditional Indian artifacts has, for many observers, frozen Aboriginal cultures in time. This unfortunate situation has aided in perpetuating outdated stereotypes of Indian beliefs and practices. Also, some items on display were never meant to be shown to the public. These are sacred items, and in the past were sometimes released to museums with the understanding that they would not be displayed (Irwin and Farrell, 1996: 70). Today the scene is changing as museum curators are calling upon Indigenous elders to help interpret the proper use and meaning of museum pieces that represent the Indigenous community, in order to respect Aboriginal protocol.

As more sympathetic perceptions of Aboriginal cultures developed in the second half of the twentieth century most aspects of their lifestyle were perceived in a more sympathetic light. No longer were their underlying beliefs called superstitious, but spiritual beliefs (Layton, 1981: 31). It was the French sociologist, Emile Durkheim, who opened the way for a more sympathetic understanding of the role religious beliefs and practices play in the life of any society. In 1912, he penned his book, *The Elementary Forms of the Religious Life*, and paved the way to developing a new outlook on Aboriginal art. To Durkheim's way of thinking, Aboriginal people were aware of the collective forces of their social group and they chose to express that force through their symbols. He saw the use of symbolic material objects as expressions of internal states.

The majority of very old Aboriginal art objects that survive today, were selected because they appealed to Western collectors' criteria of beauty and value. This fact has affected the circulation, perseveration, study, and display of Indian artifacts, and how these criteria have changed over time (Berlo and Phillips, 1998: 9). Studying this phenomenon helps us to understand the ethical issues that arise today in relation to the ownership of many First Nations objects that were collected through the centuries and linked to the circumstances in which they were obtained.

Until quite recently, some observers have continued to classify Native art as craft rather than art, but this view has gradually been overshadowed by studies validating Aboriginal art in its own right. Crafts specialist, Una Abrahamson, has suggested that "Art is activity that begins with the head, whereas craft is activity that begins with the hands. Some people feel that the difference lies in the intention of the creator" (Colombo,

1987: 18). If that is so, it is necessary to create a new category indicating activity that "begins in the heart or soul" to accurately describe Indigenous art.

Layton (1981: 3) notes that the phrase "primitive art," often employed to describe prehistoric art forms, has outlived its usefulness. We are now at the edge of stage four in analyzing First Nations art because experts are trying to comprehend the form and style of Native art, having long passed stage three in which expressiveness reigns. It may be some time before the final stage is reached, probably because experts are not yet sure that a different genre of art may have different but equally valid forms and styles.

A monumental step towards validating Aboriginal art in the United States occurred in 1990 with the passing of the Indian Arts and Crafts Act. This is a truth-in-advertising law that prohibits misrepresentation in the marketing of Indian arts and crafts. It is now illegal in the United States to offer for sale, or display, any craft or art produced in a manner that falsely suggests that it is *Indian* art, an Indian product, or the product of a particular Indian tribe or arts organization. Individuals who violate the Act face civil or criminal penalties up to a $25 000 fine or a five year prison term, or both. If a business establishment violates the Act, it faces civil penalties and may be prosecuted and fined up to one million dollars (http://www.doi.gov/iacb.html). Hopefully Canada will formulate similar protective legislation in the near future.

Vaillant (1973: 3) postulates that the effects of Aboriginal art on modern North American culture are impossible to estimate. He admires what he calls the emotional principles that seem to back American Indian art. Actually, there are *spiritual* principles that influence Aboriginal art, even though this fact is a recent 'discovery.' Doige (2003: 144) suggests that the western secular world has, for a long time, been blind to the fact that spirituality infuses or underlies Aboriginal epistemology and, indeed, all culturally appropriate education for Aboriginal students. Spirituality is a necessary component to all forms of Indigenous action and the primary source of empowerment.

It is important to note that there was little room for individuality in traditional Indian culture since the arduous conditions of life tended to suppress it. Cooperation was essential to maintain solidarity against the hostile forces of mankind and nature. Community, clan, and group were important. The idea of the group working together for the common good is certainly reflected in the unity of tribal styles. There is a balanced harmony of presentation like the natural laws to be obeyed in adjustments to the finite and the infinite. Balance, order, repose, majesty, naturalism, and awe are terms to describe Native art instead of those used to portray European art, that is, love, mercy, hate, or mysticism.

Critics sometimes belittle any connection between ritual and religion or spirituality, but we do well to remember that the highest achievements of humankind in the New World evolved through religious channels. The civilizations of the Aztecs, Zapotecs, and Mayans bear testimony to this fact. Art, mathematics, philosophy, and

architecture once all served religious ends. It was as though the current of intellectual development in the New World worked toward a perfect religious expression wherein the supernatural forces could be constrained to work for the benefit of humankind. As Vaillant (1973: 6) notes;

> Many things, lovely in terms of our own aesthetics, have emanated from this anonymity of production, so that the author has tended to select with a European eye rather than try to recapture the inner significance of Indian psychology, an elusive process at best. Yet the objects selected for illustration have been themselves the final arbiters, for an outstanding work is pre-eminent in any civilization.

To appreciate Aboriginal art, it is necessary to step outside the unconscious bias of perception inflicted upon us through convention and tradition and expand our thinking beyond the biases of our culture. This will require mental readjustment, but the rewards will be significant. As the late Canadian media philosopher, Marshall McLuhan stated;

> In this sense the role of art is to create the means of perception by creating counter environments that open the door of perception to people otherwise numbed in a non-perceivable situation (Colombo, 1987: 18).

Principles of art – attention is given to line, shape, and direction, as well as dominance, repetition, and harmony.

Chapter Two
What is Aboriginal Art?

To the American Indian, everything he made had a function. . . . We might say that Indians tended to decorate almost everything they used, as time and materials allowed.

– Norman Feder (1971: 8, 21).

The Indians did not set out to create art for its own sake. In traditional Indian thinking, there is no separation between art and life or between what is beautiful and what is functional. Art, beauty, and spirituality are so firmly entwined in the routine of living that no words are needed, or allowed, to separate them.

– Anna Lee Walters (1989: 17).

It has often been assumed that traditional societies based on a hunting, gathering, and fishing motif, were restricted to a survival mode of living using only very simple technology. It is further assumed that before European contact, Aboriginal peoples probably did not have sufficient spare time to be able to indulge in leisure activity or artistic expression. In fact, the very opposite is true (Ewing, 1982: 17). It has been erroneously postulated that when the Aboriginals did create art, they undertook such activities on the basis of three very fundamental human happenings – birth, death, and food supply (Brandon, 1975: 341). This observation must be brought into question because evidence exists that the First Peoples of this continent spent a great deal of time fancying up virtually every item of their cultural repertoire, primarily because they believed that every item, no matter how ordinary, was a gift from the Creator and somehow interconnected. Beautifying that article then, was a form of spiritual acknowledgment, thanksgiving, or worship, and indicated that the people were appreciative of every gift they received. This is what differentiates Aboriginal art from forms already known to those who migrated to the New World. White (1979: 180) notes:

> The Indian lived intimately with nature; it was the object of his unceasing awe and reverence; he addressed constant prayer and propitiation to the spirits who were its embodiments. . . . Indian art was steeped in religion.

Defining Aboriginal Art

The first outsiders to judge Aboriginal art represented a variety of professions; they were explorers, traders, missionaries, administrators, curators, and anthropologists, and their initial perceptions were quite faulty (Chalmers, 1995: 114). Some eighteenth century European visitors viewed Native art as artificial curiosities to be traded or bought as souvenirs. In fact, First Nations people themselves were viewed as curios. Early anthropologists preferred to perceive Nature art as objects of ethnological interest, while the Franciscan diarists who accompanied Spanish navigator Juan Perez, described Haida art as craft. Early Anglican, Catholic, and Methodists missionaries were agreed on one thing; they described most Native art works as heathen graven images.

Walters (1989: 20) suggests that the nature and quality of traditional Aboriginal art has long been misjudged. In fact, Aboriginal art is in a class by itself on four counts. In the first instance, it is very old art with its roots stretching back at least 25 000 years (Champagne, 1994: 549). Second, the art of the original peoples is a natural form of art. Native artists and craftspeople used only natural materials – animal, mineral, and vegetable to complete their works. They also used primarily natural phenomena as themes, including animals, plant life, and the galaxy as subject matter. Elements of artistic expression could include a multiplicity of natural objects such as nuts, berries, bones, teeth, fur, skins, as well as animal hairs, feathers, and quills. These objects were never randomly modelled or copied, however, for their order would probably have been revealed to the artist through a dream or vision.

Third, Aboriginal art is a pure form of art. Aboriginal artists have only recently found it necessary to incorporate externally induced modifications, influenced no doubt, by the abundance of synthetic materials available. Fourth, and finally, the expression of Indigenous art is always and unilaterally a form of spiritual relation and obligation. During its long endurance as original North American art, Native artistic works have always implied spiritual connections, whether this was in the form of weaponry, housing, ceremony, or other technology, an underlying obligation to the Creator and to all creation was always implicit.

Hidden meanings behind artistic expressions vary in the sense that they may be representative of different cultural aspects. Gebhard (1974: 9) projects four possible embellishments or bases of art including: (i) technical; (ii) simple aesthetics; (iii) ideographic; and (iv) sacred. Technical and aesthetic categories may be classified as pertaining to form; that is, they may be described as comprising art for art's sake. Ideographic

art may viewed as a pictographic link emphasizing cultural beliefs and values. This kind of art is intended to tell a tale or relate an episode of history. The art form is therefore instrumental as an avenue of expression; it serves as an additional guidepost to cultural maintenance. Viewing such an art form should assist individuals in gaining clarity, or intensified or renewed appreciation for specific cultural aspects.

An example of a design resulting from a vision quest.

Serious questions arise from this categorization if it is to be applied to Aboriginal art because the First Nations of Canada historically believed that every behavioral enactment had spiritual or theological implication. In fact, many art works were inspired by spiritual revelations. There is little or no evidence to indicate that First Nations artists categorized cultural obligations as different from spiritual ones. These obligations were viewed as one in the same. The concept of interconnectedness, so deeply embedded in Indigenous thought, mandated that individuals were spiritually accountable for every thought and action. Creating art for art's sake or engaging in purely technical acts would clearly violate this belief. In this sense, all traditional Native art would have to be considered fundamentally, but not exclusively, representational. All drawings and designs, and other forms of artistic expression, whether

implanted on rocks, teepees, shirts, or war axes, were indicative of something, and had spiritual implications. The universe was viewed as an interrelated entity with all parts and processes closely intertwined. To affect any one component would affect others. Obligations to one aspect could not be severed from obligations to the others. The earth was viewed as a unity in which the individual played only a small part. The role of individuals was to be good stewards of the resources available to them and they were mandated to show appreciation for them in every human enactment.

The Aboriginal concept of the God of the universe, the Creator, did not provide for any notion of the Creator as a personal friend, protector, or comforter; the Creator was traditionally regarded from a distance with awe. It is important to recognize that the Indigenous people saw the origins of all of their works of art and craft as the result of what they had been shown in dreams and visions and these were somehow connected to the Supreme Being. Something about the form and decoration of each item always moved the owner to a point beyond its earthly purpose (Mails, 1997: 5).

Young Man (1992: 81) posits that it is virtually impossible to comprehend the meaning of Aboriginal art unless one understands the arguments that rage around it. He insists that when judging Aboriginal art, a Native perspective should be applied, rigidly and boldly, and made an integral part of the various critical, analytical, and historical instruments that make up the lexicon of art. This is particularly necessary whenever the edges of the Native American art world rub against that of contemporary society. For example, some observers are reluctant to buy into the notion that Native cultures, like any other, are apt to change with the times. The perspective seems to be, "Dominant society is *expected* to change, but Aboriginal cultures are best left as they are." The reality is that Native cultures enjoy the right to change just as any other society does. Aboriginal people may add elements and meanings to their cultural repertoire or amend them at will, and their art will reflect these changes. Pen and ink drawings , for example, are now being used by some artists to represent an art form that was traditionally accomplished with porcupine quills and birchbark. This decision to change is a basic right, but western society does not always practice what it preaches. Too often, the view is that classic forms of Indian culture should be maintained not only as a token of the past but in order to provide perpetual subject matter for historians of the First Nations past. In this sense there is no such thing as "authentic" Indigenous art because each example is only authentic in so far as it reflects a particular historical moment (Berlo, 1992:4).

The current need in the field of art is to encourage artists of Indigenous descent to infuse the contemporary scene with the fruit of their own visions, not too much bothered by the philosophies, language, dance, drama, and worldview of dominant society. Too often there is real conflict between the values of a conquering, consuming society and one that descended from a more naturalistic view. As Young Man (1992: 86) states,

"there is a deep-seated need in Western and Native American thinking to resolve these conflicts to our mutual satisfaction."

A good place to start an appreciative study of Indigenous art is at the beginning or, at least, where we *think* we have a beginning. This is with regard to the genre of rock art in the form of petroglyphs and pictograms. It is relevant to note that where Indian art is concerned, the only major corresponding form of art between traditional Native North Americans and the art once located in Europe, is probably petroglyphs and pictograms.

Traditional Aboriginal Art Form

Rock Art

Rock art is probably the oldest form of Indigenous art. Rock art is made up of pictographs and petroglyphs (engravings), both of which can be located throughout North America on vertical cliffs, rock shelters, boulders, and flat rock surfaces. These engraved effects were realized by scratching, scraping, grinding, or pecking, and both painting and engraving lend themselves to a solid or outlined technique. Archaeological estimates suggest that these art forms are at least 25 000 years old, and were produced by nomadic gatherers and hunters of the past. Many contemporary artists have been inspired by these images and have attempted to decipher their often hidden meanings.

Rock art has fascinating stories behind each scene, but unfortunately, many sites have been lost or deliberately destroyed over the years. One very unique site, Ludlow Cave in South Dakota, has been completely destroyed. Although it is speculated that rock art was originally created for a variety of purposes, many sites are still regarded as sacred places by Aboriginal people. It is fortunate for rock art enthusiasts that more than 1 200 sites remain in the Northwest including Alberta, Saskatchewan, Montana, Wyoming, and the Dakotas.

The first written records describing rock art were made by explorers Lewis and Clark after 1804, who noted that some rock art was designed for such ceremonial purposes as puberty and fertility rites, hunting magic, weather control, and possibly healing ceremonies (Haberland, 1964: 19; Grant, 1971: 242). Many rock sites chronicle the long histories, hunting ceremonies, and religions of the region's First Peoples. Often located near awesome natural scenes of beauty, rock art forms were created to reflect a deep respect for the mystery of nature which was viewed as charged with spiritual energy. Ethnographic, archaeological, and historic records are replete with references to visions, offerings, and burials at such places. There is also evidence that imagination was a potent force in the conceptual thinking of the prehistoric peoples. As Brandon (1975: 347) points out, paleolithic sketches of females were not in any way exact likenesses, and did not delineate facial features. They were purely creative and imaginative, not representative forms. This indicates that female portrayals were carefully overemphasized or deemphasized as a means of projecting more imaginative forms.

Among the best-known rock art sites is Writing-on-Stone Provincial Park in southern Alberta. Here, hundreds of petroglyphs as well as some pictographs are located on sandstone bluffs and spread along some 30 kilometres or so on the Milk River. Blackfoot elders say that people used to go to this site for vision questing. One respected shaman, for example, went there to commune with the spirits about the future. Individuals with artistic inclinations were sometimes inspired to create their drawings by resident spirits. To commemorate a successful vision, the seeker might give thanks to the spirit world and perhaps paint pictographs of the guardian spirit or other dream subjects. One elder who visited the site reported getting the power to hunt from a deer and the power to gamble from a fawn (Keyser and Klassen, 2001: 38). The best portrayed scene at Writing-on-Stone is the battle scene. It may have been recorded after the battle between Peigans and Gros Ventre. Some say it may have been put there before the battle as a warning to the Peigans.

Another site of interest is the Peterborough Petroglyphs, discovered by anthropologists in 1962, and located near the City of Peterborough, Ontario. Recently the site has become an international attraction, motivating authorities to erect a covered building to protect the site from damage and natural decay. The most distinctive scenes at this site are narratives describing battles and other activities in graphic detail. Images of carts, horses, and rifles give evidence of the continuity of rock art well into the post-contact period (Champagne, 1994: 553).

McMaster (1999: 87) suggests that the Peterborough petroglyphs are equivalent to France's cave paintings at Lascaux in being the most famous of their kind in that country. The Lascaux paintings narrate art history throughout Egypt, Greece, Italy, the colonial North, and South America. The Peterborough Petroglyphs date the beginning of Canada's Aboriginal art history. One difference between the two sites is that the Peterborough Petroglyphs are still used by Aboriginal people as a source of inspiration,

wonder, truth, and understanding. In a real sense, these petroglyphs are visual mediators between two worlds, past and present.

Authorities have identified two basic types of rock art, distinguished by such characteristics as subject matter, forms used to illustrate subjects, compositional relationships, techniques used to produce designs, and specific landscape setting. Procedures used to date rock art include association with dated archaeological deposits, that is, sometimes a piece of rock art may have fallen off and appears to be older than the materials burying it. Sometimes rock art may be associated with dated portable artifacts or art, and sometimes the same design may be placed on a rock panel as well as on a nearby portable object that can be dated. At times it is possible to date portable items introduced by Europeans (like guns) and use them as a base by which to date nonportable rock art. Also, if a number of certain designs are consistently superimposed on a piece of rock, a generalized chronology may be implied.

Experts sometimes use patination and weathering to date rock art, for example, when a petroglyph is pecked or incised, it exposes a lighter color stone beneath it, and the rock varnish may slowly reappear. Over time the design may become repatinated so that it is changed to the same color as the unaltered rock face. Finally, it is sometimes possible to date rock art with chronometric methods such as radiocarbon dating, which measures the radioactive decay of unstable carbon isotope relative to its stable isotope, accelerator mass spectrometry, and cation ratio dating.

Centuries ago, Aboriginal artists used quite primitive technology and created rock art mostly made by incising and pecking. Their pictographs were usually painted on rock surfaces using only one color with pigments taken from a variety of elements and made permanent with a covering of blood, eggs, animal fat, plant juice, or urine. Created forms were often representational in the shape of humans, animals, plants, weapons, teepees, real objects, or celestial bodies.

Keyser and Klassen (2001: 28f) suggest that in the traditional Aboriginal way of life, a great deal of rock art originated in the spirit world. Since the Indigenous people believed that everything in life represented a celestial order, all objects and beings were seen as having sacred spiritual powers. This perspective has sometimes been difficult for researchers to appreciate. As a result, rock art has often been misunderstood. It is now realized that interpretations which take Aboriginal metaphysics into account, allow for knowledge flow that is not obtainable anywhere else.

Anthropologists who first interpreted rock art produced descriptive studies, basically because no one knew what else to do with them. Original EuroAmerican speculations ranged from the notion that petroglyphs were mere doodles executed to relieve boredom to the arbitrary application of a host of weird religious or superstitious speculations. Some early observers conceived of the petroglyphs as maps of buried treasure, diagrams of astronomical phenomena, or regarded them as proof of the existence of foreign language groups (Haberland, 1964: 19). Consultation with elders has

been undertaken only recently and resultant interpretations have been quite different. Now, thanks to increased faith in the oral tradition and the assistance of elders, it has become possible to decipher some degree of function or meaning from rock art. As it turns out, using inferences from known pieces, it has been deduced that most rock art depicts traditional explanations for images and relationships between rock art and other aspects of human nature. A more difficult challenge is to determine the underlying dynamics of the belief system that influenced these creations.

Penney (2003: 112) suggests that ancient rock art was primarily used as an aid to memory. Potawatomi healers, for example, would carve signs to indicate the location of medicinal plants in order to remember where the plants were when they needed them. Woodland Indians used small indicators carved on rock to indicate tribally-important locations. Most rock art, like other art forms had spiritual or cosmological implications. Other purposes included recording significant historical events. Ojibway men carved war clubs that had explicit images of military and spiritual biographies. Plains warriors recorded visionary experiences on war shields made of double buffalo hides as a permanent reminder of heroic deeds or battle honors. Visions were powerful motivators for a variety of behaviors. For example, a Paiute prophet named Wovoka had visions that led to the origin of the Ghost Dance. He promised that performances of the dance would bring about the return of the buffalo and resurrect the traditional Indian way of life. The western magpie was Wovoka's spirit guardian.

By the 1860s, AmerIndian cultures had changed significantly, and rock art became a diminishing art. Plains Indian men often resorted to use of ledgers or account books that they had traded for or found through some source to record important events. Two decades later Aboriginal women also entered this domain and began putting pictographic illustrations in their beadwork designs. By the 1890s, several decades later, portrayals of cultural and ceremonial life began to appear, many of them produced by young people who had never seen traditional battles. The winter count, a pictorial expression of naming the years from winter to winter was suddenly portrayed in various art forms. For example, an entry might be, "I was born the year they left the bad corn standing." Then, as though nothing was considered too sacred any more, even the Sundance was recorded in beadwork. Afraid that their traditional beliefs and art forms would be lost when the reserve system was established, many individuals began to use pictographic forms on paper to preserve accounts for succeeding generations.

Many such drawings were commissioned by Indian agents and their sale brought necessary funds to needy families and set the stage for the new genre of Aboriginal art that was to follow.

Flint Art

The fluted point has sometimes been depicted as representative of ancient Aboriginal art since it dates back to the time of big game hunters who lived around 10 000 to

5 000 BC (Wedel, 1978: 188f). The big game hunters pursued mammoths that were far bigger and more terrifying than the buffalo of later times. Stone quarries where flint was first mined and shaped provide information about the relationship of maker to material. The fluted point is an independent North American version of Old World productions. Finds of abandoned carcasses show that the hunters worked in teams and used fluted points that differed significantly to reveal the individuality of the maker (Patterson, 1973: 8).

One of the most important mammoth finds was discovered in 1974 at Hot Springs, South Dakota. This mammoth site is the world's largest find of Columbian mammoth bones and dates back about 2 600 years. Scientists believe that as many as 100 mammals died in this former slippery-sided sinkhole over a period of 300 to 700 years. To date, 51 mammals have been discovered including a mammoth nearly five metres (14 feet) in height. Twenty-seven other species have also been identified.

A flint point.

The Mammoth Site was discovered in this fashion: One day a building contractor was excavating a site not far from the Town of Hot Springs when his surprised crew unearthed the bones of several mammoth-sized creatures. Work on the site was stopped immediately and archaeological experts were called in to investigate. It turned out that not far beneath the ground were the remains of a giant sinkhole into which many animals had slipped over the passing years. The contractor sold the site to the state historical society at cost, and work on restoration began. Today, the site's successful research and interpretive programs serve as models for developers of paleontological and archaeological sites in Colorado, Kansas, Nebraska, South Dakota, Texas, Virginia, Wyoming, and Saskatchewan.

Tree Art

A long time ago the First Nations of the northwest coast created art by carving and painting designs on trees. In a sense, these art forms are similar to petroglyphs and pictograms, but placed on trees instead of rocks. Very little of their artistic expression exists today, although some elders know where to go to find these treasures which are often hidden in inaccessible pockets of the landscape. One form of tree art consists of carving a face into a tree trunk, sometimes exposing the wood of the tree by removing the bark. Blackstock (2001: 4) suggests that on first viewing such a phenomenon, the viewer senses that he or she is looking at a living spirit. Some elders suggest that the spirits will guide sincere, appreciative searchers in finding these art forms.

West coast elders believe that tree carvings and paintings are markers of their history and culture. They are symbols created to transmit important messages to succeeding generations. By using trees as background to these art forms, they metaphorically convey the truth that trees have branches, and may be thought of as representing succeeding generations. In fact, a forest may be perceived as a set of stories, rather than as a single account.

The number of functions for tree art are staggering, but may be classified into three categories: (i) arborograph, which is a drawing on the exposed wood of a tree; (ii) arboroglyph, which is a carved image on the bark or exposed wood of a tree; and, (iii) arboroscript, which is a written or printed text in the bark or exposed wood of a tree (Blackstock, 2001: 9). Carved human faces may have been created as a means of remembering individuals who have passed on. Others may have been created to convey special spiritual messages. Still others may have been designed for the purpose of marking trails, property boundaries, or hunting or fishing grounds. As Blackstock (2001: 187) observes,

West coast style tree art.

> The artists of long ago, and a few contemporary First Nations artists, have created these markers as witnesses to events such as visions quests, burials, trapping practices, trading, or the establishment or exchange of territory. . . . I hope people can appreciate tree art for its aesthetic and spiritual power.

Basketry

Native American basketry has been accorded special importance in the idealization of Aboriginal culture and art, possibly because so many First Nations created it. Using the evolutionary approach that dominated anthropological thinking in late Victorian times, baskets were thought to represent the first stage of women's art, manifesting a rather high degree of sophistication before pottery and weaving became mainstays. Basketry was also interpreted to be indicative of a time when Native North Americans lived close to nature. For example, Herbert Spencer, a nineteenth century anthropologist, believed that primitive peoples' keen awareness of the environment precluded them from functioning at a higher conceptual level (Potter, 1999: 47). This view also helped perpetuate Jean Jacques Rousseau's myth of the "noble savage." Cohodas (1992: 90) observes,

> Native American basketry also exemplified a second tenet of the Arts and Crafts style: ornamentation must be true to the material and form of the object, so that aesthetic and utilitarian components exist in perfect balance. . . . She [the basket weaver] retains in her baskets the full measure of usefulness, while, at the same time, she inscribes upon them her personal translation of the world lying about her.

Before pottery and weaving, First Nations relied on the art of basket making.

As the curio trade continued to flourish, basket makers responded in kind. To satisfy the demand, a rash of inferior baskets using simplified methods of informal techniques were released to the market, often debased by the incorporation of letters or words into designs. Weavers sometimes complained they were bored with replicating older "traditional" designs that their purchasers considered "authentic." The weavers wanted to invent new arrangements of locally accepted elements. These new designs were woven and sold to unsuspecting tourists who thought they were purchasing "traditionally-pure" baskets (Schevill, 1992: 171). In some instances, patrons moved in on the scene to represent particular basket makers, perhaps as a means of promoting a particular standard of production or simply to exploit the artist.

Interpreting Aboriginal Art

Three major theories dominate the interpretation of First Nations art including the evolutionary approach, the historical-diffusionary approach, and the psychological approach. The evolutionary theory was popular among anthropologists around the beginning of the twentieth century – these interpreters prognosticating that as time progressed, Aboriginal artists developed better skills in reflecting the foundations of their cultures. The historical-diffusionary approach concentrated on the linkage between form and meaning and the spread of motifs and styles across cultural lines. This theory would account for cultural borrowing of artistic designs among AmerIndian tribes as well as the influence of European-derived styles. Third, the psychological approach adopted a slightly wider swath to include consideration for cultural change, the integration of culture, and the role of the individual (Jacknis, 1992: 136).

Anthropologists use the word *diffusion* to describe the manner in which objects and behaviors trickle across cultural borders from one people to another, and art is no exception. Simply put, when the Europeans arrived, the impact of their artistic forms on Aboriginal art was immense. Simple drawings featuring humans and animals were suddenly being accompanied with embellishments such as guns and horses. Other previously omitted items now appeared including villages, teepees, hills, rivers, and trees. Nonrepresentational art forms became evident and human forms lost their rectilinear forms; instead the contour of their bodies became curvilinear. Arms and legs were drawn anatomically more correct and faces began to reveal specific features. Use of mass-produced European materials allowed a more hectic and flamboyant surface appearance and seemed to further liberate the already vivid Indigenous imagination. Native artists enjoyed the bright and bold patterns which helped affect a change in clothing styles. Before the Europeans came, the Aboriginals did not wear shirts, jackets, or other European-styled garments, and women did not wear blouses. After the Europeans arrived Aboriginal women adopted their form of dress and easily took to silks, satins, velvets, ribbons, and sweeping skirts (White, 1979: 184). The end result of European influence was a modified form of Native art that incorporated three characteristics: (i) it reflected the conventions of European artists, (iii) it was ideographic, and (iii) it still depicted Aboriginal cultural life.

The initial perception of traditional Indigenous art as inferior by European explorers pretty much remained as a template for the next two centuries. Diamond Jenness' popular work published in 1932, perpetuated this viewpoint. As Jenness noted (1986: 209),

> On the plains there was no sculpture worthy of mention, and the realistic paintings on robes and tents were pictorial records rather than expressions of artistic impulse. Geometric figures on rawhide bags (parfleches) showed considerable skill in line-drawing and often produced pleasing effects, but

their repetition of straight lines, zig-zags, triangles, and rectangles, had the
taint of monotony.

It was Jenness' position that European impact on Aboriginal music was insignificant,
but their other art forms were so severely impacted that it became difficult to differen-
tiate older forms from those influenced by diffusive influences. Jenness noted that the
intensive process of assimilation was evident in realistic instead of representational
forms of animals, birds, and human beings that were being carved on stone pipe bowls
of clay. Jenness perceived Indigenous art, before European contact, as simplistic and
crude suggesting, for example, that on the plains there was no sculpture worthy of
mention, and the realistic paintings on robes and tents were pictorial records rather
than expressions of artistic impulse. He did acknowledge the considerable skill of line
drawings on rawhide bags (parfleches), but went on to interpret them as repetitious
and monotonous (Jenness, 1986: 200).

In denouncing Aboriginal art forms, Jenness was inadvertently expressing the
opinion of the times which he described as economic and social apartheid (Getty and
Lussier, 1983: 160). Confined as they were to reserves, the First Nations were given lit-
tle opportunity to acquire technical training or experience that would have fitted them
for the changing economy of the times. Not only was their standard of living inferior
to that of their non-Native counterparts, they also lacked the opportunity to acquire a
good education. These circumstances did not change until the latter part of the twentieth
century, and even then, they affected only a small portion of the Indigenous population
of Canada.

Ewers (1981: 108) cautions that historians have often failed to take into account the
validity of pictures and photographs as integral portrayals of past happenings. These
resources need to be evaluated by the same scholarly identification, explanation, and
determination of authenticity as other, more familiar sources. In fact, during the second
half of the nineteenth century, there were at least one hundred fifty artists who paint-
ed portraits as well as aspects of Plains Indians lifestyle. Many of these pictures
appeared in popular publications such as *Harpers* and the *Illustrated London News*.
Unfortunately, not all photographs featuring First Nations were accurate in any sense
of the word.

Historians are familiar with the work of Edward S. Curtis who, around 1900, decided
to capture the image of the Indian in a series of twenty books covering First Nations
cultures from Alaska to the American southwest. The series contained 1 500 prints,
each volume also containing corresponding copperplate photogravures (Francis, 1992:
39). Although Curtis was praised for his authentic portrayals of Indigenous life, in fact,
he doctored his pictures to render a particular lifestyle. He often equipped his subjects
with props, such as wigs and other selected items of clothing, as a means of showing
Indian life the way it was perceived before the coming of the Europeans. Curtis
believed in a timeless Aboriginal past where nothing really ever changed. He was not

interested in the way Native people actually lived; he was more concerned with perpetuating a picture of what might be called "the imaginary Indian."

Curtis's view was shared by Edmund Morris, a Canadian painter-author of some note. Morris felt a certain tragedy about the First Nations because Canadians generally failed to have regard for their contributions to Canadian history and culture. Morris was primarily a painter of Indian portraits and generally portrayed his subjects as members of a passing noble race that had simply been overwhelmed by civilization. Morris's view was shared by Canadian playwright Nancy Rankin, who described the First Nations as primitive people who had been placed on reserves and forced into a way of life for which they were not suited. This explained why they had become "total degenerates" (Haycock, 1971: 9). Rankin expressed her sympathy for educators charged with working among Aboriginal people. She cautioned that they would need a lot of faith, hope, and charity in order to function effectively in their jobs.

The misrepresentation of First Nations culture after European contact was basically two-sided: first, no one bothered to study and perhaps understand the Native way of life; and, second, those who made the above statements were driven by ethnocentrism which, at best, tends to steam-roll across any different cultural belief or practice in its path. One of the reasons why Aboriginal art was misunderstood was because it, like every aspect of Aboriginal culture, was steeped in spirituality. Much of the inner meaning of their creations was lost on incoming Europeans. White (1979: 180) contends that the resultant cultural clash caused the loss of many traditional meanings. He suggests that only in a few places, such as the southwest and the Arctic, have the rudiments of Indian culture and art been preserved. Even then, those that persisted have been subjected to myriad mislabels and misinterpretations. Champagne (1994: 557) agrees, contending that very few colonial period artworks remain within Native communities where their genre might be continued. Most art works were "collected" (purchased, stolen, received as gifts, or otherwise appropriated), by early traders, settlers, missionaries, and government agents.

A second reason why Aboriginal art has been misunderstood is because it was executed in a style unfamiliar to incoming Europeans. To them, art had to be produced in approved forms and comply with specific criteria in order to be considered valued art. Unlike much European art, which was essentially objective or representational in meaning, Indian art was primarily subjective, and dealt with dreams, visions, the imagination, and interior life. Its purpose was to appeal to the inner senses, to demonstrate meaning in expressionistic and symbolic avenues. Although it took some time, centuries in fact, for non-Natives to appreciate the genre of Indigenous art, this did eventually begin to happen. As White (1979: 245) observed,

> It is in his art and in the revival of his handicrafts that the inner life of the Indian seems to express itself most forcefully and effectively. . . . into them he pours his heart and soul. . . . The voice of the Indian writer is vivid and

distinctive, and his subject-matter possess a mysterious and elevated quality
that is already acting as a leaven in the American and Canadian literature
in which it is embedded.

In the early part of the twentieth century, there were attempts to reclassify Aboriginal arts as art instead of ethnography, but these were not successful until the 1960s and 1970s. A group of curators and patrons in Santa Fe, New Mexico, helped broker this shift by trying to influence popular opinion about the positive value of American Indian culture and art. They feared that most tourists who visited the area still wanted to purchase curios, not genuine Aboriginal art. The arrival of the turbulent 1960s gave opportunity for North Americans to reevaluate all aspects of life and determine what was important to them. This was an opportune time to emphasize that Native Americans, too, were part of the evaluation process. Many hippies and new age worshippers began to study Native American spirituality and determine if it had a place in their soul search. The intellectual and social climate of the continent was ripe for discovering and embracing First Nations cultures and spirituality. With that appreciation came a new perspective on Indian art.

In the 1970s, things continued to change. Exhibitions at the Whitney Museum in New York City, the Walker Art Center in Minneapolis, and the Nelson-Atkins Museum in Kansas City, permanently altered the long standing status of American Indian art (Bernstein, 1999: 60). These exhibitions emphasized the religious and ceremonial aspects of Aboriginal culture instead of its ethnographic essence. It was finally the Indians' turn, and the development of American Indian art galleries soon became a reality. Although operated by non-Natives, and strongly promoted in the American southwest, the move did change the public's perspective of Native art as craft or curio. Non-Native purchasers began to seek out Native artists and this encouraged the foundation of Native-run galleries. Gradually, First Nations art was being awarded its rightful place alongside that of representing cultural heritages.

An anthropological concept that is gradually coming into its own is cultural relativity – the ability to view a different cultural configuration from the vantage point of that particular culture. Most observers of cultural patterns other than their own, tend to judge them from the perspective of the culture within which they were raised. It takes real effort to throw off the yoke of prejudging lifestyles other than one's own. When it does happen, new insights and expanded horizons can emerge.

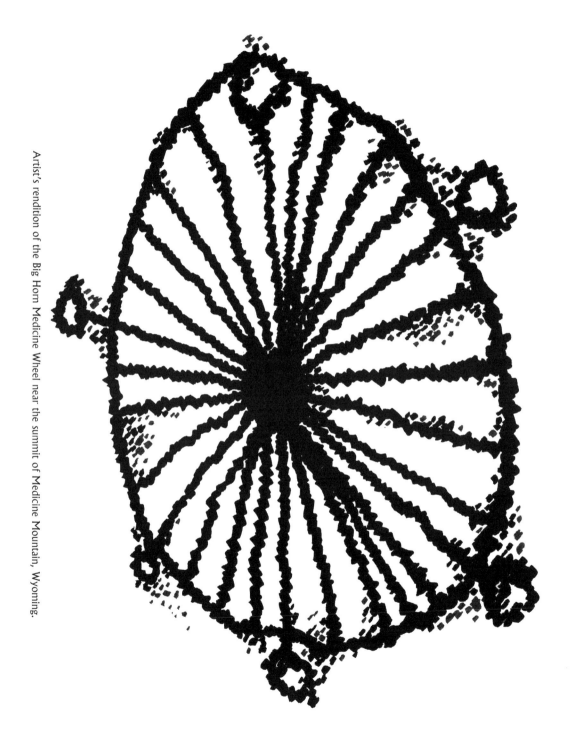

Artist's rendition of the Big Horn Medicine Wheel near the summit of Medicine Mountain, Wyoming.

Chapter Three
Aboriginal Art and Spirituality

They extended symbolic thinking to many everyday acts; for example, when a woman did some beadwork or painted a skin bag to beautify it, the designs she used were given names suggesting hidden meanings and sometimes ideas of deep religious import (Wissler, 1966: 110).

We saw the Great Spirit's work in almost everything: sun, moon, trees, wind, and mountains. Sometimes we would approach the Great Spirit through these things. – Tatanga Mani (Walking Buffalo), Stoney First Nation (Kaltreider, 1998: 138).

The cosmological principle of balancing antithetical elements is also hinted at subtly in the asymmetrical use of color in decorative designs on formal clothing. Contrasting colors may be used on either side of otherwise symmetrical designs, or pairs of designs may alternate colors (Penney, 2004: 67).

It was an awesome moment. We stood on top of one of the Big Horn Mountain peaks in northern Wyoming and gazed at a magnificent medicine wheel constructed many years ago, perhaps by Arapaho, Cheyenne, Crow, or Sioux Indians. Designed as a site for spiritual worship, the Big Horn Medicine Wheel lies at an altitude of about 3 000 metres (4 800 feet) near the summit of Medicine Mountain, one of the highest peaks in the Big Horn range. The medicine wheel measures 25 metres (80 feet) in diameter and features 28 spokes and six cairns. This is probably the most elaborate and best protected of known medicine wheels on the Great Plains. It is commonly believed that the spokes of the wheel were originally aligned with astronomical events such as the position of the sun on the day of the summer solstice. Another interpretation is that the medicine wheel was purely symbolic and intended as a visual representation of sacred principles by which to interpret the universe. Traditionally it was the practice to build medicine wheels for a variety of different purposes, either as burial mounds or for decorative or commemorative purposes.

The Big Horn Mountains were considered sacred by a number of Plains First Nations including Arapaho, Cheyenne, Sioux, Shoshone, and probably others. Oddly, when news about the existence of the Bighorn Medicine Wheel was made public in the early twentieth century, none of these tribes claimed to have known about its existence. There were only vague clues about the existence of the wheel, but no concrete information was available (Eddy, 1977: 150). Archaeologists estimate that the wheel may have been built for calendric purposes, specifically to mark the summer solstice and certain stars of the midsummer dawn. Today, the Big Horn Medicine Wheel is guarded by a fence although it is open to cardcarrying Indigenous people who wish to offer prayers or conduct ceremonies at the site. During our visit we observed individuals engaging in offering prayers, and knew we were part of something very special.

At one time, there were hundreds of medicine wheels in North America, usually constructed by Plains Indians for spiritual purposes. They were built on mountain tops or on the plains, wherever the First Peoples felt they were needed. Much of the land on which they were constructed was glaciated during the last (Wisconsin) ice advance. This formation made available the high short-grass plains and foothills where there was abundant glacial or loose rock to pile. Authorities estimate that at one time there may have been as many as 40 or 50 medicine wheels in Canada, specifically on the plains of Alberta and Saskatchewan. So far, only one medicine wheel has been located in the Dakotas, four in Montana, and three in Wyoming (Eddy, 1977: 153). As an art form, the medicine wheels were usually quite simple in design. Built in the formation of a circle with a cairn of rocks in the centre, they typically had four spokes emanating from the centre in the four directions. Although uncomplicated in design, the purpose of these structures firmly expressed the underlying spiritual foundation of Plains culture.

Defining Spirituality

Unlike the spiritually tumultuous decade of the 1960s, when many protesting groups defied all forms of organized religion, today it is quite appropriate to discuss spiritual matters since religious themes are so often affiliated with topics on the world news. Many international sites of political unrest are connected to religious fanaticism of one kind or another, and viewers are becoming familiar with references to related underlying belief systems. Unfortunately, a deeper knowledge of the basic fundamentals of the represented belief systems is often lacking.

A similar situation prevails with regard to Indigenous faith perspectives which, in the past, have often been construed as just another form of religious belief – heathen or superstitious at that. Historically, it was a EuroCanadian habit to describe alternative belief systems as heathen simply because the First Nations were not Christians. There was no middle ground; people were either categorized as Christians or heathen, and

the heathen had to be saved. This ingrained perspective obviously made it very difficult for the European newcomers to appreciate the intricacies of Aboriginal metaphysics.

Although some scholars still use the word 'religion' to define traditional Aboriginal spirituality, it is fundamentally inaccurate to describe their belief systems as "religious" in the modern sense. A careful analysis of traditional Indigenous belief systems reveals that the word 'spiritual' is much more appropriate since theirs was a perspective that pervaded all aspects of life. This statement cannot easily be exaggerated because the ancients, daily, spent much time in spiritual activities. As Sioux leader Charles Eastman, put it, "In the life of the Indian there was only one inevitable duty – the duty of prayer, the daily recognition of the Unseen and the Eternal. His daily devotions were more necessary to him than daily food" (Friesen, 1998: 21). For Aboriginal people, spirituality has always been understood as an effort to participate in the mystic; the search represents a need to deal with the grand existential and metaphysical questions that we must all face (Rushing, 1999: 170).

Among traditional Indigenous societies, the earth was regarded as a foundation for spiritual activities and even *being* itself. Mother Earth was regarded as the Provider and Caregiver, the Sustainer of life itself. As Paula Gunn Allen (Houle, 1991: 61) describes it,

> The earth is the source and the being of the people, and we are equally the being of the earth. The land is not really a place, separate from ourselves, where we act out the drama of our total destinies; the witchery makes us believe that false idea. The earth is not a mere source of survival, distant from the creatures it nurtures and from the spirit that breathes in us, nor is it to be considered an inert resource on which we draw in order to keep our ideological self functioning, whether we perceive that self in sociological or personal terms.

Although scholars have reliably documented significant cultural differences among the various Aboriginal peoples at the time of European contact, their belief systems featured a degree of unanimity. Fundamentally, the daily spiritual activities of the First Nations of North America centuries ago, overshadowed and completely absorbed their lifestyle. Arts and crafts were no exception because spirituality was an all-pervading phenomenon. By contrast, contemporary Canadian forms of religion may be defined as "fulfilling a separate, innate category of the human consciousness that issues certain insights and indisputable certainties, about a Superhuman Presence" (Friesen, 1995: 19; Runes, 1967). There are other differences; formalized religion can be dichotomized, broken down, and separated into parts, and it may be differentiated from other life concerns. Being religious means to be sincere about something; it could be an activity, a cause or campaign, or an enterprise, and it will absorb a great deal of devotion and

energy. By contrast, Aboriginal spirituality does not target an activity or cause, it is not a significant component of life; in a very real sense, it constitutes life itself.

An examination of First Nations spirituality reveals that the three criteria – beliefs, duties, and hopes, can only minimally be applied.

Beliefs, Duties, and Hopes

The original peoples of North America had fairly definitive beliefs about the universe and their role within it, but these beliefs were never mandated as individual necessities. The universe, the earth, and all natural resources were perceived as gifts from the Creator, the Great Spirit. It was assumed that appreciative behavior for these gifts would be a logical response on the part of recipients and frequently expressed in prayer. The expectations of appreciation were not explicitly spelled out; neither was any form of institutional membership required as one might expect in a Bahai, Christian, Jewish, Muslim, or Sikh organization.

The First Nations traditionally built their cultures on a foundation of reverence for the universe and for all living things. They did not differentiate between material and nonmaterial phenomena or between humans and animals. The threads of ordinary life and spirituality were so tightly interwoven that the sacred and the secular were indistinguishable (Zimmerman and Molyneaux, 1996: 767). The First Nations believed that the universe functioned on the basis of interdependence and interconnectedness. Theirs was a holistic perspective. All living things, indeed every living entity was perceived as having a connection to every other living entity including humans, animals, birds, fish, and plants. The universe was viewed as a complex unity, composed of variety and diversity, but still comprising a synthesized whole. The implied obligation of humankind, therefore, was to live in harmony with the rhythms of nature and respect its balance. For Indigenous people, this implied affording equal respect to all living things, hence the Sioux saying, "All my relations."

The Aboriginal awe shown the universe naturally translated into a resignation to work with the forces of nature. No attempt was made to dominate or exploit nature; instead individual and community responsibility was to work in harmony with it. A profound regard for the earth was central to this view, a gift from the Great Spirit. The earth was never regarded merely as soil; it was seen as the source and sustainer of life – a foundation of energy flowing through the circuit of soils, plants, and animals. Land was never owned, but assigned to the stewardship of humankind by Divine authority. Divine approval for care of the land, which was evident in the form of ample sustenance and good health, was dependant on a community's humility, prayers, and obeisance.

There were other traditional Indigenous beliefs worth noting, particularly their concern about remaining spiritually in tune with the universe. In this spiritual quest,

little emphasis was placed on activity per se, because activity was always viewed as a means to an end. Another highly valued axiom was looking after family members. Any band member in need or, for that matter, anyone who was even remotely related to an individual with resources (usually by kinship), could expect to have their needs attended to by that individual. These expectations were even more firmly cemented in tribes that featured clan systems. The biblical injunction, "It is better to give than to receive" (Acts 20:35b), was core to the essence of Indigenous faith. Anyone who had resources to share was expected to do so; it was never appropriate or necessary for anyone to beg for help. Community meant just that; we are all in this together!

The word 'eschatology' refers to the study of last things. Eschatology is the division of metaphysics that deals in final events; its principal concerns have to do with the destiny of individuals and the final state of the universe. Related questions include, "What happens when people die? Is there life after death? What should individuals do to prepare for life in the hereafter (if there is one)?" and, "What will be the future state of the universe?" There are no scientifically supportable answers to these questions, of course, but that reality has never stopped theologians and philosophers from speculating. Some have even dared to elaborate their suppositions in volumes of print. As time passes and their forecasts prove wrong, the originators scramble to recalculate and reinterpret their faulty and erroneous prognostications.

The Aboriginal peoples of North America were rarely eschatologists. As a result, they seldom had to face the embarrassment of witnessing errors in predicted occurrences after unsupported speculations about the future, or about future life, not happening the way they were forecast. The original inhabitants of North America valued the present too much for that. Adherence to the oral tradition also precluded that possibility because life was viewed as a phenomenon of the here and now; it was to be lived with a perpetual appreciation of the moment. If the Creator was good enough to grant an individual another day, this was sufficient. They were not about to second guess the Great Spirit.

The Indigenous people of North America have frequently been targets of frivolous talk about eschatology with reference to their alleged belief in something called the "happy hunting ground," a place to which individuals allegedly migrate after death. Generally speaking, there is little support for such an idea because eschatological speculations were not a crucial component of the North American Indian worldview. As Eastman (1980: 149) put it,

> The attitude of the Indian toward death, the test and background of life, is entirely consistent with his character and philosophy. Death has no terror for him; he meets it with simplicity and perfect calm, seeking only an honorable end as his last gift to his family and descendants.

The notion of a happy hunting ground was invented by a non-Native source as a parallel to the Christian version of heaven, also known as the abode of the deceased

who live justly. Aboriginals, on the other hand, have never delineated a difference in kind between the spirit world of their existence and any possible future state. They have always perceived the human world as permeated by spirit beings who enter and leave the human domain. Aboriginal philosophy does not differentiate between human and animal spirits, but assumes that every living thing, soul, or spirit possesses spirit as an animating and personifying principle (Berlo and Phillips, 1998: 24). There are also tribes that traditionally believed in reincarnation in the sense that some individuals could die and return to the human domain in other forms.

If the spirit world of the Indigenous people could be separated from Immanuel Kant's perceived phenomenological realm, there have always been plenty of people willing to try to make contact with it through various means. Traditionally, the Indigenous people also believed in an afterlife domain of the spirits, but procedures for making contact with that world were never specifically spelled out. That there was a future state was not in dispute, but its precise specifications were never elaborated. What mattered was how individuals lived out their daily lives in response to the design that the Creator had designated for them. They were expected to live life purposefully and seek to understand life and its learning opportunities as a process toward becoming complete (Cajete, 1994: 148).

Spirituality and Art

> To the Indians, all life is sacred, part of the infinitely renewable cycle that permeates and defines their cosmology. A critical element in this cycle is their relationship with the land – their reverence for Mother Earth. . . . they viewed themselves as caretakers of a realm that defied individual ownership and, more important, was beyond value (Walters, 1989: 18).

The current crescendo of interest in religion and spirituality, particularly the latter, is encouraging because this means that a new appreciation for Aboriginal belief systems may also be emerging. Discussions of religion were somewhat taboo in North America during the latter half of the twentieth century, but recent world events of global proportions have spurred motivation to search out the foundations for such claims. It is useful to acknowledge that the contemporary enamor with underlying beliefs flag a spiritual interest rather than one in organized religion per se. For this reason it is essential to differentiate between religion and spirituality.

Religious influence is everywhere, and, depending how one defines the activity of "being religious," so are religious people. The *Dictionary of Philosophy* (Runes, 1967) suggests that religion fulfills a separate, innate category of the human consciousness that issues certain insights and indisputable certainties about a Superhuman Presence. This definition incorporates virtually every system of thought that acknowledges the existence of a Greater Being with powers beyond those of humankind. In a formal

sense, organized religion has three fundamental characteristics: (i) beliefs which inspire fear, awe, or reverence; (ii) a prescribed list of expected behaviors; and, (iii) a long-term promise of eventual respite (hope). Taboos are derived from the first criterion, and are usually translated into a series of "do-nots" in behavior. Most religions offer a form of relief from the human struggle only as an eventual happening, not in this life. Adherents expect to live out their lives with only a minimal experience of happiness or enjoyment.

Spirituality has a much wider cosmic base than religion. A search to satisfy the inner thirst for spirituality incorporates such questions as, "Why am I here? What is the meaning of life? What is the universe all about? Can I benefit from a study of divergent interpretations of the workings of the universe?" For some individuals, the quest to satisfy these queries results in a sombre and serious devotion of energies towards fulfilling a personally-derived cosmic calling – with or without any theistic acknowledgement. Individuals may direct their energies toward the fulfilment of psychological, emotional, or spiritual requirements, and their sincerity and devotion can easily parallel or surpass that of the loyal followers of any organized religious body.

Typically in North America, people think of a religious individual as one who believes in the existence of a Superior Being (traditionally called "God"), and the way to connect with Him is through recipes or formulae originated by an organized religious form. To be religious is to be committed to, and act in accordance with, a code of ethics derived from sources outside and considered "greater" than oneself. The code may not necessarily incorporate a personalized theism, that is, belief in Almighty God. Melford Spiro (Banton, 1966) defined religion as consisting of some form of organized or patterned social behavior, wherein religious adherents respond, both in daily activities and specific rituals, to the perceived will of some entity that is seen as having greater power than themselves. Durkheim suggested that the gods of religion may be nothing more than collective forces, incarnated, and hypostatized under a material form. Thus religion becomes a series of beliefs by means of which individuals represent the society in which they are members and the relationships, obscure but intimate, which they have with it (O'Toole, 1984).

An analysis of any organized form of religion will show that its typical repertoire consists of cultural beliefs that have been inculcated with attending actions that should be taken up (Hewitt, 1993). If individuals have been raised in a particular environment with an explicit religious bent, they may contend that the attending code posits implicit mandatory expectations for the individual, even for society as a whole. It will make little difference if the cultural milieu in question fosters belief in some form of theism. An example of an orientation without theistic reference would be the environmentalist who holds that the cosmos is a given and its origins, cycles, and mandates are not questioned because they are perceived as perpetual. There is an obligation on the part of the human race to care for the earth, keep its air and waters pure, and reprimand anyone who violates this code. Some behaviors of members of one sector of the "earth-love"

movement have, at times, been quite bizarre, for example, spraying paint on the apparel of individuals wearing coats made of animal skin. This kind of act suggests the operations of the universe are superior to people's needs, a value that runs counter to most traditional religious creeds. The incongruity of this kind of behavior is most evident when the person with the can of spray paint happens to be wearing leather shoes made of genuine cowhide!

It is probably true that every individual is "spiritual" in the sense of having firm convictions or special values that relate to or affect the very ground of their being. The criterion that posits these convictions as religious is the fact that they are held as universals with cosmic implications, but emanate from an organized form. The implied creed apparently ought to be followed by every individual, society, and nation. Most people make it easy for themselves to live out their cosmic convictions by attaching themselves to the creed of an established, recognized religious body, but this is not necessarily the only way to go.

Most religious people are misinformed about the meaning of spirituality, obviously influenced into thinking that its expressions are less valid than their own religious affiliation. Partly this happens because religiously-oriented people are not usually trained to investigate religion or spirituality without bias. They may have been taught that spirituality implies belief in spirits (pantheism) rather than belief in monotheism. Historically, spiritualism has not fared well in organized religious circles because its promoters place a great deal of emphasis on the role of the "medium" who allegedly serves as the contact between the seen and unseen worlds. Aboriginal spirituality was, for several centuries, classified as such a form of spiritualism because of the inherent belief that individuals can receive messages or learn lessons from any living entity, human, animal, bird, fish, or even plants. The primary difference between traditional spirituality and Aboriginal spirituality is that the latter does not mandate the necessity of mediation; it can only happen as a supplementary source of inspiration. It is a fact that North American First Nations individuals have always recognized the Great Spirit as a monotheistic being.

Leaders of organized religions typically contend that individuals are "either religious or they are not." If they are religious, they will be expected to defend the particular religious system to which they are connected. Conversely, and most regrettably, if they are not religious, they have probably been viewed as pagans, nonbelievers, infidels, agnostics, or atheists. In truth, they may be none of these; they may be on a spiritual search of their own, the avenues of which may take them outside of the parameters of organized form. Unfortunately, individuals on such journeys often become quite biased toward all forms of structured religion when they could be examining them as potential means by which to attain their own personal spiritual fulfillment. Antitheism, emanating from this kind of stance, is a fairly common contemporary societal force (Friesen, 1995: 21).

The above attempt at clarification may not be too helpful in assisting anyone in their spiritual search, but hopefully it will aid in the development of a more objective perspective in examining alternative ways of thinking and believing. Aboriginal spirituality offers a great deal of intrigue in this regard, having so long been bypassed as a "legitimate" way of believing. Harrod (1995: 30) emphasizes that religious beliefs have always been central to the Indian way of life. Unfortunately, Harrod uses the term religion when the word spirituality would be more accurate. Harrod states,

> Religion was an essential ingredient in the creation and maintenance of the social identities of all these peoples, and religious energies were foundational in the construction of new social relations as they responded to either improved or chosen alterations in their environment.

Today's openness to appreciating the wider parameters of both art and spirituality is encouraging. Some students of Aboriginal culture and spirituality are beginning to realize that the propensity of First Nations, past and present, to link spirituality to every human activity, could have implications for modern life. Some scientists and philosophers have come to the conclusion that metaphysical notions such as nihilism and postmodernism tend to ignore the important sector of ontological meaning. The increased interest in spirituality is most fortuitous because it would be very limiting to ignore the study of legitimate, although alternative, belief systems. If the Indigenous worldview had been explored and appreciated a bit more a few centuries ago, the realms of philosophy and art would have been richer for it. It may not be too late to make up for this deficiency.

Naturally, not all scientists, philosophers, or academics are in agreement regarding the benefits of appreciating or perhaps even incorporating elements of the Indigenous worldview. Nor are they convinced of the merits of its hidden meanings or degree of sophistication, and so tend to designate it as belonging to an earlier, more primitive stage in evolution of civilization. Dissanayake (1990: 92, 95) for example, raises doubts about the claims of individuals who intimate that their personal actions may be influenced by a Divine connection.

> Both artist and perceiver often feel that in art they have an intimate connection with a world that is different from if not superior to ordinary experience whether they choose to call it imaginative, intuition, fantasy, irrationality, illusion, make-believe, the ideal, a sacred dream, the supernatural, the unconscious, or some other name. Often the work is considered to be symbolic of this other realm, as in primitive rituals or in modern psychoanalytic interpretations of art, e.g., primary process; Jungian archetypes.

If Dissanayake's concerns have merit, the implication is that individuals who perceive themselves as having access to a special sacred realm, may be looked upon with suspicion, fear, or awe. This perspective differs from the Indigenous view that *all* individuals can avail themselves of such opportunity and should explore it. This

suggests that not only artists, but individuals engaged in any meaningful human activities, could enhance those enterprises by remaining open to the influences of the universe's unknown realm.

The spiritual bases of Aboriginal art may be explored in a variety of genres dating back to the earliest knowledge we have of First Nations cultures. As the previous chapter has shown, Native art was in plentiful supply before European arrival. More recently a kind of classic Indian art has appeared, much of which has garnered a great deal of interest in the non-Native world.

Classic Aboriginal Art

Historians are generally dependent on archaeological evidence in tracing the development of Indigenous art, and such evidence grew to a crescendo with the arrival of European explorers, traders, and missionaries. Journals kept by these individuals have provided historians with a great deal of information about Aboriginal lifestyles with some reference to their arts. Those who took an interest in Native art and collected and preserved samples, performed an even greater service by sometimes making these forms available for later scientific study. As will later be discussed, the art forms identified in the various culture areas of the country reflected a great divergency of genius and style.

The arts created and practiced by First Nations before the cultural clash, influenced all aspects of their lifestyle from sustenance to social life, hunting, and warfare. Creative designs, styles, and methods were evident with regard to clothing, utensils, weapons, tools, and burials (Ewers, 1939: 3f). Plains Indian painting was done on robes and skins, quivers and medicine cases, teepee covers and linings, shields, drums, and on materials introduced by incoming Europeans. Clothing was decorated with weaving and embroidery, and colors used were usually red, yellow, and brown, and sometimes black, blue, and green. Red, for example, was produced by treating an original yellow ochreous plant with heat. Black was made from charcoal. Typically, paints were ground on shallow stone mortars and preserved in skin bags. During the painting process, artists used hollowed out stones, turtle shells, or old potsherds as containers. A paint brush was made of a beaver's tail, the spongy porous part of a buffalo's leg bone, or from a piece of willow bush or cottonwood tree. A separate brush was used to apply each color.

Ewers (1939) points out that art traditionally served a multiplicity of purposes among Plains Indians. This included social events, sacred ceremonies, councils, and formal events such as special visits. In the latter case, artistically decorated garments symbolized asserted community identity, and expressed individual personal wealth and accomplishment. Many designs were rooted in Native cosmology using the principle of balancing antithetical forms. Interestingly, male artists usually painted life forms related to war or hunting exploits while women created geometric designs such as borders, box, hourglass, or feathered circles.

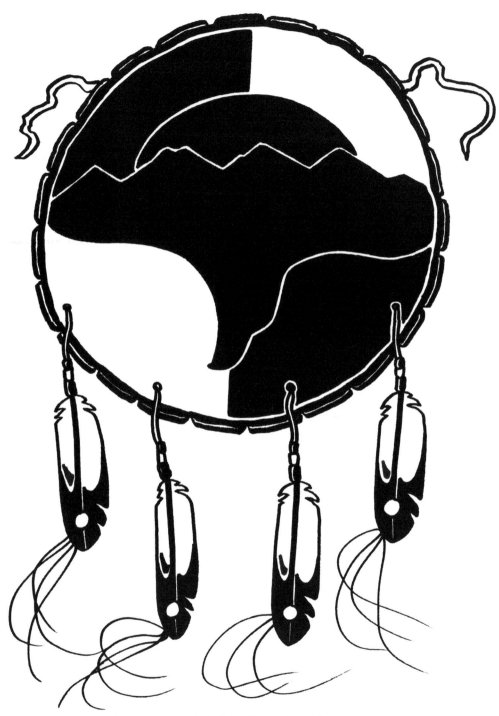

In this shield design, the eagle may represent the individual's guardian spirit.

It should be noted that many Indian designs traditionally placed on everyday items, such as moccasins, were positioned so as to be seen by the wearer, not the viewer (Ewing, 1982: 20). This was true of decorated birchbark dishes, wooden bowls, effigy pipes and pipe bags, drums, woven bags, flutes, and other items. Among the Iroquois, self-directed effigies were often carved on pipes. Directed toward the smoker, these effigies represented the individual's guardian spirit. Smoke was believed to be a kind of incense or intermediary avenue by which to connect with the spirit world. Therefore it behooved the smoker to maintain as close a connection as he could with the effigy. A contemporary interpretation might be that placing decorative symbols in any direction would be to display their beauty, but in fact artistic designs were not intended for the aesthetic enjoyment of others. Their symbolism was strictly intended as a reminder of deeper truths to the wearer. When the Europeans came they influenced the transfer of decorative designs on certain items to the viewer's direction so they could be admired by them. This arrangement fit in better with their worldview.

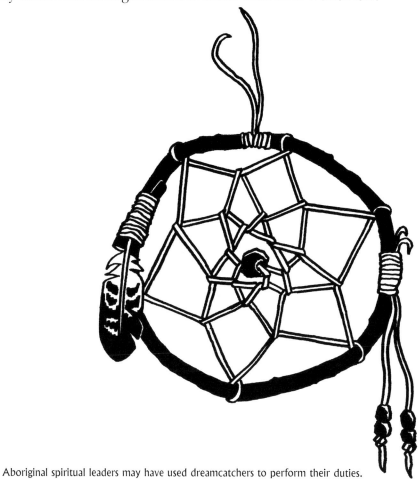

Aboriginal spiritual leaders may have used dreamcatchers to perform their duties.

Shamanistic Art

Pasztory (1982: 27) defines shamanism as a specific form of religious institution in which an individual shaman mediates between people and the supernatural by entering a mystic trance. Use of the word shaman in such a context unfortunately endows it with the magic of antiquity. This rather restrictive definition precludes the possibility that Aboriginal shamans typically fulfilled (or fulfill) the role of religious leader or priest, much as such an individual would in organized religious forms. As religious leaders these individuals do not necessarily or always engage in mystic trances, but often guide seekers toward cosmic answers to ordinary questions using a variety of approaches.

Shamans typically used or use various art forms to perform their duties. Depending on the particular religion under discussion these art forms include visible objects of all kinds. Aboriginal spiritual leaders might use masks, soul or dream catchers, eagle feathers, or sweetgrass. In these instances, the visual appearance of the artifact is not as important as the message it conveys. By comparison, Christian priests may use a cross, incense, a Bible, or a rosary while performing their duties.

European Influence

Although the European invasion influenced a major transformation of Indigenous art, their forms of music were hardly affected. The introduction of new materials usually affects traditional styles, and the First Nations were no exception. The fur trade introduced brightly colored glass beads, silk ribbons, rolled copper, tinned cones, and aniline dyes to replace the more pastel colors of native pigments. Aboriginal women adopted European methods of weaving and needle work and manipulated them to suit the needs of their people. The introduction of beadwork enabled a greater variety art work because beads were easier to work with than native materials such as porcupine quills. Many changes occurred after 1800 due to the intensified contact experienced by First Nations with Europeans.

The arrival of various European groups, explorers, fur traders, and settlers motivated many Native artisans to adapt their craft to meet the demands of trade and later tourism. Many introduced materials had no prototype in classic Indian culture. Brand new products translated into art forms required new visions and interpretations to accompany them. Some new art forms were invented entirely devoid of tradition or spiritual overtones because they were simply copies or downgraded versions of traditional forms. The widespread use of whole animal skins as containers also disappeared from everyday Aboriginal use after the First Nations acquired steel scissors and were exposed to a variety of European pouches and bags. Envelope-shaped pouches with triangular flaps became very popular among the Delaware, Shawnee, and Cherokee tribes. Beautifully decorated, these pouches were desirable items of exchange among Indian bands and were frequently found far from their place of origin. It was typical of

casual vistiors not to be able to differentiate between valid traditional forms and those that were invented strictly for the emerging market. This trend comprised another indication of the creative genius of Aboriginal cultures although informed observers might interpret the move as a weakening of traditional belief systems.

The introduction of the reserve system also affected Native art because a sedentary lifestyle voided the need for many traditional forms of interaction. Warfare was virtually eliminated, thereby affecting the decoration of weapons like shields and war clubs; hunting became a minor activity, and reduced pride in hunting tools. The vision quest also became less important. Military societies were disbanded, and what remained of their ceremonial life was transported underground.

In 1870, the religious movement initiated by the Paiute prophet, Wovoka, featuring the Ghost Dance, struck the northern plains. Wovaka made a number of prophecies indicating that the physical sufferings of his people would eventually come to an end and the buffalo would return in greater strength. He prophesied that the earth would be healed, the dead would be returned to life, and misery and ill health would be eliminated. Wovaka initiated a number of curing rites and rituals and encouraged the practice of the round dance as a symbol of unity. The Ghost Dance gained popularity, no doubt partly motivated by the desperate plight of the people. Its growth mushroomed and soon spread to other tribes but the American government opposed it, fearing that such gatherings might have military implications and give rise to Indian uprisings. The tragic outcome of the movement occurred on December 29, 1890, at Wounded Knee in the Dakotas when the massacre of nearly 300 Lakota men, women, and children broke the spirit of Native American resistance. Interestingly, the Ghost Dance Movement contributed to the artistic front when specially painted shirts and dresses designed for the dance ceremony became popular. These forms of apparel were wrongly believed to be bullet proof and ended in many tragic deaths. Their use today, like the corollary songs, beliefs, and rituals, serve a commemorative function. Artistic expression, it seems, is born even out of very desperate times.

A contemporary form of traditional religious expression is the Native American Church known informally as the Peyote Religion. The movement originated in Oklahoma in 1918 and was practiced by the Kiowa and Comanche First Nations. Its influence gradually crept north to Canada where several small groups still practice the adjoining rituals. Peyote religion has ancient roots among Indigenous people in the area of the Rio Grande River Valley, but it was not always viewed with respect. Steinmetz (1990: 104) argues that peyote visions are the source of shamanistic visions which heal through the imagination. Shamans claim to have special skills for journeying to the planes of the imagination where healing of the body and the planet are possible. The shaman's work is conducted in the realm of the imagination. During the states of ecstasy induced by peyote, healing takes place through imagination.

In modern times, to protect their interests and avoid undue criticism, leaders of the peyote religion structured their organization like that of other religious denominations. Part of their charter of incorporation advocates somewhat similar purposes. The stated objective of the American Native Church is,

> to foster and promote the religious belief of the several tribes of Indians in the State of Oklahoma, in the Christian religion with the practice of the Peyote Sacrament as commonly understood and used among the adherents of this religion in the several tribes of Indians in the State of Oklahoma, and to teach the Christian religion with morality, sobriety, industry, kindly charity and right living and to cultivate a spirit of self-respect and brotherly union among the members. (Hirschfelder and Molin, 1992: 193).

In 1921, the Native American Church organized its first outreach post in Nebraska, the first outside the State of Oklahoma. A Canadian branch began in 1954 on the Cree Red Pheasant Reserve in Saskatchewan and later spread to Assiniboine, Blood, and Ojibway communities. Total membership today is estimated anywhere between 100 000 and 225 000 members in 17 states and at least four provinces.

The Spiritual Dimension

In traditional Aboriginal societies the perception of spiritual power was not limited to human beings. It was believed that spirits infused all animate and inanimate phenomena. Animal, birds, fish, and plants were all considered to possess spirits with which humans could communicate. Trees, bones, and stones were also believed to be capable of conveying spiritual messages. Individuals did not regard lightly the divergency of creation because the interrelationships of these various entities were considered complex. The First Nations of Canada believed that art may be utilized to make visible the spiritual elements of a way of life. They viewed the arts as an avenue by which to express one's respect for, and understanding of, the spiritual mysteries of the universe.

It was traditionally customary in Indian societies to decorate commonly used items as a spiritual exercise. It took a little longer to create them by elaborating them with designs, but the extra time was always deemed to be worth it because it made the particular item more then merely functional. Functionality, per se, was never really an Indian value. The nature of decoration was intended to project the message of the article which was often spiritual in nature. An example was the pipe. Smoking the pipe was considered a sacred ceremony and pipes were often elaborately decorated. Pipe stems were decorated with carvings or applied porcupine quill work. Some tribes, like the Crows, developed special ceremonies and rituals related to agricultural practice.

The vision quest was a fairly common avenue through which artistic forms originated. The vision quest was primarily a Plains Indian ceremony, and it was not unusual to expect that a young man returning from such a search might have revealed to him

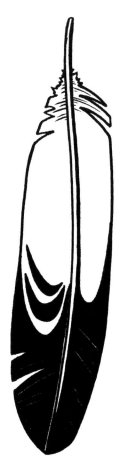

by a spirit that he ought to change the design of his apparel. There were other possibilities, as well. The successful vision seeker might be informed that he should avoid certain foods, devote his life to the healing arts, or paint a specific design on his war shield. If a young man was not successful in his quest, he might be able to purchase the protective power of someone else's shield. Sacred medicine bundles derived from vision quests tended to reflect a degree of artistic sophistication in their makeup of feathers, stones, bones, animal parts, or other materials.

Shamans were regularly involved in the artistic sphere, often sharing visions with groups of followers braced by the intention of forming a new ritualistic or healing society. Often the structure of the new society would be represented by specific art forms. The Grand Medicine Lodge (Midewiwin) of the Ojibway First Nation may have been initiated in this way. Feder (1971: 6) points out that some of the most powerful art of northwest coast cultures originated from shamans' visions which are still evident in masks, headdresses, totem poles, and house posts. Dreams were perceived as another source of artistic expression, particularly by those First Nations who created and employed masks as part of their spiritual repertoire.

Modern Shifts

As European influence intensified in the centuries that followed the fur trade, Aboriginal art underwent significant changes. It is difficult to trace precise influences because a reliable collection of clothing, for example, dates back only to the mid nineteenth century. Before that, it is necessary to rely a great deal on inference, the oral tradition, and faith. In the 1860s a new genre of regalia emerged known as "prairie style" art. The new form combined the curvilinear patterns of southeast tribes with the more solid and structured designs of the Great Lakes peoples. Artists began to feature colored glass beads and ribbon work in their creations, emphasizing vivid color combinations and floral designs contrasted against dark blue or black wool. Cree and Ojibway women west of Lake Superior began to use a pictorial style. The pow-wow regalia of present day Plains tribes derives directly from garments made for social dances during the early reserve period.

It is sometimes difficult for critics to understand that contemporary Indigenous artists not only straddle two cultures in their efforts to develop balance, they also straddle two histories. One is the modern-postmodern dichotomy that challenges every other artist, and the other is to maintain loyalty to the ancient ones. Houle (1991: 72) notes that the art tradition contemporary Aboriginal artists adhere to, and in which they continue to flourish without EuroCanadian benefit, is not a form of rebellion, but a maintenance of traditional loyalty. Today, there is still the potential restriction that works produced by Aboriginal artists are labelled "modern" only if they subscribe to western art media and formats. Some critics also tend to judge Native productions as crafts rather than art. It is true that when the means of survival changed for the Aboriginal people, many of them turned increasingly to the production of salable art commodities in order to earn a living. Some artists managed to attract patrons for their work, but this influenced the production of repetitious and stereotypical images of Aboriginal life (Berlo and Phillips, 1998: 212). Despite these challenges, many Native artists have continued to heed the spirit within them and utilize a wide range of mediums to share their unique messages with humankind.

An attempt to formalize the training of First Nations artists occurred with the establishment of the Institute of American Indian Art (IAIA) in Santa Fe, New Mexico, in 1962. Funded by the Rockefeller Foundation, the institute's curriculum was devised by Aboriginal educators to incorporate elements of Native culture, knowledge, and spirituality. The school represents the first attempt in the history of American Indian education to make the arts the central element of the curriculum. Its primary goal is to encourage cultural pride while preparing students for college and bettering their academic performance. As a result, school administrators seek instructors who will go beyond the production of "traditional Aboriginal styles" and concentrate on mainstream trends with the view to producing artists with a high degree of recognized national reputation. "Let's stop looking backward at our standards of Indian art production. We must admit that the heyday of Indian life is past, or passing. . . . [It is not] possible for anyone to live realistically while shut in by outmoded tradition" (Potter, 1999: 66).

Through the years the Institute of American Indian Art has attracted students from all over the United States and Canada, and produced a number of internationally known artists. Recently, an expanded campus was completed just outside the City of Santa Fe, a tribute to the success of the Institute. Canada has no equivalent to the IAIA, but various artists have become known for the particular styles they have influenced others to follow. These include such names as Jackson Beardy, Joane Cardinal-Schubert, George Clutesi, Alex Janvier, Robert Houle, Norval Morrisseau, Allan Sapp, Gerald Tailfeathers, and many others. More detail on these artists will be presented in later chapters.

Chapter Four
Maritime Aboriginal Culture and Art

Every human society invents technological mechanisms by which to adapt to its surroundings, and traditional Maritime cultures were no exception. Representative First Nations like the Beothuk, Maliseet (Malêcite), and Mi'kmaq once lived mainly off the resources of nearby lakes and rivers, and the Atlantic Ocean. These First Nations supplemented their diet with game from the forest and various kinds of fowl, complemented by hunts for animals such as bears, beavers, caribou, lynx, marten, and wolves. The people used rocks and bones to make tools, but quickly switched to iron when it was introduced by Europeans. Each band also invented ingenious ways to prepare food, design clothing, and manufacture weapons for hunting, fishing, and war. The Maliseet and Mi'kmaq built fish traps across rivers and stream mouths, and took ample quantities of smelt, sturgeon, and salmon when the fish returned to spawn. The Maliseet were less dependent on the ocean than the Mi'kmaq and the Beothuk because they raised small crops of maize and corn. The Mi'kmaq supplemented their diet by tapping maple trees in spring to manufacture syrup.

Beothuk

History

The big game hunters known as Paleo-Indians thrived in what is now eastern Canada some 8 000 to 10 000 years ago. Their story figures heavily in the ancestry of the various First Nations peoples who consider themselves the original inhabitants of that area. Their cultural practices greatly influenced the patterns adopted by later tribes.

The Vikings are believed to have been the first people to have made contact with the Beothuks, probably around 1 000 B.C. Sebastian (John) Cabot, an Italian navigator who was in the service of England, possibly took news of contact with the Beothuks back to England in 1497. Sir Humphrey Gilbert took possession of Newfoundland for the King of England in 1583, and while he found no Beothuks at the place of his landing, he did encounter them further north (Such, 1978: 35).

When the Europeans arrived, their relationship with the Beothuks was destined to be rocky from the beginning. With the discovery of the great cod fishing grounds in Beothuk territory, ships of many western countries arrived to exploit them. The first meeting between the two parties appeared to be quite amiable, as John Guy described it in 1612, but soon thereafter, those who followed Guy to Beothuk country made some unfortunate errors in judgment which resulted in a permanent disabling of relations. In the centuries that followed first contact, European settlements were established in Newfoundland and forced the relocation of the Beothuks from their traditional summer camps. The Beothuks shied away from contact with the newcomers, although, in self-protection, they tried to interfere with some of their practices. In pursuit of fish the settlers placed weirs or gill nets into the rivers to trap salmon and other fish and the Beothuks raided them for food. Once the feuding began, it turned into open hunting season against the Beothuk. The raids were costly in lives on both sides and the invaders eventually formulated a program of harassment against the Beothuks. The Beothuk food supply was therefore reduced and, coupled with the impact of imported diseases such as tuberculosis, the tribe began to die out.

The historical account of the Beothuk nation constitutes one of the most unfortunate cultural clash stories in Canadian history. Although the Beothuks occupied the eastern island of Canada for many centuries about one hundred fifty years ago, their history came to an abrupt end. Unfamiliar with Beothuk ways, the invaders nicknamed the Beothuks "Red Indians" because they practiced coloring their skin with red paint made from powdered ochre and mixed with oil or grease. Newcomb (1974) suggests that the origins of the term "the red man" may have come about when, in 1497, Cabot so labelled the Beothuk because of their extensive use of red paint. This label was soon erroneously applied to all First Nations of North America.

It is unlikely that a full catalogue of the Beothuk cultural inventory will ever be elaborated since there exist only a few eighteenth and nineteenth century sources on which to base even the very limited data about them (McMillan, 1988: 47). The single exception to this general source of knowledge was gleaned from the experiences of the last survivors of the Beothuk – two young women, named Demasduwit and Shananditti. These women lived, for a time, with non-Native families and shared with them first-hand accounts of their culture. Some of these interviews have been recorded and preserved. Some of the Beothuk words identified by Demasduwit have been ascribed to the Algonquin language group, but she died before the language project in which she was a participant could be completed. Shananditti was an eyewitness to the catastrophes and terrible suffering endured by the Beothuks during the last years of the tribe. She might have died unknown but for William Epps Cormack, a philanthropist who tried to save the tribe from extinction. Shananditti lived for five years with a settler family and was eventually moved to St. John's, Newfoundland, where she engaged in a project committed to writing up the history and lifestyle of her people. She also

drew pictures to illustrate aspects of her heritage and culture. Unfortunately, only ten of her sketches exist and many of Cormack's notes have been lost. Shananditti died of consumption in 1929 at the age of twenty-three, the last of the Beothuk (Rowe, 1977: 98).

Culture

Anthropologists describe the lifestyle of Beothuk predecessors, the Paleo-Indians, as basically a hunting and fishing people, but with a twist. They were probably contemporaries of huge woolly mammals – dinosaurs, spruce-eating mastadpons, dangerous saber-toothed tigers, and beavers eight times the size of those today. When the Beothuks emerged as a tribe other, smaller species of animals invaded the area and altered the hunting styles of the inhabitants. The hunted prey included lynx, caribou, foxes, beavers, bears, wolves, and marten, and a vast variety of fowl, supplemented by food from the sea. Beothuk water travel was accomplished with specially-designed canoes. Their vehicles of water travel had sharp keels and required significant ballast to keep them from turning over in the water. The boats measured about six metres long and could carry up to five persons.

The study of Beothuk housing has been the subject of serious study. The people apparently built conical birch houses called mamateeks, and investigation shows that were no other familial structures quite like them in historic Canada. Not exactly round, these houses were more like six or eight-sided constructions – something like the Navajo hogan. The roof was very much like a teepee, but the structures had a foundation wall. The roof was built in two layers with an insulation of dried moss in between. This made the homes ideal for the fierce Newfoundland winters.

The Beothuks, like neighboring tribes, engaged in forms of adult games and gambling, music, art, and various celebrations (Marshall, 1982). One of their annual events was the caribou hunt which was performed with the use of a natural or humanly-constructed pound; trees were felled and piled in such formation as to block the caribou from fleeing. Thus trapped, the animals were speared and killed and the meat dressed in order to assure a good supply for the winter. Caribou hides provided the people with clothing.

Beothuk grave inspections have led observers to conclude that Beothuk social organization was probably loosely defined and the tribe lived in small groups or bands. They likely had shamans (medicine men or medicine women) who performed religious ceremonies before a hunt or for other special purposes. While much of the information gleaned about Beothuk life is simply conjecture, the primary foundation rests on interpretations of physical remains of the culture. A supplemental source are notes made by scholars who visited with Demasduwit and Shananditti.

Little is known about the religious life of the Beothuks, but some investigators surmise that shamans were probably the most influential people in the tribe (Such,

1978: 40). The similarity of Beothuk cultural inventory and lifestyle to that of the Maliseet and Mi'kmaq configuration has led other researchers to conclude that their worldview must have been similar. Marshall (1991: 32) suggests that the Beothuk, like other tribes of that time, believed in the Great Spirit, and shared a close relationship with the creatures of the wild, the caribou probably being the most revered. This was because the Beothuks relied on that animal for food and clothing in the winter and because special ceremonies were connected to the caribou. It is speculated that the Beothuk also worshipped the sun and the moon and feared a mysterious sea monster. They also relied on shamans to help them with sidetracking an identified "Red Devil" who tried to work havoc with individuals when they hunted or went to war. Apparently the shaman possessed a special medicine bag, out of which he or she drew magical devices, partnered with unique techniques by which to overcome the evil one. Shamans were also sought for advice.

Art

Little is known about the spiritual base of Beothuk culture, but researchers surmise that because of their cultural makeup there must have been a great deal of similarity of belief with the Maliseet and Mi'kmaq. What *is* clear, is that regard for the spiritual realm was evident in every aspect of the lifestyle of all Maritime First Nations.

The Beothuks buried their dead with tools and household goods (using plenty of red ochre), thereby rendering valuable information to grave examiners. Most of their hunting weapons were ground and polished slate spears. Other items were crafted from natural materials like shells, bird beaks, bones, and claws and teeth from larger animals. A beach rock of the right size and shape made a good hammer, and sharp stones and bones were used for scraping and softening skins. When the Europeans arrived they introduced iron which the Beothuks used for the construction of arrowheads, chopping axes, and knife blades. Intricate bone carvings located in graves indicate that aesthetic or religious significance may have been attached to these objects. Most of the designs of the carvings combined small geometric patterns such as triangles, diamond shapes, ladders, or zigzag lines. Nearly all pendants found in graves are now in museums. When located in graves the pendants were found to be arranged as necklaces or wrapped up in packages of about 30 and placed next to the deceased (Marshall, 1982: 41).

The use of red ochre served many purposes for the Beothuk, and at least five possible explanations have been projected to explain its use: (i) as protection against insects; (ii) as a preservative; (iii) as a cosmetic and decorative item; (iv) as a camouflage; and, (v) for ceremonial or religious purposes. In the latter circumstance paint was smeared over the body and hair as well as on clothing and utensils and served a double function – decorative and religious. The benefits of red ochre were also applied to tools and utensils. Beothuk bows were made of smooth seasoned branches of spruce

or mountain ash and rubbed many times with red ochre and grease because this process kept them from drying out. The Beothuks also used red ochre and the juice of certain roots, especially alder, to paint their bodies. Beothuk burials also involved red paint. The deceased and his or her belongings that were buried with the person were similarly painted. Some observers suggest a deeper significance, possibly linked to the very meaning of Beothuk life itself. In any event, the secret of red ochre paint died with the tribe.

Bone carving was a representative art among the Beothuks. Their artists carved harpoon heads, spear and arrow points, and small pendants which were decorated with triangular, diamond, and zigzag lines. To complete the art, the bone was polished and the design pattern filled with red ochre. Some authorities believe that the pendants were very important to the Beothuks and probably related to their animistic religious beliefs and spiritual practices (Rowe, 1977: 128).

Unfortunately, very little is really known of Beothuk art, and a great deal of reliance has been placed on Shananditti's drawings which depict only selected aspects of Beothuk life. Patterson (1973: 19) suggests that Shananditti's most striking drawing is "Dancing Woman," which shows a woman wearing a loose garment, tied at the waist, and baring one shoulder. The robe has extensive fringing, which may have been formed of engraved bone objects.

Maliseet

History

The Maliseet (also spelled Malécite) are original natives of the geographic area between what is now the Province of New Brunswick and the State of Maine. Because their homeland was along the St. John River, they became known as the Wolastoqiyik or "people of the beautiful river." The tribe once belonged to the loose confederation of eastern First Nations known as the Wabanaki Alliance. Other member tribes included the Abenaki, Mi'kmaq, Passamaquoddy, and Penobscot. Today most members of the Maliseet First Nation live in Canada although some Maliseet reside in the State of Maine. Perhaps the name, Maliseet, originated from a bit of intertribal teasing, because Maliseet is a Mi'kmaq word for someone who can't speak very well! Its direct translation means "broken talkers" or "lazy talkers."

At one time members of the Wabanaki Alliance lived close together and shared a common language. Still, each tribe regarded itself as an independent nation and perceived the Mohawks as a common enemy. The strength of the alliance was tested when the Europeans arrived. At that time, all five First Nations sided with the French and banded together to fight European and Iroquois aggression. The result was that neither

the Maliseet nor the Passamaquoddy ever gave up their sovereignty (Maliseet Indian Tribe, 2004).

When the French arrived in Canada, the Maliseet and Mi'kmaq made friends with them, submitted to their teachings (particularly the Jesuits), and freely intermarried with the newcomers. They quickly accepted the idea of the French king as their "father," but they did not perceive that this new allegiance had anything to do with ownership of their lands. Periodically they had to remind the French that they were sharing their traditional lands with the French, and only on a tenant basis. When the English arrived, local First Nations learned to play one nation off against another and eventually forced the French to reorganize and increase their distributions of gifts to match those of the English. Thus the Maliseet and Mi'kmaq gained additional tools and equipment, guns, ammunition, food, and clothing (Dickason, 1993: 111). The French reluctantly agreed on the basis that this practice was necessary in the interests of maintaining an effective alliance with the Mi'kmaq. English officials regarded the Maliseet and Mi'kmaq with suspicion because of their close allegiance with the French. The arrival of the Europeans greatly reduced the population of local tribes by about half due to the effects of imported diseases. The Mi'kmaq were reduced to 3 000 people, and the Maliseet to only 800.

As we enter the modern period of Maliseet and Mi'kmaq history, it becomes possible to consult written historical records prepared by the European invaders. These date back to 1608. Some of the early visitors gained intimate knowledge of local Native cultures and carefully recorded the rituals and practices which they observed. Their descriptions indicate that two distinct Indigenous peoples were met by French explorers, the Etechemin and the Souriquois. Later the Souriquois were labelled "Mi'kmaq", based on the word "nikmaq" which was a form of greeting used by the tribe meaning, "my kin-friends."

Today the Maliseet are involved in an ongoing conflict with non-Natives over hunting, fishing, and logging rights. In 1999, the Canadian Supreme Court concurred that treaties signed with the Maliseet and Mi'kmaq recognized these rights, but the ruling was very unpopular with their non-Native neighbors. Some of them even destroyed Native equipment and burned a sacred site. The situation has not yet been resolved peacefully.

Culture

Many older members of the Maliseet First Nation still speak their native Maliseet-Passamaquoddy language which is a division of the Algonquin tongue. There are 1 500 speakers of both dialects today. However, members of the younger generation speak English, and those who live in Quebec speak French.

Traditionally, the Maliseet lived in conically-shaped wigwams and lived a maritime lifestyle. They built birch-bark canoes, fished and hunted, and supplemented the diet therefrom with the fruits of the forest – mostly caribou, deer, and moose. Their clothing consisted of breechcloths with leather pant legs for men, and long dresses for women. Most men and women wore their hair long, sometimes covered with a head-band with a feather in it or a distinctive kind of hood. Moccasins were their primary form of footwear.

The Maliseet were expert fishermen and used spears to catch fish from their canoes. Their economy was based on exploitations of inland resources such as freshwater fish and large game animals. They used basket traps with a conical-shaped mouth to catch eels in deeper water. These were baited with fish heads and weighted with rocks to sink them. Wooden floats attached by a line marked their location. Dickason (1984: 105) mentions that the Maliseet included muskrat in their diet, a practice snubbed by the Mi'kmaq.

Art

Like their neighbors, the Mi'kmaq, the Maliseet believed in a fictional, intermediary character named Glooscap and his heroic activities. Glooscap's power was enormous and he was considered a relative of all Wabanaki people. Glooscap helped create the world and gave it order. Although he often assisted his people in the earthly sphere, he also had a direct connection to the invisible world. Glooscap gave the people a number of rituals such as smudging, prayer, and seeking help from Divine or spiritual beings. When practiced, these rituals would link the people directly to the spiritual realm. The creation of all forms of art, therefore, implied a search for, or expression of, a spiritual quest.

Although abundant forms of Maliseet art were evident at the time of European contact, its popularity was greatly enhanced by the extent to which the newcomers were impressed with it. Soon the reputation of Maliseet art grew worldwide. Before the Europeans came, the Maliseet crafted wampum out of seashells and used it as currency and regalia, and in the commemoration of important events (Redish and Lewis, 2004). Their artists carved a number of functional objects using bark such as canoes, the bark box, the bark dish and tray, and even bark houses. After European contact, Maliseet artists quickly adapted to imported items such as beads and began to make plaited baskets out of black ash instead of creating them from birch-bark and ash splints. Patterson (1973: 25) notes,

> They have developed [baskets] in both "rough" (utilitarian) and "fancy" form, to use the terms their makers apply to them. Modern craftsmen usually concentrate on one or the other style rather than both. These are hand-made but "mass-produced," as many as a dozen a day from one family.

Plaited baskets are made by a technique whereby two sets of elements cross each other, alternately passing over and under those of the other set. Variations are made by changing the number of elements crossed at one time and by using different materials.

A number of Maliseet writers, painters, carvers, weavers, and sculpturers are working to keep the Maliseet arts alive. Their contributions will be described at the end of the chapter.

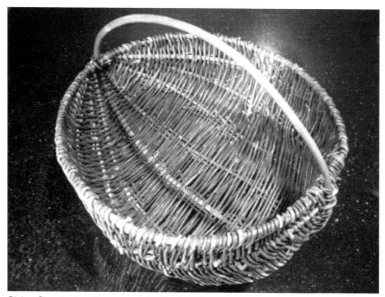

Plains Cree basket. Photograph by David J Friesen.

Mi'kmaq

History

The Mi'kmaq, of what we now know as Nova Scotia, were probably the first North Americans to come into contact with the Europeans, and were the first to be exposed to European diseases, hardware, and religion. In the intervening centuries since contact, they have lost their lands, and much of their culture and lifestyle has disappeared. In the early 1800s, it seemed as though the Mi'kmaq might disappear altogether when their numbers dropped to only 1 400 because of disease, starvation, and deliberate attempts at extermination. Those who have survived appear to have developed a resilience in the face of encroachment. This has set them apart from other First Nations in Canada.

There are indications that at one time some Mi'kmaq also lived in New Brunswick. Dating the Paleo-Indian culture has been accomplished on the basis of discovered artifacts including chipped stone tools such as awls and stone scrapers. Mi'kmaq

weaponry included wooden spears and fluted projectile points. Archaeological digs in Nova Scotia have yielded these items and provided evidence of domestic fireplaces. Primarily the Mi'kmaq functioned with a "mixed" economy, and speculations that the tribe utilized the ocean to supplement their means of livelihood are based largely on conjecture. If this was the case, it certainly was a much later development. Unfortunately, the coasts of the Maritime provinces have been submerging for the past 6 000 years to the extent that archaeological investigations are impossible. Thus, the thesis about a seafaring Mi'kmaq people will remain mere conjecture (Davis, 1991).

During the Pre-Ceramic Period, which occurred from 2 500 to 5 000 years ago, the Mi'kmaq probably engaged in a cycle of activities that included hunting, gathering and fishing, even though the latter cannot be proven. This can only be surmised from the proximity of their culture to the ocean; logically, why wouldn't people who live near the sea make use of its resources? Inland archaeological digs pertaining to the Mi'kmaq are quite sparse, and thus comparatively little is known about their traditional lifestyle. To start with, an excavation known as "Cow's Point" in Central New Brunswick has yielded information drawn from 60 graves from which 400 artifacts have been extracted. On this basis it may be concluded that two kinds of burials were practiced. In the first, corpses were evidently placed in an extended or flexed position, and in the second, the bones of the deceased were placed in a bundle. The practice was done in sufficient number to reveal that graveyards were deliberately selected, and the second practice was probably related to times of the year when people had to be buried at different locations, perhaps during inclement weather or when the band was travelling.

As time progressed the Mi'kmaq are assumed to have gone through several developmental stages such as the early, middle, and late ceramic periods. Each stage is marked with some degree of specificity by archaeological labelling based on a determinate find. The ceramic period is highlighted by pottery finds, and the craft appears to have become more sophisticated as time progressed. The early period reveals pottery characterized by cord impressions on both the interior and exterior. The middle period boasts vessels characterized by thin-walled pots decorated by a fine dentate stamping technique. Interestingly, the pottery of the later period shows a decline in quality with thicker walls and less attention to detail. Decoration was accomplished by cord and only on the exterior of the vessel. Reasons for this "decline" in quality are not known.

Culture

Traditionally the Mi'kmaq were a typical migratory people who lived in the woods during the winter and relocated to the seashore in the summer months. It is now believed that by the year AD 1 500, however, Mi'kmaq culture had transferred largely to a strong reliance on the produce of the sea. Perhaps as much as 90 percent of their food supply was obtained from this source and there is evidence that the tribe had made adaptations to this form of lifestyle. The Mi'kmaq built fish traps across the river

and stream mouths, and took ample quantities of smelt, sturgeon, and salmon when these fish returned to spawn. Larger fish and lobsters were attracted at night with torches and killed with harpoons. Corollary supplies of food came from the air; ducks and geese migrated in such numbers that they were easily snared or shot with bows and arrows. Inland animals were also hunted – beaver, bear, caribou, and moose were the principal targets and provided dining fare in seasons when fishing was partially at a halt. The Mi'kmaq also tapped maple trees in spring to provide syrup. The abundant and relatively stable food supply permitted greater population densities to develop, possibly resulting in the development of more complex cultures than among the inland hunting and gathering groups at corresponding latitudes.

Mi'kmaq territory was traditionally divided into seven regions, each governed by district chiefs who were also recognized as elders. Jenness (1986: 123) suggests that the districts were based on exogamous clans. Each clan formulated its own insignia which was worked into garments and artifacts or even on a person's skin. One clan used a cross as symbol, which was promptly interpreted by incoming missionaries as a sign for the promotion of Christianity. Operating a centralized form of governance, a Mi'k-maq grand chief usually resided on Cape Breton Island and presided over the seven governing districts. The grand chief called a meeting of district chiefs when business affecting the entire nation had to be accomplished. Local affairs, such as the designation of hunting territories was under the jurisdiction of local chiefs who, in turn, were responsible to district chiefs. War leaders were not actual chiefs but men who had distinguished themselves in fighting. Their authority was temporary, limited to immediate needs for such leadership.

The Mi'kmaq social order was arranged in a somewhat hierarchical manner with a layer of "common people" reigning over an order of slaves. Slaves (usually women and children) were taken in war, and were sometimes given to the women to undertake menial tasks such as fetching firewood or hauling water. They were kept alive strictly to be responsible for lowly domestic purposes and were often tortured at will (Miller, 1995). This was not an arrangement common to most Canadian First Nations although some tribes on the west coast had similar practices.

People of the oral tradition have in common the practice of teaching their children by the adage, "learning by doing." Mi'kmaq children thus learned adult roles at the side of their parents. Since women primarily did domestic chores, girls acquired female tasks by helping mothers around the camp. Cooking was one of the main tasks learned by the girls, and Mi'kmaq cooking was indeed unusual. The primary cooking utensil, a large pot, was made of birchbark stitched with spruce roots and sealed with spruce gum. This container was then suspended over a fire and heated rocks were removed from the fire with wooden tongs and placed in the birchbark pot until they cooled. This exercise was repeated until the contents of the pot boiled. Another domestic utensil of interest was the Mi'kmaq wooden kettle which was fashioned out of the end of a large

log. The top of the log was burned and hollowed out using a stone axe. The sides of the log were preserved, making a wooden kettle. These containers were very popular for boiling moose butter. One animal could yield five to six pounds (2½ kilograms) of this valued form of nutrition.

Boys learned to make weapons and undertake repairs with their fathers and later joined them in the engagement of the various means of obtaining a livelihood. Hunting was only one such season, for the Mi'kmaq synchronized their lives with the natural seasons of their environment. January, for example, was synonymous with seal-hunting, and February and March were primarily targeted at hunting beavers, otter, moose, and bears. In March, the fish began to spawn, which meant another form of occupation to be taken up. April was the month for the smelt season, and from May to September, the people took a break. October and November brought a second hunting season, and December featured ice-fishing (McMillan, 1988: 51). The summer solstice gave opportunity for social events – like courting, socializing, and feasting.

When a Mi'kmaq boy reached manhood, he began to search for a well-matched wife. When he identified a suitable potential mate, his father would arrange to ask for the girl's hand. If approved, the boy would then serve a year in bridal service, attempting to prove himself a good provider and generous husband. If he met with approval, a wedding feast and ceremony would be held and the couple would move to the groom's village. The arrival of children cemented the relationship, and a man could divorce his wife if she did not bear him children within a few years of marriage. Levirate was practiced, in that a widow would be taken on as a second wife by a brother or close relative of the deceased. Polygamy was also practiced to some degree. A second wife possibly meant additional children for the chief and thus more potential political supporters (Miller, 1995; 2004).

It is believed that Mi'kmaq men usually planned their own funerals, at least when they were able to do so. Guests would bring gifts and exchange them while the dying man gave out items of his property. If an individual died prematurely, the death would be accompanied by a period of mourning. Individuals were buried with gifts and personal possessions, both practical as well as ornamental, and a funeral feast was held to commemorate the deeds of the deceased. In some cases, the wigwam and other personal possessions of the deceased might be burned. The first one to speak at a funeral was the chief who would expound on the good qualities and notable deeds of the deceased. He would then go on to expand on the uncertainty of life and the necessity of dying in order to meet those relatives and friends who had gone on to the land of souls.

As the twentieth century emerged, the assimilation of the Mi'kmaq into dominant culture occurred at great speed. As early as 1932, Jenness noted that "[i]n their mode of living today the majority of the Mi'kmaq are hardly distinguishable from the poor whites" (Jenness, 1986: 269). In the second half of this century, however, Jenness'

assessment appears to have underrated the strength of Mi'kmaq culture. A renaissance of sorts propelled the intensity of Mi'kmaq culture through campaigns to bring back and strengthen known Mi'kmaq traditions. The residential schools which operated in the first half of this century failed to abolish the Mi'kmaq language for example; it is alive and healthy throughout Cape Breton, New Brunswick, and Prince Edward Island. Surprisingly, almost half of the Mi'kmaq on the mainland can still converse in their mother tongue. This is evidence that the people of this First Nation have reclaimed their rightful heritage and joined the pan-Indian renaissance movement for cultural revitalization (Lincoln, 1985; Mills and Slobodin, 1994). Because they wore European-colored glasses, this is another development that Jean Cartier and John Cabot could never have foreseen.

Today the Mi'kmaq face a struggle between developing economically viable industries on their reserves and migrating to nearby cities for jobs. Locally-controlled schools that offer instruction in Mi'kmaq history and language have helped restore waning interest in tribal heritage and increase cultural pride. A variety of annual celebrations help maintain interest in past happenings and ongoing tribal affairs. Today, there are about 6 000 Mi'kmaq Indians living in the Maritime provinces.

Beliefs

According to missionary records, the Mi'kmaq held to a belief in a superior, monotheistic Being whom they worshipped daily. They attributed respect to lesser gods, the best known perhaps was Glooscap. Like Napi among the Blackfoot and îktomnî among the Assiniboines, Glooscap was seen to have both extraordinary spiritual powers and some physical limitations. Mi'kmaq mythology includes many tales of how Glooscap transformed animals into their present forms, formulated the seasons, and rearranged features of the landscape. According to tradition, he taught people how to develop tools and weapons and then disappeared, leaving the world in the hands of his people. He promised to return to his people whenever there was need.

The supernatural pervaded every aspect of Mi'kmaq culture, and it was as important in warfare as in daily life. Everything was seen as having a spirit, animate and inanimate, and each person had his or her own *manitou* (Spirit). The Mi'kmaq regarded animals with the same esteem they awarded human beings, and believed that Divine messages could be gained through virtually every experience. In common with other First Nations, they perceived that ill health could be caused by a combination of physical reasons as well as spiritual. If a sick person did not get well, it was probably because he or she had a deeper spiritual (or psychological) problem. No doubt many contemporary counsellors and therapists might agree with the rudiments of such a diagnosis.

Art

The aesthetic qualities of Mi'kmaq life were evident in their costumes and utilitarian artifacts. Mi'kmaq mothers strapped their babies to a wooden cradle ornamented with painted designs, wampum, and porcupine-quill embroidery. Festivities could also be considered art-forms, particularly in the case of installing chiefs. The oral tradition has it that the Mi'kmaq held celebrations consisting of dances and feasts for a variety of occasions ranging from a son cutting his first tooth to a daughter's marriage. Several different musical instruments were used at these occasions, for example, rattles made of fish-skin pulled over a wooden frame and filled with tiny pebbles. Musicians also had bone whistles and birchbark slabs which were beaten with sticks like a drum. Dancers often wore bone or moose claws which clashed and clinked as they moved (Whitehead and McGee, 1983). Feasts were held before a hunt or raid and men ate first at feasts while women, children, and those not able to participate in war ate afterwards. Although there is little evidence for this, early anthropologists surmise that a kind of adolescent ceremony was in place consisting of the male youth engaging in the search for a personal guardian spirit through fasting and prayer. By contrast, most Plains tribes reserved this search for a select few, preferably those approved by the elders. If the Mi'kmaq indeed approved of the vision quest for all youth there is no indication that it was practiced as a form of adolescent initiation. Most likely, no youth could participate in the councils of the tribe until he had proven his manhood by killing either a moose or a bear.

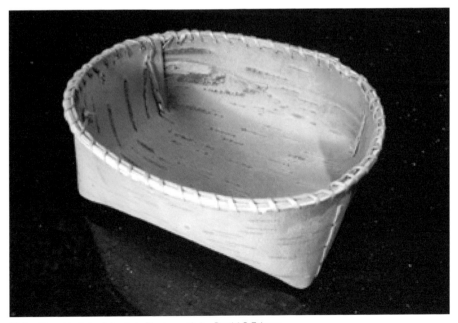

Plains Cree birch bark basket. Photograph by David J Friesen.

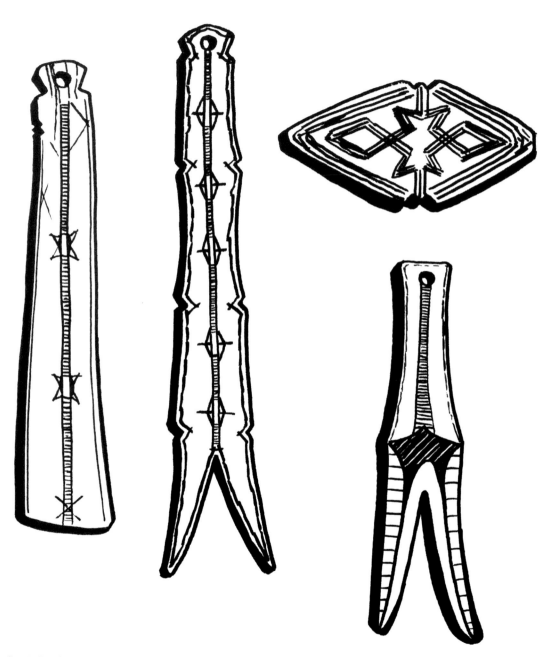

Beothuk-style bone designs.

Mi'kmaq art was evident in a variety of formats, all of them manifesting a spiritual orientation. The Mi'kmaq had a reputation for making great canoes and toboggans, both of which were immediately sought-after by incoming Europeans. Birchbark painting was also common among the Mi'kmaq. McMillan (1995: 53) notes that Mi'kmaq women painted brightly colored designs on the bark coverings of wigwams. Birchbark was used for other purposes, particularly for designing a basket-like vessel to carry water or contain clothing, food, or drink. The Mi'kmaq built skillfully woven baskets using cedar, spruce, juniper, or black ash, and used porcupine quills to decorate clothing before the introduction of beads. Weapons, tools, and robes were also painted. It was reported in 1708, that the Mi'kmaq were making a type of quill-decorated moccasin much admired by the French who wanted to purchase them and display them back home (Berlo and Phillips, 1998: 98).

Like the Beothuk, the Mi'kmaq practiced carving and modelling of figures decorated with cross designs called "cross and mountain," which looked like miniature mandalas. A favorite form of design was the "double curve," which consisted of two concave lines drawn in opposition, frequently curving into spirals (Patterson, 1973: 21). Some analysts have interpreted this design as paralleling that of the west coast First Nations, which features two animal profiles facing each other.

Another similarity of practice between the Mi'kmaq and the Beothuk Indians was the used of red ochre paint which was smeared on burial items, particularly on items buried with the deceased. These appear to be ceremonial rather than utilitarian items, and, most peculiarly, the paint was smeared on what appear to be "bayonets." Made from ground slate, these artifacts resemble those attached to modern rifles. In some cases the bayonets have geometric forms etched on them (the purpose of which is not quite clear), and are attached to a wooden spear shaft.

Artists

Maliseet sculptor Edward Ned Bear has combined study in Native education with an Honors Diploma from the New Brunswick College and Art and Design, as well as studies at the Saskatchewan Indian Federated College. Working with wood and stone (as well as being a mask-maker), Bear has also made significant contributions as a curator and instructor of Native art and culture. Since 1998, he has held exhibitions in several Maritime Canadian cities.

A native of New Brunswick, Shirley Bear is a Maliseet artist who follows the traditional teachings of her ancestors. Vitally interested in the study of petroglyphs, she believes that they have for too long been interpreted from a colonialist and male point of view and she strives to amend that. She believes that Aboriginal leaders must work together to restore the harmonious relationship between men and women that existed before European contact.

Lance Belanger is a Maliseet artist from New Brunswick who works with sweet-grass, textiles, and sealskin as mediums by which to reclaim and rewrite history from a First Nations perspective. His most recent work is distinguished by his interest in reproduction and interpretation of the giant stone balls of Costa Rica. He sees the stone balls as illustrative devices by which to portray the global concerns of Aboriginal peoples.

Arlene Nicholas Christmas was born on the banks of the St. John River, the middle child of a large family of ten children. Her Maliseet birth name was Dozay (Little Girl), and she has consistently portrayed her people's traditions and beliefs in her art work. Her career began in 1982 when she showed her drawings to an art dealer and they sold. Since then she has participated in many individual and group exhibitions, proudly showing off her images of poverty, oppression, and Native suffering. Outlets for sales of her paintings are in Toronto, Ottawa, and Vancouver.

Peter Clair is a Mi'kmaq basket-weaver and installation artist from New Brunswick with a world-wide reputation. As a result, his work is in high demand. Trained by his parents, Clair stretched his skills beyond traditional methods of basketmaking to a genre now known as wood weaving. Using traditional functional and fancy forms of basketry, he blends concerns for form and structure with respect for the natural world and Aboriginal cultural statements. He participated in his first group exhibition in New Brunswick in 1983, and ten years later, created his first installation. Its theme involved traditional basketry using ash splints mixed with contemporary sculptural elements and woven fabric.

Mike MacDonald of Nova Scotia claims both Beothuk and Mi'kmaq ancestry, and specializes in video production and photography. He has participated in numerous public exhibitions and his works are displayed in the Kamloops Art Gallery, and the Vancouver Art Gallery. One of his recent video productions, *Secret Flowers*, involves 16 video screens stacked four across and four high. Its theme is endangered species of flowers in British Columbia, although McDonald is also very much concerned with issues pertaining to First Nations in Canada.

Teresa Marshall also represents Mi'kmaq ancestry, and works as an installation and mixed media artist. Born in Nova Scotia, she studied at the Nova Scotia College of Art and Design in Halifax, graduating with a BFA degree. Marshall has won numerous awards, participated in many individual exhibitions, and serves as artist-in-residence at the Banff School of Fine Arts. Literally dozens of books and articles have been published about Marshall's work, emphasizing her concerns about First Nations issues in Canada. She describes herself as a "Mi'kmaq artist living within the boundaries of occupied Canada."

Leonard Paul is a Mi'kmaq painter and printmaker and holds a Master's Degree in philosophy and religion from Acadia University. A professional artist since 1979, Paul won the Governor General's medal in 1993 and that same year, was nominated for the

Aboriginal Achievement Award. Paul's art work is influenced by European styles including the Renaissance and the European watercolors of the 1800s. Dutch painter, Jan Vermeer (1632-1675), is one of his favorites. Paul's themes often reflect his Aboriginal background as well as his interest in nature. His paintings are hauntingly real and resemble photographic images.

Still another Mi'kmaq artist, Luke Simon is a painter and ceramist from the Big Cove Reserve in New Brunswick. Some of his training was done at the Institute of American Indian Arts in Santa Fe, New Mexico, although Simon also credits other sources for his inspiration. His paintings tend to show obvious themes of undesirable European intervention and unwarranted colonization of First Nations. He explains his technique and purpose as creative expression through playful and serious imagination.

Mi'kmaq painter Alan Syliboy attended the Nova Scotia College of Art and Design in 1975-76. His painting style incorporates images of renewal using petroglyphs as points of inspiration. A participant in a number of exhibitions, Syliboy's works are featured at the Dartmouth Heritage Museum, Mount Allison University, the National Arts Centre in Ottawa, and the Nova Scotia Teachers College. Syliboy likes to work in pencil, pastels, and printmaking and has also designed costumes. Many of his subjects deal with family, searching, struggle, and strength.

Ironically, European influence on most Aboriginal art forms was significant, but hardly affected First Nations music. The old songs still linger, as in the career of Rocky Paul Wiseman, a Maliseet musician from Fredericton, New Brunswick. Wiseman learned the old songs of his people from his 90-year-old grandmother and he helps keep them alive through his musical talent. Essentially employed as a forest and land use research officer, Wiseman uses his spare time to perform in theatres before live audiences, as well as in churches.

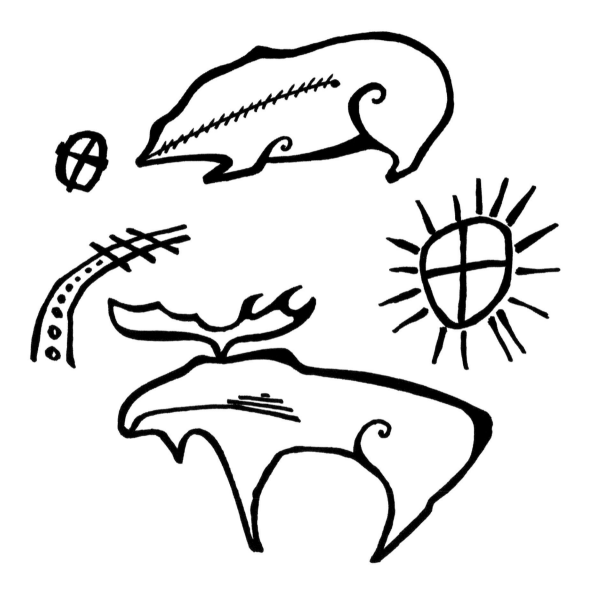

Some artists incorporate petroglyhic images as points of inspiration in their own design.

Chapter Five
Eastern Woodland
Aboriginal Culture and Art

As with art the world over, Great Lakes Indian art has its roots in the regional ideology and interpretation of the universe. Many concepts in this cosmological structure originated in ancient civilizations in the lower Mississippi region, if not further south (Ewing, 1982: 17).

Initial occupation of the eastern Woodlands probably began after the retreat of the glaciers. Stone projectile points with fluted forms from the Paleo-Indian period have been located at several sites, indicating that human occupation was present as early as 11 000 years ago. This region was once home to a wide variety of First Nations, some of whom may have later migrated to the plains. Classic Woodland cultures include the original members of the Iroquois Confederacy (Cayuga, Mohawk, Oneida, Onondaga, and Seneca), Huron and Petun, Neutrals, Algonquian Ojibway (Anishinaubae or Chippewa), Crees, Montagnis, Naskapi, and Ottawa. This chapter will deal primarily with the Iroquois, Huron, and Ojibway.

History

At one time most of the northeastern region of North America was under the control of the Algonquian peoples. A small wedge of land in the Lower Great Lakes-St. Lawrence region was an exception; this was Iroquois territory. The occupants of the area thus included such tribes as the Hurons, the Neutrals, the Iroquois, the Eries, the Andastes, the Tuscaroras, and several tribes like the Petun who had lesser military might. These tribes occupied a vast area of territory stretching from Canada to present-day North Carolina. Some of the tribes were quite closely aligned though the Jesuits recorded that they had formerly waged wars against one another (McMillan, 1988: 60).

When the French fur traders arrived in North America around 1608 and confirmed Quebec as a fur trading centre, the Huron had already established themselves as a semi-sedentary, agricultural people who were part of a larger family of an Iroquoian-speaking

culture. The term Huron originated with the French, possibly with Samuel de Champlain, who, it was said, named the group after the chief who happened to be leading them at the time. Another interpretation of the origin of the term Huron is that the word Huron means "boar's head," so labelled after the fact that the Huron wore their hair in a kind of bristly manner, not unlike what in recent times came to be called a brush-cut. For themselves, the Huron chose the name Wendat, meaning "Islanders or dwellers on the peninsula."

Early estimates place the Huron population at about 20 000 people settled in 18 villages. Together with the Algonquian-speaking groups the Huron controlled access to the lands north of the Great Lakes, in particular, the region of the Canadian Shield. Realizing this, the French decided to make allies of the Hurons and a deal was worked out to the mutual satisfaction of both sides. Thus the name of the Huron became deeply entrenched into the annals of Canadian fur trade history. In trade, the Hurons obtained valued European goods such as kettles, knives and hatchets, and beads and trinkets. The French, of course, got what they came for – furs, and possible land expansion.

French impact on Huron culture was immense but it also influenced significant geographic changes. By 1649, for example, a group of about 600 Christianized Huron settled on the Ile d'Orléans near Quebec City. Others relocated to Fort Pontchartrain, under French protection, a location which now houses Detroit City. As European civilization impinged itself increasingly upon the Huron, many members of the Nation simply became the invisible people through assimilation, thereby suffering significant language and cultural losses.

A few decades after European invasion, the Iroquois grew in military power and the Huron were faced with the difficulty of choosing to buckle to their rule or find a protector. They chose the latter route, siding with the French, but, unfortunately, the French-backed Jesuits, on whom they relied were either unable or unwilling to pay the price to save the Huron (Trigger, 1994: 41f). In 1648, the Iroquois struck and destroyed the Huron village of Teanaostaiaé, one of the largest and best fortified Huron settlements. This action sent fear throughout the Huron community, but this was only the first of many tragedies to come their way. By 1650, most of the Huron had been killed, either by war or disease, or dispersed. The few who managed to escape either joined the Iroquois or the French, or tried to blend into dominant society through assimilation. History now shows clearly that none of these First Nations could ever have predicted what their end would be if they had not formed alliances with newcomer groups to further their own interests.

The Iroquois presence in Canada has been part of the written record since the time of first contact, and even today they constitute some 20 percent of the Indian population of Ontario. The Six Nations Reserve near Brantford, Ontario, has a band membership of over 18 000 – 13 000 of whom live on the reserve. It was the Iroquois with whom Cartier had his first dealings during his voyage of 1534-36 and he subsequently

bequeathed to us one of the original written descriptions of this Indigenous People. He described his initial encounter with a group of Iroquois canoe men in this manner:

> Upon one of the fleets reaching this point (the shore on one side of the Bay of Chaleur) there sprang out and landed a large number of Indians who set up a great clamor and made frequent signs to us to come on shore, holding up to us some furs on sticks (Goldstein, 1969: 20).

At the very beginning of their conquest, the French made a fatal error to gaining supremacy in the middle Atlantic region. In 1609, under Champlain, they fired upon a group of Iroquois at Ticonderoga and thereafter became bitter enemies of all five (later six) Iroquois Confederacy nations. The Iroquois then went over to the English and effectively blocked French efforts to travel down the Ohio River. Still, Champlain was determined to be victorious and he launched a number of expeditions to this end but each of them failed. He then resorted to more severe tactics such as burning fields of Iroquois corn. Once initiated, this practice prevailed until the later eighteenth century.

The English victory over the French had significant consequences for the Iroquois. In the first place, it meant that the French were now removed to the north, thereby making the area much more attractive to outsiders. The Crown tried to forestall inevitable conflict between settlers and Indians by forbidding the taking of Indian lands in the Royal Proclamation of 1763, but this measure met with only limited success. When the English dominated the area, the Iroquois also lost their position as intermediaries between Albany and the western tribes; these people could now trade directly with Britain (Tooker, 1994: 79f).

The Iroquois suffered a severe blow in 1783 when it became clear that the borders of the newly-established United States of America would become permanent. This meant that despite their faithful support of the British, that allegiance won them nothing. Although they occupied most of what is now New York State, the Iroquois were forced northward. To diffuse their anger at being short changed, British officials offered them a portion of Confederacy lands in Canada on the north shore of Lake Ontario at the Bay of Quinte and in the Valley of the Grand River. By this action the Iroquois in the latter region figured prominently in the provincial and Indian affairs of the later eighteenth and early nineteenth centuries. In 1792 and 1793, the Six Nation League held councils to discuss concerns about the approaching settlements of recent immigrants. These activities concerned both American and British officials. The latter feared that the councils might give rise to a united Indian front and jeopardize British interests in Canada (Surtees, 1985: 67f). In the final analysis, there was always a fear of French reprisal, particularly if the French thought the Indians might not side with the British.

The Ojibway were originally settled in northern Ontario, not far from modern-day Sault Ste. Marie. Their lifestyle was virtually indistinguishable from the Ottawa and Potawatomi Indians of lower Lake Michigan. Some observers have labelled a subsection of the Ojibway as Chippewa-Ojibway, the name originating from the concept of

"those who make pictographs." The pictographs were engraved on pieces of birchbark found by explorers, and represent one of the closest forms of formal documents among Canada's First Nations. The Chippewa-Ojibway called themselves Anishinaubae, meaning "first" or "original" man.

Historically the Ojibway Nation was subdivided into numerous tribes, numbering 300 to 400 individuals in size, each of which had their specified hunting territories mapped out. The tribes were politically independent of one another, but closely affiliated through marriage. It has been suggested that the Ojibway practiced cross-cousin marriage, that is, the preferred mate was an individual in the same kin category, such as an aunt's or an uncle's offspring (Bishop, 1994: 275f). Tribes were led by chiefs and were further broken down into bands with political implications. They also featured totemic clans which had limited religious significance and no political clout. Clansmen regarded one another with close affinity even if they belonged to different tribes. Individuals possessing the same totem were considered close relatives and could not intermarry. Each totem group was traceable through the male line and identified by the name of an animal, bird, fish, or reptile.

The Ojibway probably made contact with the Europeans in the 1640s, at which time they numbered around 30 000. As the fur trade moved westward, the Ojibway followed the Woodland Crees to what they hoped would bring them a better standard of living.

Culture

For the most part, people of the Woodlands were agriculturalists, particularly the Hurons and the Iroquois, and they supplemented their larders with the produce of fishing, hunting, and gathering. With a few exceptions, the Woodland tribes could be called semi-nomadic peoples. Irwin (1994: 287) suggests that no cultural group had a more diverse terrain nor a greater variety of animal life from which to extract their means of existence than the original people of the eastern Woodlands. As a result, few cultural groups had a greater repertoire of weapons, skills, and techniques at their disposal. Huge forests surrounding their places of abode fostered the development of expertise in a variety of related knowledges and skills.

The major crops of the Woodland agriculturalists were corn, beans, and squash. They also planted sunflowers and extracted oil from them for cooking. Tobacco was cultivated, although in more limited supply among the Huron. The Iroquois grew considerably more of it. The Huron used tobacco as a kind of drug believing it to be instrumental in communicating with spirits. Its quality to dull the mind was interpreted as rendering one capable of creating special spiritual powers. Tobacco was smoked in straight or elbow-shaped pipes of clay or stone, with wood or reed stems. Smoking played an important role in most religious ceremonies. Some have compared it with

the use of incense in some Christian cultures in offering "the sacrifice of praise and thanksgiving" (Brush, 1901: 55). Tobacco was also used as a deadening influence for pain or to produce a dulling effect when people were hungry and no food was immediately available.

In Woodland culture, women took care of the fields and accomplished their work with small wooden, handmade instruments. Other female tasks included looking after children, picking wild berries, and gathering various kinds of nuts. Women also gathered hemp (for making rope) and firewood, which they split for use in their homes known as longhouses, and enclosed in palisaded villages. Palisades were made of tall trees stripped of their bark. A Woodland longhouse could be likened to a long, high grape arbor, covered with the bark of trees. These dwellings were from six to ten metres in length with the supporting poles firmly lodged in the ground and bent over at the top where they were bound together. At intervals, cross poles were lashed across the supporting poles to provide a framework, and the ends of the lodges were closed by woven mats which also served as doors. The longhouse did not afford tenants much privacy and no doubt necessitated mutual tolerance and community sharing.

Woodland men's work consisted of clearing forests, hunting, fishing, and waging war. A variety of animals were available for hunting including deer, beavers, and bears. Indicative of the skill devised in hunting over the centuries of Huron existence was the deer hunt. Deer hunts were organized in drives and the men would arrange themselves on an island in a lake or river, or in a canoe stationed a bit out from shore, and their peers would chase the deer along the river bank. As a deer tried to make its way along the shore where it was being pursued, it was shot by hunters who were either on the island or in the canoe. Sometimes the men also built enclosures in the forest and trapped the animals within it, an arrangement similar to the pound method in buffalo country further west.

Huron settlements were slightly different in appearance from those of their Iroquois neighbors. Instead of separating their various tribes or bands, they often lived in longhouse villages that stood side by side, or were located across from one another, thus sharing the hunting areas and farmlands that lay between them. This arrangement for occupying lands made it difficult for European invaders to calculate the population differences in the various groupings.

For housing, the Ojibway built lodges which were usually round, covered with bark, and expected to be relatively permanent. Several alternative styles of housing were available, although the most popular form was the dome-shaped structure known as the wigwam. Saplings were driven into the ground, then bent over and tied together at the top. Sheets of birch bark were used to cover the framework. A hole was left at the top of the structure for the smoke from domestic fires to escape. Sometimes several layers of birch bark were used as covering with moss stuck in between to provide extra insulation.

The Woodland economy operated on a combination of seasonally-exploited resources including agriculture, wild plants and animals, fish, domesticated dogs, and bird products. Other aspects of the economy included the manufacture of a variety of ground stone, ceramic, and bone products. Chipped stone tools and weapons have been identified in Huron village remains that may have been traded rather than manufactured. There is evidence that wood-working items were produced as is inferred from the numerous artifacts located at some archaeological sites. Perishable materials such as wood and other plant fibres were no doubt used quite extensively.

The Woodland Indians were ingenious at using corn. Corn kernels were dried and pounded into flour in a hollowed-out tree trunk, using a long wooden paddle. An everyday meal was corn soup, varied by adding pieces of squash, meat, or fish, at times without the bones, scales, or entrails being removed. For feasts, a thick corn soup might be served with some fat or oil on top. A bread of cornmeal, often mixed with deer fat or fried fruit to provide flavor, was baked in the ashes of a fire. McMillan (1988: 72) describes "stinking corn," a delicacy which was prepared by placing small ears of corn in a stagnant pond to ferment for several months before eating. Apparently the dish served to tantalize even the most refined palate.

The Iroquois operated according to an elaborate calendar with a special form of food-getting and festivity featured virtually every month of the year. During the winter months, December-January-February, the winter festival was held and featured such rites as dream interpretation and the performance of the great feather dance and the skin dance. February-March was the time of the maple ceremony and the celebration of the running of the sap. March-April introduced the celebration of the sun and moon influence over new growth. April-May meant seed planting time accompanied by singing, playing games, and engaging in the thanksgiving dance which implored the spirit of the "three sisters" – corn, squash, and beans. May-June was the berry ripening season and brought about the burning of tobacco and the war dance. June-July was the strawberry festival season, and July-August featured the bean festival. August-September highlighted the green corn festival and September-October was harvest season. November-December gave opportunity for hunting and fishing. Each season was appropriately accompanied by relevant theme-centred celebrations. One could consider this elaborate arrangement of celebrations as an early Canadian calendar of festivities.

A special Iroquois claim to fame is Chiefswood, birthplace of Canadian poetess, Pauline Johnson. Also known by her Indian name, Tekahionwake, Johnson was born to an English mother who was married to a Mohawk chief. Johnson's mother tutored her daughter in English culture privately and when Pauline was grown, she was invited to England for a recital. Johnson took great pride in her dual cultural background and her poetry reflects this. She died in Vancouver, British Columbia, in 1913.

The desire for furs and the acquisition of arms motivated the Ojibway to move westward to what is today known as northern Minnesota. In a way this proved to be

an unfortunate move since by the end of the War of 1812, the Ojibway tribes had lost pretty well all of their military power and independence. Treaties were forced upon them and they were compelled to relinquish their lands. Even then it is noteworthy that large numbers of Ojibway still reside in the states of the Upper Great Lakes although their living conditions are less than adequate (Josephy, 1969). A special gift to North American diet is maple syrup, a gift from the Ojibway.

The Iroquois Confederacy

Today people of Iroquois background constitute about 20 percent of the Aboriginal population of Ontario. Their history in the region is so significant as to warrant separate mention in this discussion. Tooker (1994: 79) informs us that the homeland of the five nations making up the Iroquois Confederacy at one time, comprised the region from the Mohawk River to the Genesee River in what is now the State of New York. When the Europeans arrived, the Mohawk had three major villages, all located in the middle of the Mohawk Valley. The Oneida had one village situated south of Oneida Creek. The Onondaga had two villages near the present city of Syracuse, and the Cayuga had three villages at the northern end of Cayuga Lake. Finally, the Seneca had four villages in the region between Canandaigua Lake and the Genesee River.

The Iroquois Confederacy probably came into being somewhere between 1450 and 1600, but certainly before the arrival of the French. Decisions were made by consensus of a council of leaders who had no police power. Each tribe was allotted its own hunting territory and agricultural land, and political loyalties were severely tested with the burgeoning growth of the fur trade, but the people prevailed. No one Iroquois nation wanted to be dominated by the other, so a cooperative spirit was maximized. Member nations sometimes likened their confederacy to a longhouse: the Senecas were considered the keepers of the western door, and the Mohawk keepers of the eastern door. This was important because of the direction of the transport of furs through the vicinity.

The five nations of the Iroquois League were not equally represented on the league council because representation was based on population. Council meetings were held in Onondaga territory since they were centrally located and therefore recognized as, "firekeepers of the league." Wampum, in the shape of cylindrical beads of shell, came to be a valued means of negotiation within the league. Sometimes wampum belts were made to indicate the importance of a reached decision.

The Iroquois League operated as a loosely-knit governing alliance led by a council of sachems or elders selected from maternal families. The parameters of the league's operations were originally confined to domestic matters but grew to include being empowered to declare war or make peace, send ambassadors, and conclude treaties. The office of civil chief was subordinate to elders, and chiefs presided mainly over local matters or as advisors to the sachems.

In its more domestic form the Iroquois Confederacy was the climax of Iroquois social structure of which the maternal household was the core image. The primary kin group of this matriarchal society was made up of all male and female progeny of a woman, tracing the descent of blood in the female line and of such persons as may have been adopted into it. When such a group joined with other lineages, a clan was formed which then became know by its own totem – turtle, deer, bear, etc. The government established by the clans was firmly in the control of women who enjoyed the right to select and depose chiefs, make land allotments, supervise fieldwork, care for the treasury and settle disputes (Johnston, 1964: xxix). Goldenweiser (1968: 565f) outlines the principal characteristics of the clan as follows: (i) the clans were exogamous; (ii) each clan had its own set of individual names; (iii) the majority of clans claimed a chief in the confederate body and participated in the election process; (iv) traditionally, a clan could own a particular burial-ground and possibly communal lands; (v) clans have been associated with particular longhouses, but this may not necessarily have been the case to any degree of specificity of occupation; (vi) clans may traditionally have been associated with villages; (vii) clans could adopt outside members; and, (viii) clans elected their own ceremonial officials.

The defeat of France and the American Revolution greatly affected Iroquois supremacy. Some Iroquois sided with the revolutionaries while others thought it best to yield to British control. In 1777, the council fire was extinguished and each of the five member nations was left alone to decide their fate on their own. As it turned out, the Mohawk, under the leadership of Chief Joseph Brant, sided with the English, and were subsequently attacked by an army of Senecas. The Oneida sided with the American revolutionaries who eventually burned Onondaga, Cayuga, and Seneca villages to the ground. When Chief Joseph Brant negotiated a tract of land with the crown in 1783, a number of Cayuga, Onondaga, Tuscarora, and a small number of Senecas went with him. Some Cayuga joined Brant's forces after their lands in New York were sold. One group of Oneida left New York State and moved near London, Ontario. Others remained in the United States where they reside to this day.

Spirituality

Like other Canadian Indigenous peoples, the Huron were deeply spiritual and many of their religious activities were targeted at appeasing or gaining the favor of the forces of nature. As one Jesuit described their philosophy, "They regulate the seasons of the year by the wild beasts, the fish, the birds, and the vegetation" (Heidenreich, 1971, 216). The Huron saw a strong correlation between nature's operation and daily life, and their sacrifices, arts, and rituals reflected this. As farmers they feared drought and frost and other possible natural damages to their crops. The role of the shamans, or priests, was prominent in this context because these individuals were perceived to

have special gifts of understanding concerning the workings of nature. Their prayers to the Creator for improved crops were accompanied by offerings of tobacco or the awarding of other gifts. Hunting and fishing were similarly spiritually-significant activities, and hunters often sought the advice of the shamans before engaging in such activity. The men were careful not to burn any of the bones of the animals or fish they caught, or let any drops of animal fat fall into the fire, because they believed that these acts were spiritually reprehensible. It was believed that live fish did not like dead bodies so fishers always kept carcasses away from the water in order to please the fish. They also refrained from fishing when a loved one had passed away.

The Huron metaphysical system was based on an underlying presupposition that the universe and all things in it belong to all the people – to all generations. They also conceptualized a Supreme Being who, according to the Jesuits, was invoked in times of grave danger. The Huron were deeply committed to the transmission of their belief system to successive generations, this responsibility being entrusted to a respected band of older, wiser men. Life in a Huron village also had its lighter side, and the people frequently held dances, and participated in games and celebration feasts. The people made use of every opportunity to celebrate a joyful occasion or mourn a sad one. Singing, farewell, and thanksgiving feasts, and feasts to cure the sick were held; tribal council meetings were also causes for festivities. Celebration feasts often included the sacred rite of stories being told by the "wise ones" as a means of perpetuating the belief system. The system was premised on the assumption that all entities in the universe, animate and inanimate, possessed a spiritual dimension. The heart was associated with being the essence of everything, and for this reason a warrior sought to partake of the heart of his enemy after he had slain him. The warrior's intent was that the power of the enemy would become his. The Huron concept of the soul also featured a second dimension, one that pertained to the intellect and possessed powers of self-awareness, knowledge, memory, and reasoning. It was the warrior's duty to develop this aspect of self and possibly try to contact the spiritual dimension through this means.

Perhaps the most ritualistic feast which the Huron celebrated was the "Feast of the Dead." The feast was held once in a decade and usually involved a series of villages. Its purpose was to honor the dead, and its celebration often coincided with village relocation. The related practices included a raising of corpses from their graves, their flesh being stripped off, and the bones placed in decorated beaver bags before a final burial. Presents were brought by family mourners and distributed among the villages. When this was done the bags were lowered into a pit lined with beaver pelts and the pit was sealed. The feast was regarded as an act of reverence and intended to promote inter-village goodwill.

According to the Huron, the universe was perceived as being "full of spirits" who resided in the sky, rivers, mountains, and elsewhere (Trigger, 1969: 90f). The spirits had

control over human ailments, fertility, and strengths, and their favor should be invoked in the event it was needed for a cause or mission. A series of specific Divine beings was postulated – Ondoutaehte, Louskeha (both males), and Aataentsik (female), all of whom had important heavenly positions. Ondoutaehte was a spirit associated with warriors and often appeared as a dwarf or a woman. Louskeha had charge of the living, and tried to make the world a suitable place for people to live. He never died, though he grew old; when he grew old he simply rejuvenated himself and went on. Aataentsik was the first woman to appear on earth and she became the mother of all living things. She spent much of her time trying to undo some of the things Louskeha did. Louskeha and Aataentsik were identified with the sun and moon respectively.

The Iroquois also viewed the universe as comprising all manners of life – plants, animals, humans, and supernatural beings – from the smallest insect to the Creator (Tooker, 1979: 11f). Each was to be respected in its own right. All spiritual entities were capable of utilizing the power awarded them for positive or hindering purposes. It was an extension of this fundamental presupposition that all things are interrelated that motivated the league to enter into negotiations for confederation with other nations; after all, all phenomena (including other nations), were considered interconnected (Becker, 1995).

As a further explication of the principle of interconnectedness, it may be noted, for example, that the mythology of the Iroquois is replete with allusions to corn, its cultivation and its uses. Their religious belief system similarly reflected the importance of their crops as significant gifts from the Creator. Three corn-related divinities, earlier referred to as the three sisters (after the three main crops), included the Spirit of Corn, the Spirit of Beans, and the Spirit of Squash. The sisters were depicted as having great physical beauty with apparel made of leaves. In the Iroquois language the sisters are known as De-o-ha-ko, meaning "Our Life" or "Our Supporters." Other spirit agents were related to the control of medicinal plants and herbs, rivers and streams, and other natural objects. At the very foundation of the Iroquois belief system, however, was a strong faith in the Master of Life, or Supreme Being, the most powerful of all (Josephy, 1968: 93). This concept, too, could have found its easy parallel in the faith system of the incoming Europeans.

The religious schema of the Iroquois incorporated a concept of personalized evil in the form of demons who wrought havoc with human beings in diverse ways. Two religious societies functioned to offer assistance in warding off the influence of evil spirits, one antidotal and the other more preventative. These were the False Face Society and the Secret Medicine Society, roughly analogous to institutions dedicated to performing missions of good or evil. The ceremonies of the former society were held for the purpose of exorcizing evil spirits and voiding diseases. Masks were worn by society members and in the spring and fall they went from house to house to perform their function. The ceremonies of the Secret Medicine Society were mainly positive and

offered to give thanks. A great deal of time was spent in preparing for the various feasts and rituals sponsored by the society and a "good time was had by all." After all, enjoyment of life was considered to be a vital part of thanksgiving.

The Iroquois code for daily living hardly fits with the typical image of Indians promulgated by the media, for the Iroquois valued highly such Christian-like doctrines as immortality of the soul, one's duty to prepare for immortality, reverence for the aged, respect for the deceased, and obeisance to the workings of nature's forces. Hospitality and brotherhood were among the cardinal virtues, and the Iroquois practiced a variety of social sanctions by which to bring deviant members into line.

Traditional Ojibway life was centred also on spirituality. The people perceived and respected the spirits (manitous) of the universe, and often enlisted the help of the spirits in a hunt or other activity. The manitous were considered as much a reality as were trees, valleys, hill, wind, and fire. It was in sessions taught by the elders that the youth learned about Kitchi-Manitou (Creator) who had infused everything and everyone with manitou-like characteristics that imparted growth, healing, character, and identity (Johnston, 1995: 115f).

A reverence for the supernatural was ingrained in Ojibway customs. At birth, a baby was wrapped and placed on a cradleboard. Parents attached charms to the cradleboard to ward off evil spirits. A special naming ceremony was held, attended by the child's family, relatives, and friends. At the ceremony the child's grandfather or elder kinsman would offer prayers on behalf of the child. Fundamental to Ojibway philosophy was the concept of "power," sometimes also called "medicine," and translated in terms of either "good medicine" or "bad medicine." An individual gained "power" through dreams or via the vision quest during which the spirits might bless that person. One could increase one's power during one's lifetime through fasting. Those who possessed an extra measure of power could become shamans or medicine men or medicine women. They were viewed as people of special power and that power or medicine could be used for two basic purposes, either for good or evil, depending on one's perspective. Those who used this power to protect and care for their group were considered positive users of power. Power could also be used to punish, to prophesy future events, or to divine the whereabouts of missing people or objects (Rogers, 1994: 330). Sometimes hunters would carry a medicine bag given them by a shaman to afford them success.

The vision quest was quite common among the Ojibway, and in precontact days boys were sent out by their parents to seek visions. A youth would fast and meditate for several days until his personal manitou manifested itself. This guardian spirit might reveal itself in the image of a creature such as an eagle or a bear, after which the young man would include related charms in his medicine bundle, for example, a bear claw or an eagle feather. Charms were used to ward off evil spirits. Although atypical of most Canadian tribes, Rogers (1994: 330) suggests that young Ojibway women were also sent

out on vision quests. Driver (1961: 542-543) notes that if a boy had experienced sex before his vision quest, the supernatural would not bestow upon him the blessing necessary to a successful life. To avoid this possible catastrophe parents probably watched the social involvements of their young sons very carefully.

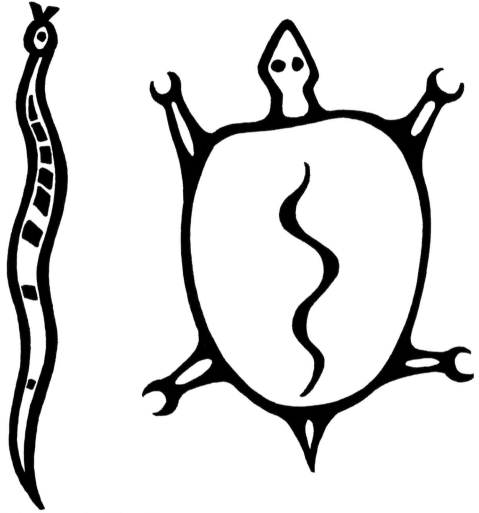

Illustrative creatures of an Ojibway vision quest.

Times set aside for prayer rituals were frequent among the Ojibway. They prayed and feasted and made sacrifices to propitiate the evil spirits who sometimes played havoc with a hunt or caused sudden storms to arise. Stone boulders and erratic pieces of copper were raised to the dignity of idols, and sometime hunters embarking on their quest would make sacrifices to the spirits which they represented. Offerings of tobacco, bread, clothing, and trinkets were usual fare.

A formal religious organization, the Midewiwin, or Grand Medicine Society, was in charge of maintaining and developing Ojibway medicinal-religious practices, and several years of instruction were necessary before adherents could complete the required four levels of attainment. The following words were used at the commencement of the Grand Council Conference or assembly of the Pipe of Peace Smoking Ceremony:

> Let us conjoin all our thoughts, intentions, dreams, and aspirations and all our petitions and prayers in the thanksgiving to Kitchi-Manitou for having bestowed upon us such bounty and beauty beyond imagination . . . and for granting us such increase in our days as to enable us to gather together in communion as in the days of old . . . to enable us to see our children's children (Johnston, 1995: 4).

A special annual feast brought together various Ojibway bands in the celebration of a very special social and religious event, although other feasts were common. The annual feast was accompanied by sports events including ball games, lacrosse, and an event called "maiden ball play" designed especially for women. Food-racing, gambling, and other recreational forms were enacted to provide diversions for a people whose principal occupation was their livelihood.

Art

Bragdon (1990: 107) is of the opinion that the spiritual beliefs of the eastern Woodland peoples were bound to the others as parts of a single continuum. Beliefs about the spiritual realm, the physical world, and the place of human beings with respect to them, were fundamental to all aspects of Native life in this zone. Although the Woodland peoples believed in a monotheistic supernatural Being, they also held to the notion that the world was inhabited by a number of spiritual lesser beings called *manitous* with qualities such as being able to communicate with humans. From time to time, they would engage in acts of treachery, irrationality, or even hostility toward the human occupants of the earth and might have to be appeased. This arrangement of belief confirms the conclusion that the distinction between the natural and supernatural could not easily be made in Aboriginal thought, for each impinged upon the other.

The use of Iroquois masks underscored their relation to life functions such as healing, and, as Savard (1969) notes, they represented the most spectacular aspect of Iroquois religious life. There were legends about the origin of the masks and numerous rituals demanded their presence. Masks were won by members of the False Face Society and the Shuck Face Society. The former group was often engaged in curative activities and the latter related to the role of prophet.

The Woodland peoples used a variety of natural substances to create art or embellish necessary items with artistic beauty, birch bark was one such substance. Birch bark products included containers, cutout figures, decorations of various kinds, pictures,

transparencies, and canoes. Woodland women chewed artistic designs on birch bark, and used cones of bark as moose callers. They boiled food in water-filled bark vessels by dropping hot stones into the water, later taking the stones out to be heated again (Price, 1979: 76). Iroquoian cultures manufactured ceramics, pipes, twined fabrics, and even bird-bone beads (Patterson, 1973: 45). Huron and Iroquois women formed naturalistic floral designs in quillwork on bags and moccasins, sometimes dying moose hair as a decorative substance. For example, birch bark dishes and containers were sometimes decorated with floral designs in moose hair (Glover, 1978: 5).

Early Ojibway art was evident in myriad forms. Ojibway women were known for their weaving skills long before European contact. To make a blanket, they cut a rabbit skin round and round in a narrow strip so that the hide made one continuous strip. As the strip dried, it became twisted and resembled a soft cord. Weaving was done on a warp of cotton twine with a space of one and one-half centimetres between the rows of skin. The blanket was firmly woven as the skin was tied around each thread of the warp (Seton, 1962: 137). In addition, floor mats were woven out of bulrushes or cedar. Berry drying racks were literally screens made out of woven reeds. The first Ojibway drums consisted of hides stretched over stakes placed in the ground.

Berlo and Philips (1998: 89) point out that archaeological evidence from the early Eastern Woodland period confirms oral tradition reports of trade between Woodland peoples and tribes further south, perhaps as far as Mexico. One find includes clay and stone pipes whose bowls depict effigies of birds and animals which very much resemble those produced in Mexico at about the same time. Other parallel items include antler combs with handles carved in low-relief with "cutout" images of bears and other animals, as well as whole concho shells and shell gorgets that may have come from the Gulf of Mexico. Cylindrical calinite beads from the Minnesota area were also located.

One of the reasons why the Woodland peoples welcomed European fur traders was because of the opportunity to acquire the new items they brought with them – metal tools and implements, glass and silver ornaments, and cloth (Penney, 2004: 53). The diffusion of these elements naturally caused significant changes in various sectors of First Nations' lifestyle. Hunting practices and methods of warfare changed, as did aspects of the domestic scene. Women adopted European-originated decorative designs which could subsequently be recognized on traditional clothing and other items. Because of new technology, time to achieve certain tasks were often shortened, leaving individuals time to shift their energies in other directions. Not all introduced items were immediately put to use, but had to be slowly incorporated, based on the extent to which they were deemed useful. Locals often judged the value of an introduced item on the basis of increased productivity or security.

There were also spiritual implications related to diffused items. It has been suggested that symbolism was attached to the introduction of white, red, and blue beads, for example, because they played to longstanding indigenous values that extolled them as

expressions of success, wealth, and leadership. Works produced by Woodland artists often portrayed their cosmological beliefs. Penney (2004: 60) provides an example:

> Images of the Thunderbird, the equal-armed cross, and the Underwater Panther are often found in Eastern Woodlands art in ways that suggest a kind of cosmological diagram. Underwater Panther is the Thunderbird's nemesis yet compliment. . . . All three symbols together describe the basic structures of the larger cosmos, the terrestrial earth bracketed by the sacred and powerful realms of sky and water above and below. Human beings, suspended amidst these powerful forces, strive to live within their precarious yet potentially rewarding state of balance.

Europeans were immediately impressed by Woodland art and often procured articles to take back home with them as gifts to important officials. Some wealthy aristocrats and merchants collected Woodland art works and showed them off to acquaintances. It became a status symbol to possess such collections because ownership indicated that the owner was probably a well-travelled individual and therefore had vast knowledge of different parts of the world. Fortunately, many of these collections have been preserved and study of them has provided the contemporary art world with a great deal of valuable knowledge.

Artists

A burgeoning of Woodland art occurred in the late 1960s and 1970s with the work of now deceased artists Benjamin Chee Chee and Carl Ray. At that time, a group of painters banded together and formed the Indian Professional Artists' Corporation in Winnipeg. Informally known as the Aboriginal Group of Seven or Woodlands Artists, the members included Jackson Beardy, Eddy Cobiness, Alex Janvier (Dene), Norval Morrisseau, Daphne Odjig, Carl Ray, and Joe Sanchez. Morrisseau introduced the concept of portraying Indian legends in his paintings and this idea was followed up by a number of Woodland Ojibway artists including his own brothers-in-law, Joachim and Goyce Kakegamic, their cousin Carl Ray, and Daphne Odjig.

Other artists who followed this art form included Samuel Ash, Del Askewie, Leland Bell, Lloyd Caibaiosai, Blake Debassige, Fred Green, Francis Kagigi, John Laford, James Simon Mishibinijima, Ron Noganosh, Roy Thomas, and Saul Williams. A summary of the work of this genre of artists follows.

Born in Manitoba, on July 24, 1944, Jackson Beardy was a painter and illustrator with a great reputation. Educated in the School of Fine arts at the University of Manitoba, Beardy first became a commercial artist and was a founding member of the Aboriginal Group of Seven. He was a leading figure in First Nations matters during the 1970s, politically and artistically, and addressed treaty issues in his paintings. Beginning in 1965, he held many individual exhibitions, and witnessed collections of his work

in many museums across Canada. He eventually became art advisor and consultant to the Manitoba Museum of Man and Nature, and was active in many related organizations. He was awarded the Canadian Centennial Medal, and when he died in 1984, his memorial service was the first ever held in the Blue Room of the Manitoba Legislative Building.

Eddy Cobiness (1933-1996), a member of the Indian Group of Seven, was born in Warroad, Minnesota, but raised on the Buffalo Point Reserve in Manitoba. Basically self-taught, he was influenced by the work of Benjamin Chee Chee, but altered his style to more abstract forms. Cobiness worked in oil, acrylic, watercolor, pen and ink, and always signed his paintings with his treaty number: 47. Today several key museums across Canada, including the Royal Ontario Museum in Toronto, and the Woodland Cultural Centre in Brandford, Ontario, house collections of his work.

Benjamin Chee Chee (1944-1975) was born on the Temagani Reserve at Bear Island, Ontario. He rose to national attention in 1970 with the formation of the Woodland School of Art. Although his career was relatively short, he influenced many younger Ojibway artists. Chee Chee primarily painted abstract scenes and smaller drawings. The former were often created by applying stamping techniques with a wood block. Later, he also used stencils, textured sponges, and feathering techniques. His Black Geese Portfolio comprises 18 images which are often seen on postcards, posters, and unnumbered prints all over Canada.

Blake Debassige is an Ojibway painter, graphic artist, carver and printmaker. Born on Manitoulin Island, he attended the Manitoulin Arts Foundation Summer School and Laurentian University. He participated in individual and group exhibitions beginning in 1973 and collections of his work are in dozens of Canadian museums. Inspired by Norval Morrisseau and Jackson Beardy, Debaggise began painting while still in high school. Thematically his paintings and graphics explore traditional Anishinaubae teachings about nature and the universe.

Francis Kagigi was born in 1929 on the Wikwemikong Reserve on Manitoulin Island and followed the style of the Woodland artists in his work. A self-trained artist, Kagigi's early work featured cardboard from shoeboxes and old notebooks, showing abstracted, stylized Native symbols. He taught art in his home community and his work was exhibited with that of other Woodland artists in museums such as the Canadian Museum of Civilization in Hull, Quebec; Indian and Northern Affairs in Ottawa, Ontario; and the Thunder Bay Art Gallery in Thunder Bay, Ontario.

A Cree painter and printmaker, self-taught artist Goyce Kakegamic, was born on the Sandy Lake Reserve in Ontario. Using the familiar black line formation of the Woodland school, Kakegamic's paintings and graphics tell stories containing detailed information about Woodland life. Also from the Sandy Lake Reserve, Joachim Kakegamic studied with Norval Morrisseau and became one of the most important members of the second wave of Woodland artists.

Canada goose done in the Chee Chee style.

Born in 1954, Ojibway painter John Laford makes his home on the shores of Lake Superior, from which much of his inspiration comes. He has travelled extensively and held shows across Canada, the United States, and Spain. His paintings are housed in collections at the National Museum of Civilization at Hull, Quebec; the Royal Ontario Museum in Toronto, Ontario; and the Museum of Anthropology at the University of British Columbia in Vancouver, British Columbia. A recipient of a Canada Council Award, Laford's paintings comprise a vibrant statement of the spiritual and natural world of Canada's First Nations.

Norval Morrisseau is easily the best known artist of the Woodland tradition. Born on the Sandy Point Reserve in Ontario on March 14, 1931, Morrisseau greatly influenced both colleagues and successors with his portrayal of Ojibway legends in art. Multiple exhibitions, numerous awards, publications, and museum collections mark Morrisseau's contribution to Aboriginal Canadian art. He regards the message of his work as an extension of Ojibway shaman knowledge.

Ron Noganosh is an Ojibway graphic artist, photographer, and installation artist from the Magnetewan Reserve. Born on May 3, 1949, he studied welding and graphic design at George Brown College, and visual arts, sculpture, painting, drawing, and lithography at the University of Toronto. Dozens of books and articles chronicle Noganosh's career, supplemented by his participation in individual and group exhibitions. Many of his works address Aboriginal concerns such as the Lubicon First Nation's quest for land, the loss of Indian lands, and traditional culture.

Painter Daphne Odjig was born in 1919 on the Wikwemikong Indian Reserve on Manitoulin Island. The recipient of several honorary doctorates, Odjig's work is unique in portraying aspects of contemporary First Nations life in Canada. She began participating in individual and group exhibitions in 1967 and is considered a forerunner in emphasizing Aboriginal political and cultural concerns through the medium of art.

Carl Ray (1943-1978) was a Cree painter and printmaker from the Sandy Lake Reserve, Ontario. His background employment included working as trapper, miner, logger, editor, printmaker, and summer school teacher with the Manitoulin Arts Foundation. His grandfather and brother were active in Cree spiritual leadership and so his early paintings illustrated Cree legends and teachings. Later, he was influenced by the Woodland school and included more personal content in his work.

Roy Thomas is basically a self-taught Ojibway painter from Longlac, Ontario, although he studied at the Saskatchewan Indian Federated College in Regina. Raised by his grandmother when his parents died in a car accident, Ray attributes his personal sense of spirituality to her. As an artist in the Woodland tradition, Thomas' paintings reflect great appreciation for Anishinaubae spirituality. His exhibitions, publications pertaining to his career, awards, and museum collections are numerous.

A family done in Morriseau style.

A chorus in the style of Daphne Odjig.

Many other Woodland-influenced artists deserve mention as well, such as, Gary Meeches, Don Peters, and the late Isaac Bignell.

Ojibway artist, Carl Beam, is a mixed-media artist as well as a sculptor, printmaker, and painter. Beam was born in 1943 on Manitoulin Island and studied art formally. He graduated from the University of Victoria with a Bachelor of Fine Arts in 1975, then pursued graduate studies at the University of Alberta. He eventually dropped his studies to become a full-time artist. As a member of both Ojibway and EuroCanadian societies (his father was non-Native), Beam has emphasized aesthetic themes that fit into contemporary, dominant society. His work has been described as intensely personal, yet curiously universal. One of his paintings, *The North American Ice-berg*, became the first Native artwork purchased by the National Gallery of Canada in Ottawa since 1927.

Rebecca Belmore is an Ojibway performance and installation artist from Upsala, Ontario, and Ojibway by tribal affiliation. Born in 1960, Belmore graduated from the Ontario College of Art and began participating in individual and group exhibitions in 1988. Unlike members of the Woodland school, Belmore struggles with the juxtaposition of Aboriginal and non-Aboriginal cultures, and is also concerned with global considerations. One of her more outstanding performances occurred in 1988 in Calgary, Alberta, when she presented herself as a living, boxed artifact by the side of a road along the Olympic torch route.

A member of the Cayuga First Nation on the Six Nations Reserve, Vincent Bomberry is a well-recognized sculptor in Canada. Born in 1958, Bomberry participated in his first individual exhibition in 1980. Since then he has honed a place in the world of sculpture by creating unique images that sometimes exhibit a duality masked in abstraction featuring aggressive, and sometimes, violent moods. He often uses Native mythology as a basis for his work, mixing primal and contemporary styles. His works are housed in a number of national museums.

William and Mary Commanda are widely known for their exhibitions of birch bark canoe-making although they also have many other interests that may be linked to Aboriginal nationalism. In a conversation with the late Prime Minister Pierre Elliott Trudeau, William mentioned that when it came to matters affecting Canada's First Nations, the Canadian court system spelled the word "justice" incorrectly. When the prime minister objected, William insisted that in reality the word should be spelled J-U-S-T U-S! The Commandas belong to the River Desert Algonquin Band of Maniwaki, Quebec. William was chief of his band from 1951 to 1970, and both he and his wife Mary, are fluent in Algonquin as well as in French and English. Today the Algonquin peoples are the only makers of Indian birch bark canoes (Gidmark, 1995: 9-11).

Patricia Deadman was born in Ohsweken, Ontario, on April 24, 1961, and is recognized as a Mohawk photographer. She also earned a diploma in fine art from Fanshawe College in London, Ontario, a BFA from the University of Windsor, and studied at the Banff School of Fine Arts. A second generation Aboriginal photographer, she followed

the footsteps of Rick Hill, Jeffrey Thomas, and Tim Johnson. Her work is easily recognized by its colorful images of pow-wow dancing, often creating dancing collages to the delight of her observers. She also does excellent work in black and white photography. Vitally interested in promoting Aboriginal themes, she is a member of the Native Indian/Inuit Photographers Association.

Guy Soui Durand is a Huron-Wendat sociologist, theoretician, art critic, activist, and independent curator in actual art from Wendake, Quebec. He believes the art field became his imaginary territory and a vehicle through which he could affirm his Native identity. He believes artists should create works, events, and other forms of intervention that not only flout the sophisticated mechanisms of prohibition, but also show solidarity with cultural workers. Artists must no longer be content to sign petitions, but take to the streets and display their solidarity instead of providing security to those in power.

David General was born in 1950 at Ohsweken, Ontario, an Oneida by affiliation. He attended Wilfred Laurier University and Hamilton Teachers' College before becoming a self-taught artist. His resume includes steel worker, elementary school teacher, and senior cultural development officer with the federal Department of Indian and Northern Affairs in Ottawa. He has many exhibitions, museum collections, and publications to his credit, and is best known for his creation of peaceful and serene sculptures. Leaning toward abstraction in his work, General also endows his creations with specific and purposeful character.

Actor Graham Greene is a member of the Oneida First Nation from the Six Nations Reserve at Brantford, Ontario. During the 1970s, he worked as a sound engineer for a popular Canadian band when one of his friends suggested that he would be a good actor. Greene applied for a role on the London, Ontario, stage and the rest is history. In 1963 he obtained a role in the movie, *Running Brave*, and thereafter worked in television, on stage, and on the big screen. Mostly cast in strong, positive roles, Greene's most famous role to date was Kicking Horse in Kevin Costner's *Dances With Wolves*.

Roy Henry is a Cayuga-Ononadaga sculptor from the Six Nations Reserve at Brantford, Ontario. He first became interested in art when he was twelve years old, then expanded his interest by going on stone-gathering expeditions throughout Canada and the United States. Essentially self-taught, Henry now teaches his skills to budding young artists on his home reserve. In addition, he participates in pow-wows as a singer of traditional ceremonial songs.

Stanley R. Hill (1921-2003) was born to a Tuscarora father and a Mohawk mother, and by tradition, adopted his mother's cultural line. He attended Ohsweken schools as well as Metalsmith School in Boston, Massachusetts, then joined the United States Navy, serving as a deep sea diver. He spent 33 years as a construction and iron worker, and became a full-time carver in the mid-1960s. Originally he carved animal forms on moose and deer antlers, animal bones, and ivory, then switched to carving human

forms. He participated in his first individual exhibition in 1977, and in a group exhibition in 1985. He won more than 50 awards and his works may be seen in galleries all over North America.

Born in 1942, George Longfish is a painter of Seneca and Tuscarora affiliation, and grew up in Oshweken, Ontario. He studied painting, sculpture, printmaking, and film-making at the School of Art Institute in Chicago where he became a teaching assistant in photography and filmmaking. He graduated with an MFA degree in 1972. Easily recognized for his endeavors in various aspects of Native art, Longfish completed a series of paintings based on war shirts, authored several books, and participated in more then 200 individual and group exhibitions. Many awards have been bestowed upon him, and he is perceived as a leading figure in contemporary Native art. His roles as artist, curator, professor, and writer have influenced many areas of the field.

Born in 1952, in Oshweken, Ontario, on the Six Nations Reserve, Bill Powless is a painter of Mohawk extraction. Powless studied art at the Mohawk College in Brantford, and then in the early 1970s, painted bridges and industrial steel. He officially entered the world of art by participating in his first group exhibition in 1975, and slowly gained a modest profile as a painter, sketch artist, cartoonist, and illustrator of childrens' books. Pen and pencil is a favorite Powless medium, although he also follows the example of Ron Noganosh by constructing three-dimensional sculptures from found objects.

The accomplishments of this rather long list of Woodland artists affirms the perpetuity of their genre of art well into the future.

Chapter Six
Plains Aboriginal Culture and Art

The popular media inspired version of the Plains Indian culture usually features a band of fearless, bareback mounted Aboriginal warriors charging bravely and uninhibited into battle with the American army. Sadly, this stereotype too often overshadows more objective descriptions of a very unique cultural configuration. Now, thanks to more realistic portrayals rendered by anthropologists and historians (many of them Aboriginal), the traditional Plains Indian way of life is being more accurately described.

Although they were one of the last cultural groups in North America to obtain the horse, the Plains Indians became some of the most skilled and respected horsemen on the continent. Plains horse culture essentially lasted about 150 years, but the extent to which the nomadic wanderers adapted the versatility of this magnificent animal in every aspect of their lifestyle will long be remembered. In this domain, the various plains tribes experienced a kind of unity, probably replaced by another, later twentieth century kind of bond, the bond of a colonized people. Classic Canadian Plains tribes include the Assiniboines, Blackfoot Confederacy (Blood, also known as Kainai, Peigan, and Siksika), Cree, Dakota, Ojibway (Saulteaux), Tsuu T'ina, and Stoney.

History

The Great Plains comprise an area of vast, semi-arid grasslands stretching from the Mississippi-Missouri Valley on the east to the Rocky Mountains on the west. This region includes the territory from the forests of northern Saskatchewan to the Rio Grande River in central Texas to the south. Non-Native explorers who first searched out the land considered the area basically uninhabitable because of its varied temperatures, unpredictable seasons, and generally semi-arid conditions. Once it was established that this region had been populated for some time, however, it became a question of determining how long this had been the case. Soon after European explorers arrived in the area local inhabitants were inundated with a multiplicity of cultural forces that caused significant shifts in their lifestyle. One of the hardest adjustments was the abolition of the buffalo in the early 1880s.

The earliest inhabitants of the Great Plains were probably hunters of large game animals associated with the Pleistocene period, dating back at least 10 000 years. The years between 5 000 BC and 2 000 BC are commonly known as the "Dark Ages" in North American archaeology because so little is known about this time span. Scant archaeological evidence has, so far, been uncovered relating to this period (Wiley, 1968: 8). The relics left by pedestrian hunters and gatherers around 2 500 BC suggest a wide-spread interest in the plains by small groups of wandering Indigenous People. Some-time before the missionaries entered the plains, there is evidence of influence from tribes further south, like the moundbuilders of Ohio and Mississippi. Woodland cultures also entered the area, probably between 500 BC and AD 1 000, and some agri-cultural lifestyles were established. These farms were abandoned around AD 1 500 with most of the people returning to a hunting and gathering format. By the time the Europeans entered the plains, a fairly-established buffalo culture could be identified in the core region (Josephy, 1968: 114).

The languages spoken by North American plains tribes have been subdivided into six language families: Algonquin, Athapaskan, Caddoan, Kiowan, Siouan, and Uto-Aztecan. The Algonquin language family is represented in southern Canada by the member nations of the Blackfoot Confederacy. Their occupation of the plains dates back thousands of years. The Plains and Woodland Cree are also Algonquin-speaking, and probably divided into two configurations and moved onto the plains in connection with the westward movement of the fur trade. This may also be true to some extent of the Saulteaux or Chippewa (Plains Ojibway). The Athapaskan-speaking Tsuu T'ina (Sarcee) broke with their northern mother tribe, the Beaver First Nation, in the latter part of the eighteenth century. Neighboring northern tribes of the same language family include the Chipewyan and Slavey tribes. The Stoney First Nation and the Assiniboines speak a form of Siouan, specifically Nakoda Sioux (Wilson and Urion, 1995: 22f). There is evidence that the Kootenay (Kutenai), Shoshone, and Atsina (Gros Ventre) also lived on the plains in prehistoric times, but they had pretty well been displaced by the middle of the nineteenth century.

Despite their language differences, the plains tribes often communicated with one another using a universal sign language. Lowie (1968: 489) suggests that this method of communication made it possible for a member of one tribe to recount his war deeds to a member of another tribe without the latter understanding a single verbal utterance. A Shoshone once related to Lowie, wholly by signs, the folk tale of how a giant bird snatched and ate people, and in similar vein a Kiowa gave General High Lenox Scott an account of their complex Sundance ceremony. Based on these factors, it does not seem presumptuous to note that international trade and communication were well-established in North America long before the Europeans came. Trade was essentially a system of barter between sedentary and nomadic tribes, primarily involving perishable goods. Nomadic tribes traded dressed buffalo meat, deerskins, lodge covers, and items

of clothing for corn, pumpkins, and tobacco. Grobsmith (1990: 183) has identified two major Aboriginal trading centres that were in operation long before the French came, one in what is now North Dakota and the other in South Dakota. Horses and guns were two of the most important items traded but gradually the demand for other items increased, including axes, knives, kettles, awls, mules, riding gear, gunpowder, bullets, brass, and iron tools, and decorative items. Once the fur trade got underway the focus of the industry developed a broader base.

With the demise of the fur trade and the influx of settlers, the Plains First Nations faced the new challenge of adjusting to the restrictive lifestyle of the reserve. This adjustment was gradual in scope, because the handwriting was on the wall that major shifts in perspective would be required with the continual pressure of constant population increases. The steady demands for more Indian lands indicated that the newcomers thought there would not be room for everyone on the prairies. Thus the nineteenth century became a major watershed for Canada's First Nations (Hildebrandt and Hubner, 1994: 29). Ahead of them lay the prospect of adapting to AngloCanadian culture, a subsistence form of agriculture, and a lifestyle that was controlled by federal government regulations and missionary influence. Behind the First Nations lay a long tradition of adaptation to forest and plains environments. There was no way they could be prepared to adjust to reserve living, and the thinly-disguised program of extermination through assimilation promoted by the Canadian government (Cardinal, 1977: 65f).

Culture

Traditionally the Plains People lived a nomadic lifestyle, occupying portable teepees that have long become associated with the pinnacle of plains cultural development. Before the Spanish introduced the horse, the Indians domesticated dogs to pull travois and travelled on waterways in dugout canoes. They dressed in animal skins, but pursued no particular aptitude for weaving, basket-making, or woodworking. Alternately, Plains women made a good deal of fine porcupine-quill embroidery and showed skill in their attachment of feathers for decoration.

The first acquisition of horses by Plains Indians dates from 1740-1800, largely following the principle of diffusion. From the start the horse complex became an integral part of the plains way of life. The animal was used as a riding animal in hunting and warfare and as a burden bearer, replacing the dog. Horses lightened the work of harvesting buffalo by permitting the rapid surround of a herd, a kind of instant corral which rendered unnecessary the building of a fence, or the risk of losing a herd if it stampeded (Kehoe, 1981: 291).

Weatherford (1991: 174) suggests that when the horse arrived on the plains, hunting proved to be so lucrative that some agriculturally-inclined tribes gave up growing crops and turned to hunting almost exclusively. When they needed varieties of food,

The introduction of the horse changed Plains culture.

tools, or other goods that the buffalo did not supply (and these were few in kind), they traded their vast harvest of buffalo meat and hides for what they needed. As a commodity and status symbol the horse was highly prized among Plains tribes and horse stealing soon became an established way for a young man to prove himself to his peers. Ambitious young men needing horses to gain economic and social status among their own people, often stole the animals from neighboring tribes. In this context horse raiding not only engendered intertribal wars but tended to perpetuate them (Ewers, 1968: 496). The horse was also a symbol of a man's wealth and made a valuable trade item when young males bargained for brides.

The influence of the horse on Plains Indian culture has been the subject of debate among anthropologists for nearly a century. Wissler (1927) argued that most of the important aspects of Plains culture were in place and remained relatively unaffected by the introduction of the horse. These components included the teepee, the travois, the foot war party, the practice of counting coup, the Sundance, the camp circle, men's societies, and the circumscribed range of winter and summer camps. Kroeber (1907) held an opposite view, arguing that these factors would have had to be influenced by the horse; how could any good-sized group have lived permanently off the buffalo on the open plains while the tribes and their dogs were dragging their dwellings, furniture, provisions, and children? How large a teepee could have been regularly set up and dismantled? Using dogs as a means of transportation, how often could several thousand people have congregated in one spot to hold a four day Sundance? Unfortunately, both views are the result of speculation since the lack of archaeological evidence cannot prove either view. The oral tradition might have helped us here, but its orientation core, first and foremost, has consistently pertained to the transmission and preservation of revered truths and customs, not to a study of cultural change. Social scientists do know for certain that the horse enriched Plains cultural life and altered the habits of daily life. It also served to provide a need for new manual and motor skills and changed the people's concepts of the physical environment and social relationships.

As nomadic peoples, the prairie tribes lived in easily-moved teepees with a base diameter of about five metres (16 feet), requiring about 15 to 20 hides as cover. A wealthy chief might have a larger teepee with as many as 30 supporting poles covered with as many hides. Chief Crowfoot of the Siksika, for example, had two teepees; the larger one required 30 buffalo hides as covering. Crowfoot needed the extra living quarters for he had a total of 10 wives in his lifetime, but never more than three or four at one time (Dempsey, 1995: 401). In the southern plains, where trees were less plentiful, teepees were often smaller. At the centre of the teepee was the domestic fire, its smoke circling up to a hole at the apex of the structure. Making a teepee was sometimes carried out as a communal effort. The intention to make a teepee was publicly announced, and a feast would be held. An experienced designer would be called on to oversee the project, and sometimes as many as 20 women collaborated on sewing the skins (Berlo and Phillips, 1998: 115).

Among some tribes, particularly Blackfoot, teepee covers were decorated with significant images to commemorate a design that the owner would have seen in a dream or vision. The design might extol a particular war exploit or represent a special spiritual message or messenger. Teepee designs could be transferred to other individuals who might wish to have the benefit of the power of the design, but a price had to be arranged and a special ceremony enacted by individuals who had authority to do so.

A Plains Indian village usually consisted of several dozen teepees arranged in a circle or semicircle, usually located close to water, generally on a bluff above a stream or river, and often fortified by a ditch or other form of natural terrain. There was considerable variation in the placement of dwellings within villages since the lifespan of a village was apt to be brief. After relocating a camp, and perhaps meeting up with another band, social visits, games, gambling, and foot and horse races transpired, councils were held, and ceremonies conducted. One of the most important rituals to be undertaken was the Sundance which was held in the summer and sometimes sponsored in conjunction with other, more social events.

Plains clothing was appropriately fitted to the occasion. A Plains Indian male wore a breech-cloth and moccasins, to which were added hiplength leggings, and a buckskin shirt. A buffalo robe was added during inclement weather. Women's dress varied a bit more, but usually consisted of a sleeveless dress of deerskin reaching to the ankles, leggings, from the knees down, and moccasins. Hair-styling was quite another thing; Newcomb (1974: 92) suggests that men spent more time dressing their hair than the women did. The latter commonly braided their hair, and a streak of paint was added at the part. Painting of the face and body in a number of colors and with a wide variety of styles was widely practiced, and tattooing was in vogue among the more southern tribes. Men generally plucked out all facial hair, often including eyebrows. Both sexes utilized decorative devices in the form of earrings and necklaces made of shell, bone, copper, and brass where available. The hair pipe breastplate, composed in later years of tubular bone and shell beads obtained from traders, became an ornate and unique part of the more formal attire of Plains warriors (Newcomb, 1974).

Animals skins were put to a multiplicity of uses by plains people, particularly bags (*parfleches*) and containers. These containers were used to transport personal items or store food. Smoked leather, processed from rawhide with fat and brains, was used to make clothing and containers.

With the advent of the nineteenth century, new cultural forms of metaphysics, social organization and warfare began to evolve among Plains First Nations. Farb (1968: 125f) suggests that when Plains culture reached its own particular form of maturity, warfare became as ritualized as that of medieval knighthood. Tribes fought each other not only for territory or to capture slaves, but for a variety of other reasons – to obtain horses, to strengthen tribal uniformity, and to win status. The latter activity primarily featured a sort of game called "counting coup," derived from the French word

for "blow." Originally, counting coup signified that a warrior had struck an enemy's body with a special stick or lance designed for that purpose. To play the game, exploits were graded according to the dangers involved. Another meaning attached to the term "counting coup" referred to the recital by a brave of his war deeds. He did this by striking a pole with his axe for each deed. Whenever a warrior had opportunity to tell of a recent battle he took advantage of the situation and recounted his previous deeds as well. Among the Blackfoot, stealing an enemy's war weapons was considered the highest exploit, but among other tribes the bravest deed was to touch an enemy during battle without hurting him – and live to tell the story. The Cheyenne counted it a brave act when several warriors touched the same enemy, but ranking was done according to the order in which the enemy was touched. Among some tribes braves were awarded an eagle feather for the act of counting coup.

Intertribal warfare was a common activity on the plains, generally characterized by swift, short raids, and sometimes with only few casualties. An individual warrior, anxious to earn a name for himself, might encourage a few friends to join him in stealing horses from an enemy camp or to count coup on an enemy band. Of course a successful raid on an enemy camp also brought reprisals, so battle lines would be drawn again and again.

Supermarket of the Plains

The first Europeans to witness the western plains probably saw them as vast, treeless tracts of open ground. In 1870, Captain William Butler described the plains as a great ocean of grass with no past – a place "where men have come and gone, leaving no track of their presence" (Carter, 1995: 446). To the Plains people, the buffalo was the foundation of their economy, providing the people with all of their basic needs – food, shelter, clothing, containers, and tools. As Ewers (1981: 14-15) describes it,

> This big-game animal furnished a host of other useful materials. Dressed cowskins sewn together with the sinew of the same animal served for lodge covers. The heavy winter hides covered with thick, shaggy hair, were wrapped around the body, hair side in, to make warm, snug overcoats. They also served for bedding. From winter hides they also made mittens, caps, and moccasins to protect their extremities from the freezing cold. They made shields from the thick of the buffalo's neck and used green rawhide for securely binding stone clubs, knives, mauls, and berry mashers to wooden handles. From soft-dressed buffalo skins they fashioned bags to hold their household goods when they moved camp.

It is difficult to overestimate the importance of the buffalo to Plains culture, and history underscores the close interrelationship of the buffalo and the Plains Indians lifestyle. The bison was a child of the Pleistocene or Ice Age, but along with the

Supermarket of the plains.

musk-ox, survived to live on to modern times. Climatic changes determined the buffalo's destiny to a large extent, and researchers speculate that ice over the northern area of the prairies was two to three kilometres deep. Historians theorize that when the bison migrated here across the Bering Strait it faced severe weather conditions of extreme cold. Still, the magnificent animal survived, well-equipped to handle its adopted habitat, and skilled enough to find grass to eat even beneath mounds of snow. The beast possessed the ability to confront blizzards that made cattle turn tail and die. Conservationists praised the buffalo's grazing habits, for the animals never totally consumed full blades of grass, but always left just enough of the natural crop to refurbish itself next spring. Unlike cattle or horses, these habits were ideally suited to the native grasses of the Great Plains. This unique adaptation has other facets; today consumers are discovering that tasty buffalo meat contains less fat than beef and less cholesterol than chicken (Hodgson, 1994: 64f).

The buffalo possessed other, almost magical characteristics. One minute it looked like a placid cow in a park paddock, and the next it was a fighting monster. It was not naturally a belligerent animal, but if wounded, it would stand and fight, particularly in the case of a mother defending her calf. The buffalo had remarkable speed and amazing endurance, often putting a hunter on horseback to the ultimate test of skill. Observers said that a buffalo herd, including calves, could run 150 kilometres (94 miles) to escape a prairie fire (MacEwan, 1995).

To the Indians the buffalo was much more than a prey animal or provider of food and other supplies. Quoting a Cheyenne elder, Hodgson (1994: 69) explains,

> "When the Creator made the buffalo, he put a power in them," says Les Ducheneaux, former guardian and ceremonial slaughterer of the Cheyenne River herd."When you eat the meat, that power goes into you, heals the body and the spirit. Now we have the poorest diet. We have alcoholism. We have juvenile and adult diabetes. When our spirituality comes back, when we see buffalo as or grandfathers saw them, then we'll be on the road to recovery."

The buffalo was a spiritual entity, and a complexity of related metaphysical beliefs were developed concerning it. Several creation myths attributed to the buffalo, the essence of life itself, and other tales of human/bison interaction underscore the fundamental belief that while all entities in the universe are interconnected, the human/bison bond is unique. Archaeologists frequently find bison bones, particularly skulls, in prehistoric human graves, possible indications of hunters' special burial rituals (Bryan, 1991: 71f).

McHugh (1972: 110) suggests that the buffalo was the highest-ranking figure in many hierarchies of tribal gods, figuring in a large body of religious practices, symbols, and rituals. The animal's appearance and movements were poetically described, and parts of its body were valued as charms or sacrificed to spirit powers. The buffalo was

the Creator's special gift to His children. Buffalo skins were made into teepees, clothing, robes, and rawhide parfleches. The meat, including the liver and the lungs, were their food; the heart was eaten raw immediately after the hunter made his kill (Thom, 1992). The animal figured in dances, superstitions, taboos, societies, visions, and cures (Neidhardt, 1979: 204f). Some Plains tribes believed that the buffalo had particularly been placed on earth for the sustenance and support of humankind. Others saw the buffalo god as the patron of chastity, fecundity, industry, and hospitality, all of the qualities they saw desirable in a woman. In short, the buffalo was worshipped as no other animal in the domain of the Plains Indians. It was their way of showing their appreciation to the Creator for His provision of food and other needed supplies.

The Blackfoot termed the buffalo's flesh "real meat," implying that other meat was inferior. Before the horse came, warriors hunted buffalo on foot in small nomadic bands of 50-100 people or as many as could effectively handle a drive. The drives required excellent organization, particularly when the animals were driven over buffalo jumps. One of the oldest and best preserved of such locations in North America is Head-Smashed-In-Buffalo Jump in the Old Man River Valley some 18 kilometres (12 miles) west of the Town of Fort Macleod in southern Alberta. The complex consists of the jump, an associated campsite below, and the gathering basin with drive lanes. The jump has become a well-known landmark in the area since the first European settlement in 1874. An archaeological inspection by a team from the University of Calgary in 1965 revealed it to be at least nine metres (29 feet) deep and about 3 000 years old. Additional excavations were carried out in 1966 and 1972.

A tribute to Blackfoot ingenuity, Head-Smashed-In Park has preserved the essence of the concept of the buffalo jump by showing in natural form, how the technique worked. First, a special site had to be selected, hopefully one with which the buffalo were not too well acquainted. Then the bison were carefully maneuvered toward the precipice in much the same way as they did with the pound method. The hunters drove the buffalo toward and then over the cliff while women and older men waited at the bottom, ready to slaughter the bison after their fall. Excavations below the cliff not far from the site, show that people throughout the centuries gathered there to organize the drive, wait for the kill, then butcher and skin the animals (Bryan, 1991: 50-52). In most cases the fall over the precipice killed the beasts instantly. As soon as the last bison tumbled to its fall, those waiting below the jump moved in quickly to club those animals to death who had not died in the fall, and prepare them for butchering. Even a few days after the drive, the stench of decaying blood and offal carried some distance downwind, a symbol of the rigor and courage required by the lifestyle (Irwin, 1994: 181). The Blackfoot word for a jump was *piskun*, meaning "deep blood kettle."

One of the most dangerous ways to hunt buffalo was on horseback, a favorite of the Métis who called it "running the herd." Some horses could run faster than bison, to be sure, but the lumbering bison were difficult to chase. They were much heavier than

horses, and if a buffalo struck a horse during the run, both horse and rider could quickly be knocked down – perhaps directly into the path of the herd behind. This method required a great deal of skill and stamina on the part of the rider to say nothing of the horse's agility. The Kootenay Indians insisted that running a buffalo required a "five-mile (8 kilometre) horse" (McHugh, 1972: 76). When a hunter's mount wearied, the rider abandoned the chase and went back to finish off any animals he could find that had been wounded. Sometimes, toward the end of a buffalo chase, the remaining buffalo were surrounded by a circle of expert horsemen. If an animal broke loose from the herd, a horseman would follow it. It was from this situation that buffalo-running, which had proved to be such an efficient means of catching escapees, outgrew its original function as an emergency measure, and evolved into a hunting style in its own right.

Before a hunter embarked on a buffalo chase he would address his horse in a personal way, urging his steed to work with him on his important mission. Running the herd was an art of the finest order, particularly in pre-rifle days. The average hunter selected a short bow with finely-tuned feathers on his arrows. Each hunter carried about 50 arrows and an expert bowsman could launch them so fast that a shot arrow was still in the air while the next was being released. The hunter aimed his arrow at the bison's heart, and if his missile did not strike accurately, or penetrate deeply enough, the brave rider might try to get close enough to the running beast to pull his arrow out again. Mortally-wounded buffalo usually betrayed the gravity of their wounds by frothing blood through their mouths and nostrils. If an animal failed to show these signs, it was pelted with additional arrows. Expert hunters sometimes bragged about shooting an arrow so hard that it went through one buffalo into another, although the second was rarely killed this way (McHugh, 1972: 80). Some hunters marked their arrows so that when the hunt was concluded they could validate their claims about how many animals they had downed.

Before the advent of the horse spring, bands of Indian hunters began searching for the buffalo on foot as soon as snow melted in spring. A major slaughter was planned for later in the year but the hunters hoped to find a few stray animals as close to camp as possible. If located and killed, the buffalo meat was returned to camp by backpacking and by dog travois. This limited both the distance that could be travelled and the amount of meat that could be toted back to camp. A particularly fortuitous arrangement would be that they found some animals close to their winter camp. Under such circumstances an occasional hunting foray might take place (Irwin, 1994: 173).

The pound method of hunting buffalo was popular among most Plains tribes, particularly the Crees and the Assiniboines. The undertaking of such a hunt, like most other methods, involved a great deal of spiritual preparation. First, the pound was consecrated by a shaman who then sent for scouts to locate a herd. These men carried spiritual charms with them and often had to roam as far as 50-80 kilometres (30-50 miles) away from the pound in search of a herd. While they were gone, the shaman

sang songs and said prayers to the steady beat of his drum. A month or more might pass before the bison were spotted and skillfully herded toward the pound. The chase had to be conducted slowly, lest the animals catch a sense of what was happening to them. Often the hunters slapped their folded robes in an effort to move the buffalo in the right direction. There were some tribes who used a lure method in drawing the bison toward the pound. Indian decoys, disguised under buffalo robes, would mimic the movements of the animals, passing as close to the herd as possible to encourage them to follow the decoys. As one observer described it, "Their gestures so closely resembled those of the animals . . . that had I not been in on the secret, I should have been as much deceived as the buffalo" (McHugh, 1972: 65).

In planning for a pound kill, hunters often selected a natural site in the terrain – like a valley or the sides of two hills, if such a place was available. The alternative was to construct a corral consisting of a walled enclosure, generally circular in shape, ranging from 10 to 75 metres (30 to 200 feet) in diameter. Extending from the entrance in a "v" shape were two wings of spaced stations made of piles of rocks, wood, or dried buffalo chips. Sometimes the stations were manned by camouflaged hunters. These lines stretched out for several kilometres and the open mouth of the "v" was almost two kilometres (1½ miles) in width. The pound itself was hidden from the view of the bison as they ran toward it, following the lines of the "v," which grew ever narrower, and then it was too late. The animals were trapped.

A rather unusual method of buffalo hunting, (if it may be called that), was practiced by the Arikara, Hidatsa, and Mandan tribes further south. Known as the "Buffalo Calling Ceremony," the event called for buffalo to be lured to the Indian camp through a special ceremony consisting of songs and prayers, led by shamans. Since these First Nations were not nomadic peoples, it was a hardship for them to pursue the wandering supermarkets of the plains. Instead, they "invited" the animals to come to them. As they waited, dogs were muzzled and babies were kept quiet until the buffalo showed up. After that it was up to the hunters to "bring home the bacon." The historical record will verify that the Buffalo Calling Ceremony was successful.

One of the luxuries of hunting buffalo was the "prairie feast" that could be enjoyed at the end of a hunt right on site. If hunger plagued the hunters, an animal could be butchered on the spot and turned into an all-meat banquet. Stones would be heated in a fire and thrown into the cleaned belly of the animal and very soon the roasted buffalo ribs were ready to eat! Often the site of the butchering could become a tumult of people cutting and slashing carcasses, shouting clamorously, talking loudly, and exchanging humorous remarks with their neighbors. Some tribes ascribed special attributes to certain parts of the buffalo, believing these powers to be transferred to the eater. The Crees, for example, ladled up and drank hot buffalo blood in the belief that this would prevent them from being perturbed by the sight of blood in battle. Among the Assiniboines, the choicest cut – the tongue – as well as the hide, were set aside for the

man who had slain the animal. The Kootenay tribe threw out most of the entrails of the butchered animal, saving only the highly-prized heart. They considered crude organs repugnant, and held the neighboring Blackfoot in contempt for eating raw meat (McHugh, 1972: 86).

When the meat from a successful buffalo jump event was cooked, dried, or consumed, the bones were boiled to provide grease. Sometimes the bones would be broken open to extract the marrow. Years later, the sites of successful buffalo jumps were raided to gather up buffalo bones for sale to companies whose employees would grind up the bones for fertilizer (Friesen and Friesen, 2004: 63).

Next to food, the most important commodity provided by the buffalo was its hide. Preparing a buffalo hide for domestic use was no mean task. Schultz (1962: 32-33) described the procedure.

> It was arduous work. The hides were fleshed; that is, cleaned of all adhering scraps of meat and fat, then laced into lodgepole frames, where they dried as stiff and firm as thin boards. Then, standing upon the hide, smooth side up, the tanner, with an elkhorn-handled, steel bladed-instrument the shape of a hoe, chipped it to about one-half its original thickness, and rubbed it with grease. When that was thoroughly soaked in, the hide was then smeared with a mixture of boiled liver and brains, folded and rolled, and laid away for several days in order for the mixture to neutralize its glue. Then came the hardest of the work: the tanner for an hour or so at a time rubbed and seesawed the hide against upright, stretched things of rawhide, until, at last, it became almost soft and pliable as velvet. The result: a well-tanned cow buffalo robe for which we gave five dollars worth of trade goods.

A great deal has been written about the ruthless destruction of the prairie bison, and the fault for its extinguishment may be attributed to a number of factors. It is possible, for example, that the manufacture of pemmican as a trading item contributed to a higher degree of slaughter than may have been necessary, and the introduction of the breech-loading rifle was another factor. Because of its ability to allow

Stretched buffalo hide.

the hunter to shoot a bullet every few seconds, hunters were able to kill many more animals than they needed. At times, so many bison were killed that only their tongues were ripped out and the carcasses left to rot. The Métis made a business out of their annual buffalo hunt, often marketing the natural proceeds from as many as 100 000 animals each year in addition to supplying their own needs. The bulky hides were valued for the leather they provided and for their use as robes (Friesen and Friesen, 2004: 58f).

Once the rifle was effectively incorporated into Plains culture, an arms race began on the prairies. Just as the Indians had earlier discovered the benefit of the horse, and those without horses had to struggle to obtain them, the acquisition of rifles now became a fervent objective. As soon as one tribe acquired firepower, the competition among other tribes became fierce. It should be noted however, that the early guns introduced problems of obtaining ammunition and weapon repair. If a gun failed, it was useless to the owner until he could make a long trip back to the trading post for repairs. This was usually possible only in spring when travel was easier. The repair of guns also created a new vocation for men at trading posts even though it was not easy to consult with repairmen during severe winters when travel was restricted. This was a problem that would require years of catchup experimentation (Ray, 1974: 75).

A decade before the animal's destruction, buffalo meat was a common staple across the plains. Buffalo meat was sold in butcher shops, or served in hotels and eating houses as a delicacy. Sometimes it was labelled buffalo and at other times sold as beef. Fresh buffalo meat was shipped to eastern cities in winter, and in all seasons, the cured hams and tongues were popular items of traffic, commanding prices of 20 to 30 cents a pound. To top it all off, on many Sunday afternoons, sport-shooters on slowly moving trains made their way through massive herds of buffalo killing as many as they could on both sides of the track. In the United States during the 1870s, the indiscriminate slaughter of the huge animals was so severe that it attracted the attention of the American Congress. That body voted in 1874 to end the slaughter of buffalo in its federally-controlled territories. Shockingly, the bill was vetoed by President Ulysses S. Grant, whose army was losing one trooper for every Indian killed in a campaign to confine them to reserves (Hodgson, 1994: 64f).

Despite the unfortunate behavior of many humans in destroying the buffalo, there were also natural forces which contributed toward its demise. Ernest Thompson Seton, one of Canada's first naturalists, listed the seven major enemies of the bison (MacEwan, 1995: 144f). These included (i) ice-covered rivers on which the ice still looked strong but was actually weak. In 1795, for example, one fur-trader counted 7 360 buffalo carcasses lining the shores of the Qu'Appelle River and Lakes; (ii) the repeating rifle; (iii) prairie fires, which not only eliminated the food supply for animals in some areas, but also killed many of them through the direct means of smoke suffocation; (iv) natural predators like grey wolves that particularly liked to prey, in packs, on young buffalo calves;

(v) epidemic diseases that took an increasing number of buffalo in the years following European settlement; (vi) bogs; and (vii) blizzards.

Through these and other means, the buffalo were gradually eliminated from the prairies, although the last stage of their destruction was much hurried. By the 1880s, the animal had virtually disappeared and now the prairie lands were safe for settlers to occupy. The Plains Indians had no recourse but to go to reserves which the government designated for them, accompanied by promises that they would assist the Aboriginals in making the necessary adjustment to becoming an agrarian society. A few tribes, like those further north and the Stoneys, who lived on the east side of the Rocky Mountains, were able to maintain their buffalo-centred way of life for a few more decades (Dempsey, 1988: 46). Finally, they too, had to make the adjustment to a new way of life – one without the faithful buffalo to rely on, and one that took their children away to religious residential schools, and forced parents to obey the instructions of the local, federally-appointed Indian agent.

As the twentieth century neared its end, the mighty buffalo began making a some-what unexpected comeback At the peak of its population, the prairie buffalo numbered around 60 million head, and by comparison, today's herd size is small. It is estimated that about 200 000 buffalo graze on public and private lands, some of them being raised by Indian communities, primarily for ceremonial purposes. The down-side of this good news is a disease called "brucellosis," which causes spontaneous abortion in domestic stock. Humans who handle meat infected with the sickness can fall victim to a debili-tating disease called "undulant fever," which is difficult to diagnose. The organism that causes brucellosis is believed to have come to North America from cattle shipped from Europe and knowledge about it goes back nearly a century. Government officials have been trying to eradicate the disease by banning shipments of animals infected by it. In the winter of 1988-89, fear of infection led the State of Montana to authorize hunters and wardens to kill some 600 of the animals (Hodgson, 1994). This trend has continued and to this day about 450 free range buffalo are killed annually in the USA, mostly in Montana.

Spirituality

Like many counterpart tribes in North America, spirituality was fundamental to Plains Indian culture. Theirs was a deep respect for the workings of nature, best described as a resignation to work with the forces of nature and obtain the assistance of guardian spirits. Natural forces were viewed as rhythmic patterns which, if respect-ed, guaranteed a sufficient food supply and Divine approval. In fact, the Blackfoot believed that they had a covenant relationship with the Creator whose blessings and grace they were obliged to seek. While these prescriptions were generally adhered to corporately, there was a distinctive role for individuals to play as well. Vision-questing

provided opportunity for young men to contribute to the spiritual welfare of their band. After four days of fasting and praying, a young man might indeed obtain a vision and its benefits were expected to flow to the band.

The most significant ceremony in Plains culture was the "thirst dance" or Sundance as it came to be known. The Sundance was celebrated during the summer when various nomadic tribes met to socialize, trade, and worship together. Among the Blackfoot the event was initiated by a respected woman of the community and lasted four days. The *sodalities* (secret societies) played an important role in the ceremony, and their representatives presided over special rituals performed in a teepee at the centre of the camp. Many important items played a part in the Sundance such as the pipe, tobacco, drums, eagle feathers, and whistles.

Pipe.

Art

Among the Plains Indians, stone sculpture was mostly absent as an art form, and there was very little basketry. However, Plains artists did a great deal of painting and decorative art in quillwork, and later, in beadwork. Berlo and Phillips (1998: 122) point out that plains men sometimes fashioned pipe bowls from catlinite, and war images, feast bowls, and spoons were sometimes carved out of wood, antler, or steamed and bent bone. Painting was primarily done on buffalo robes, teepee covers, parfleches, and other hide or skin objects. Colors were mainly derived from iron-containing clays or plants. Pictography was probably used more as a means of communication rather than artistic expression. Pictures drawn on robes (story robes), often served to record significant events, accounts of battle or hunting, or visionary exploits. The Dakota Sioux, for example, kept calendric hides on which to depict events of successive years. Robe drawings were rarely done to scale with little attention paid to perspective; it was the record that was important, not artistic accuracy (Lowie, 1954: 145-147). When beads were introduced, they soon became a much wanted item. Berlo and Phillips (1998: 117) suggest that when the demand was at its highest, a horse would be traded for only 100 beads.

First Nations used a variety of beading patterns.

Quill embroidery was long established on the plains before the introduction of beads. Bead embroidery probably developed after the turn of the nineteenth century when European traders began to bring china and glass beads into Indian territory. The early beads were usually white and sky blue in color and the dominant style of working with beads was known as the lazy-stitch sewing. As Lowie (1954: 152) notes,

> Dominant designs included the equilateral and isosceles triangles, generally resting on or hanging from a transverse stripe; chains of right-angled triangles; bars and oblongs; and series of concentric oblongs. The impression conveyed is one of massiveness.

Various bands developed unique styles that bespoke their identities; the Blackfoot, Tsuu T'ina, Crees, and Flatheads, for example, developed a northwestern style which consisted of hundreds of little oblongs or squares united to form large patterns. The Dakota had names for their designs such as "twisted, full of points, filled-up," or "cut-out." They also ascribed symbolic meanings to colors used. Red, meant sunset or thunder; blue, signified the sky, clouds, night, or day; yellow, the dawn, clouds or the earth; black, the night; and green, summer.

Weapon-making was one of many craft arts and required great skill. Good arrows, for example, were not easy to make. A crooked arrow or one with improperly placed guide feathers was essentially worthless, so the men took great care in their manufacture. Warriors and hunters used a variety of woods in making arrows such as gooseberry, juneberry, chokecherry, ash, birch, cane, dogwood, currant, willow, and wild cherry. Warriors of different tribes seemed to each have a favorite wood from which to develop their tools. Arrow-making was a tedious undertaking and described by Carlson (1998: 62) as follows;

> Over a period of days they used their teeth, and a special arrow straightener – a bone or horn with a hole slightly larger than the shaft through which they passed the arrow back and forth – to make the arrow perfectly round. They scraped it to proper size and taper. Most of the better arrows they grooved from the end of the feathers to the head of the arrow point. Next they polished and painted the shaft. Finally, they attached the feathers – owl, turkey, or buzzard feathers preferred – with glue and fixed the point, which after the white contact increasingly became metal. In fact, after the 1850s many men could not remember using stone points.

Plains Indian art was always symbolic, religious, colorful, and dynamic. The first Plains people painted, sculpted, carved, wove, sewed, made pottery, and otherwise engaged in a variety of art forms, all of which spoke to their respect for the universe and awe for the Creator. In traditional times, the Plains Indians designed arrow heads, projectiles, spear points, spear heads, knife points, and polished celts (rounded stone forms used for pounding and rubbing). Some tribes also made cord-wrapped pottery, sometimes using paddle edged forms, or an oblique pricked decoration. They dressed skins for shirts, leggings, moccasins, and buffalo robes decorated with such items as elks' teeth; they created ceremonial garments decorated with weasel fur and painted stripes. Horse culture gave opportunity for additional avenues of expression; now Native artists decorated bridles, quirts, ropes, and cruppers.

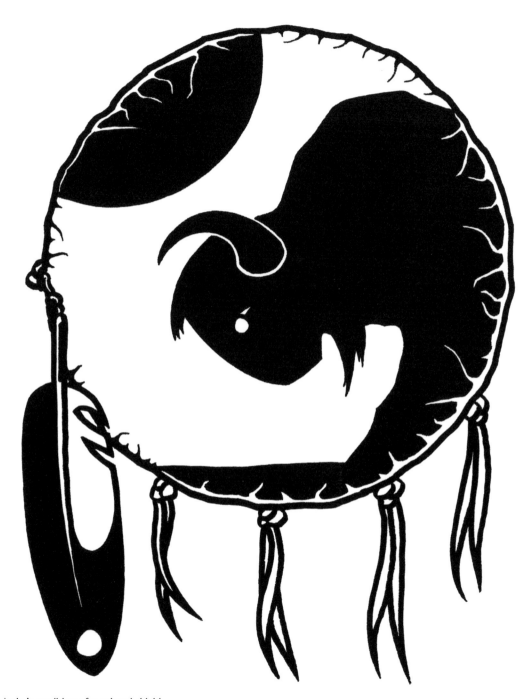

Artist's rendition of a painted shield.

The Stoney First Nations designed war charms, shields for protection, skin shirts, and war bonnets. The Assiniboines had special teepees for military societies decorated with war exploits by warriors.

The Plains Cree organized religious dancing societies and decorated buffalo robes with designs drawn with a buffalo hipbone dipped in water. The Plains Ojibway used coup-counting eagle feathers cut into patterns and painted to reflect various deeds to symbolize war honors. Honored warriors who captured horses, painted horse tracks on their teepees and clothing. Their lances and wands were also decorated. Warriors sometimes carried war charms in place of medicine bundles. The skin was that of the wearer's dream guardian. The Canadian Dakota decorated bold mosaics on elevated sites. They also honored medicine rings, sometimes erroneously called teepee rings. (Teepee rings are a kind of earth effigy.)

The Blackfoot painted their teepees, war shirts, and shields. These paintings were believed to possess spiritual power accompanied by narratives of a vision and the singing of songs. The owner's use of prayers and songs kept the vision alive; otherwise its message would be lost. Teepee designs were considered personal property. They recounted historical events and religious symbols and could be associated with medicine bundles and related ceremonies. The teepee was considered a symbol of the cosmos; the lowest band was the earth, the middle was for animal protector or other spirit protector, and the highest layer to show the sky and the place of lunar bodies (Patterson, 1973: 79).

Settling on reserves caused a major cultural upheaval for the Plains people. There were many traditional items for which they now had no use, many of them concerning hunting and warfare. Some men began to record their deeds in ledgers that were provided to them. Women's arts burgeoned for the tourist trade, particularly beadwork arts. Designs became more elaborate and complex and applied to a much wider spectrum of products – suitcases, handbags, vests, and other items of clothing. The introduction of trade cloth, ribbon, and other manufactured goods greatly modified clothing styles. Gaily-decorated outfits were created for such ceremonies as the Ghost Dance, Sundance, and pow-wows. Annual county fairs gave opportunity for crafts-persons to display their talents.

In 1908, the annual agricultural fair in the City of Calgary, for the first time, featured a parade with Indians. Everyone was very excited by the great show of feathers and buckskin. Every Native tribe within travelling distance was invited to participate, and remuneration was promised for each entry. Although the show was staged to display economic development and progress in the west, the reverse was true for First Nations. Many of them no doubt participated in the show for different reasons; some, because they were proud of their culture and heritage, and others because they needed cash flow. A local Calgary paper, the *Herald*, described the event in this fashion:

In their glorious blaze of glory, their traditional war paint, their gorgeous feathers and their many blankets, the Indians brought back vividly the long and romantic history of Canada's great western land, the struggle of barbarism with civilization, the eternal contest between what has been and what is to come (Francis, 1992: 97).

Some government bureaucrats were opposed to the celebration of what they termed "the old ways," fearing that such events would keep the First Nations in the past without "becoming civilized." Government officials wanted the Indians to participate in more contemporary performances dressed in modern clothing and exhibiting agricultural products like everyone else, though it was permissible that artifacts and exhibits from the "warpath days" be in the background as a reminder of how the Indians *used* to live. Duncan Campbell, a senior official in the Indian Affairs Branch at the time, drew up a regulation that forbad First Nations from performing in fairs and exhibitions promoting "senseless drumming and dancing," and wearing traditional dress (Francis, 1992: 98).

Ewers (1981: 108) suggests there are at least 150 artists who pictured Plains Indians from life before the end of the nineteenth century, and these often fictional portraitures prevail. The Plains Indians of North America have worked hard to retain their customs and language and try to promote a more realistic portrayal of their culture and heritage. Many of their sacred rituals and ceremonies persist, thanks to their commitment and dedication. Many reserve schools are locally controlled, and include Aboriginal history, language, and art as part of the curriculum. In addition, in the interests of sharing their knowledge, many tribal celebrations, like pow-wows, are open to the public.

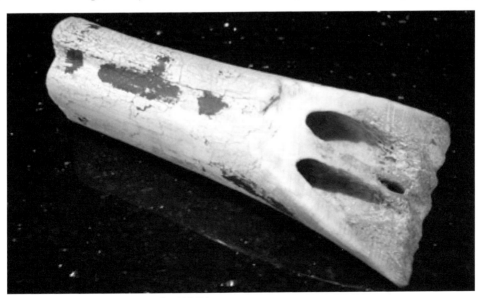

A Plains Indian scraper. Photo by David J Friesen.

The Southwest Connection

In April of each year, the City of Albuquerque, New Mexico, is host to the Annual Gathering of Nations, a pow-wow that draws more than a thousand dancers and many more observers. The event has become so well-known that members of virtually every First Nation in North America have attended it at one time or another. This intermingling of tribes has influenced a great deal of cultural exchange resulting in exchange visits and even marriage. The southwest, of course, is home to unique forms of art primarily involving turquoise and silver, and pottery, principally among Hopi, Navajo, and Zuni tribes. Pueblo pottery has also become the subject of intense study. Various forms of southwest art have been diffused to the Canadian plains where their ownership has become commonplace. Turquoise and silver jewellery is available at many plains stores and most pow-wow-dancers and observers are the proud owners of representative pieces. Thus the southwest connection is at once typified by artistic, social, and even marital bonds.

Artists

Aboriginal artists whose affiliation is Plains culture, are numerous, and their artistic skills have influenced many fields. Don Burnstick, for example, is a comedian from the Alexander (Cree) First Nation near Edmonton. Burnstick uses humor for a specific purpose, namely to conduct workshops that provide a holistic approach to healing. He is particularly concerned with the struggles faced by youth relating to alcohol, drugs, and sex. He has produced several comedy albums: *You Might Be a Redskin*, *Redskin Club*, and *Redskin Radio*. He has also produced two videos, *Rockin' the Rez*, and *Redskin Club*, which was filmed on the Alexander Reserve.

Jane Cardinal-Schubert is a famous Peigan painter, printmaker, and installation artist who holds a fine arts degree from the University of Calgary. She began participating in the first of a series of individual and group exhibitions in 1978 and has been cited in a variety of publications. Collections of her art are available in many galleries across Canada. Cardinal-Schubert's art is critical, insightful, and emotionally direct, and deals with various aspects of Native history and culture.

Faye Heavyshield is a member of the Kainai (Blood) First Nation in southern Alberta. Nationally recognized as a sculptor, installation artist, and mixed media artist, Heavyshield attended the Alberta College of Art and hosted her first individual exhibition in 1993. When her work was first introduced to the public, it became apparent that she used minimal material expressions while investigating the textual qualities of objects. Her works basically deal with Native issues, and are subject to a variety of interpretations. Her collections are housed in several national museums including the

Glenbow in Calgary, Alberta; the Indian Art Centre of the Department of Northern and Indian Affairs in Ottawa, Ontario; and the Heard Museum in Phoenix, Arizona.

Actress Tina Keeper was born in a Cree community in northern Manitoba shortly before her family moved to Winnipeg where she attended the University of Winnipeg. Majoring in history and theatre, Keeper aspired to become an actress, a dream which eventually came true in her role as RCMP Corporal Michelle Kenidi on CBC's *North of 60*. The role brought her three Gemini nominations for best actress and a Gemini Award in 1997. In 1998, she won the American Indian Festival Award for best actress. She has served as host of two television series, *The Sharing Circle* and *Hot Topics*, and directed documentary films for the National Film Board of Canada.

Gerald McMaster is a Plains Cree painter, mixed media artist, installation artist, and photographer. Born on the Red Pheasant Reserve in Saskatchewan, McMaster attended several post-secondary institutions including the Banff School of Fine Arts. He taught art on several university campuses and won many awards for his work. Collections of his work are available in museums in virtually every province, and he has participated in many individual and group exhibitions. Descriptions of his work include such adjectives as spiritual, thorough, haunting, and profound. McMaster is regarded as a major figure in the world of mainstream contemporary Aboriginal art in Canada.

Wilma Pelly is a Saulteaux actress who was born in the Fort Qu'Appelle Hospital in Saskatchewan. A member of the Muskopetung First Nation, Wilma was actually raised on the Sioux Standing Buffalo Reserve near Regina (her stepfather was Sioux). Best known for her role as elder Elsie Tsa' Che' on *North of 60*, Wilma also appeared in the movies, *In the Blue Ground*, *My West*, and *A Good Day to Die*. If any one individual on North of 60 represented the heart and soul of the mythical Lynx River, it was Elsie. A strong-willed elder (excellently portrayed by Pelly), Elsie was always consulted on matters of importance, political or religious.

A descendant of the renowned Plains Cree leader Poundmaker, Gordon Tootoosis was born on the Poundmaker Reserve in Saskatchewan. Once a champion cowboy and calf roper, Tootoosis served his band as chief and as vice-president of the Federation of Saskatchewan Indian Nations. He made his movie debut in 1972 in *Alien Thunder* with Donald Sutherland, and eventually went on to his most popular role as Alberta Golo in *North of 60*. Tootoosis has starred and co-starred in dozens of movies, special roles, and mini series. In 1998, he earned a Gemini nomination for his role in *North of 60*, and won a second Gemini nomination for his guest role in the *North of 60* movie, *Hunting in the Dark*. In 2001 he won the Eagle Spirit Award at the American Indian Motion Picture Awards.

Born in 1929 on the Red Pheasant Reserve in Saskatchewan, Allen Sapp is a Plains Cree painter whose grandfather was a first cousin to the famous Cree leader, Poundmaker. Originally a woodcutter (many of his paintings reflect this occupation), and a

clerk in a hobby shop, Sapp studied painting with Saskatchewan artist, Wynona Mulcaster. He was greatly assisted in his work by a Saskatchewan merchant, Eileen Berryman and Dr. A. Goner who initially purchased Sapp's work and later became his agent. Sapp's work frequently portrays Cree life after 1900, before the era of government control. He was elected an Associate of the Royal Canadian Academy of Art in 1972, and received the Order of Canada in 1987.

Chapter Seven
Plateau Aboriginal Culture and Art

Inland from the Pacific Ocean, between the Cascade and the Sierra Mountains on the west and the Rocky Mountains on the east, is a vast stretch of intermontane country known as the "Great Basin" to the south, and the "Plateau" to the north. The Great Basin is made up of dry steppes and half-deserts interspersed with narrow mountain ranges covered with pinyon pines. It is significant that the few rivers in the area do not reach the ocean, but instead feed lakes and marshes in the interior of the Great Basin, including Great Salt Lake in Utah. The Plateau comprises the interiors of the present states of Oregon and Washington, northern Idaho, western Montana, and portions of the Interior of British Columbia, and is drained by the river systems of the Columbia and Fraser rivers, which connect to the Pacific (Bolz and Sanner, 1999: 146).

The Plateau is often divided between the Canadian (or Northern) Plateau and the Columbia (or Southern) Plateau. This division reflects not only contrasting historical and political contexts of American versus Canadian Indian experiences, but features a significant ecological contrast as well. The Northern Plateau is largely forested, while the Southern Plateau hosts a semi-arid steppe environment. As a result many anthropologists contend that the variety of First Nations cultures that once thrived in the Plateau represented a markedly different lifestyle from that of both the West Coast First Nations and the Plains Indians. Not all experts agree that the differences are sufficient enough to warrant separate historical regard, but most of the ethnological literature seems to recognize this distinction.

The northern boundary of the Canadian portion of the Plateau has been subject to various interpretations. Jenness (1986: 370) perceived it to extend as far north as the southern Yukon and to include such tribes as the Tahltan and Tagish as dwellers. Other writers have included the Carrier Indians and occasionally the Sekani of central British Columbia as being part of this community. Most authorities, however, identify these groups as part of the Subarctic culture area (McMillan, 1988: 161). The Columbia and Fraser Rivers were traditionally arteries of travel and communication for these First Nations and their ample stock of salmon provided a staple food. The area includes seven bioclimatic zones ranging from sagebrush deserts to sub-boreal spruce forests. Temperatures in the Plateau range from 40 degrees Celsius to 50 degrees below, but the

range of weather brings a comfortable seasonal availability of resources such as root foods, for example, bitter-root, lomatiums, and camas (Hunn, 1990: 361f). Dry winds that blow across the Plateau facilitate the preservation of food like roots, fish, and berries.

History

Before European contact, the largest group of Aboriginal peoples in the Plateau was the Interior Salish made up of five tribes who were sometimes hostile to each other. The first estimate of their population was in 1835 when they allegedly numbered about 13 500. Later their numbers shrank as their population was reduced by the impact of epidemics of imported diseases (Patterson, 1972: 161). The tribes occupying the Southern Plateau were Lillooet (Wild Onion or Stl'atl'imx), Thompson (Nlaka pamux), Okanagan, Lake Indians of the Arrow Lakes and upper Columbia River, and Shuswap (Secwepeme) Indians who controlled the Fraser River Valley from Lillooet to Alexandria and east to the Rocky Mountains. Further north were the Athapaskan-speaking Carrier Indians who are sometimes also identified as comprising part of the Interior Indian cultural complex (Furniss, 1995: 48). Although some west coast Indian tribes also speak Salish, their dialect, cultural habits and even physical appearance are quite different from their more inland counterparts. The length of residence of the tribes in the Plateau is undetermined, but indications are that they may have lived there for at least 10 000 years.

The Plateau, or Interior Indians, as they are sometimes known, generally trace their origins to antiquity. Not unlike other Indigenous peoples, they claim they have always been in the Interior and they resent experts trying to pinpoint an exact time period for their beginnings. In any event, specificity of origin in terms of time or location is not important to First Nations generally. They may explain their origins through stories and elaborate in them conceptualizations of how the earth was formed or how human beings became distinct from the rest of nature's creatures.

Archaeological approaches tend to be more precise, investigators wanting to nail down such details as exact origins, linguistic affiliation, and nature of original culture (Hudson and Furniss, 1995: 461f). On the positive side, certain facts do become evident through research. We know that members of the Lillooet tribe, the most westerly of the Interior tribes, were the chief negotiators and tradespeople with the Indians of the west coast. They bartered berries, hemp bark, skins, and goat wool for shells, slaves, and occasionally traded dugout canoes. They were probably the only Interior tribe to adopt an exogamous clan system, although, in their format, the system was not subdivided into castes. We also know the gun and the horse were introduced into the Interior of British Columbia at about the same time, near the end of the 1700s. Together these two

items revolutionized Plateau society and eventually rendered traditional means of transportation and weaponry obsolete (Carstens, 1991: 28).

The Plateau Indians played an intermediary role in the fur trade as that economy pushed its way west. It did not take long for the people to rely on European-made trade goods so they relocated their homes nearer to trading posts. Conflict between tribes heightened, and epidemic diseases were introduced, accompanied by new industries. During the nineteenth century when settlers were heading inland, the Plateau peoples lost some 500 million acres of tribal lands to government action. The land was needed to accommodate incoming settlers. Tribes were consolidated and forced onto reserves ruled by Indian agents. Even today the people of the Plateau have to contend with sometimes interfering outside influences, such as tourism. Although this form of industry is necessary to their survival, it also places greater pressure on the people to preserve their traditional ways.

Culture

The interior British Columbia Plateau area was traditionally home to a unique culture area, quite unlike that of the Plains people to the east or the First Nations fishing configuration on the west coast. The lifestyle of the Plateau dwellers was greatly affected by their lush natural surroundings consisting of mountains, streams and rivers, forests, and meadows. These topological features combined to offer the inhabitants an enriched way of life, enabled by the utilization of a rich admixture of natural resources that were cleverly used for food, housing, clothing, and the fulfilment of other human needs.

Plateau Indian cultures were developed on a foundation of gathering, fishing, and hunting. These activities were fundamental to the maintenance of life and many societal features were built around them. Since roots, berries, and other plant parts were used for food, drink, and medicinal purposes, a first roots ceremony was held in the southern Okanagan, for example, to celebrate the passing of winter into spring. A number of other related social activities accompanied the event and eventually the month of April became known as "bitter-root month" (Hudson, 1995: 489). The fishing configuration involved an even more lavish set of social structures and behaviors. In all, five species of salmon plus steel-head trout were harvested from the Fraser, Skeena, and Columbia Rivers. Other, lesser caught varieties included sturgeon and eels.

Once caught, salmon were dried for trade, pounded for meat, and packed into cattail bags lined with salmon skin. The primary techniques for fishing included the use of large dip nets which are still used today. The nets are held steady in the water by means of an anchor rope. Other fishing paraphernalia include the use of harpoons, spears, and a cylindrical basketry trap, the latter also being employed to catch steel

trout. Gaff hooks were also used until prohibited by government authorities in 1944 (Kennedy and Bouchard, 1992).

For the most part, Plateau men traditionally constructed fishing gear and had primary responsibility for fishing, while the women cleaned and prepared the catch. While a weir could collect literally thousands of fish, the availability of female help dictated an upper limit as to how many fish could be taken. Each family had to catch enough to last the winter, but they also needed a surplus for trading purposes. Sometimes when the fish catch was ample, a local site would become a festive ground of fishermen, children, and onlookers. Games were played and a spirit of celebration prevailed (Hudson, 1995: 489). Not only did the accompanying events make the work lighter but illustrated that no clear line of demarcation between work and play necessarily existed in Plateau society.

Essentially, the Interior peoples lived according to a seasonal round of activities, occupying winter villages from November to February and, occasionally, year round. In spring, the Chinook salmon run on the Columbia River began in earnest, but the June thaws temporarily suspended fishing activities. The winter villages were abandoned at this time as the people moved higher into the mountains. Now it was time to begin harvesting roots, which were dug up and dried so they could be transported to the winter camps at the end of summer. By July and August, the fishermen were back at the river. With the first snowfall, the Plateau people abandoned their summer camps, which were located near rivers and streams, and moved into their winter lodges. Here, social activities increased, religious rituals were celebrated, stories were told, and guardian spirits were honored. Winter was also a time to rebuild or repair tools used for fishing.

In lean times when food supplies ran low, moss and the inner bark of certain trees would be gathered and cooked into a gruel. At such times, some tribes, like the Carrier in the northern Plateau, and the north Thompson Shuswap, dispersed into small groups and turned to ice-fishing and rabbit-snaring in order to survive. In this, their cultural practices became cousin to those of the northern Inuit. In the lean months of spring when resources were at their lowest, families also dined on black lichen or the sugar-rich rind of the jack-pine.

The Plateau region featured no agriculture nor pottery, but the people were highly skilled in making grass baskets, mats, and other useful items. Cooking was accomplished mainly by dropping heated stones into ground holes or baskets which were so tightly woven to be able to contain water. Even today, basket-making is one of the outstanding arts of the Plateau Peoples.

The typical Plateau winter home was a circular, semi-subterranean dwelling about 12 or 13 metres in diameter, and entered by a ladder from the roof. The house was covered with a low conical roof made of a wooden frame and covered with bark, grass, and soil. The summer home was an oblong or conical lodge constructed out of a framework

of poles and covered with rush mats. In addition, there was the long lodge which was a lean-to construction built as a temporary shelter at fishing places or for social gatherings at some special event. Food was stored in large boxes under shelves constructed for that purpose within the house; sometimes food was cached outside the dwelling in boxes on raised platforms.

The social system of Plateau cultures was unique, and the various villages were fairly well autonomous. A sparse population tended to favor this arrangement. Villages were headed by chiefs whose office was probably based on their display of wisdom, generosity, good judgement, and eloquence. The office of chief was hereditary, but power was primarily centred in the tribal council. There were exceptions, of course, for example, among the Shuswap, where a chief had the authority to announce when the berry-picking season officially started.

War chiefs were selected for particular raids but any line of authority they were assigned was extinguished with the conclusion of battle. During combat, only women and children prisoners were taken but they were integrated into the tribe as soon as possible, usually through marriage or adoption. Shamans, known as "salmon chiefs," offered a more specialized form of leadership, but the glue that held Plateau society together was based on links of friendship or economic arrangements (Hunn, 1990: 370-372). On a smaller scale, it was the family that framed the foundation of Plateau Indian society. The most productive salmon-fishing sites were controlled by specific individuals or families. Ownership of domestic items was matriarchal, and women generally passed on goods to their daughters. Every family had a stock of hereditary names which were selected by the father and assigned to the next newborns.

When a newborn child entered the Okanagan family, mother and child were exempt from social obligations for about 30 days. A small lodge was erected for the purpose of providing them with privacy. When the period of "exile" was over, the mother and her child reentered village life with an introduction by the elders. Sometimes a feast was given in their honor. As children grew up, social roles were defined by modelling. Education was basically informal, and elders occasionally told stories which contained informational data or implied moral obligations. Certain harsh activities, like taking a swim in icy water, were undertaken, or rather, forced, upon children as a means of hardening their bodies and building character.

Puberty was a special time in Plateau culture, and this life stage was set apart as a significant time in a person's life. Marriage among the Salish-speaking peoples consisted of a simple ceremonial feast. Men purchased brides and the women's relatives later repaid the husband. The opinion of parents mattered somewhat in the selection of a mate, and many marriages were actually arranged by a go-between who represented both parties. Some marriages were political in that people were concerned about guarding their positions in the social hierarchy. On the whole, marriages seem to have been stable and monogamous. Polygamy was practiced, although to only a limited

extent, and then only among high-ranking officials. It was also practiced in the case of the death of a man's brother when the surviving male would be required to marry the widow and look after her needs (this practice is called levitate). Among the Salish people, at least, the widow was given a choice as to whether or not she chose to follow this route. In the Okanagan tribe male-female relations were so complicated that an amazing number of very complex rules applied. For example, males and females used different terms to describe or address their next-of-kin, including brothers and sisters and first and second cousins, as well as more distant relatives. There were also strict rules about who might qualify as an appropriate marriage partner (Carstens, 1991: 11-12).

There is evidence that the Plateau peoples were heavily influenced by the two neighboring cultural configurations on the west coast and the interior plains. During the early 1800s, as a result of the intensification of social and trade relations between the interior and west coast Nations, the tradition of clan organization, and the formation of social classes that recognized a nobility who sponsored potlatch ceremonies, began to appear among the peoples of Interior. Through time, there were modifications to these customs; clans, for example, became bilateral in order to fit the operant social system. Some west coast influence was also evident in such habits as flattening one's head, piercing one's nose, and using shredded bark to make clothing. Extensive water travel was another common cultural trait.

Plains cultural influence was evident in Plateau life via the introduction of the horse in the early part of the eighteenth century. The Plateau tribes took quickly to the horse, and the local terrain provided ample grass, water, and protected valleys so these animals could thrive. The unique species of spotted horses, known today as the Appaloosa, was redeveloped in this region (Newcomb, 1974: 175). Along with the horse came other borrowed traits evident in clothing, for example. Skin clothing, leather-covered teepees, parfleches, feathered headdresses, beaded ornamentation and decoration, and other elements gave evidence of Plains Indians cultural influence. Before this kind of contact occurred, Plateau clothing was fairly skimpy even by today's standards. In summer, men wore only a breechcloth and women wore an apron woven of bark on their front and back. In colder weather, additional bark and/or fur robe blankets were draped onto the body to provide warmth. When explorers Lewis and Clark reached the Plateau area in 1805, they still found sharp differences in lifestyles between horse-owning Indians of the middle Columbia drainage area and the canoe-using peoples in the western part of the region (Josephy, 1968).

Eventually, some of the Plateau tribes even became involved in the fur trade economy as it pushed its way west. Soon the Plateau people became dependent upon trade goods, often moving from their old homes to nearby trading posts to accomodate their trade needs. Conflict between tribes was heightened as they competed with one another for the benefits of this new way of life. Epidemic diseases accompanied the new industry, and missionaries also made their way west, followed by settlers looking

for land, thereby contributing toward more crowded living conditions. In a way, the Plateau Indians inadvertently contributed to this situation by welcoming the newcomers, especially the missionaries. The formula worked this way, however: once the missionaries were welcomed to a new community, the settlers were not far behind.

The Plateau Indian culture complex incorporated several interconnected advantages that made for smooth operation. In the first place it offered a healthy outdoor environment that involved the whole family and featured a very functional division of labor. It did not necessitate long periods of absence on the part of breadwinners as some forms of hunting did. Fishing also proved to be a conservationist occupation, featuring a small-scale business operation that combined elements of both individual property ownership and pride, as well as a degree of communalism in terms of sharing the spoils (Hawthorn, Belshaw, and Jamieson, 1960). It is anyone's guess as to how long this form of culture might have prevailed had the Plateau peoples not dealt in extensive trade with their neighbors to both the east and west and witnessed their territories invaded by outsiders.

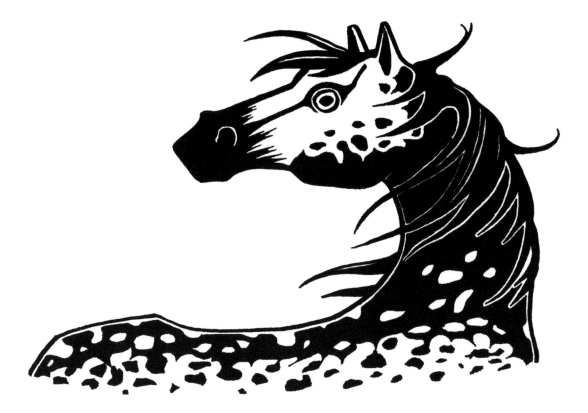

Plateau peoples favored Appaloosa horses.

Spirituality

It is important to differentiate between "nature worship" and the Plateau First Nations concept of recognizing the universe as occupied by "personal spirits." The latter position posits that the universe is made up of a multiplicity of personal beings, some of whom inhabit it in the form of plant life, others in animal form, and some as human beings. These spirits were not traditionally viewed as powerful animals of mythology, but desired helpers of any sincere, seeking individual who persistently sought some form of Divine approval. The implication of this belief is that all living things should be respected, regardless of the particular form in which they appear. A derivative of this belief is that every individual life form has a unique place to fill in the universe.

In this context the concept of vision quest was central to Plateau Indians spirituality. It was a way for young men to affirm the uniqueness of any message that the Creator might have for them – their special place in the scheme of things. Young men in their teens used to seek out uninhabiited places approved by the tribe in quest of a guardian spirit, and those who obtained such a vision might eventually become shamans.

Underhill (1963: 102) suggests that among the Plateau peoples a favored route to making spiritual contact with Divine powers was to engage in a form of "fanatic cleanliness." The process involved behaviors that required severe self-discipline. The would-be visionary might plunge repeatedly into a deep pool, sometimes tying a stone to his feet so he would remained submerged longer. Then he might rub himself with thorny branches until he bled. All during this time he would fast and remain continent.

The culminating point of the vision quest was the annual winter feast during which a great deal of celebration, socializing and dancing took place. The feast lasted several days and was presided over by people who possessed guardian spirits. They formed an integral part of the spirit complex on the Plateau, thereby linking band with band, and regional group with regional group. From the point of view of the participants, each dance reinforced ties of both kinship and friendship, drew attention to the reality of life, and generally prepared people for the next step in the cycle of life. As Carstens (1991) described it, each person sang the songs he had received during puberty and imitated the sounds and behaviors of that spirit while dancing. During the dance, opportunities were made for those who had recently acquired guardian spirits to participate in spirit singing and dancing (Josephy, 1968). Anyone who denied his spirit's desire for recognition was expected to become ill and eventually die (Hunn, 1990).

The role of shaman was important in spiritual questing, and these individuals were usually sought out for spiritual advice. The shamans were believed to have related special powers by which they could imbue power into the body of sick individuals and help them to get well. The shamans also had powers to diagnose spiritually sick

people and heal them by overpowering harmful, intrusive spirits or by recovering or placating lost or offended spirits (Hunn, 1990).

Contrasted with males, teenaged women in Plateau culture went into seclusion at a certain age in preparation for marriage, and were not candidates for spiritual visions. Older female relatives taught the young women about adult life and hygiene and how to fix their hair in a special way. They were also provided with body scratchers and combs. They were required to bathe in cold water to toughen their bodies for childbirth. This period of training also emphasized proper female etiquette which, if followed, would guarantee a woman good fortune throughout her life.

Plateau Indian theology has an element of apocalyptic prophecy to it in that they, like some other tribes (the Hopi of the southwest, for example), believe that a revitalization process for First Nations spirituality is imminent (Lincoln, 1985; Mills and Slobodin, 1994; Alfred, 1995). The basis on which this forecast is founded relates to the spread of imported diseases among First Nations. As Hunn (1990) points out, the extent of the ravages of these diseases upon First Nations peoples is seen as evidence of the Europeans' overwhelming and evil power which is soon coming to an end. The only hope for humankind is to reaffirm a unified reverence for the earth and the sun which alone can bring and sustain life.

Art

[A] society based on a philosophy emphasizing technology, worship, economic expansion, and commodity accumulation is doomed to failure, as it leaves out an understanding of and respect for the sacredness of nature and the limits to human endeavor (Robert Houle, 1991: 48).

Like their neighbors on the west coast, the Plateau people lived a comfortable lifestyle with ample time for leisure. Winter was the season for storytelling and recounting tribal history. It was a time for learning as elders related highlights of cultural life and stories of the past. The tasks of making clothing and weaving baskets were always undertaken with creativity and artistry, and some very special Plateau costumes were worn during feasts and other social events. Winter was also a time for giving and receiving gifts, gambling, communing with the spirit world, and looking forward to spring. The Winter Dance was particularly viewed as an expression of the sacred spheres of life, and hosted by people who possessed guardian spirits. Like other art forms, the Winter Dance had spiritual and moral implications, and was never regarded a mere art form. The dance emphasized kinship, drew attention to the reality of life, and prepared people for the next cycle of life. Those individuals who possessed guardian spirits were reminded of their obligations to the metaphysical world and reinforced the moral codes of the Plateau people (Carstens, 1991: 9-10).

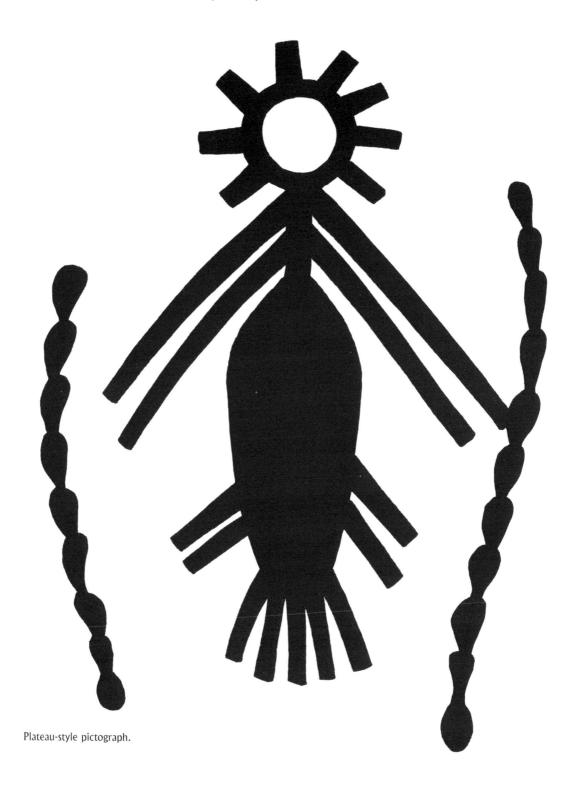

Plateau-style pictograph.

Before European contact when new metals were introduced, only copper was made into objects for personal decoration. Tools such as hammers, pile-drivers, seed-grinders, and weights for nets were made of rock. Special stone materials such as chert, obsidian, and basalt were also manufactured into spears, cutting tools, and scrapers. Stone carvings served as ceremonial objects and included animal designs of bears, birds, or stone bowls with human figures inscribed on them. Plateau artists also made small pendants from soapstone, figures carved from antlers, and decorated combs, digging sticks, bows, and clubs. Pictographs and paintings on rocks, using red ochre are still visible at specific locations depicting a variety of subjects such as human and animal forms. Some scholars believe that these paintings may have been related to the vision quest.

As the influence of the fur trade impacted the Plateau region, a kind of cosmopolitan influence was evident. Major trading sites along the Columbia River and its tributaries brought people together from both east and west to exchange goods. Dentalium shells from the West Coast were traded inland to the Plains through the Plateau, while catlinite pipes were brought from the east. Eventually trade flourished to the extent that fur trappers held annual fairs featuring exchange of commercial goods and Native arts.

Confinement to reserves necessitated the development of alternative means of sustaining life and providing for one's family. The old ways of livelihood were gone, and the Plateau peoples adjusted quickly. Plateau basket-making flourished, as tourists marvelled at their ingenious works and strove to obtain them. Although basketry is certainly one of the most ancient of arts, if not the earliest, it seems to have been intensified by the Plateau peoples through sheer necessity. As Seton (1962: 173) notes,

> Basketry in some way or another entered into clothing, furniture, family life, and religion of the American Indians. Indeed, it supplied a tremendous number of domestic needs literally from the cradle to the grave.

Baskets were made of animal, vegetable, and mineral materials, woven and coiled, and dyed with colors derived from vegetal and organic sources.

In an effort to meet the challenge of changing times, the southern Plateau Peoples, Nez Perce, Yakima, Cayuse, and Umatilla developed corn-husk bags with colorful designs in false embroidery that quickly caught on. Although traditional designs were nature scenes and Indian iconography, they gradually changed with the times to include horses and elements of the fur trade. Eventually, pop culture symbols such as Mickey Mouse and patriotic imagery were also depicted. The original material used was hemp, since corn is not native to this area. When corn became available, women twined hemp and corn husks to form decorative regalia such as dance aprons, leggings, and gauntlets. Today the influence of this form of art is widespread and often displayed at festivals and pow-wows. Berlo and Phillips (1998: 133) suggest that Plateau corn-husk bags have even been used by Plains Indians as containers for medicine bundles.

The Plateau peoples had other arts as well, including drama, storytelling, and quite uncomplicated music. Their singing was smooth and the range small, and many of their songs had no accompaniment. Sometimes they used rawhide rattles filled with pebbles as means of accompaniment. They also developed a musical rasp that consisted of a notched stick, slightly shorter than one metre, and it was rubbed back and forth with another stick. Minor and Minor (1972: 306) note that the rasp was also diffused to Plains culture.

It was James Alexander Teit (1864-1922) who first drew international attention to Plateau basket-making. Born in the Shetlands, Teit migrated to Canada as a young man, married Lucy Antko of the Thompson First Nation, and operated a general store. He involved himself in ethnological research, working with anthropologists Franz Boas and Edward Sapir. He also concerned himself in working to protect Native rights, collected baskets, and interviewed basket weavers, determined to learn the meaning of their designs. After Teit died, Boas arranged for the publication of a monograph on Salish basketry. Unfortunately, the emphasis in the monograph was on technique, form, and selection of design motifs by individual artists. The text deals with the spread of designs throughout the community, the elaboration of designs, individual repertory, and the invention of new designs, particularly in dreams (Jacknis,1992: 151). There is no mention of spirituality although the historical development and aesthetic qualities of basketry are highlighted.

Plateau-style basket.

Teit's ample descriptions of various Plateau arts make reference to ear ornaments, necklaces, bone and copper pendants, and braiding of hair. Ear ornaments, worn by both sexes, were made of dentalia, stout bird quills, copper, teeth, and bone. Nose ornaments, also made of dentalium shells, were usually worn only by women. Scalps of red-headed woodpeckers were used as tassels. Necklaces were worn by both men and women and manufactured from dentalia, bird quills and feathers, animal teeth and claws, bone and copper tubes, silverberry bush seeds, and wampum. Some necklaces were made of buckskin, padded with deer-hair and embroidered on the outside with beads or quills. Shamans or hunters wore necklaces of grizzly-bear claws. Bone or copper pendants were round, oblong, triangular, or crescent shaped and attached to necklaces. Tattooing was not commonly done and the habit may have been borrowed from West Coast Tribes. Some tribes, particularly the Shushwap, did body painting. Hunters and warriors using this art form would try to make themselves look as fierce as possible, perhaps by painting dark streaks across their blackened faces. Hunters who were fortunate enough to kill a bear would paint themselves in a manner that would reveal their success in a hunt (Favrholdt, 2001).

Teit documented the great importance of fishing on the Fraser River by Plateau people by describing the various tools they used as well as related household items. His descriptions include the design of a salmon net and tools for net-making, a woven cedar bark mat that served as a base for cutting salmon, and a typical wooden bowl used for serving the roasted fish. His careful documentation underscores the fact that proximity to the West Coast people undoubtedly influenced the development of finely-carved spoons of wood and horn as well as a canoe with paddles (Bolz and Sanner, 1999: 154).

Artists

A number of well-known Interior British Columbia artists continue to work with the traditional art forms of their people including mask-maker Marvin Baker. Born in 1951 in Vancouver, Baker represents the Squamish Coastal Salish First Nation and is the grandson of the late Aboriginal leader, Chief Khot-la-cha (Simon Baker). Baker began carving at the age of 12, influenced by the example of his brother, Beau Dick. Marvin enjoys producing large, full-size, two-dimensional pieces which he has exhibited in many shows. Today his works are housed in galleries, corporate offices, and private collections all across the country.

Francis Batiste was born on December 6, 1920, on the Inkameep Reserve near Oliver, British Columbia, and grew up working on his family's stock farm. The son of a chief, Batiste attended the local reserve school and spent all of his spare time drawing. An educator, Anthony Walsh, helped the children of the local school develop a book, *The Tale of the Nativity*, and Batiste did the drawings for it. In 1934, his drawings were

displayed in an exhibition hosted by the Royal Drawing Society in London, England. He spent a year studying in Santa Fe, New Mexico, and later managed to exhibit his work in the United States, Great Britain, and Europe. In 1965, he was interviewed by the CBC for their Indian History Film Project.

Riley Charters was educated at the University College of the Fraser Valley and the Kootenay School of Art. A member of the Shushwap/Thompson bands, she works in a variety of mediums such as painting, printmaking, and beadwork. An up and coming artist, she assisted in painting a mural at the Vancouver City Hall and the Ramada Inn in Abbotsford. She has participated in a number of exhibitions and in 1992, made the Dean's List at a UCFV Seattle Minority Exhibition.

Darlene Emmerrencianna Gait has a Coastal Salish background and was inspired to enter the art world by her storytelling grandmother. Listening to the stories, Darlene began to create images about them in her mind. Soon she was applying the images on canvass using oil and acrylic. Later she studied at Chemainus College in Ladysmith, British Columbia; at Applied Multimedia in Calgary, Alberta; and at Malaspina College on Vancouver Island. During the last decade, she has completed over 200 paintings and exhibited them at pow-wows and various Native centres.

Printmaker Ed Archie Noisecat was born in 1959 in the residential mission school-house his mother was attending in Williams Lake, British Columbia. He grew up in British Columbia's remote mountainous interior with his mother's people, the Canim Lake Band of the Shushwap First Nation. He is a 1986 honors graduate of the Emily Carr College of Art and Design, and was the only printmaker major to be accepted into the schools prestigious master printer program. Noisecat uses a wide variety of contemporary printmaking and ancient carving techniques to make his creatures come alive. His works are available in galleries from coast to coast.

Born in Kamloops, British Columbia, Warren Ogden grew up in the Okanagan-Thompson area where he developed a great love for the outdoors. As a teenager he collected semi-precious stones and made jewellery. Later he designed leather handbags and purses, then began carving Aboriginal designs on leather articles. A trip to New Zealand inspired him to begin carving Northwest Coast Indian designs on bone.

Born in 1952, Susan Point is a member of the Coastal Salish First Nations and lives in Vancouver. Impressed with the Salish tradition, Susan began to study, and produce, fine art in precious metals, woodblock paintings, and acrylic paintings. In 1980, she opened her own gallery. To date she has produced more than 100 limited edition graphics, glass etchings, handmade paper castings, and woodblock prints. Like many Native artists, Susan finds meaning in traditional art forms which she creatively designs, revealing unique interpretations.

Wayne Thomas was born in Cranbrook, British Columbia in 1974, and is a member of his mother's band, the Interior Salish-Shushwap Indian Band. His father was

Ojibway. Thomas attended high school in Victoria and apprenticed under Victor Newman, a teacher of Native art at the school. Thomas became a carver in the Nuu-Chah-Nulth style where he apprenticed, then developed his own style. Today he works in wood and silver and has exhibited his work in several countries including Australia, Japan, Ireland, and Europe. In 1990, the Native Indian Education Division in Victoria awarded him the coveted Chief Henry Hunt Award.

A native of the Plateau region, Lawrence Paul Yuxeluptun was born in Kamloops, British Columbia in 1957, a member of the Okanagan First Nation. Yuxeluptun graduated from the Emily Carr College of Art and Design in 1983 with an honors degree in painting. His objective has been to document change in contemporary history using Coastal Salish cosmology and Northwest Coast designs. Yuxeluptun explores political, environmental and cultural issues in his work, carefully injecting personal experiences in his documentation. His political interests were undoubtedly influenced by his father's career as head of the Union of BC Chiefs, and his mother's involvement with the Indian Homemakers Association in British Columbia. Yuxeluptun has been a participant in numerous national and international art shows, and his work has been documented in a number of books.

Chapter Eight
West Coast Aboriginal Culture and Art

> The Northwest coast has been described as a culture area that is 1,000 miles [1 600 kilometres] long and one mile [1.6 kilometres] wide. . . . This area has served as a testing ground for theories about human behavior and has long been an area that anthropologists have pointed to as exhibiting "exceptions" to generalities concerning human behavior (Boxberger, 1990: 387).

Totem poles, canoes, masks, potlatches, longhouses, and salmon fishing; these are the stereotypes that are too often employed to describe this distinctive culture area. Indeed the Aboriginal cultures of the west coast are unique in character and language, and although a great diversity exists among the various tribes, they all share a love for the Pacific Ocean from which their food supply traditionally came. More than that, the underlying foundations of their culture comprise a deep sense of spiritual well-being that often profounds even serious investigators of Aboriginal ways. When photographer Edward Curtis began his study of First Nations in North America, he probably did not realize that he would be devoting three of his 20 volume set to the peoples of the west coast. One entire volume was devoted to a study of Kwakwa̱ka'wakw culture (Fowler, 1972: 122).

The western Canadian coastline, later known as the British Columbia coast, was at one time, home to the most linguistically-diverse area on the continent. Seventeen languages from five different language stocks, were spoken in this region. To the north were the Haida (Xa'ida) and Tsimshian (the latter divided into three language groups), as well as the Tlingit. The Tsimshian were named after two rivers that centre their traditional territory, namely the Tsimshian (people inside the Skeena River), and the Gitxsan (earlier spelled Gitksan) Skeena River people after the more southerly of the rivers, and the Nisha'a, after the more northerly (Steckley and Cummins, 2001: 115). The central groups originated from Wakashan stock, and included the Kwakwa̱ka'wakw (formerly known as Kwakiutl) who spoke three languages, the Nuu-chah-nulth (Nootka) who spoke two languages, and the Nuxalk (Bella Coola) who were a northern enclave of Salish speakers. Further south were six more language

groups, collectively labelled "Coastal Salish." Four of the five stocks were identifiable only on the west coast and all five are unique in Canada to British Columbia.

Diversity of language is just one of the ways in which the West Coast First Nations distinguish themselves. Each of their cultural lifestyles features unique characteristics, whether it be their language, art, skills in manufacturing canoes and artifacts, ceremonies and rituals, clothing styles, or kinship systems. West Coast culture was never a milieu of poverty or survival; it featured contentment, ingenuity, and enrichment. The abundance and diversity of natural resources, cleverly utilized by the craftspeople, afforded these seagoing people a luxurious and sumptuous lifestyle. The spectacular woods around them inspired them to become master builders, manufacturing houses up to 42 metres (136 feet) in length, made out of massive poles and long planks. Their canoes easily measured up to 13 metres (40 feet) in length and were capable of carrying 60 persons. Not surprisingly, with ample resources available to them, the West Coast peoples were able to support a relatively large population. At least 50 000 people lived along a narrow, 2 000 kilometre (1 250 mile) stretch of what later became the British Columbia coastline (Steckley and Cummins, 2001: 111). Even today, the revitalization process in which the west coast people are engaged, testifies to their creativity, adaptability, and endurance.

History

Archaeologists estimate that between 13 000 and 25 000 years ago, British Columbia lay blanketed beneath ice as much as one to two kilometres (½ to 1 mile) thick in some places. A similar sheet of ice covered all of central Canada, and at their peak the huge barren glaciers would have greatly restricted travel south of the Yukon. Some experts postulate that it would have been difficult to imagine any culture surviving in that kind of environment; the temperatures were low enough to make human habitation virtually impossible. Therefore, the origins of West Coast cultures in British Columbia must have occurred much later.

It is sometimes difficult to examine the prehistoric and early history of British Columbia because of the special series of problems connected to place names. Some place-names have changed drastically over the years while others are still known by the original names that grew out of the Aboriginal oral tradition. In addition, many First Nations place names exist only by word-of-mouth or in highly specialized archaeological works of reference. Others have been identified by variations in spelling, depending on the chart, book, or map in which that particular spelling was identified. Still, other towns and established places of settlement have disappeared altogether (Duff, 1997: 17f).

Some historians believe the hunter-collectors of the Paleoplateau tradition apparently moved northward between 9 000 and 7 000 BC, with the recession of the Cordilleran

glaciers, spreading to the coastal zone and perhaps as far north as the interior of British Columbia. There they encountered and intermingled with more northern-like cultural groups and by 2 000 BC, had formed a distinct coastal culture. This lifeway was ancestral to such cultures as Pacific Eskimo (Inuit) and Northwest Coast Indians (Dumond, 1978: 47f).

The first non-Natives to visit the west coast were Russian fur traders who arrived in the eighteenth century. The traders introduced manufactured goods such as iron-ware as well as influencing artistic orientations and designs. These new elements changed aspects of West Coast culture but the people managed to adjust, even reaching a climax in wood carving after European tools were introduced (Josephy, 1968: 79).

Essentially the fur trade shifted the emphasis of West Coast cultures from one of contentment to one of enrichment because many of the new items introduced by fur traders appealed to the locals, and the benefits of trade also gave rise to new forms of status and wealth. When the fur trade diminished, and increased European settlement along the coastline became a reality, West Coast First Nations cultures managed to flourish, continuing to express themselves in the growing lavishness of enhanced ceremonial life (Dickason, 1993: 419). Even the discovery of gold in British Columbia in 1857 caused a relatively minor disruption in their established way of life.

When Captain James Cook surveyed the northwest coast in 1778, he met the Nuu-chah-nulth and Haida tribes and was astonished at the extent of development evident in their culture. It was a lifestyle sufficient to itself and therefore Cook was quite dismayed to discover that the First Nations were, at first, not particularly desirous to trade for European goods. The richness of their own culture amply provided for their needs. This factor gave the First Nations the upper hand when trade was initiated, and when new items were defused they did less damage to local cultures because their entry was more controlled. The end result of trade relations was an enhancement of the existing culture rather than a forced adaptation to the culture of the newcomers. Besides, the objective of the traders was not necessarily to change local culture; they were primarily interested in acquiring pelts (Conrad, Finkel, and Jaenen, 1993: 308). Fortunately, fur traders and explorers like Captain Cook and Captain Alejandro Malaspina collected items of West Coast art which are still preserved in European museums. Iron nails and metal objects were particularly popular with locals who offered blankets, combs, hats, rattles, weapons, whalebone clubs, and wooden masks in exchange. Europeans were excited about these "never before seen curiosities" which landed in the hands of scholars who gave them as gifts, exchanged them, or sold them (Marsh, 1923: 75; Bolz, 1999: 163).

Before European contact, West Coast cultures enjoyed the luxury of a diverse and amply-endowed physical environment. Fish were so plentiful and easy to catch that the time spent in obtaining food was a great deal less than that of most inland agricultural, or hunting and gathering peoples, and the inexhaustible supply of construction

materials, plus the skill of the inhabitants, provided a relatively rich and varied lifestyle. Chiefs were essentially tribal economists, and held their positions simply by prestige. These leaders were responsible for laying aside sufficient quantities of food and raw materials and distributing them as necessary. They were basically regarded as figureheads, much like kings or presidents, and the force of their personalities was a major source of power. They also relied a great deal on the advice of what might be called cabinet members or councillors – influential individuals whose allegiance they contracted over time. The Tsimshian, for example, were bound in loyalty to their chief and took extravagant care of him from birth to death. The chief lived in a lavish house and did no manual work, but he financed elaborate potlatches to demonstrate his superiority over neighboring chiefs. If a neighboring band even accidentally caused harm to a chief, his people would rise up in vengeance. When a chief died, his people buried him with intensified rituals of mourning. (Farb, 1968: 136-137).

Despite their enviable economic status, the West Coast First Nations did not always fare well in written descriptions of their lifestyle. An early twentieth century anthropologist, Ruth Benedict (1959: 79), originated a less than enthusiastic appraisal of West Coast cultures when she identified their modal personality as "Dionysian" (aggressive). For many decades her assessment of the West Coast peoples held the stage in anthropological circles and was considered a watershed work. Benedict observed that Kwakwaka'wakw culture, particularly, was so loaded with emotional states that in order to save face with their cultural cohorts in celebrating the potlatch, for example, the people were virtually compelled to manifest a greater degree of emotion than they really felt. Aggressiveness, Benedict concluded, was a valued commodity among West Coast cultures. It affected marriage patterns, economic endeavors, and all forms of social organization and interaction.

Benedict observed that the Kwakwaka'wakw way of life emphasized violence, competition, and paranoia, and she concluded that members of the dominant North American way of life would depict it as abnormal (Driver, 1961: 532). Certain elements of the potlatch *were* probably intense, particularly the rivalry among chiefs to outdo one another in sponsoring a potlatch, but that is not the whole picture. At some feasts, destruction of property *did* occur, and sometimes such large quantities of food were given away at celebrations that they could not be consumed and were wasted. Also, chiefs, at times, burned blankets or canoes to demonstrate their complete disregard for the value of property and to indicate that their power of mind control was stronger than that of any rival. Josephy (1968: 76) suggests that the more a chief divested himself of wealth, the greater was his prestige and that of his clan. Josephy cites instances of chiefs freeing or killing their slaves, cutting up or throwing away sheets of copper (a valued commodity), distributing piles of blankets, and burning a store of fish oil or perhaps even their own houses. This indicates that Benedict's thesis may have had some merit. Codere (1956: 334f) challenged Benedict's evaluation and in her own study of

West Coast societies discovered that the Kwakwa̲ka'wakw were not primarily an aggressive society, but also endorsed a variety of behavior forms that could be labelled relaxed, humor-loving, and playful.

The potlatch was essentially a ceremonial event, but not without social implications. Guests came to the event in their finest clothing, usually arriving by sea in large war canoes. Commoners did the paddling, and members of nobility stood dramatically on raised platforms placed in the canoes. The greeting party assembled on the beach to welcome their guests, but their workload had only begun. Hosts to a potlatch were responsible for provisions, organizing, and presenting the potlatch as well as acting as ushers, speakers, food servers, gift recorders, and singers and dancers. After the nobility were seated and fed, they were given gifts according to their rank, following a strict protocol. Each gift was recorded, its quantity tallied by bundles of sticks. This process was extremely important because a reciprocating potlatch would no doubt be held in the future, at which, gifts of equal or greater value would be awarded. The host at the potlatch would give a speech about the occasion for the event as well as tracing the legendary history of his family, particularly with regard to the use and transfer of titles and privileges. The family history might be enacted by a group of costumed actors. Guests would offer speeches of thanks and acknowledgement followed by a closing speech from the host (Price, 1979: 203-204). When the event was over, predictions and observations would be made in anticipation of the next potlatch.

Potlatching eventually came to an unexpected end. Between 1849 and 1871 reserves were set out for First Nations in British Columbia under a policy of peaceful penetration with little regard for Aboriginal rights. A decade later, the federal government's policy of wardship was officially extended to the First Nations of British Columbia. With the institution of the attending regulation, severe restrictions on West Coast First Nations' cultures were initiated including the "low blow" of making the potlatch illegal in 1884. As Fisher (1978: 206-207) notes,

> The Indian custom that Indian agents were most anxious to eradicate was the potlatch. They felt that the potlatch was a "foolish, wasteful and demoralizing custom," and their opinions were shared by the missionaries. For the missionary the potlatch as the essence of heathenism, and nearly all of them . . . held that the potlatch was "by far the most formidable of all obstacles in the way of the Indians becoming Christians or even civilized."

On July 7, 1883, the Canadian cabinet was advised by Prime Minister Sir John A. Macdonald, acting in his capacity as Superintendent-General of Indian affairs, that the West Coast potlatch should be outlawed. The ceremony was variously labelled, for example, it was called "the parent of numerous vices that eat out the heart of the people . . . that produced indigence and thriftlessness and forced women into prostitution" (Cole & Chaikin, 1990). Educators lamented that children failed to attend school when the potlatch was being celebrated and missionaries complained that the potlatch defied

any of the good they were trying to accomplish among the Indians. Thinly-disguised, the original motivation to outlaw the potlatch was a political move, but veiled in words about the best interests of the health, welfare and economic development of the Indians. Quite bluntly, it was castigated and abolished purely on imperialistic and economic grounds. The anti-potlatch law stayed on the books until 1951, and when it was rescinded, it motivated a blossoming of West Coast art. The revival of old woodcutting techniques and the adopting of silkscreen painting led to a burgeoning of art. Carving of masks increased, some intended for potlatching, and others for the tourist trade and the art market (Bolz, 1999: 162).

Many First Nations groups reacted strongly to such a fundamental assault on their revered ways and protested strongly. Some tribes potlatched in secret, even changing the times and seasons of the potlatch, constantly on guard to evade suspicious agents whenever they could. Initial attempts at prosecution were ineffective because of the vague language of the law. After noting the government's opposition to the potlatch, one Nuu-chah-nulth leader replied,

> It is very hard to try and stop us; the White man gives feasts to his friends and goes to the theatres; we have only our "potlatches" and dances for amusement; we work for our money and like to spend it as we please, in gathering our friends together and giving them food to eat, and when we give our blankets or money, we dance and sing and all are good friends together; now whenever we travel we find friends; the "potlatch" does that (Cole & Chaikin, 1990: 26).

By the 1920s, there were several highly-publicized convictions and in 1951, the new Indian Act eliminated the restriction. As the twentieth century was ushered in the West Coast First Nations began to involve themselves in many income-earning industries of the variety that characterized the non-Native world. As Knight (1978: 7) put it,

> It is time that the generations of Indian loggers, longshoremen, teamsters, cowboys, miners, fishermen, and cannery workers, and others who laboured in virtually every primary industry in BC were recognized. Wage work in the major industries of this province has been an intimate feature of Indian lives for five or more generations. Indian workers and producers have been important in some industries for well over a century – right from the start.

Like many other First Nations cultures, the West Coast peoples have managed to live through to modern times without too many negative effects, despite being portrayed in the media and related literature via a series of stereotypes – totem poles, potlatches, and well-crafted canoes. The canoes and totem poles do exist, of course, and the potlatch was (and is) certainly an absorbing ceremony, but West Coast cultures incorporate a great deal more than these items imply. In fact, these First Nations are the bearers of a rich tradition, their culture having been described as one of the most

unique among the First Nations of North America. These westerly tribes occupied a landscape that traditionally provided them with resources in such bountiful manner that they had ample time to develop a culture rich in food production, folklore, recreational activities and very special art forms. Basically a fishing people, their villages and camps were located in sheltered harbors close to salmon spawning routes but also allowed access to shores and shoals naturally stocked with halibut, cod, herring, oolichan, shellfish, and marine mammals. Unique, localized resources were exploited by the various tribes, but frequent contacts between neighboring groups along the coast stimulated the sharing of ideas and techniques throughout the area, creating the patterns that outsiders have designated Northwest Coast or West Coast culture (Anderson, 1995a: 547).

Culture

Although they live in relatively close proximity to one another, West Coast Indian cultures have always exhibited a great deal of variety in cultural makeup. They have also shown a great deal of ingenuity in terms of mapping their lifestyles. One characteristic the various tribes have shared in common is their orientation to the sea coast and rivers, and the resources found there. On this basis it makes some sense to speak of the northWest Coast as a distinct culture area because there are some similarities among the various tribes that overshadow their differences.

In a hasty effort to simplify data, observers sometimes overlook the finer details of a specific cultural configuration. As a result, West Coast cultures are sometimes characterized as having relied primarily on cedar and fish (salmon) to make things work, but in reality their environment was more richly endowed than that, and their way of life, much more complicated. Like any cultural group who worked in harmony with the forces of nature, the activities of the "calendar year" were determined by those forces. Roughly, February was the time to catch shellfish, and April saw the start of sea mammal hunting. Other fishing commenced in June, and in July, salmon fishing was initiated. In the summertime, certain plants became available for domestic purposes and the fall yielded additional varieties. December and January offered somewhat of a brief solstice from these labors.

The basic occupational involvements of the West Coast peoples bear mention. To begin with, the procuration of cedar was a very important commodity, since it comprised the basis for making clothing, basketry, housing, and transportation. Its bark could be torn away from the tree in large sheets and applied to a multiplicity of purposes. Cedar wood provided lumber for building homes, canoes, and other forms of construction. Shredded cedar bark, woven into capes, blankets, and skirts was the major material used for clothing. Naturally, with this aura of importance attached to it, cedar wood was assigned some measure of spiritual significance as well. Fishing for

salmon was equally important. The West Coast peoples assigned salmon top priority as a life-giving venture with an array of attending technical and complex ramifications. Observers have catalogued as many as 12 different methods for catching salmon among West Coast peoples. Catching shellfish was a sideline among West Coast tribes since they saw this activity as one that served a subordinate role. Shellfish were sometimes seen as a supplemental food only, a commodity that could be obtained most any time.

The domestic scene of West Coast cultures included the construction of dwellings that consisted of rectangular houses with gabled roofs. Round doorways usually faced the ocean and for additional space, pits were often dug inside the home with steps leading downward. Sleeping accommodations were quarters placed along the insides of the house whose walls were portable for easy relocation from season to season. Among various Salish groups long, shed-like houses were characteristic, and in the southern section of the coast, houses were constructed set in pits. Homes of the Coast Salish were unlike those of any other West Coast peoples. The roofs of the houses were long and gently pitched so they made excellent platforms for feasts and dances. During the wintertime, the tribes engaged in intensified religious activities since the business of obtaining food was minimized by climatic and weather conditions. The political structure of the villages was informal in design, without "official" governing offices, but considerable prestige and influence was assigned to the higher ranks of people in each village.

Clothing styles among the West Coast tribes were very simple. In warm weather, men generally wore nothing except a few ornaments and women wore a brief cedar-bark apron or skirt. In cold weather, a blanket woven of mountain-goat wool and yellow-bark twine on a half-loom were added, and highly decorated. The southern Salish groups used a wider variety of materials, and in the rainy season bark capes and hats were added. People mostly went barefoot during all seasons and basketry hats were used – again decorated with woven designs.

Northwest Coast kinship types varied a great deal. In the north (Tlinget, Haida, Tsimshian), one could identify matrilineal orientations, but patrilineal arrangements were the preference further south. The Coast Salish and Nuu-chah-nulth were basically bilateral, and the format for the Kwakwaka'wakw has been difficult for anthropologists to classify (Hunn, 1990: 370-372).

The social organization of the Tsimshian was quite complex. The four principal clans were subdivided into subclans or branches. An individual was attached to a particular clan on the basis of their sharing a common myth of origin. Every house in each village was made up of a number of matrilineal lineages, which may not necessarily have been related to one another by blood. Lineage was viewed as a significant functioning unit, since the members often lived together in one dwelling or in one village. Personal names were controlled by each clan and remained their exclusive right.

Property rights (which included names) and the use of resources from the land were transmitted within lineage wherever possible.

In each Tsimshian village lived a chief who was the social and ceremonial head of the tribe, although they had very little political power. Their authority was exhibited mainly through prestige. For example, the organization of the winter festivities was in the chief's hands, and they alone could remove the influence of the spirits from the dwellings and the people at large. They worked with his councillors in deciding the time of the event, who should give the initiations, and when they should be given. The chief also ordered the potlatch and worked with other chiefs from other villages in managing intertribal affairs (Garfield, 1939).

Spirituality

Traditionally, West Coast Aboriginal groups held in common the belief that supernatural beings controlled the structures and events operant in the universe and human beings should strive to develop workable relationships with them through ceremonies, prayers, and rituals. Gift-giving feasts through the celebration of the potlatch were at the heart of West Coast cultural life and reflected the wealth and power of the great chiefs who apparently had the ability to mediate with spiritual powers. Potlatches were essentially occasions for passing on inheritance and ceremonial wealth to oncoming generations. Each was given in honor of a person or event, though attention was focused largely on the host chief (Kirk, 1986: 59). The potlatch was at the core of Kwakw<u>a</u>ka'wakw social organization. It was an all-inclusive, all-encompassing kind of institution, with attached political, social, economic, and spiritual implications. At its very basis, the potlatch involved a payment of goods and food to assembled guests who gathered to witness the host's claim to ancestral rights or hereditary position. This kind of claim could only be transacted in a public ceremony and the guests fulfilled the role of required witnesses. By accepting gifts, the guests helped to confirm the rights that the host publicly claimed (MacNair, 1995: 599). At a marriage potlatch the father-in-law gave names and other wealth to his son-in-law to hold in trust for the former's grandchildren. Sons-in-law, however, sometimes used these names for their own advantage before passing them on to their children.

Common to the belief system of the Northwest peoples was a complex centred around the guardian spirit (Muckle, 1998: 49). Guardian spirits formed a special relationship with individuals and blessed them when they hunted, engaged in battle, or required healing. Guardian spirits manifested themselves in various animate and inanimate forms, featuring an interesting mix of individual expression and hereditary rights. A guardian spirit was usually obtained during a period of self-sacrifice, fasting, and praying. Sometimes an individual would obtain the spirit through a kind of family lineage. Guardian spirits might be celebrated at the winter festival through songs and

dances, but their identity would not be revealed. Despite this secrecy, people close to the individual would probably know the identity of the guardian spirit based on the words and movements of their songs (Boxberger, 1990: 398-399).

Among the Tsimshian people, any public occasion at which property was given away was called a potlatch. A great many potlatches were commemorative in that they were given by individuals who were publicly acquiring names, powers, or other intangible possessions that were hereditary, and whose originator had to be honored in the potlatch. A man wishing to organize a war party threw a potlatch and distributed wealth to all who might join with him. Intertribal potlatches, usually given by chiefs, are the most often described by informants because they were the most spectacular. A further ramification of the potlatch complex was played out in this way:

> A new totem pole directly benefited the owner, but as it was raised into place, other poles erected by his predecessors were recalled, and the crests illustrated on it had been used on previous poles. When a new house was built all the former houses of the same lineage were recalled and their names and housefronts paintings recounted (Garfield, 1939: 192).

A unique kind of potlatching among Kwakwa̲ka'wakw was called "play potlatching" and consisted of having fun, conducting nonsense activities, and promoting congeniality. Only items of little value were given away at play potlatches and everyone, including chiefs, took part. Some say the chiefs had more fun at these events than anyone else. The goods distributed ranged from quite useful articles to mere favors, or things like pigs or chickens that were not the donor's right to give away. Thus the exercise became somewhat of a fraud or joke and added to the levity (Codere, 1968: 326-329). From every point of view the play potlatch seems to have had the theme of being a free-for-all and offered welcome relief from the seriousness of life. It did not, however, diminish the significance of the purely ceremonial potlatch. Winter ceremonial dances, often lasting months at a time, represented the supernatural forces that created order in the universe and assured perpetuity for the tribe (Anderson, 1995b: 562).

There were variations in the practice and meaning of the potlatch among the tribes. For example, the Tlinget practiced the potlatch primarily in honor of the dead, along with a series of other honorary activities (Newcomb, 1974: 219). Among the Haida, on the other hand, the social meaning of the potlatch quite overbalanced the religious. When a chief gave a great potlatch, he did it primarily to increase his reputation and advance his standing in the community. The idea of giving property to a member of one's own clan was altogether abhorrent to Tlinget notions of propriety.

The Tsimshian version was premised on the idea that the ceremonies and dances attached to the potlatch brought supernatural power to the Tsimshian world. Chiefs controlled supernatural power for the people, manifesting their abilities in dramatization of a special set of names. Shamans practiced various types of healing and combatted the effects of witchcraft. The great potlatches were generally given at the time of

assumption of an ancestor's name and payments for services and gifts were given throughout life to members of one's clan (Anderson, 1995b: 573).

A kind of incarnational character, Raven played an important role in West Coast theology, particularly in the Haida configuration. It was Raven who gave the people their cultural institutions, taught them how to use them, and endowed them with natural resources. Other spirits were entreated for specific purposes as well. The killer whale spirit who controlled the main sources of food was often requested to allow whales to wash up on shore. There were elaborate rules about how to entreat the spirit world and shamans played an important role in defining these regulations. In West Coast country, shamans claimed to have received special powers from the supernatural world in answer to prayers and fasting. A deep appreciation for ritual enabled them to elaborate the fasting process and adopt styles of dress that set them off from other tribal members.

Art

Today, West Coast Aboriginal art is well-known internationally. Most people associate the concept either with the highly structured linear art of the northern regions of the coast, or with the dramatic and colorful dance masks of the southern Kwakwa̱ka'wakw. In fact, a tremendous diversity in artistic expression exists among the various peoples of the West Coast, so it would be much more accurate to refer to West Coast art as multifaceted. Before European contact, regional artistic styles abounded so that individualistic styles could be traced to a single village. Of course there are also some artistic characteristics that were (are) common throughout the West Coast area (Wyatt, 1991: 160).

Historian and artist Bill Holm's book, *Northwest Coast Art: An Analysis of Form*, published in 1965, is a watershed study of Haida, Tlinget, and Tsimshian art. By studying thousands of artistic works, Holm tried to determine inductively, the rules and general principles followed by the various artists. He identified three basic forms which are considered the building blocks of West Coast art: the slightly squared off oval with a concave bottom contour, the "U" form, and the "S" formline. Holm concluded that a West Coast

West Coast art building blocks: U-shape, ovoid, and S-shape.

artist creating a three dimensional object would first conceive of the design in two dimensions and then mentally wrap it around the third dimension. Painted compositions were usually symmetrical with the West Coast artist systematically avoiding absolutely parallel lines and true concentricity in the placement of ovoids and other forms.

Unlike the First Nations who occupied the northern areas and plains of North America, the West Coast First Peoples lived in relatively lavish conditions in so far as a food supply was concerned. There was an abundance of fish from coasts nearby and the people maintained permanent dwellings with the accompaniment of a great range of possessions. This situation gave birth to a wide expression of artistry and technical achievement. Archaeologists estimate that West Coast art as we know it may be as old as 4 300 years. Deposits exhibiting art forms with decorative or incised symbolic patterns that old have been discovered along the outer coast of Vancouver Island. As Duff (1974: ii) elaborated,

The result of this combination of sculptures' and painters skills is that art pervaded all aspects of [West Coast] Indian life. It ranged from the whole gamut of size, from tiny charms to huge totem poles. It applied to almost all utilitarian objects, from fishhooks to dishes. Ordinary life was enriched by art on every side. The occasions of ritual were staged almost completely within environments created by the artists.

Carving and painting were two of the major art expressions of West Coast peoples, but they also excelled in shellwork, using muscle and clam shells. Several stone carvings such as bowls and effigies have been found in the Fraser River area, dating back to at least 1 000 years before Christ. The effigies

West Coast-style fish hook.

resemble human and animal forms, and one of them, produced several centuries later, is carved in the form of a seated human figure whose lap or abdomen forms a bowl-like receptacle. It has been suggested that there may have been a conceptual similarity between the carved bowls and the feast dishes and other carvings of the post-contact Kwakwaka'wakw (Berlo and Phillips, 1998: 180).

West coast artists used horn for a variety of purposes. Mountain goats, for example, had small black horns whose graceful curve formed a generous bowl. The handle was carved with intricate animal crest patterns on a reversing curve to its terminal point. Smaller bones were made into spoons used for potlatches. Slender deer and elk horns were manufactured as shamans' equipment, and porous whale bones were made into clubs. Whale vertebrae became stools and masks, and the tiny bones of birds made drinking tubes. Ivory walrus tusks were cut into small pieces and used for decoration (Patterson, 1973: 123).

The West Coast peoples manufactured clam shell beads, wampum, runtees, necklaces, inlaid pendants, chumash pendants, conch shell trumpets, ceremonial vessels, engraved shell gorgets, and dentalium embroidery. Their basketry styles were unique to the area and served as a substitute for pottery which was never developed here (Hawthorn, 1967: 234). West coast craftsmen were superb canoe makers (particularly the Haida and the Nuu-chah-nulth), and found an eager market for their boats with other First Nations. The giant cedars from which they made their boats were turned into vessels some 16 metres (52 feet) in length and nearly three metres (10 feet) in width. As Newcomb (1974: 215) noted;

> Their round-bottomed northern type of canoe had a high protecting bow and stern, often elaborately painted, with bowsprits bearing carved designs of family crests. The Nootka [Nuu-chah-nulth] built exceptional canoes that differed from the northern type in having a squared-off, low stern and a flat-bottomed hull with graceful and practical sheered sides, which "made it one of the finest seagoing vessels built by any primitive people." It is even said that the famous American clipper ships borrowed their sleek, racy bow lines from Nootka canoes.

The winter festival of the Kwakwaka'wakw emphasized another dimension of their artistic repertoire, namely songs and dances. The object of the festival was to assist youth in gaining membership in religious societies. The various religious societies had their own musical repertoire but dances were all performed in a "sunwise" (clockwise) direction. In the first part of the winter festival, members would perform songs and dances while it was believed that youth would approach the secret society by "flying through the air" (Boas, 1967: 182). During the second part of the festival, spirits would be exorcized (taming of the novice), and songs would be sung in honor of the new member. Most songs consisted of four verses and were accompanied by the beating of batons and by a drum. Boas (1967: 183) reported that sometimes the beating of the drum was so loud that it drowned out the singers.

West coast tribes other than the Kwakwaka'wakw also featured dance societies. The Nuxalk, for example, had two dancing societies, and the Tsimshian had four dance societies and four kinds of dances. The Salish had a series of "spirit quest" dances and a masked dance that was inherited and performed by healers. The Nuu-chah-nulth

sponsored a wolf dance in which a novice was initiated by wolves. Family crests might be displayed at such an event. The Haida held special dances for the building and validation of a new lineage house and the installation of a chief. Potlatches for this occasion were accompanied by initiation of members into the shaman's society (Hawthorn, 1967: 49).

The two major divisions of West Coast art were: (i) applied design and formalization of representation, and (ii) three-dimensional sculptural art that combined realism with an impressionistic suppression of nonessential detail. The origin of the designs is unknown; they were probably the result of a long evolutionary development. In the north, the Haida, Tsimshian, and Tlinget to a lesser degree, developed an elaborate style in which conventionalized forms were used to decorate a variety of objects. Some southern tribes developed a simpler but more vigorous style that emphasized mass and movement rather than convention (Drucker, 1968: 337). The Coastal Salish copied the carving designs of the Kwakwaka'wakw and the Nuu-chah-nulth although they simplified them.

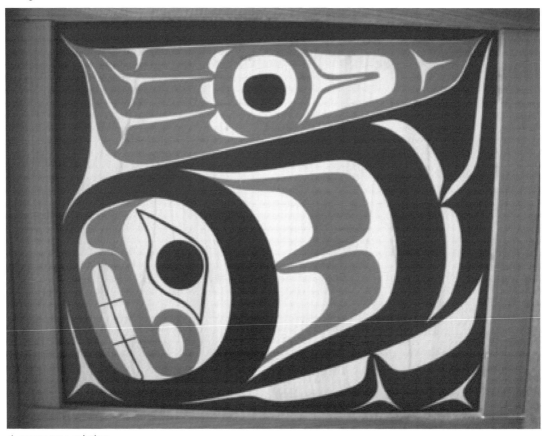

A totem type painting.

The specific features of the northern West Coast peoples, which was essentially applied art, included two dimensional (painting) or three dimensional (carving). These artists exhibited a passion for symmetry and balance, often emphasizing certain features such as head, face, and paws or tail, while minimizing other parts. Usually no parts of a painting or carving were left vacant but filled in so as to set the art in motion and draw the viewer's eye from one part to another with ease. Drucker (1968: 341) notes that two dimensional painting, other than that used for accent and embellishment of high relief carving, was applied to a great many objects such as storage boxes, backrests, cradles, globular wooden rattles, canoe hulls, and paddle blades. Other forms of artistry included twined, woven spruce-root hats, Chilcat blankets, and basketry.

Artistic themes of West Coast artists included supernatural creatures, animal and human forms who were lineage or family ancestors or associated with them. The reason for this art form was to honor and respect individual and family status. Although individual First Nations developed unique approaches to what became recognizable as West Coast art, they tended to use studied symmetry and balanced designs. At times painted animal forms were split and spread out in ways that were unusual but intriguing. West Coast artists had a penchant for filling in blank spaces by interlocking and intertwining figures. At other times, certain parts of an animal or other painted forms were emphasized as though to defy the conventional.

Stewart (1979: 19f) notes that the basic components of West Coast art featured the ovoid (rounded rectangle), usually in black and red colors. West coast artists also employed the inner ovoid (circle within a circle) with a black line around it. The U-form was used for contour of bird or animal, and split U-form for ears, feathers, tails, and open spaces. The S-form was used for filling in space. Anatomical features had specific forms, for example, eyes were painted in a circular or ovoid shape, noses were shown very obviously, ears were usually U-shaped, but could be human-like, and eyebrows had a fairly realistic appearance. Arms, legs, hands, feet, and claws were frequently red in color and hinged to the body.

Each creature painted by West Coast artists was informally assigned a specific role and painted accordingly. It was believed that a whale could capsize a whole boatload of people and drag them down to his home. There they would become whales. Bears were perceived as powerful and human-like; in fact, the bear was called Elder Kinsman. The wolf was revered because he was a great hunter, and associated with the special spirit power that a man had to acquire to become a successful hunter. The mountain goat provided the basic material from which the Chilcat blanket was made, but sometimes the woolly hair of a special breed of dog was used. These dogs were kept in pens and sheared twice a year. A third alternative was a yarn made by pounding duck down, mixing it with the fibres of fireweed, and rolling the mixture into thread (Kehoe, 1981: 422).

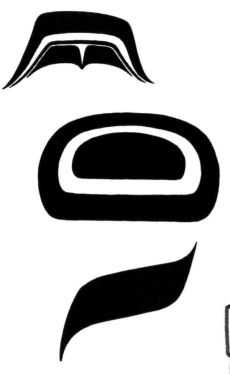

West Coast style building blocks II: split-U, inner ovoid, and S-form.

Symmetry and balance on a Haida style storage box.

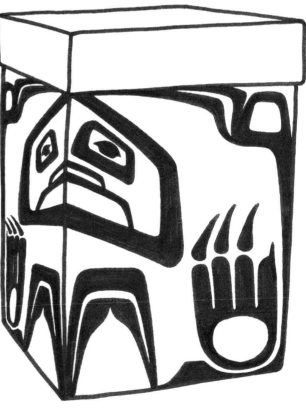

It was believed that the otter had power to transform people into animals, and sometimes took the role of trickster. The eagle was seen as a symbol of power and prestige, the raven as the most important of creatures, because he gave the people many things. However, he too, sometimes assumed the role of trickster. Other frequently appearing creatures included the hawk, salmon, beaver, sea lion, seal, hummingbird, thunderbird, loon, owl, frog, mosquito, and sea monster.

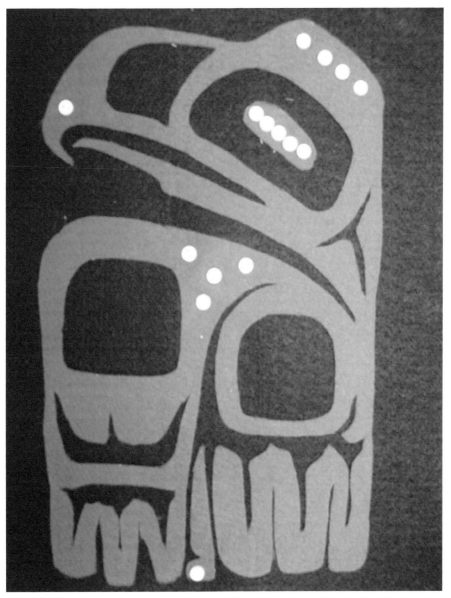

West Coast style button blanket made of red and black felt, and embellished with white buttons.

Haida style canoe.

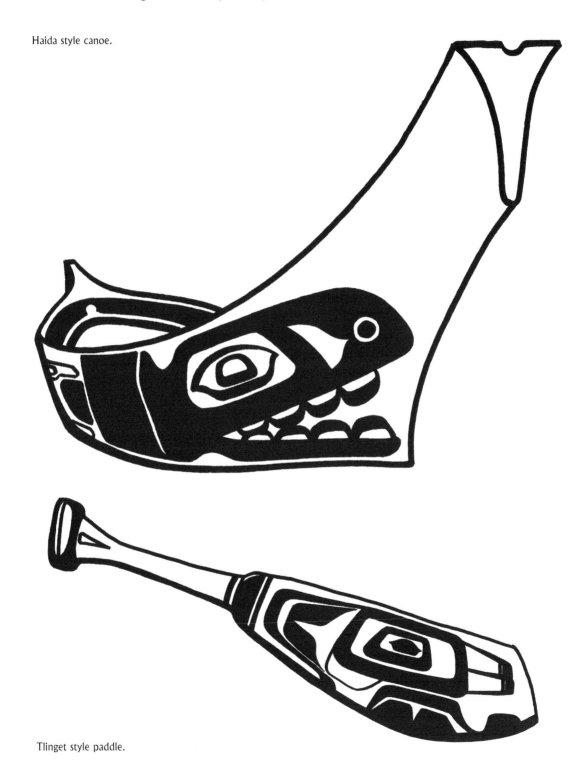

Tlinget style paddle.

Tlinget artistic bent, like that of other northern West Coast First Nations, reached its pinnacle in the architecture of their homes (McMillan, 1988: 207). The fronts of their homes were elaborately carved as religious expressions, complemented by carved totem poles, masks, woven Chilcat blankets, and batons. The woven Chilcat blanket, another example of Tlinget ingenuity, was considered by many as equal to the best weaving of the ancient Peruvians and Mexicans. Made of twined cedar bark and goat hair, women were responsible for weaving and followed patterns drawn on flat cedar boards by men of the tribe. The men hunted goats for their hair and made looms using two upright poles connected at the top by a crossbar from which the warp strings dangled. It took three goat hides to make a Chilcat blanket, and weavers first made a series of panels and then sewed them together (Heizer, 1974: 233). Named after a Tlinget tribe who supplied blankets to people all along the west coastline, some believe the blanket actually originated among the Tsimshian. From 1850 on, button blankets made of wool and Chinese mother-of-pearl buttons, began to replace Chilcat blankets as ceremonial attire (Kammler, 2000: 311).

Houseposts and screens of the Tlinget were as important as their intricately-carved totem poles. The four corner posts of the house were carved and painted, each telling the story of a clan ancestor. The Tlinget also applied their artistic expressions to all material objects in their culture including their canoe designs, food boxes, and dishes, tools and weapons. Their creative genius was also exemplified in their various ceremonial objects, the most important of which were crest hats worn by representatives of the most important houses and clans. Masks made of wood and painted to represent great animals and birds played a leading part in the dances. Ancient rattles made in the form of birds were brightly colored and highly polished (Oberg, 1973). At the base of Tlinget art, whether carving or painting, chanting, or dancing, was a rich and varied origin story. These tales accounted for the origin of the people, the world of the spirits, and the ancestors of the clans. Raven ranked as the head of the spirit world. It was he who stole the sun and gave it to the people, stole the waters and made the rivers run, and stole the fish and kept them in a basket far out in the Pacific. He was the trickster, and he could be kind or cunning, lustful, and wicked.

Basketry

The artistry of the West Coast First Nations is highly distinctive and is supplemented by an ancient history unique to the area. Their major art works were in carving and secondarily in painting. They manufactured a variety of boxes and containers, some beautifully carved and painted, and were also skilled in basketry, manufacturing twined and coiled products, and carving. A unique product was the basketry hat which had painted and woven designs (Newcomb, 1974: 216). Mothers rocked their babies securely tied in basketry cradles sometimes hung on springy poles. Families slept on

mats woven of cedar bark, and spread mats as "dinner cloths" when entertaining guests. They wore robes woven of cedar bark softened by soaking and pounding. Women wore cedar bark aprons and twined and wove containers from birch bark, often mixing in selected grasses. They made pouches to contain dried salmon and other small implements. They also manufactured stiff baskets with coarse mesh, some of which were designed as traps to catch salmon. Others were used for gathering clams, berries, or firewood. Other basketry items included boxes that were used as containers, and elaborate chests that held ceremonial regalia or items of wealth. Women even cooked in boxes by heating stones and putting them into the boxes to which water and food were added (Kirk, 1986: 109-111).

In 1915, Marius Barbeau arrived in Port Simpson to begin fieldwork among the Tsimshian. He purchased Tsimshian baskets from some of the finest basket-makers in the community and later recorded the details of this art form for posterity. His collection is virtually the only documented collection of Tsimshian basketry available for study. Although the Tsimshian shared some techniques of basket-making with other tribes, their style was distinctive. Tsimshian basketry, it turns out, also represented a wide repertoire of forms (Laforget, 1993: 215, 248-249). Birch bark containers apart, functional classes of traditional Tsimshian art included plaited bark containers used for berry-picking, plaited mats, oolichan baskets, and twined-root cooking baskets.

The material culture of the Tsimshian was a magnificent manifestation of their artistic bent. It reflected an intricate, coherent, and symbolic vision. Ownership of certain domestic items was restricted to persons of rank while others would exclusively be owned by shamans. Tsimshian houses were carved and painted with designs, representing the crests of the owners. They were fronted with complex poles erected in honor of past chiefs. Less significant items like baskets, canoes, clothing, fish hooks, and storage boxes were finely made, frequently displaying complex symbolic decoration. Tsimshian sculpture was widely acclaimed and much sought even during traditional times (Anderson, 1995b: 563).

The Coast Salish produced excellent basketry with traditional designs imbricated with cherry bark. They also used hand-spun wool dyed with natural dyes to make blankets, wove wool blankets, and carved bowls and plaques for wall hangings.

Crests

Crests are designs embellished on carved woods to display images of significance featuring clan origins, history, and lineage. Many of them have their origin in mythical time when it was believed that animals were able to transform themselves into humans. Chiefs had the right to commission complex paintings and carving of crests which served as visual statements of ancestry. Crests usually feature supernatural beings, animals, birds, fish, or celestial bodies. A family might have obtained its crest through

an ancestor who had contact with a transformed supernatural being. The ancestor may have killed the creature, but what is important is that from that time on, his descendants had the right to use the creature's likeness on their crest. If the ancestor received a song at the time of his encounter, his descendants had a right to use it too. Crests could be obtained through marriage, victory over an enemy, traded, or obtained for rendering special services, or through the extinction of a family name (Stewart, 1993: 33).

Crests often appeared on totem poles, but there were specific regulations about their use. For example, if a crest appeared on a memorial or mortuary pole, it was considered part of the lineage property which both the chief and his successor (who had the pole put up), were entitled to use (Drucker, 1968: 344). This art was more than decorative because it expressed how the members of the particular culture viewed themselves and the invisible forces that shaped the world and human destiny. Crests were displayed to the public so that everyone would know their nature. They confirmed a chief's ancestry, rights and privileges, depicted spirit helpers, and marked private relations between individuals, families, and the supernatural (Kirk: 1986: 49). No one would copy or steal a crest because it would be too obvious. Also, no unauthorized individual would attempt to explain the meaning of a crest because that would be interpreted as an invasion of privacy.

Masks

The masks of the West Coast peoples are among the most remarkable artistic creations of their culture, and a great deal of care, ingenuity, and attention were lavished on them. The explorers who first came into contact with these folk were most impressed with them. The visitors began to collect masks along with other articles and artifacts such as fishing equipment, tools, weapons, and household items like carved and painted bowls and spoons. Some of these items survive, having found their way into the repertoire of provincial and national museums.

King (1979: 5) elaborated three basic reasons for the carving of masks: (i) as a representation of chiefs and ancestors of high rank; (ii) as accompaniment for the performance of dances reenacting legends; and (iii) for shaman healing practices. Masks were usually worn during winter evenings, and the attending atmosphere would be tense, with expectations high.

Mask carvers learned the trade by modelling and imitation. Those depicting the human face often had mechanical parts for manipulating eyes, eyelids, jaws, and lips. Larger masks known as bird masks were sometimes nearly two metres in length. The artistic impact of masks was supplemented by implicit assumptions which were unlikely to have been publicly discussed. Their artistic forms have drawn attention in terms of their highly stylized symbols for different animals and mythological creatures, the repeated use of specific shapes, volumes, lines and colors, the carving and painting styles, and the use of highly-abstract two-dimensional symbolic functions and meanings

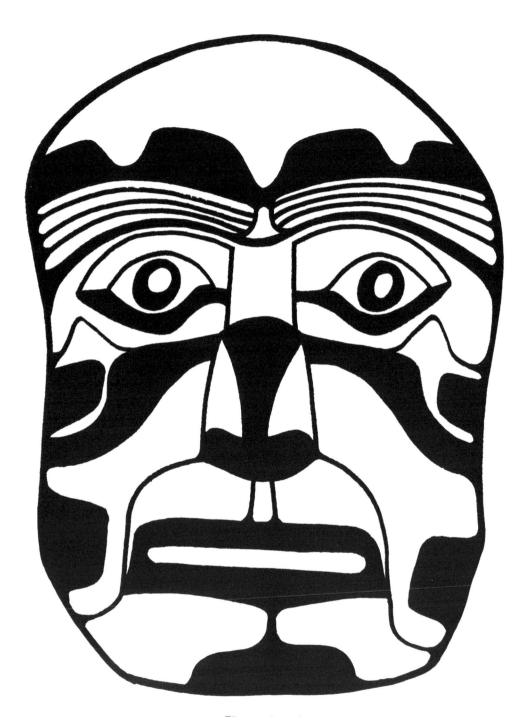

Tlinget style mask.

(King, 1979: 28). Like rattles, masks were seldom complete in themselves; they were integral to particular rituals and affiliated with accompanying songs, drum rhythms, and dances. The context of a mask was essential to defining it (Kirk: 1986: 50).

West Coast First Nations varied in their creation, styles, and function of masks. The Coast Salish had only one ceremonial mask which was of elaborate form in three dimensions. The Kwakwaka'wakw probably designed the most exquisite masks which they used for ceremonial purposes. Their repertoire of masks included animal masks, bird and insect masks, natural element masks, human and speaker masks, and complex masks. The Komokwa mask represented the king of the undersea world, the master and protector of seals. He was also associated with rising tides and whirlpools (Hawthorn, 1967: 239). It was a symbol of wealth, and many human supplicants of legendary history tried to reach into this kingdom.

During the winter the Kwakwaka'wakw held dances and rituals to reclaim people who had been stolen by spirits. These festivities were also designed to initiate novices who were taken away for a time and then welcomed to rejoin the activities. The Nuu-chah-nulth had two celebrations during which masks were used; the Shaman's Dance and the potlatch. The Shaman's Dance was a ritual enactment of the seizure of a novice by a wolf and the bestowal on him of ancestral rights and powers. This was a method of introducing novices to the rituals and rights of their people. Masks were also worn during the announcement of a potlatch, often up to two years in advance so that the event would not clash with other similar celebrations. Only chiefs who owned the appropriate masks could announce a feast in this way (King, 1979: 43).

Among the Haida, chiefs and people of high rank were permitted to wear masks which were decorated with crests. Approximately fifty different kinds of masks were available, representing natural phenomena such as animals, killer whales, or the new moon. Crests were either mythological in origin or procured from the Tsimshian First Nation. Like Nuu-chah-nulth chiefs, Haida chiefs gave potlatches and feasts and wore masks with crests. The potlatches were given to commemorate an ancestor, tattooing of a crest on a child, or cutting a lip for a labret (an ornament worn in the lip). The Tsimshian and Tlinget used masks for much the same purpose; sometimes Tsimshian shamans performed ceremonies that involved wearing of masks. Tlinget shamans owned and wore a variety of masks that were associated with their spirit helpers. The most important of such ceremonies took place in the winter during a full moon. Tlinget masks generally revealed the same kind of carving on feast masks as they did on clan and war helmets. Carved war helmets with grotesque features were intended to terrify enemies and protect warriors.

Although each of the West Coast First Nations traditionally had their own language, social system, and material culture, over time they developed a fairly common culture. This occurred through the natural process of diffusion – the transference, adaptation, and adoption of each other's ideas, art forms, and ceremonies. Spirituality was at the

base of their lifestyle because the people believed that it could not be separated from any component of their way of life.

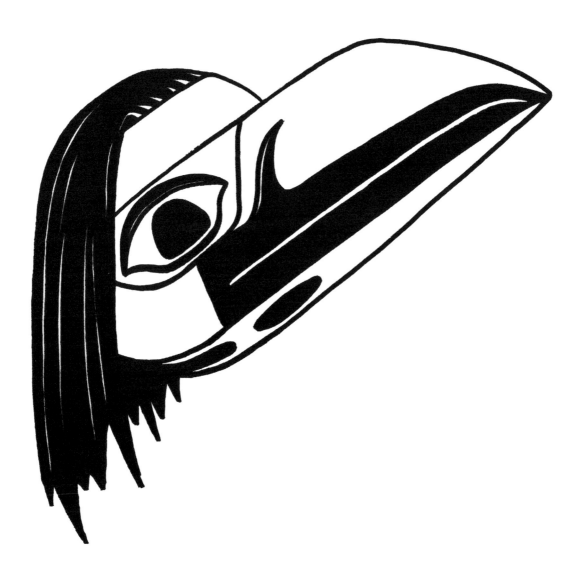

Haida style White Raven mask.

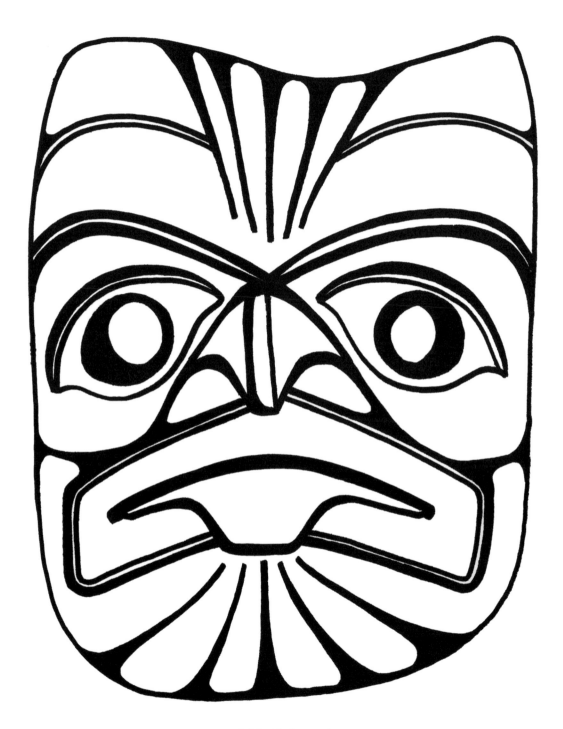

Salish style frog mask.

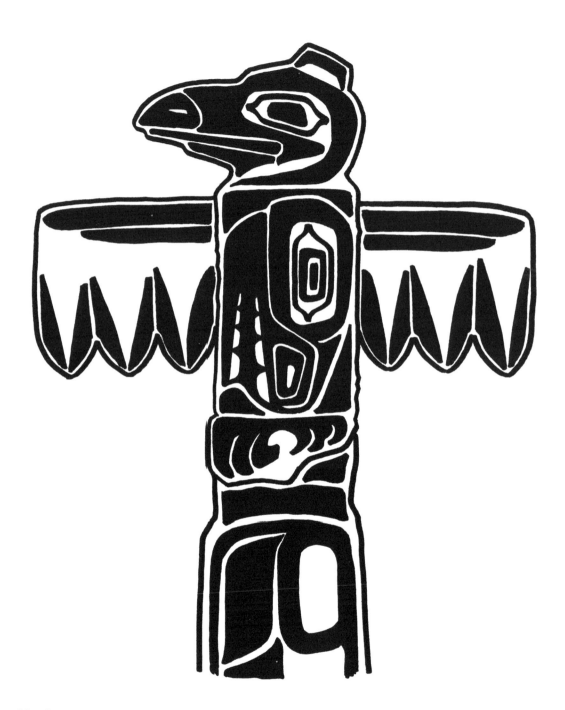

West Coast style Raven totem pole.

Totem Poles

No discussion of West Coast art would be complete without reference to the famous totem poles of British Columbia, most of them found in former Haida and Kwakwa̱ka'wakw communities. Basically the only West Coast peoples who did not have anything to do with totem poles were the Coast Salish. However, they did not make any less use of painted embellishments, and had among them, very imaginative artists who followed an ancient wood-working tradition.

Originally, totem poles were viewed as a creature or object and associated with one's ancestral traditions; they should therefore be respected. True totemism commands a feeling of awe or religious appreciation. The belief was that totems originated when a specific supernatural spirit took the place of a creature such as a raven, eagle, or bear. This did not imply that such a creature could not be killed, for it could.

Totem poles were erected for a variety of reasons including:

(i) **The house portal pole**, usually supported by the two central beams of each communal house. It featured crests that symbolized memorable events or recorded a tale of interest that was commemorated in the decorated poles. Each post might tell its own story or the tale could be linked together in both poles. House poles were the shortest of all totem poles.

(ii) **The house frontal pole** (first reported 1690), usually placed front and centre of the house and had a doorway through which people might pass to enter the house. Haida frontal poles usually carried the totem of both the husband and the wife. In ancient times, slaves might be killed and their bodies placed in the hole which the base of the totem would fill.

(iii) **The memorial pole**, traditionally erected in front of, but not attached to, the home and after 1880 represented a kind of tombstone for a respected person. These poles were usually raised a year after the individual's death. Responsibility for raising the pole fell to the individual who had inherited the wealth of the deceased, usually a nephew. This kind of pole was found in Haida, Kwakwa̱ka'wakw, Nuxalk, Nuu-chah-nulth, Tlinget, and Tsimshian villages.

(iv) **The mortuary pole**, erected in honor of someone who died; sometimes the individual might have been buried directly beneath the pole or in a box at the back of the pole. This was a Haida and Tlinget custom.

(v) **The heraldic pole**, always nicely carved and free standing, symbolized the family tree of an important family.

(vi) **The potlatch pole** came into being after the arrival of the Europeans. Newly acquired riches via the fur trade influenced the construction of totem poles by former commoners who could now afford to have a place in the potlatch

configuration. This development contributed to a significant change in tradtional West Coast social systems.

(vii) **The ridicule or shame pole** was initiated by an individual of high rank to embarrass a peer who had failed to live up to community expectations. The insult could be rectified only by purchasing the pole and dismantling it. Today these poles exist only in museums.

Drucker (1968: 344) makes reference to a "special privilege pole" that could be erected, for example, by a chief who had inherited the prerogative of being the first to invite important visitors to the village for a feast. This was a practice limited to the Nuu-chah-nulth and the southern Kwakwaka'wakw First Nations.

There were tribal differences with regard to the carving, raising, and perspective of totem poles. The timing of their appearance is also important. For example, in 1825, there were still many totem poles in Haida villages, but by 1880 the Haida had ceased pole-carving. The Kwakwaka'wakw, however, carved most of their totem poles after 1880, and the Tsimshian made most of theirs between 1900 and 1940. Traditionally, the Coastal Salish did not have freestanding totem poles, although they did design large cedar planks carved with figures of animals and humans on the walls of their dance houses. The Nuu-chah-nulth set up a welcome pole with outstretched arms near their village beach (Stewart, 1993: 24).

Symbolism was highly important in totem poles and it was the front of the pole that had the most significance. Unless one knew the story behind the pole, it meant little to the observer. Certain legends repeatedly appeared on totem poles and observers could tell the story by the familiarity of the carved figures. Details of the stories might vary slightly from one First Nation to another, but the essence of the tale was still preserved. Totem poles were not to be perceived as religious symbols; rather, they tended to have hidden clan meanings. Traditionally, totem poles gave honor and prestige to the person for whom it was erected. If a chief obtained a new crest, he would invite members of neighboring tribes and show off his crest by erecting a new totem pole. Feasting would accompany the ceremony of raising the pole.

Sometimes totem poles were carved with movable parts; eyes, for example, could be moved by attached cords to animate the figure. Creatures carved on totem poles usually had exaggerated features. The eagle usually had a long and bent down beak, as did the thunderbird, but the latter would also have a pair of horns on his head. The raven had a strong, straight beak, the bear had large paws, ears, and a mouth with teeth, and the killer whale had a tall dorsal fin with a white spot. The beaver featured large incisors and a scaly tail. Totem poles sometimes exhibited a bewildering array of characters, and usually human and animals attributes were portrayed together.

Modern Times

As the twentieth century arrived, interest in West Coast art blossomed. Collectors began stripping coastal villages of Native artifacts and selling them to museums around the world. Giant totem poles were the most prized, because they had come to symbolize the people of the Northwest Coast. By the 1920s, there were few totem poles left in the villages and those that remained were quite broken and dilapidated. In 1936, a flood of the Skeena River washed away totem poles in a number of villages, but the people scurried to refurbish them. In the mid-1940s, potlatches were held in villages where the poles had been raised again. A total of 70 poles remained in several villages along the Skeena River and became a major tourist attraction for travellers on the Grand Pacific Railway. One Montreal newspaper estimated that they were the most photographed tourist attraction in Canada after Niagara Falls (Francis, 1992: 183). During the 1920s, the Vancouver Art, Historical, and Scientific Association undertook to build a model Indian village at Lumberman's Arch in Stanley Park. Four Kwak-waka'wakw poles were erected in 1926, and 10 years later, two additional poles were added. This exhibit was taken down in 1962 and established in a new location.

During the 1930s and 1940s, a dozen Haida poles and two Nass River poles were erected in city parks in Prince Rupert. In the 1960s, William Jefferies, a local carver, was commissioned to make copies of the old poles and six of the originals were sent to the provincial museum for permanent storage. In 1947, a program of totem restoration was established by the University of British Columbia which grew to be recognized by a variety of institutions, such as museums. Within a decade, the British Columbia provincial museum sent three Haida poles to the university for preservation. These poles later served as models for a Haida preservation project in a totem park. Between 1960 and 1962, carver Bill Reid helped develop a Haida village on site with the aid of a Canada Council grant (Duff, 1997: 123-125).

Recent government financial assistance has enabled the refurbishing of totem poles as a symbol of past cultural brilliance and as an effort at cultural preservation. The Canadian National Railway made an effort to restore and preserve Gitxsan totem poles, working with the Indian Affairs Branch, Canada Parks, and the Victoria Memorial Museum. The concept was to create a special park in the Skeena River area but local First Nations leaders objected. They did not want their sacred grounds to become public curiosities. A planned model Indian village featuring totem poles did not materialize. Instead, the Province of British Columbia informally adopted the totem pole as a representative symbol and soon many public buildings contained totem poles in one form or another. Virtually every public milestone was celebrated with the raising of a totem pole.

In 1991, the federal government unveiled an impressive sculpture at the entrance of the new Canadian embassy building in Washington, DC. The five ton sculpture is a bronze statue depicting a canoe over mythical Haida figures, carved by Haida artist,

Bill Reid (Francis, 1992: 186). Apparently the marketing of Canada through Indigenous symbols is not a campaign of the past.

Artists

Aboriginal West Coast cultures are not only rich in varied art forms, but the artists perpetuating them have been very successful. Dempsey Bob, for example, is a Tlinget carver who has been carving since the later 1960s and his work is internationally known. Born in Telegraph Creek, British Columbia, Bob bases his work on the skills and knowledge of past generations. His work is much sought after and he is regularly commissioned to create items of West Coast culture. Trained by his parents and grandparents, Dempsey Bob has contributed a great deal toward the revival of traditional West Coast art. His preferred style is traditionally conservative and rule-governed.

Robert Davidson was born in Alaska on November 4, 1946. He is a Haida carver, jewellery designer, and printmaker. His training included apprenticing with Bill Reid and studying at the Vancouver School of Art. The purpose of his art is to express the contemporary lifestyle and meaning of his Haida ancestral culture. Like Reid, he studied older Haida art in order to acquire fundamental knowledge about the style. In the mid-1960s he cooperated with Wilson Duff, Bill Holm, and Bill Reid in what came to be called the "Northwest Coast Indian Art Renewal" movement. He began to participate in group exhibitions in 1971 and individual exhibitions in 1973. His collections may be viewed in several Canadian museums, as well as in Dublin, Ireland, and in the Vatican.

Frieda Diesing, a Haida carver, jewellery designer, printmaker, and button designer, was born in Prince Rupert, British Columbia in 1925. She is perhaps best known for her portrait masks which she calls "imaginary persons." Semi-realistic in design, the masks depict women and are life-size so they can be worn in ceremonial activities. Diesing's work has been shown in several group exhibitions and described in more than a dozen books. Most of her work is in sculpture and printmaking, but she has also ventured into the world of textiles. Using traditional designs, her 1985 eagle-crest button blanket was featured in an important publication of that time. During the last 20 years she has devoted her time to teaching the arts with which she is familiar.

Another Haida artist, Charles Edenshaw (1839-1920s), was born in Da.axiigang, Skidegate, on the Queen Charlotte Islands. Although he only participated in one group exhibition (1927), and one individual exhibition (1967), Edenshaw's work is portrayed in more than a dozen books. Raised during a time when Native cultures were not respected (the potlatch was outlawed, for example), Edenshaw defied the odds and started carving when he was 14 years of age. At least three Haida poles from Skidegate have been attributed to him. Many artists have been inspired by his work and seven years after his death the National Gallery of Canada sponsored the *Exhibition of Canadian West*

Coast Art, Native and Modern, and featured his work along with that of Emily Carr, Paul Kane, and A. Y. Jackson.

Born in 1899, Chief Dan George was a member of the Salish band of Burrart Inlet. George was probably one of the most popular actors of his time, but until the age of 60, he was a longshoreman and logger in British Columbia. His acting career began in 1959 with a series of roles on stage and with the Canadian Broadcasting Corporation. His name became associated with the Big Screen with his appearance in the movie *Little Big Man* with Dustin Hoffman. In 1970, he received an Academy Award nomination for the role he played, and in 1976, he starred with Clint Eastwood in the movie *Outlaw, Josey Wales*. Starring in at least eight movies, George also wrote two books, *My Heart Soars* and *My Spirit Soars*. Chief Dan George died in 1981.

Doreen Jensen is an artist, curator, writer, teacher, historian, and cultural leader of the Gitksan First Nation. Internationally known, she has organized and supervised exhibitions of carving, and narrated video programs for educational use. She maintains a strong community connection by serving on numerous boards and working with several associations, locally, provincially, and nationally. Jensen received her Indian name "Hahl Yee" to represent the killer whale crest of the House of Geel of the Fireweed Clan. Very active in the field of art, she is vitally interested in promoting the oral history, language, music, legends, and customs of her people.

Brant Johnny is a member of the Cowichan First Nation. He was born in Duncan, British Columbia, in 1954. He once worked as a logger and learned carving at the feet of such masters as Francis Horne and Gary Rice. Johnny's carvings are made out of red and yellow cedar wood and tend to feature totem poles, plaques, portrait masks, bowls, and wall panels. His favorite designs are the thunderbird, eagles, killer whales, salmon, and frogs. His work is well represented in both public and private collections across Canada. He once carved a portrait mask that was displayed at the commonwealth games in Victoria.

Bill Reid (1920-1999) was a leader in rejuvenating Haida art and promoting Haida land claims, and his creations were often controversial. Of mixed parentage (his mother was Haida and his father was non-Native), Reid did not learn of his Haida ancestry until he was a teenager. He then met his grandfather, Charles Gladstone, who was a stone carver of argillite and an engraver in silver, and his uncle, Charles Edenshaw, a noted Haida sculptor. These individuals became his mentors during which time Reid also studied jewellery-making at what is now Ryerson University and the Platinum Art Company. As Reid grew more successful, he began to employ Haida and non-Native artists to do much of his work. This is the cause of the controversy surrounding his career. Thus Reid's position as a Haida artist is complicated even though he is respected for popularizing Haida art (Steckley and Cummins, 2001: 114).

Although often beset by foreign influences, today the West Coast First Nations have found their second wind and are reinventing their cultural structures and institutions

to fit the changing times of the twenty-first century. As tribal governments continue to clarify their role, and as the economic value of Aboriginal labor and resources begins to work for the benefit of the First Nations, Canadians will witness the growth of stronger, more independent Indigenous communities all along the West Coast.

Besides being heavily involved in helping to make the various business enterprises in British Columbia prosper, the First Nations peoples have had to struggle against the deeply-rooted vestiges of prejudice and discrimination. In addition much of their energy is spent trying to deal with the plethora of obstacles they face in their attempt to gain a fair settlement of their many outstanding land claims.

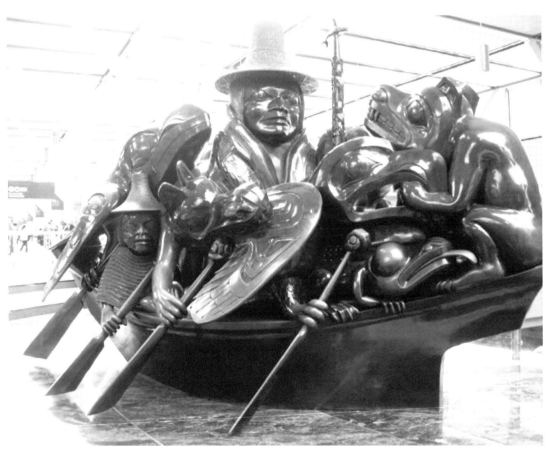

"Spirit of Haida Gwail" bronze by Bill Reid displayed at the Vancouver International Airport. Photograph by David J Friesen.

Chapter Nine
Northern Aboriginal Culture and Art

You have not seen Canada until you have seen the North (Pierre Elliott Trudeau, Canadian Prime Minister, July 5, 1970).

We have found a people highly gifted by nature, who lead a good life and who, in spite of their faults, were at a high moral level. But through our cultural influence, our mission, and our goods, their material conditions, their morals, and their societal order have all sadly deteriorated, and the whole community seems doomed (Fridtjof Nansen, Danish explorer, 1891).

The Canadian northland is important, since much of Canada's wealth is generated by exploiting the resources available there. Many North Americans however, know little about the north, and most have never travelled there. In fact, 90 percent of all Canadians live within 160 kilometres (100 miles) of the American border, and when they travel, many go south, not north. Throughout much of the area termed the North by Canada's southern inhabitants, the Indigenous population predominates. The Dene, Inuit, and Métis comprise a majority in the Northwest Territories and Nunavut. They are also a sizable majority in Yukon Territory and in the northern regions of the four western provinces, and Ontario, Quebec, and Labrador. Many of the larger, more southerly cities such as Regina, Saskatoon, Winnipeg, Edmonton, Calgary, and Toronto, have large Native communities.

The northernmost cultures live in an environment almost entirely void of trees and surrounded by great amounts of snow and ice. The Arctic is covered with snow for about eight months of the year. Large portions of its water areas remain frozen. On the positive side, however, the long summer days in the Arctic tend to balance the long bleak winter nights. The Arctic's unique physical environment is primarily a result of the sun's relative absence. The tilt of the earth on its axis keeps the northern area facing away from the sun throughout the winter months and facing the sun during the summer months. This means that the Arctic is actually completely dark from about mid-October to mid-February – four long months!

During the summer the Arctic becomes the Land of the Midnight Sun, and daylight persists for several months. When the Arctic does experience summer, snow melts, plants grow, and the sun brightens most of the land area. One could say that the Arctic has only two seasons, winter and summer, because spring and fall are very short seasons.

An obvious tree-line separates the Subarctic from the Arctic and consists of four distinct zones: the wooded tundra, the lichen woodland, the closed boreal forest, and the forest parkland. The wooded tundra forms the transition zone beyond which lies the tundra. This wooded area contains sporadic patches of spruce and larch trees, and the lichen woodland has a few stands of spruce and pine. The closed boreal forest offers a denser stand of fir, spruce, and pine, while the forest parkland combines elements of forest and grass milieu.

The existence of wildlife in the Subarctic region is more plentiful and includes some 50 species of birds and 600 species of plants. There are other features which influenced the formation of the two very unique cultures, Arctic and Subarctic, in the north. Over time the inhabitants developed cultures and technologies suitable for living as hunters and gatherers in each region. The people have grown accustomed to the climate over the centuries of their existence, but the fragile nature of the physical environment poses unique challenges for modern times. The cold climate and slow rate of natural growth in these areas means they take longer to recover from modern industrial accidents such as oil spills.

The era of the modern north was particularly accentuated in the 1950s when the government of Prime Minister John Diefenbaker introduced its "northern vision." Popular writers like Farley Mowat, Pierre Berton, and Vilhjalmur Stefansson probably helped set the stage for the foray into the north, although governments are not usually known to react positively to challenges posited by populist prophets.

History

Archaeological evidence about the ancient northern peoples is scant, primarily because their ancestors lived in harmony with the forces of nature and in accordance with the oral tradition. They did not have a need to reduce, recycle, or reuse because they lived entirely in touch with the rhythms of nature. Thus they left little debris, except such that would eventually fade into the woodwork of the universe – remnants of tools and household items like knives, spears, and arrowheads or other artifacts made of natural substances like rock or bone. From these remains we can deduce that the original dwellers of the north were hunters who made their living primarily from the resources of the sea. This evidence establishes a direct linkage with the culture of today's northern peoples of that area.

It has long been fashionable to view the northern peoples as primitive, but more contemporary archaeological research shows this view to be incorrect. The Inuit ancestors who migrated to the northern region brought with them a very complex culture, similar to that of any nonagricultural or nonindustrial people of the time. Only in the last three centuries or so, when the climatic conditions of the north have deteriorated dramatically, has the Inuit way of life been reduced to a survival culture. But then, as now, the people have made many ingenious and unique adaptations to cope with changing conditions. Many of these creative and inventive adaptations have been described in detailed writings by early European explorers, and reveal a magnitude of very remarkable shifts.

Archaeologists have traced several main ways of life among the prehistoric ancestral peoples of the north. Each period of development fostered distinct cultural patterns, each of which lasted thousands of years. Some of the designations ascribed to the prehistoric peoples include: People of the Small Knife, the Long Spear People, People of the Old Rock, People of the Arrowhead, the Harpoon People, the Denbigh People, the Dorset people, and the Thule Inuit. The latter culture developed a successful whale-hunting technique around AD 900, and the contemporary Inuit probably descended from them (Crowe, 1977: 19). The following breakdown offers a more precise identification of the various Inuit groups: Mackenzie, Copper, Netsilik, Sadliq, CaribouIgloolik, South Baffin Island, Ungava, and Labrador.

The designation, Copper Inuit, was conferred upon the inhabitants of the area because they used native copper, which was mined by hand from the surface and hammered into knives, chisels, and harpoons. As early as four thousand years ago, other of the tribes developed a variety of cultural items for which their successive generations have become known – soapstone, snow houses, snowshoes, snow goggles, and dog sleds. The stone tools show a high degree of delicate workmanship and an almost artistic level of flaking techniques. There is evidence that a fairly widespread exchange of various minerals occurred among the tribes – soapstone, iron and copper, and products made from natural materials like ivory or whalebone.

At the time of first contact, it is estimated that about 22 000 Inuit lived in the north. For most of their history these people had always been an ocean-oriented culture; the sea has been a major influence in virtually every aspect of their lifestyle from providing food, to technology, domesticity, and the arts. We must be grateful to archaeologists who braved many unknown elements in these northern regions in order to provide us with documented evidence of Inuit life dating 7 000 to 9 000 years ago, even to the pre-Dorset culture (Bertulli, 1994). Their studies have revealed an unbroken line of cultural evolution among the Inuit. This link is similarly evident with regard to language; generally-speaking, all people who speak the Inuit language today are related to one another. In fact, the language of the Arctic Inuit is closely connected to some of the peoples of Siberia and their culture is, in many respects, the same.

The history of European-Inuit relations goes back several centuries, but written descriptions of these contacts are scant. A Hudson's Bay Company post was established on the Churchill River in 1717, and goods from this post trickled through to Inuit country in the same manner that they did from Russian sources in Alaska. The journals and diaries of several explorers contain bits of information about the Inuit, for example, in the writings of Alexander Mackenzie, Samuel Hearne, Roderic Mackenzie, and Sir John Franklin. In 1912, Captain Henry Toke Munn made contact with the Inuit of Baffin Island and described them as

> a strenuous, indomitable, cheerful little people, in general kind to their old folk and affectionate to their children . . . they meet life or death with a high gallant bearing, and I have always found them faithful to their word with the white man to whom they have given their confidence and in whom they trust (Finnie, 1948: 182).

Captain Munn went on to describe the Inuit as a "passing race" destined to extinction because of the coming blight of complex European civilization without whose influence he felt they would be better off. His pessimistic prognosis appeared to have been substantiated until about the 1960s when the Inuit population fought back against the effects of the imported diseases. Still, the near demise of the Inuit Peoples was once a seemingly stark reality. Known as a disease called "consumption," for many centuries, tuberculosis once took a steady, heavy toll on the Inuit population, but tuberculosis was stopped cold by the introduction of antibiotics. In 1887, Father Emile Petitot (1981: 15) quoted a chief of the Chiglit Eskimos as saying: "We are all dying . . . we are getting snuffed out day by day and nobody cares about us. No one looks after our sick or pities our misfortunes."

Much later, in 1940, Finnie made a similar observation when he witnessed the Copper Eskimos "dying like flies" in Coronation Gulf. Eventually the situation was averted, and only about 30 years ago, the Inuit began to adjust to the various challenges foisted upon them by the encroaching EuroCanadian civilization and began to endure. Today the lifeways of many of the northern settlements are representative of many small towns much further south. These northern settlements now have stores, churches, sports arenas, and other institutional establishments generally familiar to many other small northern Canadian towns.

In what is now northern Canada, there once lived about 20 Native tribes whose people spoke dialects of the Athapaskan or Dene (sometimes spelled Dinneh or Déné) language. They shared this language with the Apaches and Navajo Indians of the American southwest. The word "Dene" means simply, "the people," a term that has been applied to a great variety of First Nations. It has been suggested that the northern people used the word "Dinneh" to identify the larger population and then distinguished separate groups by adding the name of a river or lake associated with their particular hunting grounds.

There were only slight cultural differences among the various Dene tribes, and sources vary as to the names of those who may specifically be included under the rubric, the Dene. Crowe (1974) includes the Chipewyans, Dogrib, Hare people, Kutchin, and the people of southern Yukon. Ryan (1995) identifies the Chipewyans, Dogrib, South and North Slavey, and the Gwich'in. Massey and Shields (1995) include the Chipewyan, Dogrib, Slavey, and Nahanni. Irwin (1994) has the longest list including the Chipewyan of the Canadian Interior, (not to be confused with the Chippewa-Ojibway of Lake Superior); the Dogrib, between Great Slave Lake and Great Bear Lake; the Beaver, along the lower Peace River in Northern Alberta; the Slavey, along the southern shore of Great Slave Lake; the Hare, northwest of Great Bear Lake; the Klaska or Nahani, west of the headwaters of the Mackenzie River; the Sekani, in central British Columbia; the Carrier, (named from their custom of forcing widows to carry the charred bones of their dead husbands on their backs); the Chilcotin, south of Carrier lands; the Tahlan, on the upper Stikine Rover in northwestern British Columbia; and the Tuchone in southern Yukon Territory. An official document issued by the Dene of the Northwest Territories (NWT) (1975) cites the Chipewyans, Dogribs, Slaveys, and Loucheux as member groups of the larger community.

In 1905 an American sportsman named Charles Sheldon met some members of the Nahanni tribe who had never made contact with the European newcomers. He described them as follows:

> they were the healthiest and finest looking Indians I have ever seen in the northern country. Most of the men were fine specimens, and also the women, who bore children abundantly and reared them in health and vigour. They were absolutely honest and lived a primitive Indian life (Finnie, 1948: 40).

The history of the Dene is largely based on speculation. Crowe (1977: 5), for example, suggests that significant migratory relocations took place among the ancestral peoples. He cites as evidence, that the languages of the Navaho and Apache peoples of the southern United States are very close in makeup to the Athapaskan language, and this indicates movements of the tribes long ago. Interestingly, the oral tradition of the Navaho would tend to support this presupposition.

Although still huge, the Northwest Territories, once known as Rupert's Land and the North-western Territory, were established in 1912. Until 1905, the designation, Northwest Territories, used to include Alberta, Manitoba, and Saskatchewan as well as the Yukon. Today exciting socio-political things are happening in the north as a new territory has been carved out in the western region now known as Nunavut. The Native land claim and the proposal to create a new territory were submitted in 1976 by the Inuit Tapirisat of Canada organization, reinforced by the results of the NWT 1982 plebiscite and eventually accepted by the federal government. After years of exhausting negotiations, boundary disputes and meetings with Dene and Métis representatives

who each had their own agenda, the residents of the NWT held their own plebiscite in 1992 (Momatiuk and Eastcott, 1995: 42f). Since then the motivation to form a new territory gained momentum. Nunavut is now the permanent home of the Inuit, and about 85 percent of the population in the new territory are of Inuit heritage. The settlement of Iqaluit, formerly known as Frobisher Bay, is the capital of Nunavut. This site was selected over Rankin Inlet by a 60-40 margin in a plebiscite in December, 1995.

Culture

Most observers of the Inuit way of life are amazed that anyone could continually live in an environment almost entirely void of trees, amid extremely cold temperatures, surrounded by much snow and ice, and still enjoy life. For about eight months of the year, most of the Arctic is covered with snow and extensive portions of its seas are frozen. To those raised in such an environment, by contrast, to live in a crowded, fast-paced urban environment, would be tantamount to suicide. Besides, the summer months in Inuit country offer a brief but much appreciated solstice from the long bleak winter.

Traditionally, Inuit summer homes reflected the break from doing combat with the cold; these dwellings generally comprised a portable tent of sealskin or caribou skin. Winter homes were built of more permanent materials; in the Arctic, of course, the classic igloo came into being. Based on the fact that warm air rises, the builders carve the doorway significantly lower than the rest of the house in order to trap warm air and reduce drafts while still providing ventilation. In the south, where driftwood was plentiful, the Inuit used to build rectangular, semisubterranean turf-covered houses of logs with long underground passageways and entrances in the floor. Greenland Inuit, for example, lived in large loghouses, while their counterparts in the Bering Strait occupied stone houses roofed with whalebones or driftwood chinked with earth.

The Inuit were traditionally unique among First Nations of Canada in functioning with a noncomplex social system, unencumbered by elaborate hierarchical forms of governing individuals or bodies. They had no chiefs among them, partially this may have been because of the limited size of their settlements and the tremendous distances between them. They tended to function more communally than hierarchical, thus voiding the necessity for centralized forms of governance. Their lifestyle was essentially individualistic, and centred on the family. When food was scarce, supplies were stretched out as far as possible and a spirit of goodwill prevailed. If times were good, they celebrated their special bond with the universe in a festive spirit.

Lighting a home in Inuitland was indeed accomplished in the somewhat romantic manner in which most storybooks about the Inuit describe it, employing lamps that burned blubber from sea mammals. Many tribes employed this method for cooking as well, using utensils fashioned from pottery or soapstone. In the summertime they

utilized open fires with whatever fuels they could find on the barren land, often starting the fire by friction using a thong drill.

Depending on materials available in each location, the Inuit fashioned weapons and other useful items to a highly developed degree. Arctic Inuit, for example, primarily used antlers and bone, particularly ivory. From these materials they made harpoons and arrows, ice-chisels, sled-shoes, toggles, thimbles, and thimble-holders. They also carved many decorative items in human or animal forms, a trade that has taken on significant commercial value in today's market. These decorative pieces, combined with other forms of aesthetic expression, support the thesis that Inuit life was certainly not without its pleasurable and aesthetic dimensions.

The Inuit wore clothing that was well adapted to their harsh climate. Both sexes wore fur trousers and shirts usually made of caribou hide, but were sometimes of polar bear or other animal fur. Hooded parkas were added in the wintertime and women with very young children cut their clothing a little larger than men in order to accommodate their babies beneath their clothing. Stockings and boots and other items of clothing were made of fur and sewn together with sinew. Women made clothing especially loose-fitting in order to allow body heat to flow freely so individuals could be heated by the heat of their own bodies. Women decorated clothing and bags with bird and porcupine quills while the men were proficient stone carvers, manufacturing smoking pipes and ornaments (Glover, 1987: 5).

Hunting for seals taught hunters to have patience; at times hunters might wait for hours by a breathing hole, harpoon poised, ready to spear a supply of food. Women often accompanied their husbands on seal-fishing expeditions and performed the job of peering into the ice-hole or holding the line attached to the husband's spear. Other methods of seal-hunting appear to have evolved from the "peephole" method. The hunters knew that a seal must rise to the surface to breathe, and thus maintained several holes in the ice that covered the sea from October or November in the fall to May or June in the springtime. It required the keen eye of an experienced hunter to locate these breathing holes and a great deal of patience to wait until the creature came to breathe. As Wolforth (1968: 112) describes it,

> If . . . a man has any reason to suppose that a seal is at work beneath the surface, he immediately attaches himself to the place, and seldom leaves it till he has succeeded in killing the animal. . . . he first builds a snow-wall about four feet in height, to shelter him from the wind, and, seating himself under the lee of it, deposits his spear, lines and other implements upon several little forked sticks inserted into the snow, in order to prevent the smallest noise being made in moving them when wanted. . . . In this situation, a man will sit quietly sometimes for hours altogether.

A typical annual cycle utilized by the Netsilik around the turn of this century was as follows: the sea began to freeze around October, the caribou herds departed for the

south and the building of snow-houses commenced. Char continue to be taken from the sea until the middle of November, and the women were busy making winter clothes. During December and January, the people remained at home, relying on provisions laid up during the previous summer and fall. The breathing-hole seal hunting began in February when the snow was deep on the ice, and by April and May, other hunting techniques were employed. These included crawling up on the seal or catching new pups at the breathing holes. A few stray caribou may have shown up, and in June when the snow-houses caved in from the hot sun, the people moved into tents. Kayaks were prepared for hunting caribou, an activity which continued until the herd disappeared south again.

Historically the Athapaskan peoples were not formally divided into tribes, but functioned as groups of friendly neighbors. Each group adapted to its immediate terrain, though generally they lived by hunting or fishing; there was little food to be gained by growing or gathering. The Hare, for example, lived in small extended families in ego-centred bilateral kindreds. They, by the way, derived their name from their use of rabbit skins for clothing and shelter, even though they also hunted larger game. Among the Hare, cross-cousin marriage divided relatives into two opposing groups, although actual cross-cousin marriages were rare. A definitive view of this division was that cross relatives were potential affines (effectively in-laws), while parallel relatives were likened to parents, siblings, or one's own children (Ives, 1990: 84f). A similar situation prevailed in Slavey country where the people identified two kinds of relatives, kinsmen and in-laws. The dichotomy applied to relatives linked to a given individual through members of the same versus the opposite sex.

Spirituality

Although the Inuit religious system was not elaborated in any series of specific credal tenets, they did believe in a numberless host of supernatural beings around them, many of them deemed quite harmless. A few of these spirits or gods were even helpful on occasion, although all of them possessed powers to do the individual ill. This is analogous to the orientation of many other Canadian First Nations who believed that the spirits of the universe, resident in plant or animal life, could help or hinder them on a hunt. It was the God of the Universe, the all-watchful Sky Father (Creator) who cared for His people. Among the Inuit, the souls of the dead were also respected, although the people generally held quite vague concepts of life in the hereafter.

The Inuit feared a sea-goddess who allegedly controlled the weather and regulated the supply of seals. An early visitor to the north, Jenness (1986: 416) generally depicted Inuit religion as gloomy and incapable of bringing them any comfort. His ethnocentrism shone through, however, when he described Inuit religious beliefs as ranking "lower than most Indian tribes in Canada." He was perplexed by the fact that a people

so "misled by a gloomy religion" could be so happy and carefree about life. The Labrador Inuit had two main deities, a female deity named Supergu'ksoak, who presided over the land animals (especially reindeer), and a male deity named Tornga'r-soak, who presided over sea animals. The two deities were considered a couple and their adventures were related in many legends (Hawkes, 1916). Their stories were told by shamans who held a relatively important status in Inuit society, and aided people who had developed illnesses, by helping to diagnose the causes of misfortune and sickness. The shamans also interceded with the gods when hunting or fishing was limited or when someone might be in danger. Training in the art would come through apprenticeship, and sometimes special spiritual gifts were acknowledged through visions. The people did not contrive a particularly long list of herbal medicines but rather ascribed illness to spiritual causes. If someone turned sick, it was assumed that they had probably displeased the spirits of the universe in some manner. Valued Inuit cultural beliefs and values were transmitted to the young via modelling and storytelling. In some tribes, storytellers were designated while in others, both men and women of respect could relate stories. Among the Labrador Inuit each village had a designated storyteller, while in Alaska certain old men monopolized this art.

Father Petitot, a nineteenth century visitor to Dene country (Savoie, 1970) suggested that the beliefs of the Dene tribes, the Dene-dindjie, reflected the impact of their legends and traditions in their daily practices but they did not formalize their beliefs or their divinities. In a sense, this concurs with the observations of early explorers – Hearne, Thompson and Mackenzie – who commented that these tribes seemed to have no ceremonies or other evident religious practices. Of course religious observance was not a primary objective for the explorers; they were basically interested in economic matters. Father Petitot identified a series of celestial beings who were worshipped as deities, for example, the midnight sun, who was a real national and tutelary god, supremely recognized and worshipped. Petitot described this group as having a primordial knowledge of a Good Being who was placed above all other beings, and possessed a multitude of names. The most usual one would be Béttsen-nu-unli (He by whom the earth exists). The Hareskin and Loucheux peoples saw this Supreme Being as a triad made up of father, mother, and son. Frequently the spirit beings would personify themselves in the form of birds, such as the eagle, and according to legend, the male spirit brought the day and the female spirit brought the night.

Like their Athapaskan neighbors, the Dene perceived the universe as being presided over by spirits, the best-known of which would be Schédim, the god of the winds and the air. He was also identified as the god of jealousy, quick to anger, and to take offence; he possessed powerful and indefatigable lungs. In addition to struggling with the daily onslaughts of the world of the spirits the Dene believed that their departed souls could become celestial beings – such as the northern lights. According to Father Petitot there was some indication that the concept of reincarnation was acknowledged

by the Dene. For example, babies born with one or two teeth were believed to have been resuscitated or reincarnated from previous existence (Savoie, 1970).

According to more recent sources (Ryan, 1995), the Dene traditionally had explicit rules that were originated by elders to govern their society. These rules pertained to three specific areas: natural resource rules, family rules, and rules for local government. Naturally these rules were somewhat intertwined with the people's holistic view of the universe. Individuals who broke the rules were punished in various ways. For minor offenses, the guilty party might be verbally dealt with by an elder. Individuals committing more serious offenses were often made the subject of a gathering requiring an admission of guilt and restitution followed by a process of reconciliation. Abel (1993: 39-41) summarizes these observations of Dene philosophy:

> [S]pirituality permeated every aspect of life. The natural and supernatural worlds were one, and every person lived simultaneously in both the spiritual and physical worlds. . . . A person who enjoyed particularly effective communication with the spirits might turn that power for the community's benefit and as shaman could perform a variety of useful roles. . . . Both men and women were capable of developing contacts with the spirits.

When priests of the Roman Catholic Church arrived in Dene country (Dogrib, specifically), they introduced practical concepts that blended well with traditional Dene beliefs – love your spouse, be kind to your neighbors, take good care of your children and raise them well, and stay together as married couples forever. The European formal style of marriage was not practiced when the missionaries first arrived so the locals were expected to adapt to Christian regulations. Still, local couples often lived together in traditional style and had several children before they appeared before a priest for a formal European-style ceremony. Priests were viewed in the community as individuals with special gifts given by God, and recognized as having spiritual power and authority. In a sense, they served as elders, providing advice and direction, resolving disputes, and meting out disapproval for acts of violation. In this context the transference of respect from the office of shaman to that of the priest appeared natural enough.

The nomadic days of the Athapaskans are over and today most of the various tribes live in permanent settlements. Their children attend day schools, the people use hospitals and other modern facilities for assistance, and the dog-team has been replaced by the pickup truck and the snowmobile. Some families continue to live off the land, living in fish camps in the summer and organizing hunting parties in the winter (Massey and Shields, 1995: 85).

The entrenchment of Aboriginal rights as a feature of land claims is far from being conceded by the federal government, and this is nowhere more obvious than in the case of the Dene. In 1990, the Dene/Métis Western Arctic Land Claim Agreement was cancelled after 14 years of negotiation. The agreement would have given those parties

title to 181 230 square kilometres of lands, and had been named "Denendeh" by the Dene in 1981. The deal was also to include special hunting and fishing rights, $500 million in cash, and subsurface rights to 10 000 square kilometres of territory (Dickason, 1993: 414).

As the Dene continue to adapt to outside influences, there are many challenges for them to face, not the least of which is the justice system. The judiciary in the Northwest Territories, while expressing some sympathy in Dene traditional ways, continues to go its own way – applying non-Dene laws. These, in many ways, contradict the essence of Dene culture and the end result is that the people are not being served justly or equally. Significant adjustments need to be made if any of the major elements of the traditional Dene way of life is to be preserved.

Modern Times

Today, the challenge of economic development in northern regions is supplemented by two important matters – concern about adequate educational delivery systems and the settlement of land claims. It may seem a bit far-fetched, but the truth is that many northerners over the age of 40 have little or no formal schooling and could be classified as functionally illiterate. This reality limits the employability of the people and impacts negatively on their potential for entering the work force. The struggle of the present-day Inuit is to integrate some of the imported values of the southern lifestyle while clinging to some vestiges of their cultural heritage.

Public schooling has only been available in the north for just over half a century and at first it was primarily delivered by missionaries armed with an out-of-town curriculum and otherworldly allegiances. Missionaries set up schools for Arctic and Subarctic children in the 1940s and 1950s. These were residential schools, operated by authoritarian rule. Before World War II, direct federal investments in health and educational facilities were virtually nonexistent in northern regions. Teachers were usually unfit from a pedagogical perspective, local language training was downplayed, and religious practices related to Aboriginal spirituality were discouraged. Many parents objected to the fact that attendance at school provided children with little opportunity to observe and participate in traditional Native life. Boys no longer hunted or trapped with their fathers and young women were removed from situations where they could take up domestic responsibilities.

Growing civil tensions in the 1960s and 1970s brought the matter of Native land claims to national attention. Native leaders began to realize that actions were unilaterally being undertaken by government and outside industries that could impact negatively on their traditional way of life. They began to pressure government about their role in economic development and demanded to have a say in the use of their lands.

"Bird" by Pulalik Shaa, in the authors' collection. Photography by David J Friesen.

Settlement of legitimate claims is currently holding up pipeline projects because the transfer of Crown lands has been frozen. The legitimacy of Native land claims in the NWT and Yukon has been based on the principle of first occupancy. While this principle has not been spelled out in precise legal language, it has a strong customary foundation, supported by legal enactments such as the Royal Proclamation of 1763, and the Order-in-Council ceding Rupert's land to Canada in 1869. Other common-law cases have buttressed this principle.

Challenges emanating from the land claims phenomenon are legion. Huge costs are involved in negotiations and there is some dispute about who should rightfully pay for them. At times it is difficult to determine whose interests are best being served by government – those of private firms or those of the First Nations. While most Native leaders are convinced that economic development is essential to the future well-being of their people, questions about the possible impact of these developments on Indigenous values and culture remain a constant concern.

Art

The traditional arts of the Northern peoples featured bone, ivory, and wooden carvings of animals and people (Swinton, 1972). Some animal carvings were realistic in form, and others more fanciful. Many human forms were nearly realistic, others grotesque. Occasionally, an artist might depart from this stereotype and produce a large figure with full torso, legs, and arms, and a face whose features showed animation and life. Some carvers plied their trade out of sheer pleasure, making small dolls and toys such as miniature kayaks, sleds, dogs, and other things for children to play with.

The People of the Small Knife (9 000 to 0 BC), only left campsites from which anything by way of art could be identified. The Long Spear People (5 000 to 2 000 BC), made beautifully chipped long spearpoints of flint as well as other tools for cutting, scraping, and drilling. Their way of life probably resembled that of the Slavey First Nation. The People of the Old Rock (5 000 to 1 000 BC), made pottery, and left only two winter houses for archaeologists to explore. The Arrowhead People (3 000 to 1 000 BC), were bison hunters, and the Harpoon People, who lived at about the same time, were seagoing. We know little about their art works. Things changed with their contemporaries, the Denbigh People, who used tiny blades of flint to cut bone and ivory for their harpoons and other tools. Archaeologists like to refer to them as having started the "Arctic small-tool tradition" (Crowe, 1977: 13). The Denbigh also made skin-covered boats, used bows and arrows, and sewed special clothing fit for survival in very cold climates.

The Dorset People (1 100 to 1 000 BC) of Baffin Island may have begun as an outgrowth of Denbigh culture, and rapidly spread across the Arctic. This group made snowknives of bone, invented the snowhouse, and wore crampons of ivory tied to their

feet. They heated their homes with oil-burning lamps of stone and shod their sleighs with bone and ivory. From the few Dorset art specimens that are available, investigators are usually impressed with their originality and craftsmanship. However, the trend toward more sophisticated art featured a slow development with their cultural successors, the Thule people. Thule culture probably emerged over three centuries and led to the formation of what today is known as Inuit culture. The Thule people probably reworked some Dorset items and invented few of their own such as combs. They also developed more efficient methods of hunting and domestic technologies, and produced decorated amulets and bone carvings.

Artist's conception of a polar bear carving.

One of the most popular art forms associated with the north are inuksuit (plural), simple piles of stones that imply a variety of meanings. The term inuksuk (singular) implies an object in the capacity of a human being. Seeing one can provide comfort to a weary traveller, lifesaving direction to the disoriented, or a focus of veneration to the spiritual seeker. They are among the oldest forms of construction in the north, and are still being made today, some for pleasure and some for a more functional purposes. Smaller versions are intended for the tourist trade. Built from whatever stone was accessible, inuksuit can be quite complex in meaning, some of which is not necessarily intended to be deciphered.

Some inuksuit were built as navigational indicators, pointing the way for weary searching travellers as directional signals. Others were constructed to indicate that a food cache was nearby. Still others mapped out good hunting or fishing areas. Some inuksuit were placed so they would be visible from long distances, while others seemed suddenly to appear before the searcher. Occasionally an inuksuk was built as a memorial to a deceased individual while another might be designed to depict a specific place or to form a circle. Some Inuit elders revered inuksuit as materialized forms of power – not as symbols– but actual loci of power. These inuksuit were never approached by humans (Hallendy, 1996).

Inuksuite served a variety of purposes.

Outsiders will find it necessary to study carefully the appearance of an inuksuk and perhaps thereby discover some of its meaning. An inuksuk built in the shape of a window might suggest that it frames a precise view or direction. A specially positioned inuksuk made of black and red rock is sure to designate a good fishing spot. One that appears to sprout horns could indicate a cache of food supplies nearby. An ancient inuksuk laced with black lichen is probably a memorial to a revered predecessor. When a small stone is placed on top of a larger one at the top of the inuksuk, it is an indication to a family following a hunter that he has changed his mind and taken a different direction. Still another form of inuksuk, placed high on a knoll, indicates the location of a rich spawning area. When it was deemed necessary to scare animals away from a certain location, inuksuit were built with the capacity to make noise. Bones might be hung so as to make sounds when the wind blew them against carefully placed stones. Finally, at times an inuksuk may appear in the shape of a human being and intended to inform the presence of other human beings, perhaps to indicate the location of a meeting place. Hallendy (1996: 44) observes that Inuksuit constitute a form of communication that has much in common with other ancient stone constructions found throughout the world. Their uniqueness is that they represent a form of "grammar" based on necessity and therefore comprise a form of spiritual significance.

Another art form, not entirely unique to the north, was the production of masks that were viewed as capable of communicating meaning through visual form as well as subject matter. Masks were originally intended to give visual form to the spirit world. In the minds of the Northern people, all things animate and inanimate – men, animals, plants, seasons, stones, shadows – were seen as being endowed with an inner vitality of spirit. The world of spirits could be seen rarely, only under special circumstances, and most often by shamans who it was believed, could communicate with that world and influence the spirits for the good of the community (Vastokas, 1982: 64). Some Inuit groups used masks for more secular, even comic function. On some social occasions, masked performers wearing tattered clothing and carrying sticks, might indulge in comical antics for the amusement of the audience.

Inuit and Dene art was manifested in many other ways including work with caribou hides, which were made into all manner of items, such as clothing. The Naskapi, for example, elaborately decorated the clothing of the hunters in honor of caribou. They believed the caribou preferred to be killed by hunters whose clothing was decorated with designs (Penney, 2004: 183). Contact with the outside world dramatically changed the Inuit way of life, bringing the rifle to replace the harpoon, and the whaling boat to replace the skin-covered kayak. Summer tents were soon covered with canvas instead of caribou skins, and even winter structures gave indication of European influence. The establishment of whaling stations upset the seasonal economic cycle of the settlements which became handout stations soon known as places where "weekly biscuits are handed out" (Wilson, 1976: 85). Gradually the Inuit and Athapaskan peoples adjusted to the changes and took on new roles in order to survive in a technological world.

Inuit style mask.

One of the most successful industries introduced in the northland was the commercial art program. Although a limited number of small carvings had been sold by the Inuit prior to 1950, the modern Inuit art period began at that time. James Houston, a Canadian artist, visited several Inuit communities and became impressed with the quality of their work, particularly in soapstone carving. Backed by the Hudson's Bay Company and the federal government, Houston devised a market for northern arts which flourished. Initially, Houston encouraged the Inuit to carve soapstone into small sculptures for sale to outsiders. Later, in 1957, in response to a seemingly trivial question regarding how cigarette package labels are duplicated, Houston expanded the program to include printmaking. Houston published a number of very appealing works which drew attention to Inuit culture and art. He wrote so well and told such a good story, that along with the best of photographic illustrations about Inuit art forms, his writings were enthusiastically embraced. Some critics accused him of blurring the line between fact and fiction, and blatantly disregarding historical accuracy. Houston obviously had a penchant for purple prose. (Potter, 1999: 40-41).

Because of Houston's efforts, many Inuit carvers were soon able to live off the proceeds of their work, although the artists had to change their products to meet the expectations of more southerly located purchasers. The sale of these items unfortunately contributed to the development of armchair tourism; purchasers could buy and admire a particular work of art without having to know details about the artist's lifestyle or any difficulties he or she might be experiencing. Armchair tourists also had the opportunity to concoct background stories about their purchases and romanticize the situation of the artist from whom they bought the artifact.

Earlier Inuit art was primarily produced in ivory while soapstone was used for lamps and cooking pots. The carvings tended to be small and portable, often depicting spiritual themes. During the modern period, they have gravitated toward representing animal, hunting, or domestic scenes in order to satisfy the market (McMillan, 1988: 288). The success of soapstone art encouraged the move to introduce other genre such as printmaking, the most important being stoneblock print which was introduced to Cape Dorset on Baffin Island. Stoneblock print consists of a design carved into a slab of soapstone which is inked and

Inuit style stone block for printing.

paper pressed into it to make an image. Stencilled prints and copper plate are also being produced. Several prominent artists involved in printmaking have become nationally known. Potter (1999: 39) conjectures that one of the reasons why Inuit art quickly became so popular was because Canadians were searching for a sense of identity after World War I and art played a significant role in this search. In addition, the war assisted in promoting global interaction so that the work of Aboriginal people gained more recognition the world over.

Patterson (1973: 91) describes the artistic bent of the Chipewyans to include story-telling and painting. Certain plants and barks were sought out and preserved in bags to provide color for dyeing. Elaborately-decorated objects were made out of moose hide and dyed to give them color. Jenness (1986: 388) claimed that Chipewyan art was "confined to some very crude painting on wood, and a little work in porcupine-quill and moosehair that was much inferior to the work of [other] tribes." Like other critics of his time, Jenness was undoubtedly using a culturally inappropriate yardstick by which to assess Chipewyan art. Since then things have changed.

Artists

When it comes to acknowledging contemporary northern Native artists, the potential is virtually limitless. The names of many Northern carvers, printmakers, and sculptors are now familiar in Canada, but space permits the mention of only a few, randomly selected. A few artists of other genre must also be named.

A recent arrival on the music scene, singer Susan Aglukark, was born on January 27, 1967, in Churchill, Manitoba, but her family moved to the Northwest Territories shortly thereafter. The daughter of a Pentecostal minister, Susan had seven brothers and sisters. She completed high school and moved to Ottawa to work for the Canadian Department of Indian Affairs and Northern Development. Three years after her arrival she gave a live performance in her home town and the rest is history, so to speak. She performed on CBC Radio and her video won a Much Music Award for outstanding cinematography. In 1995, she won a Juno as New Solo Artist and in 1996, appeared with Ben Heppner on *Pamela Wallin Live*. In 1997, she was a guest on the *Annual Aboriginal Achievement Awards Show*. She and her husband, Jacques, had their first child, Cameron Joseph Allyaq, on October 16, 1996.

Alasuaq Amittu Davidialuk (1910-1976), an Inuit sculptor and printmaker was born in an igloo in Nunagiirniraq, Quebec. His resume proves that he was one of the most successful Inuit artists of his time. Although he did not participate in a group exhibition until 1965, literally dozens of museums across the nation portray his art. Davidialuk was a talented storyteller and his engravings and paintings were inspired by various aspects of traditional Inuit life. Succeeding generations have been moved by Davidialuk's encapsulations of the fundamentals of Inuit philosophy and lifestyle.

A native of northern Quebec, Johnny Inukpuk is the first Inuit artist to be honored by election to the Royal Canadian Academy of Arts. During his early years he spent his time engaged in nomadic hunting, trapping, and fishing, then began carving while still living on the land. Born in 1911, it was not until the 1950s that his art was recognized. At that time, he also took up sculpting which he pursued well into his 80s. One of his favorite themes was exaggerated figures of women, particularly big heads on little bodies. Today his son Charlie is continuing the family tradition.

Painter Alex Janvier identifies his cultural affiliation as Dene and lives in Alberta. Born in 1935, Janvier is easily one of Canada's most accomplished Dene artists and has attracted international attention with his work. Janvier grew up speaking the Dene language and was raised in a traditional setting. He studied at the Alberta College of Art in Calgary and served as a teacher at the University of Alberta's extension department. He was appointed as Aboriginal advisor to the 1967 Expo, and helped form the Indian Group of Seven in Winnipeg. Patterson (1973: 93) notes that Janvier has also "proven himself capable of producing highly original strong, sinuous, hard-edge works of considerable power with curvilinear forms suggestive of beadwork." Janvier's works adorn the office building of the County of Strathcona in Sherwood Park, the Muttart Conservatory in Edmonton, and the National Gallery in Ottawa. In 1998, he designed a $200 gold coin for the Royal Canadian Mint, and in 2002, he won the prestigious National Aboriginal Achievement Award. He also created murals for the Canadian Museum of Civilization in Hull, Quebec.

Helen Kalvak (1901-1984), was a renowned Inuit graphic artist whose career was encouraged by an Oblate missionary, Father Henri Tardy. The first exhibition and sale of Inuit art in New Brunswick occurred in 1965 and included several of Kalvak's prints. Originally a migratory hunter, Kalvak was talented in the arts of skin sewing and parka making before she honed her skills to the graphic arts. She usually drew in pencil, but later adapted to using felt-tipped pens. Kalvak was elected to membership in the Royal Academy of Art in 1975 and she was named to the Order of Canada in 1978.

John Kavik (1897-1993), was a well-known Inuit carver, painter, and ceramist. Born in the Northwest Territories, Kavik was originally a hunter and fisherman who later worked in a nickel mine in Rankin Inlet. Basically self-taught, Kavik took up art at the age of 60, and became quite successful. The human figure dominated Kavik's work, generally portraying figures of mothers and children and other pairings. Using crude tools, Kavik carved a unique niche in the world of northern Canadian art and even took up ceramics in his final years. His works may be found in major galleries across the nation.

An Inuit filmmaker, video artist, and sculptor, Zacharias Kunuk was born near Igloolik, in the Northwest Territories in 1937. After working at various professions, Kunuk took a position with the Canadian Broadcasting Corporation in the 1980s. Later, he and several colleagues formed the Igloolik Isuma Production Company devoted to

Inuit film-making. Since then the company has made several films and videos depicting aspects of Inuit life. Many of these are shown on local cable television, and have been screened in major cities throughout Canada and the world. Kunuk won the Bell Canada Award for video in 1994.

Ernie Scoles, an accomplished painter, is a member of the Cree Barren Lands Indian Band. Raised in northern Manitoba, he developed a deep feeling for nature and wildlife, taking every opportunity to explore the woods and lakes around his home. Largely self-taught, his works may be viewed in galleries across Canada, the United States, Europe, and Asia. In 1992, he won the Governor General's Canada 125 Medal for his contributions to the community.

Abraham Pov (1927-1994), an Inuit sculptor, was born in northern Quebec and became one of the most admired and prolific Native artists of his time. His sculptures always have a monolithic bearing, are irregular in shape, and nonrepresentational. Although largely disportionate in shape, these figures have a way of leading the eye of the beholder to the most striking aspect of each character. Beginning in 1953, Pov participated in at least two dozen group exhibitions and saw his work depicted in many publications.

Marion Tuu'luuq is an Inuit textile artist from the Northwest Territories. She was born on the back river delta of the Northwest Territories in 1910. Tuu'luuq is one of the first Inuit textile artist to be nationally recognized in Canada, and is best known for her vibrant and richly colored wall hangings, many of them reflecting the changes that have affected Inuit life in the north in the past century. She successfully adapted her skills to making souvenir clothing and handicrafts and later to other forms. Tuu'luuq has participated in many group exhibitions and her work is currently portrayed in many collections in Canada. Her honors include being made a member of the Royal Canadian Academy of Art in 1978, and an honorary doctorate from the University of Alberta in 1990.

Chapter Ten
Métis Culture and Art

A new day is dawning for the Métis people of Canada. The pleas of their leaders over the last few decades for increased political recognition of their role in Canadian history have not gone unheeded. A Supreme Court of Canada decision on September 19, 2003, granted the Métis official status as an Aboriginal people. Background to the event includes reference to two separate cases regarding Aboriginal hunting rights. More recent recognition of Métis rights was noted in a Special Meeting between First Ministers and Aboriginal leaders which took place in September 2004, and identified a strategy for Aboriginal health which, for the first time, will include the Métis people as equal partners in federal health programming (*Alberta Native News*, September 2004: 2).

It may take some time before the Métis case for cultural integrity gains national acceptance, and Métis researchers are hard at work to document their claims (See Metisnation.ca). One of the challenges growing out of the supreme court decision is the identity issue – who really is Métis? Ontario Judge Vaillancourt stated that a Métis is an individual who claims to be Métis and whose claim is accepted by other individuals whose Métis identity is not in question (*Calgary Herald*, January 9, 1999: H5). The intent of the supreme court's interpretation seem to be as follows: A Métis is someone who lives according to the Métis lifestyle, considers himself or herself part of that community, and is considered part of the community by his or her peers.

Métis Origins

The word "Métis" in French means "mixed" or "crossover." This definition may therefore be interpreted to suggest that, historically, the Métis were a bridge between two nations – local Aboriginals and incoming European explorers and traders. The Métis were born a unique race well suited to populate a new country geared to framing a new national identity. Although it is somewhat uncertain as to the specificity of origin of the Métis Nation (Louis Riel is usually credited for this), the merger of the two cultural communities responsible began several centuries ago. The mixing of races started shortly after the first European explorers and fur traders arrived and negotiated marital unions with women of Indigenous background. The result was that a new

subgroup originated, people who had both Aboriginal and European heritage. As successive generations have unfolded, however, it is highly likely that members of the first generation were probably the *only* ones to equally represent the two bloodlines.

Sadly, the "bridge" people have received little formal recognition over the centuries that they have held their unique status. Their descendants have too often occupied the lower rungs of Canada's socioeconomic ladder, and formal recognition of their identity at any level by government did not occur until quite recently. Today things are slowly changing as the Métis gain political strength and a measure of public support. Their growing population is also a factor. There are currently 292 310 people in Canada who identify themselves as Métis, an increase of 40 percent over the last five years. Over the past century, the Canadian Aboriginal population grew by 22 percent, while the Métis population grew by 43 percent.

Social descriptors of the Métis differ significantly from those of the non-Native population. The related statistics are not particularly enviable. For example, 23 percent of the Métis people changed residences in Canada during 2002, while only 14 percent of the general population did so. Nearly one-third of the Métis population is under the age of 14 compared with 19 percent of the general public. Only 4 percent of Métis are over the age of 65 compared with 13 percent of non-Aboriginals in Canada (Statistics Canada, 2003). Despite obvious social and economic differences between Métis and non-Métis, which characterize the former as occupying a less advantageous status, there is evidence to suggest that the Métis are gaining a political stronghold in the Canadian cultural milieu. They are now the fastest growing and youngest sector of population in the country.

Documentation

Recent literary efforts to emphasize Métis identity in Canada include collections of documents such as that produced by the Gabriel Dumont Institute of Métis Studies and Applied Research in Saskatoon, Saskatchewan, and the Louis Riel Institute of the Manitoba Métis Federation in Winnipeg, Manitoba. A recent joint release is entitled, *Métis Legacy: A Métis Historiography and Annotated Bibliography* (2001), edited by Lawrence Barkwell, Leah Dorion, and Darren Préfontaine. This extensive publication contains an impressive accumulation of data about Métis material culture including the largest collection of previously unpublished articles. Another recent book posturing the case for the Métis, edited by Jacqueline Peterson and Jennifer S. H. Brown, is entitled, *The New Peoples: Becoming Métis in North America* (University of Manitoba Press), and shows encouraging signs of public interest by being made available in its fourth printing.

Not many years ago, Métis historian, Olive Dickason, set the record straight on Métis history with two significant books: *The Myth of the Savage and the Beginnings of the French Colonialism in the Americas* (1984), and *Canada's First Nations: A History of Founding Peoples from Earliest Times* (1993). Dickason filled in the blanks about the life and times

of the Indigenous peoples before European arrival, and defended their cultural lifestyle. Although commonly described by European newcomers as "savages" or "uncivilized people," Dickason pointed out that many of the atrocities committed by European invaders easily outranked anything the Aboriginal peoples had done to one another during times of war. Dickason's analysis did not go unnoticed by her academic peers, and shortly thereafter, all published works of history in Canada began to acknowledge the historical role and cultural contributions of the country's First Nations.

On another positive note, when formal negotiations became part of interaction at the time of first contact, the First Nations were in fact regarded as political equals and governors of separate states. This perspective was maintained in the process of treaty-signing (Patterson, 1972: 1). When the economic benefits of the fur trade began to decline, however, the invaders wearied of the arrangement and initiated a colonial system aimed at diminishing the rights of the Indigenous peoples. Now the pendulum appears to be swinging back, and the Indigenous people are slowly being recognized and their rights are gradually being honored.

The formal origin of Métis culture is generally tied to the fur trade dating back to the seventeenth century when French Canadian voyagers and Hudson's Bay employees began trading in the area. Their marital unions with local Aboriginal women produced children labelled "Natives, Mixed bloods," and "Halfbreeds" by the Hudson's Bay Company. The latter term, which is biologically impossible after the first generation, gradually acquired a pejorative connotation (Payment, 1990: 20). It has been a long struggle for individuals of Métis background to squelch the negative propaganda surrounding their origins and convince Canadians to acknowledge their legitimate place in the country's history.

Nationalistic movements are frequently propelled by charismatic leaders who arise from within the ranks of the community in question and the Métis are no exception. Their founding leader, Louis Riel, had strong ancestral linkages within the Métis community. Riel was born at St. Boniface on October 22, 1844, to a family who could trace their ancestry back to the closing days of the seventeenth century and the founder of their line – Jean Baptiste Reel of France, who immigrated from Ireland. Riel's mother, Julie Lagimodiére, was the daughter of the first white woman to make her home in the Canadian west (Anderson, 1974). Riel's father, Louis Riel Sr. was mostly French, although there were claims that *his* mother's family had Chipewyan bloodlines (Purich, 1988, 47). This would mean that Louis Riel Jr. was one-eighth Indian, but born and raised in a distinctly French cultural configuration. His place in our history, however, does not rest on his hereditary linkage. It was his devotion to the Métis cause that earned Riel a permanent place in the annals of Canadian history.

National Status

The roots of the Métis story, quite bluntly, are bathed in racism. The Métis interpretation is that the story began in Europe in the sixteenth century when business leaders needed cheap labor to help them glean profits in the new world. Since the Native people were expert hunters and trappers, the fruits of their labors were envied and sought after. To "keep them in their place" so that exploitation of their wares and labors might continue, the European explorers manufactured a philosophy of Native inferiority backed by theological and educational foundations (Adams, 1975: 5). This imperialistic campaign continued without interruption even though neither the conversion nor education of Aboriginal people reached any remarkable proportions.

The effects of a continual onslaught against First Nations cultures has had severe repercussions for the Métis. The Métis community has borne the cross of scorn from both Status Aboriginals (those Natives legally recognized by the Indian Act), and non-Aboriginals with a measure of dignity. Their cultural pride has been maintained along various avenues ingeniously devised by their leaders. Perhaps being the target of perpetual disdain has aided them the most, and with the possibility that Louis Riel's contribution to Canada will finally be seen in its true light, Métis pride is undoubtedly at a new high.

Today a movement to vindicate the Métis cause is underway by trying to persuade Canadians to acknowledge the validity of a distinct Métis culture. As an additional power thrust, Peterson and Brown (2001: 6-7) argue that mixed-blood peoples with Aboriginal ancestral bloodlines from all over North America are becoming cognizant of their common heritages and values. The increasing tendency of related ethnocultural groups in both the United States and Canada to use the word "Métis" as a symbol of a collective identity is a strong indicator that the quest is sincere. Since 1965, Métis associations and federations have been founded in every Canadian province as well as in the States of Michigan, Minnesota, North Dakota, Montana, and Washington. The objective of Métis nationhood is definitely realizing stronger support, identity, and unity.

Culture

Although there is no official record of the precise start up dates of identifiable Métis settlements in western Canada, there were definite signs of such emerging communities by the outset of the nineteenth century. Before that, the Métis moved around a great deal, basically to follow the fur trade, but later, also because of discrimination. When the fur trade dwindled, the Métis began to settle in permanent communities and develop distinct cultural elements. One of the highlights of Red River life in Manitoba, for example, was the annual buffalo hunt which provided the community with the bulk of its

subsistence. With a plentiful bounty of food and hides laid up for the winter season, the men could use their leisure time for storytelling, music, philosophy, and the development of the arts (Sealey and Lussier, 1975: 23).

Michif Language

Over time, the Métis originated a unique language for themselves known as *Michif*, a mixture of Algonquin Cree and French with a few contributions from the Saulteaux language. The Métis probably developed a mixed form of language because they were a mixed people. Essentially, the Michif language uses French for nouns and Cree for verbs, thereby comprising two different sets of grammatical rules. Although not classified as a separate language because of its syncretic nature, Michif nicely represents the intercultural nature of Métis culture. Essentially a domestic language, Michif is unique to itself in terms of its makeup and cannot be defined as belonging to a single language family (Bakker, 2001: 177). Remarkably, Métis culture and the Michif language are uniquely representative of one another.

As it emerged, Michif was primarily used by the Métis as an in-house language and outsiders were generally not familiar with it. Its origins are often associated with the fur trade and no doubt some words primarily associated with the fur trade are included in Michif vocabulary. More importantly, however, are concentrations of words and phrases that have to do with distinct components of Métis culture, such as buffalo hunting and life in wintering camps. The dispersal of the Métis after 1885 may have reinforced the use of Michif as the people tried to maintain some semblance of their cultural identity. Many of them clung tenaciously to their mutual tongue and gradually lost facility in Cree, French, and Ojibway. The difficulty of maintaining the language intensified, however, as further generations intermarried with individuals of other races, cultures, and religions.

Métis Knowledge

When the European and Aboriginal races merged, they developed a form of knowledge that combined conceptual constructs of both worlds. Like their Indian peers, the Métis exhibited a strong reliance on the land. Everything they needed came from the Mother Earth; every social, physical, and spiritual need was provided by the land and it was therefore worthy of respect. Some settlements featured community use of lands following clan lines; access to land was passed from family to family, either directly or by naming a new partner (Acco, 2001: 131). Regard for the land was distinguished by explicit sex roles. Women informed their husbands about their needs to run the household and men would go hunting or engage in other means of employment to provide for their families. Domesticity was the domain of women, while men looked after outside relations, trade, and earning a living. Métis women who adopted an Aboriginal form of spirituality, looked after the spiritual needs of the family, although there were

also many Métis families who adopted the Roman Catholic faith which they inherited from their fathers.

Arts

No culture would be complete without its artistic forms of expression and the Métis are no exception. Their highly decorated forms of apparel, such items being skin coats, pouches, moccasins, and horse gear, were visual expressions of this fact, supplemented by their unique forms of music and art. Using floral designs, Métis women created a style "marked by both complexity and sparkling delicacy" (Racette, 2001: 182). Since clothing is sometimes perceived as a means of signifying cultural affiliation, in the case of the Métis, that expression was obvious. Other forms of artistic bent were evident in the construction of material artifacts, crafts, and tools. Emphasis on Canadian multiculturalism by the federal government in the 1960s brought to life a variety of Métis art forms such as painting, literature, and beadwork embroidery, and as a result, the work of a number of Métis artists sprang to national attention (Mattes, 2001: 190). Anyone even remotely acquainted with Métis history is familiar with the highly acclaimed Métis fiddle music and the Red River Jig.

Music

As with their cultural makeup, Métis music and dance are a synthesis of Scottish, Irish, French, and Aboriginal origins, mainly transmitted to succeeding generations via the oral tradition (Whidden, 2001: 172). McLean (1987: 45) suggests that the well-known Red River jig is based on a pattern of rhythm borrowed a thousand years ago by Plains First Nations from the incredible mating dance of the male prairie chicken. Once seen, the Red River Jig is not easily forgotten. The Red River Jig is not a highly structured dance, and although it does have a basic pattern, it allows for individual variations of the dance steps. In addition to serving as a cultural practice of the past, the Red River Jig is often the basis of individual dance competitions sponsored by various Métis organizations. Other dance movements include the rabbit dance, duck dance, and *La dance du crochet* (Whidden, 2001: 171). The rabbit dance shows the excitement of chasing a rabbit, and is accomplished with a side step gallop. The duck dance imitates the movements and sounds of swimming ducks with two steps and a third step imitating ducks swimming in the water. *La dance du crochet* means "hook dance" in French and consists of four couples hooking arms while they dance.

Over the years, old time family dances have died off in many Métis communities (some blame bingo for this development), partially because improved roads have given easier access to larger urban centres that provide more modern means of socializing. Modern technologically derived forms of entertainment like movies, videos, CDs, DVDs, and computer games are undoubtedly contributing factors to the demise of old

fashioned leisure practices. Contemporary fiddling contests held at annual community gatherings have helped to keep fiddle playing alive and served to maintain traditionally inspired celebrations. In July, for example, the Annual Batoche Days celebration in Saskatchewan draws hundreds of Métis together for a time of reminiscing, socializing, and competition. Every November 16th, the Métis of Edmonton gather to commemorate the death of Louis Riel and engage in music and dance. Mel Bedard, an acknowledged master of the Red River style of fiddle music, became the first recording artist of Métis fiddle music in 1981. Well known Métis accordionist, Ray St. Germain of St. Vital, Manitoba, recently released a song, "Thank God I'm Métis," but he will probably best be remembered for his hit single, "The Métis," which tells the story of the 1885 Battle of Batoche. Singer Edgar Desjarlais recently released a single entitled, "Welcome Home Louis David" to commemorate the official recognition of Riel's contribution to Manitoba's provincial status.

Fiddle playing is central to Métis culture and there used to be very few homes that did not have a resident fiddler. If the family could not afford to buy a fiddle from a mail order catalogue, someone would attempt to make one. As long as there was fiddle music in the home, the future looked promising. Métis fiddle music comprises several unique characteristics. For example, Métis fiddlers have invented a number of ways to tune their instruments. Instead of relying only on the standard tuning form, the fiddlers sometimes retune their instruments to better suit them to melodies played. Whidden (2001: 169) points out that Métis fiddle music sometimes includes a bagpipe beat, like that of a Scottish march. At other times Métis fiddlers deliberately tune their fiddles to replicate the drone of a Scottish bagpipe. The fiddlers also vigorously tap their feet while they are playing, an adaptation of the Celtic hand drum. They exhibit different bowing techniques as well, principally using short strokes (one stroke per beat), and employing techniques known as stringing, sliding, and playing heavy offbeat accents.

Like their Indian counterparts, the Métis traditionally relied a great deal on the oral tradition. Their songs were passed on from one generation to the next, and sometimes modified to suit the occasion. Singing was primarily was done in the home, supplemented by participation in church and community celebrations. Even during hard times, there was always plenty of time for late night gatherings of singing and dancing. Louis Riel himself was a poet and songwriter, and he left a significant legacy in this regard. Today Riel's talents are supplemented by a variety of Métis artists. During the 1970s, Henri Létourneau accumulated more than one hundred tapes of songs and stories of early Manitoba Métis (Whidden, 2001: 173).

Often maintained simply through the efforts of a select group of dedicated men and women, Métis leaders argue that their cultural practices should be assisted by government support in the same manner and to the same degree that other cultures expect government support for their brand of cultural pursuits (Roberts, von Below, and Bos, 2001: 197). Riel, by the way, never published any of his poetry although his poems are

said to take up about 500 manuscript pages. Riel's poetry contains political and religious content as well as folksongs, fables, and love poems. One of his poems entitled, "Incendium," composed entirely in Latin, is autobiographical (Campbell, 1973: 96).

Clothing

Métis style, French Catholic influenced etched crucifix (Manitoba).

During the heyday of Métis culture at Red River, women tended to wear a somewhat standard form of apparel (*Expressing Our Heritage*, 2001). Often made of dark colored fabric, dresses usually had a high neckline, long sleeves, and a long, ankle length skirt. Younger women might choose lighter colors for their dresses, but elderly women were very conservative in apparel. Often the only ornament they would choose would be a crucifix. Many Métis women decorated their clothing, sometimes with ribbon sewn just around the edge of the skirt. Essentially, their apparel reflected both their Aboriginal and French heritages. A woman might wear trade silver and beads linking her to her fur trade family, as well as ribbon on the edge of a shawl which would identify her as an affiliate of both Indigenous and EuroCanadian cultures. Men's clothing also linked the two cultures; hide coats, for example, were decorated with fringes and embroidery work in a floral pattern running down either side of the opening. Vests and leggings were lavishly decorated in stylized floral designs sometimes called "high plains design."

Métis women did not commonly wear hats, although young women might wear bonnets on occasion. With men, it was another story. A type of pillbox hat was particularly popular with younger men. It featured a short, round, flat top and was worn more as a decorative item than for practicality. Sometimes called a "smoking cap," the pillbox hat was much in vogue in the Saskatchewan Qu'Appelle Valley during the 1870s. Made of velvet, hide, or fine wool, the pillbox hat was often decorated with embroidery or beadwork or with tassels of silk that hung down the side.

A unique item of apparel that equipped hunters for the cold Canadian winters was the buffalo coat. Popular among Métis men and members of the North West Mounted Police, the coats were made of the skin of bison, with the hair of the animal left on and

the hide tanned. The coats were lined with cotton or flannel with a high collar to protect the neck from extreme cold. Buffalo hides were harvested in the winter and the coats were quite inexpensive to produce. These long coats offered warmth and comfort and were made in a variety of lengths. They were often decorated with brass buttons and fancy wool braid loops (*Expressing Our Heritage*, 2001).

There was scarcely any piece of clothing or related item that escaped the sharp eyes of Métis designers. Their artistic repertoire included coats, moccasins, mittens, gauntlets, hoods, shawls, leggings, capotes, vests, watch pockets, pouches, bags, and cradleboards. Even dog blankets captured the intense interest of Métis artists. It was not unusual for men to carry highly-decorated gun cases, knife sheaths, or embroidered accessories. Porcupine quills were used to decorate a wide variety of clothing items as well as bags, pouches, saddles, and horse trappings. Red, white, and blue were predominant colors. Several handmade items were sewn of caribou skin which were bleached almost white if left in the sun.

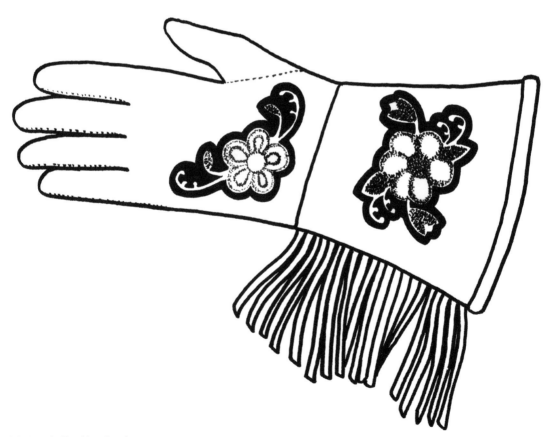

Métis style floral beadwork pattern.

Decorative arts

During the fur trade, many Métis women became cultural liaisons by providing skills essential to the survival of incoming traders and explorers. They sewed much of the clothing worn both by their menfolk and as well as by employees of the Hudson's Bay Company and decorated the fruits of their labors with unique designs. Even today, many Métis women maintain the arts taught them by their mothers and grandmothers, particularly beadwork, fingerweaving, and rug hooking. They also engage in moose hair tufting and horsehair arts.

Traditionally, Métis women created unique floral designs by combining a multiplicity of cultural heritages including French and Scotch, Assiniboine, Cree, and Ojibway. Nineteenth century Métis beadwork designs included doublelined stems with small accents of two or three beads on either side of the stem. They beaded small circular berries which were often described as small floating circles as well as tiny floral buds and feathered stems. It was difficult to obtain a variety of colored beads so primary colors tended to be red and green. Contemporary artists have tended to adhere to traditional designs but now include many colors as well as a new technique called layering of buds (*Our Shared Inheritance*, 2002).

The 1960s witnessed the emergence of special interest in Aboriginal arts, and Métis creations were no exception. The well-known Métis sash, for example, made a sort of comeback in craftstores. Several Métis organizations now award the "Order of the Sash" to individuals who have made artistic contributions to the community. The Métis sash was originally created by fingerweaving using European materials and designs. The originators used plant fibre and locally produced wool until imported lamb's wool became available to them. The availability of lamb's wool allowed for expanded experimentation so that a difference between manufactured and hand woven sashes was readily visible. Individual weavers also displayed their own particular designs. As the move to obtain sashes increased, manufacturers started to produce a standardized form of the sash which took considerably less time to make. By comparison, it required some 200 hours to make a high quality sash by hand, but a lesser quality sash required only 70 to 80 hours of labor. Most popular sash colors were red, light and dark blue, green, and yellow. Today the Gabriel Dumont Institute in Saskatoon, Saskatchewan, offers classes in several Métis arts including fingerweaving, hooking, and beadwork.

The sash was more than a decorative piece of clothing. In addition to keeping clothing secure, men tucked a variety of things into their belt sashes – pipes, tools, or other paraphernalia. The sash could be used as a rope, for example, as a means to pull canoes overland on a portage, or as a substitute makeshift dog harness. Sometimes it became a towel or washcloth or it was tied to packages of furs or taken apart to serve as an emergency sewing kit. Sashes eventually became a much wanted commodity sold or traded by fur trading companies. The Hudson's Bay Company started to make sashes

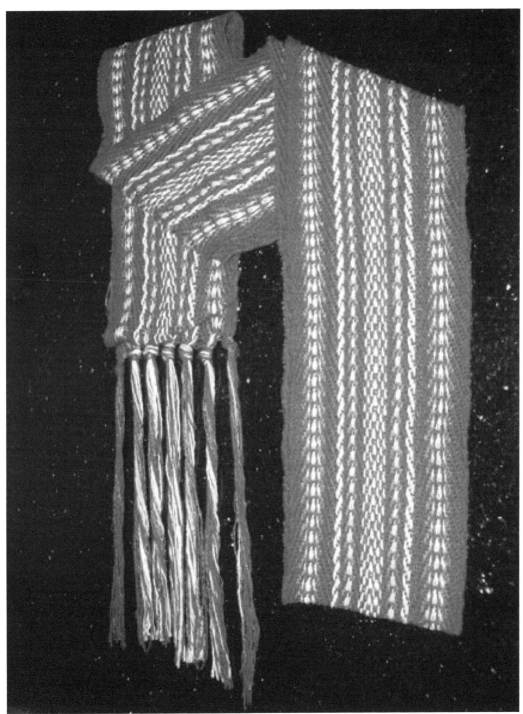

Métis Sash in the authors' collection. Photograph by David J Friesen.

commercially, but these sashes were less attractive and less durable than those woven by the Métis, and almost led to the abandonment of fingerweaving. Today, there are still a few individuals who remember the skill of sash-making well enough to pass the art along to the younger generation. Learning to fingerweave a sash requires knowledge of a few simple items: yarn, popsicle sticks, masking tape, and scissors. Three colors of yarn are often used for beginners including blue, red, and white (*Métis Fingerweaving*, 2003).

The development of Métis crafts was partially influenced by the instruction they received as students in residential schools where some semblance of arts was taught. The Métis foray into the Canadian art scene was recognized as early as 1942 when B. W. Thayer produced an article lauding "Red River Half-breed Art" as an artistic genre in its own right. This publication was followed up by a series of studies, most of which have concluded with disappointing results. As Racette (2001: 183) observes, Métis art has not yet received the recognition it deserves.

Although they always found time to indulge in the arts, Métis women were also engaged in a wide spectrum of other activities including gathering and preparing food, raising children, practicing healing arts, and sewing (*Métis Hooked Rugs*, 2002). Many Métis women were skilled seamstresses. They also crocheted, braided, and hooked rugs with unique Métis flowered designs surrounded by leaves and tendrils. For many years, these women both provided their homes with artful works, and sold some of them commercially. Several women in the Qu'Appelle Valley sewed uniforms for the Royal Canadian Mounted Police and the Salvation Army. During the height of the fur trade, many Europeans purchased Métis clothing and accessories, believing them to be authentic Aboriginal works. Employees of fur trading companies sought out Métis seamstresses to repair their outfits. Locally, there were times when decorative art products were exchanged for essential food items with neighboring farmers. The Métis-produced video on rug hooking outlines six steps essential to the art: (i) preparing your rug hooking materials; (ii) building a frame; (iii) preparing your work surface; (iv) cutting and tracing your patterns; (v) how to hook your rug; and, (vi) backing and finishing touches (*Métis Hooked Rugs*, 2002).

Métis women did other things besides caring for their homes and families and engaging in decorative arts. Some of them hunted and trapped alongside their husbands, after which, they skinned animals and tanned hides. They were familiar with local water routes and often travelled by canoe to fulfill their food-getting conquests. However, the majority of their time was devoted to cooking, cleaning, sewing, and engaging in various art forms. It seems the women often experienced a form of spirituality when sewing garments for family members because of their motivation to provide for them and their affection for them. Like their Indian counterparts, both male and female Métis hunters did not take their hunting responsibilities lightly. They perceived the killing of an animal as a form of personal transformation, an

"animal-human bonding" through the vehicle of sewing clothing. "The taking of an animal life for the purpose of making clothing communicated a personal unspoken prayer to a perceived universe" (Racette: 2001: 183).

Although certainly not a positive factor in cultural maintenance, it is true that discrimination against the Métis by their AngloSaxon neighbors often aided in the development of their cultural pride. The latter noted that the Métis love of open spaces and range hunting prevented them from becoming "sensible and steady farmers." Critics suggested the Métis despised agriculture and preferred to substitute participation in the annual buffalo hunt to becoming typical participants in the vicissitudes of the imported European lifestyle. Eminent historians, missionaries, and explorers described the Métis in their writings as "indolent, thoughtless, improvident, unrestrained in their desires, restless, clannish, vain, and irresponsible" (Sprenger, 1978: 118). Against that kind of prosaic portrayal, the only logical recourse for the Métis would be to formulate a cultural antidote in the form of a strong sense of peoplehood. Today, the Métis are hard at work proving that their cultural contribution to Canada is rich in content, authentic, unique, and worthy of preservation.

Artists

A number of Métis artists have drawn international attention in the past few years. One of the most popular musical artists is singer Buffy Sainte-Marie who was born on the Piapot Indian Reserve in Saskatchewan on February 20, 1941. Buffy was adopted and raised in Maine and Massachusetts. Acknowledging her kinship to both Native and non-Native cultures, she proudly calls herself a "double breed!" After graduating from high school in 1962, she became actively involved in social justice and staked her claim in folk music. She was blacklisted in the United States during the Lyndon Johnson years, then suddenly reappeared to take her place in the art world. Buffy has made at least 17 albums, appeared on three television shows, and for five years, appeared on the children's show, *Sesame Street*. In addition, she earned a Ph.D degree in fine arts at the University of Massachusetts, raised a son, and won an Academy Award Oscar for the song, "Up Where We Belong."

Born in Prince Albert, Saskatchewan, in 1948, Métis artist, Bob Boyer, completed a Bachelor of Education degree at the University of Saskatchewan and later assumed the position of associate professor at the Saskatchewan Federated Indian College in Regina. Boyer began his artistic career in 1970, featuring paintings on Hudson's Bay blankets. His first public exhibition was sponsored by the art department of the University of Saskatchewan in 1973, the first of more than 30 to follow. In the late 1980s, Boyer began to experiment with installation, emphasizing colonizing efforts against the Indigenous people of Canada.

Douglas Cardinal, was born in Calgary, Alberta, on March 7, 1934, and is probably the best known Aboriginal architect in the world. A graduate of the University of British Columbia and the University of Texas, Austin, Cardinal began his formal career in Red Deer in the 1960s. One of his earliest works is St. Mary's Church in Red Deer, Alberta, followed by the Space Services Centre in Edmonton, and the spectacular Canadian Museum of Civilization in Hull, Quebec, across from the parliament buildings in Ottawa. The recipient of many awards, Cardinal designed and supervised many famous buildings such as the National Museum of Man in Hull, Quebec, the Saskatchewan Federated College, and the National Museum of the American Indian, Smithsonian Institution, in Washington, D.C.

Probably best known for her role as Blackshawl in the film, *Dances With Wolves*, Tantoo Cardinal was born on July 20, 1950, in Fort McMurray, Alberta, and raised in the bush country of the northeastern part of the province. Basically a self-taught actress, Cardinal completed high school in Edmonton, the target of racist taunts and other hardships. Now, two decades later, she holds an honorary doctorate in fine arts from the University of Rochester, the distinction bestowed upon her in 1993. Cardinal has received numerous awards and was listed on the *Maclean's Magazine* Honor Role in 1991. Her film credits include *Loyalties* and guest appearances on *North of 60*.

Born on the West Coast, Old Bear Grinning traces his ancestry to Pierre Parenteau, a buffalo hunter who was appointed president of the provisional government that Louis Riel had formed before his death. Many of Grinning's relatives still live at Batoche, Saskatchewan, the site of Riel's last stand. Grinning started carving as a youth, using red and yellow cedar, partly because he liked the smell of the wood. All of his pieces are carved by hand; no power tool is used once the wood is in the hands of the carver. Most finished pieces are given a simple bee's wax finish, while other are painted.

The name, Tom Jackson, is well-known in Canada, mainly because of his role as Chief Peter Kenidi in the CBC series, *North of 60*. One of Canada's most popular singer-actors, Jackson's career spawns more than 40 years. He is also known as a humanitarian for sponsoring The Huron Carole concerts in support of the Canadian Association of Food Banks, and is always looking for new ventures; in the 1990s, he was one of the driving forces behind the short-lived Arts and Media Club in Calgary. Jackson has acted in more than a dozen films including *The Water Giant* in 2003, and *A Distant Drumming: A North of 60 Mystery* in 2005. In January 2000, he was named to the Order of Canada, the country's highest civilian award.

Terry Jackson is a longtime carver in the northwest tradition who studied with Tony Hunt at North Island College. Originally a wood carver, Jackson was introduced to porcelain by his wife. Subsequently, he pictured in his mind the light and shadow of relief carving. He mastered all the steps from moldmaking to slipcasting technique, using the very best materials for his craft. His style may be described as a contemporary mix of West Coast First Nations and mythology influenced by the Haida First

Nation. Today he and his wife create delicate porcelain artifacts and make them available through the Tsolum River Studios.

Jim Logan was born in 1955 in New Westminster, British Columbia, of Cree, Sioux, and Scottish ancestry. He studied graphic design at David Thompson University and travelled to Europe to study the works of the classical masters. His first public exhibition was sponsored by the Yukon Gallery in Whitehorse in 1985, the first of many to follow. Since the mid 1980s, Logan has been producing paintings and mixed media works about the social realities of being Native in Canada. In 1983, he moved to Whitehorse to work as graphic artist. A founding member of the Métis Arts Council in 1993, Logan has been concerned with the status of Native values, issues, and images.

Kent McBride is a carver and painter of Scottish, Irish, Ojibway, and French descent and was born in Starks Corner, Pontiac, Quebec. Impressed with his natural countryside surroundings, McBride spent most of his early years in the bush. Today his paintings reflect that background – landscapes, wildlife, and Native themes. He works with a variety of woods, using acrylics and oils to paint. Loyal to his Métis background, he is a member the Métis Arts Council and the Canadian Métis Council.

Born in Regina, Saskatchewan, in 1953, Edward Poitras attended Manitou College and the Saskatchewan Federated Indian College where he later served as instructor. He was employed as a graphic artist at *New Breed Magazine* and lectured at the University of Manitoba. The host of many individual art exhibitions, Poitras has also been the subject of a number of published articles. Throughout his career, Poitras has been particularly distinguished by his installations and sculptural work. His recent works have explored issues of identity and place, representing a kind of rewriting of Aboriginal history.

Rick Rivet was born Richard James Rivet in 1949 in Aklavik, Northwest Territories, and attended the University of Alberta, the University of Victoria, Banff School of Fine Arts, and the University of Saskatchewan. A full-time artist since 1976, Rivet also taught art in Newfoundland and Saskatchewan, and served as jurist for the selection of works for the Indian Centre for Indian and Northern Affairs Canada. He has been the recipient of several awards and participated in many selected group exhibitions. Most of his painting evolves around the concept of dual identity, a tribute to his Métis ancestry. His paintings are filled with subtle contrasts that require a great deal of thinking on the part of the viewer.

Chapter Eleven
Storytelling as an Art Form: An Aboriginal Context

"Then what do you believe in?" The answer came to my lips without thinking. "Stories," I said. So saying, I knew it was true; and saying so, I made it and made it true. – W. S. Penn, *The Telling of the World: Native American Stories and Art* (1993: 11).

That the Indians should possess this mental trait of indulging in lodge stories, impressed me as a novel characteristic, which nothing I had ever heard of the race prepared me for. . . . To find him a man capable of feelings and affections, with a heart open to the wants, and responsive to the ties of social life, was amazing. – Henry Rowe Schoolcraft (1793-1864) in *Clements* (1996: 115).

It is pedestrian to conceive of representative art forms such as painting, sculpture, weaving, or engraving, but such a view is far too limiting. Usually music, dancing, and specific physical skills are also categorized as art, but it takes special appreciation to include storytelling as a unique art genre. In fact, Aboriginal storytelling is a very complicated form of verbal art (Clements, 1996), and a great deal needs to be learned about it before it can properly be appreciated.

Native storytellers have always been greatly respected because of their sagacious knowledge, eloquence of delivery, and powers of invention. They used to occupy preferred places in teepees and wigwams, and were offered the choicest of food wherever they went (Clark: 1971, x). They were often relied on to help preserve tribal histories and spiritual knowledge.

Legends comprised only a part of a tribe's spiritual structure, which also included ceremonies, rituals, songs, and dances. Physical objects such as fetishes, pipes, painted teepee designs, medicine bundles, and shrines of sorts, and the telling of legends

supplemented the whole of Aboriginal knowledge. Familiarity with these components informed individuals of sacred knowledge, and everything learned was committed to memory. Viewed together, these entries represented spiritual connections between people and the universe which, with appropriate care, resulted in a lifestyle of assured food supply, physical well-being, and the satisfaction of the needs and wants of societal members. Storytelling played an important role in the spiritual realm as well, and functioned as an avenue in which elders could speak with voices that reflected individual vision and the wisdom of the ages. A study of Indian legends is, for the present generation, a way of learning about the customs, habitat, and principal occupations of the First Nations that have preserved them. Legend content reveals some of the inner workings of the Aboriginal mind, the people's beliefs, hopes and fears, and what they lived, fought, and died for (Macfarlan, 1968: ix). As Erdoes and Ortiz (1984: xv) note,

> Legends are the magic lenses through which we can glimpse social orders and daily life: how families were organized, how political structures operated, how men caught fish, how religious ceremonies felt to the people who took part, how power was divided between men and women, how food was prepared, how honor in war was celebrated.

Fear of losing Indigenous knowledge as well as valued traditions and customs, has in recent decades, motivated writers of both Aboriginal and non-Aboriginal backgrounds to record and publish Indian legends. Ella Clark (1988: xvii), who took it upon herself to conduct pioneer research in this area, estimated that many legends have been lost or amended from their original form because of outside influences. A publication of the Workers of the South Dakota Writers' Project Works Project Administration (Reese, 1987) of Interior, South Dakota, is illustrative of the commitment to remedy this loss. The project was a cooperative effort by a group of concerned Sioux who gathered stories from older men and women, many of whom could not speak English. Other First Nations individuals, after due consultation with elders, have followed suit (Tate, 1975; Stiffarm, 1983; Hale, 1984; Zitkala-Sa, 1985; Grant, 1990; Shaw, 1992). Ojibway artist, Norval Morrisseau, contributed to the preservation of Indian stories in a unique fashion. He became known as the founder of the "legend painting school" by portraying legends on canvas (Feest, 2000: 14).

A phrase frequently encountered in traditional Aboriginal research is "all living things," which literally means all living life forms including humans, birds, animals, fish, and plant life. The Sioux probably originated the saying, "all my relations," which has reference to the fact that all living things are worthy of respect. In fact, "The First Nations believed that happenings in every river, waterfall, echo, thunder, and even the changing positions of the stars resulted from actions by indwelling spirits" (Edmonds and Clark, 1989: xv). It was the way the Creator ordered the universe, that *all* living entities have a function and must be respected for it. Only in this way could the universe prevail. Thus, in Indian tales, animals are regarded in the same manner as

humans (Brown, 1993: 9). In legend form, animals can interact with humans on the same level and intermarry with them. Sometimes, they even change identities and become human beings (Krause, 1971: 185). In the beginning all living things were friends; even the earth, trees, and rocks spoke a common language and met together as friends in the council of things (Palmer, 1946: xii; Desbarats, 1969: ix). Legends are not simply *about* living things; they *are* living things" (Norman, 1990: xiii).

The illustrative Aboriginal stories contained in this chapter have been drawn from many different sources including fieldwork, personal contact, classroom exchanges, literature, and anthropological studies. These stories represent both Canadian and American First Peoples. These are stories designed for public consumption in that they represent one of two kinds of stories in the classic Aboriginal repertoire. Some traditional stories were intended specifically for a mature audience while others were related to children and mixed audiences. Some contemporary writers tend to "sanitize" adult stories before publishing them (Mourning Dove, 1990: ix), but such is not the case here. These carefully selected legends are appropriate to any audience.

Through the years, we have visited many of the First Nations communities represented in this book, and have taught university courses in Native communities including Blackfoot, Chipewyan, Cree, Stoney (Nakoda Sioux), and Tsuu T'ina (Sarcee). We have been fortunate to have had Aboriginal students representing many different First Nations in our classes. The legends in this series represent First Nations in both Canada and the United States. We have made more than a dozen field trips to the southwest, toured the West Coast several times, and visited virtually every Plains First Nation from the Canadian prairies to Texas and New Mexico.

The essence of each story contained in this chapter has been preserved although the legends have been shortened in the interest of space. This is not an unusual approach because Indian legends were frequently modified over time "as a reflection of changes in the cultural traditions of those who learned them" (Shaw, 1992: xii). At the time of contact, there were also a few instances where Indian storytellers fabricated tales of the kind they understood European explorers wanted to hear (Terrell, 1994: 14, 151).

Legends have always been subject to the individual interpretation of the teller. The storytellers related tales as they were moved by time and place. As Wissler and Duvall (1995: 5) point out, "It seems equally probable that the various versions . . . represent individual contributions, and, in a certain sense, are the ownership of the narrators." The main theme of a legend might be preserved, but for anyone to suggest that a particular version of a legend is the correct one would be preposterous because they probably never did have an absolutely fixed form (Wissler and Duvall, 1995: 5). This fact does nothing to diminish the importance of Indian legends. Through this means, students of Aboriginal ways can learn a great deal about Indian philosophy and, hopefully, increase respect for their ways.

It is important for non-Natives to familiarize themselves with the background of the First Nation responsible for originating a particular story. That community's history, lifestyle, and method of earning a living is germane to the meaning of a legend and may serve as a foundation for the story. There are some aspects of First Nations cultures that can be generalized, for example, the role of the mythical creature known as the trickster. As a player of tricks, this character is called different names by various tribes. Entertainment legends usually feature the actions of this character. The Blackfoot call him Napi, the Crees call him Wisakedjak, the Ojibway call him Nanabush, the Sioux call him îktûmni, and other tribes have different names for him like Coyote, Tarantula, Raven, or Veeho. Stories about the trickster are principally fictional and can be invented and amended even during the process of storytelling.

To begin with, virtually every component of Aboriginal culture has a story about creation and/or tribal origin (Mullett, 1979: x; Wallas and Whitaker, 1989; Jones and Molyneaux, 2004: 70). From the beginning of time, humankind has pondered the question of origins – the origin of humankind, and the origins of other life forms, as well as the workings of the universe. To compensate for this kind of knowledge, and to alleviate the uncertainty of life, philosophers have developed intricate and sophisticated stories about the origin of life as well as conjecturing what life after death might be like (Coffer, 1978: vii). Consider the Mi'kmaq story about the origin of Reversing Falls at St. John, New Brunswick. Much of the meaning of this story can be lost if one is not familiar with the traditional lifestyle of the Mi'kmaq. Essentially the Mi'kmaq were a migratory people who lived in the woods of Cape Breton Island during the summer months and relocated to the sea's edge during the winter.

Glooscap, the main character of many Mi'kmaq stories, was believed to possess unusual powers assigned to him by the Creator (Robertson, 1969: 21f; Macmillan, 1962: 2). Unlike the wily trickster who is a regular actor in many Aboriginal stories and who constantly plays tricks on people, Glooscap had a special element of the Divine about him. Glooscap cared for his people, and though he long ago vanished from among the Mi'kmaq, he promised he would return whenever they had need of him. He taught the people many things, particularly about origins and functions of natural phenomena. The story of the Reversing Falls goes like this:

> One day Glooscap decided to take a bath in the St. John's River but the water was too shallow. He wanted to take a deep bath so he needed plenty of water. He called his friend Beaver, and told him to build a dam that would completely block the river. That way the water would stop running and form a deep pool.

> Beaver did as he was told because no one ever refused Glooscap. After all, Glooscap usually did nice things for the people and animals so it was considered a privilege to do something for Glooscap.

While Glooscap was having his bath the river water became very shallow downstream. After all, the dam that Beaver had built was blocking the water. This made it difficult for larger fish downstream to swim. Whale was particularly unhappy because he was stuck in the mud. Whale called out, "Who took my water? Why is there no water in the river downstream? What happened to my water? How can I swim if there is no deep water?"

Whale struggled upstream to where the dam was located. He began breaking up the dam with his huge tail, thrashing about great heaps of mud and water. Suddenly the dam broke and the water began rushing downstream again. Now Whale was happy. He had plenty of water to swim in, but Glooscap was left sitting in the mud upstream.

The battle between Glooscap and Whale continued for many days. Glooscap ordered the dam rebuilt, and Whale broke it down. One day there was plenty of water upstream and the next day there was plenty of water downstream. This battle continued until it became permanent. Ever since that day, the river has flowed in both directions every day.

Today when you visit the city of St. John in the Province of New Brunswick, you will see the water sloshing back and forth each day as Glooscap and Whale continue to have their fun.

Artist's conception of the Mi'kmaq "Reversing Falls" legend.

Indigenous legends are frequently subject to misleading interpretation by uninitiated storytellers. Although each story obviously has an underlying reason for being told, a non-Native telling it might be tempted to assign a non-Native motive to the originator of the tale (Grinnell, 1962: xiii). Erdoes and Ortiz (1984: xii) caution that applying conventional wisdom or western logic to Indian legends is not only impossible but inappropriate. Relating a story can be accomplished with a particular slant depending on the story-teller's purpose, mood, or familiarity with the background of the story. If, for example, the storyteller wishes to encourage listeners to appreciate the origin and context of the story, he or she may be quite positive about the tale. If, on the other hand, the storyteller is not too familiar with underlying belief systems or the lifestyle of the people who originated the story, a degree of misrepresentation could occur. Obviously no self-respecting storyteller would want that to happen, so a study of the representative tribe would be essential.

Legends have sometimes been identified as one of the most common means of transmitting First Nations cultural values and beliefs. Legends or stories shared among families and communities convey important belief systems, and knowledge about ceremonial rituals and cultural symbols. This generation is very fortunate in being able to access Native legends, thanks to their having been preserved. Appreciation for the preservation of these tales must be extended to several sectors, particularly elders who took upon themselves, the responsibility of maintaining the essence of the oral tradition during times when their people were under siege to abandon traditional ways. These guardians of revered knowledge have been successful in keeping many of their valued beliefs and practices alive through turbulent times. Adherents to the written word who first came into contact with Indigenous cultures, such as traders, missionaries, and anthropologists also rendered a valuable service by committing to writing, many stories they learned from their newfound acquaintances.

Aboriginal legends have a unique identity. They are truly Indigenous stories, and as such they constitute the oral literature of each particular tribal cultural configuration. As oral literature, Indian legends were never written down in precontact days, and some elders still have reservations about the wisdom of doing so today. Four Guns of the Oglala Sioux First Nation once observed, "The Indian needs no writings; words that are true sink deep into his heart" (Friesen, 1999: 38).

The study of Native legends can be a rich source of cultural learning. Traditionally, legends appear to have been told for a variety of purposes, both formal and informal. Formal storytelling was usually connected to the occasion of deliberate moral or spiritual instruction or in connection with ceremonial celebrations. In fact, among Plains Indians, some legends were considered so sacred that their telling was restricted to the celebration of an extremely special event, such as the Sundance. Others were told only during specific seasons. On these occasions, only recognized or designated persons could engage in their telling. Nearly anyone could engage in informal storytelling, and such legends were usually related for their entertainment or instructional value.

Classifying Legends

First Nations stories are pictures of Aboriginal life verbally drawn by Indigenous storytellers, portraying life from their point of view. Legends deal with a variety of human experiences ranging from humorous to deeply spiritual. It is possible to classify Indian legends into several, rather general, categories although there is often overlap. Marriott and Rachlin (1975: xi) categorize legendry into three classifications – explanatory stories, which explain why things are the way they are; historical legends, about men and women who are long remembered by the people for their deeds; and folklore, which constitutes the lore and wisdom of the people. Folklore is as old as time and as new as tomorrow. Folklore stories may be told by ordinary people and may be based on personal experiences or hearsay. Macfarlan (1968: xiii) denoted four categories: (i) sacred and creation myths, (ii) historical legends, (iii) traditions (stories about tribal practices), and (iv) local legends, although he emphasized that it is difficult to differentiate between myth, legend, and tradition.

For our purposes, we will describe three kinds of legends: (i) those designed for historical or descriptive instruction (such as origin legends), (ii) moral legends (which deal with preferred behavior), and (iii) entertainment legends. The content of legends convey a vast range of cultural knowledge including folkways, institutions, values, and beliefs. Legends often outline the very basis of a particular cultural pattern.

The sacred number four is frequently referenced in Indian legends as it did in ceremonial procedures, customs, and actions. Teaching the importance of the number four was invariably used to denote the completeness of any task, enterprise, or song. Plains tribes regarded the number four as a cosmic universal. This belief was based on the observation that there are four faces or ages: the face of the child, the face of the adolescent, the face of the adult, and the face of the aged.

There are four races: yellow, red, black, and white, and there are four things that breathe: those that crawl, those that fly, those that are two-legged, and those that are four-legged.

There are four things above the earth: sun, moon, stars, and planets.

There are four parts to green things: roots, stem, leaves, and fruit, and there are four divisions of time: day, night, moon, and year.

There are four elements in the universe: air, earth, fire, and water, and even the human heart has four compartments.

Finally, vision quests classically lasted four days and four nights and songs were sung and prayers were said four times (Clutesi, 1967: 13).

Artist's conception of the Semeca Nation "Origin" legend.

Instructional Legends

Origin legends are one example of instructional legends and generally have a historical base, such as the beginnings of a particular tribe. Some writers include stories about how things came to be as origin stories. For example, stories about why squirrels have pink eyes, why rabbits have short tails, and why ravens are black, have sometimes been labelled origin stories (Grant, 1990: 4).

An example of a tribal origin story comes from Seneca First Nation in Ontario.

> When the world began, all Indian tribes in the northeast lived together as one large family. Their leader was Chief Medicine Woman. A river ran through the village so that half of the people lived on one side of the river and the other half on the other side of the river. Whenever the people wanted to trade goods or meet for a visit, they had to cross the river. The assembly house in which the people met for council and for dances was located on one side of the river.
>
> The river current flowed very fast, and the river was deep. It was extremely difficult to cross the river. Although the people had canoes, the river was too swift for them to make it across. The only way to cross the river was on a bridge made of saplings and branches that were tied together. When the people on one side of the river wanted to get together with families on the opposite side, they had to cross the swift-flowing river in this way. This was very dangerous.
>
> One day, there was an argument in the village. It was about the ownership of a white dog. The people were soon divided into two groups, both claiming ownership of the dog, Chief Medicine Woman tried to make peace, but she was unable to bring the two sides together. Finally she decided to take one of the groups to a new site. There they would build a new village and begin again.
>
> Chief Medicine Woman asked all the people who wanted to follow her to build some new canoes and go down river. It took some time to finish the canoes, but finally the party was ready to leave. The people who agreed to Chief Medicine Woman's leadership got into the canoes and paddled off. After a long while they came to a fork in the river. Half of the river flowed in one direction and the other half in another direction. Now the group had to decide which fork in the river to take.
>
> Again an argument broke out and Chief Medicine Woman was unable to make peace between the two groups. Finally the people divided into two bands. One band travelled down one fork in the river and the other band travelled along the other fork.

After the two bands were separated for many years their language became different and they could no longer understand one another.

One of the two bands became known as the Seneca Nation.

Stories explaining why some aspects of nature are the way they are may also be called instructional legends. Repeating them to listeners will inform them as to why certain phenomena appear the way they do. Consider the story explaining why grizzly bears live in the mountains, a gift from the Salish First Nation.

Grizzly Bear used to live in a big forest near the people. Grizzly Bear acted as though he owned the forest and would not let people hunt there. Whenever anyone came near the forest, Grizzly Bear would frighten and chase them away by roaring loudly and waving his claws at them.

Owl served as Grizzly Bear's scout so when anyone came near the forest he would warn Grizzly Bear. Owl would give a loud "hoot" when people came near the forest.

The people wanted to hunt in the forest. They *needed* to hunt in the forest because they had to have food. The people prayed to the Creator for help and Crawfish came to their aid. Crawfish received special powers in order to help the people. The powers that Crawfish received made him very large with very strong pinchers.

When Crawfish approached the forest, Owl gave a loud "hoot" to let Grizzly Bear know that someone was coming. Grizzly Bear immediately let out a loud roar, but Crawfish kept right on coming. Grizzly Bear went into his den to exchange his summer claws for his winter claws because they were bigger. Surely this would scare Crawfish. Crawfish saw the winter claws but kept right on coming.

By now Grizzly Bear was furious. How dare Crawfish invade his territory? He decided to finish Crawfish off fast by giving him a great big Grizzly Bear hug. Before he could do this, Crawfish pinched Grizzly Bear with his two very large red fingers. Grizzly Bear spit in Crawfish's face, but Crawfish only pinched him harder. Grizzly Bear howled in pain and begged for mercy.

"I want you to leave the forest," said Crawfish. "Go to the high mountains and live there and let the people hunt in the forest." Grizzly Bear agreed to do so, but as soon as Crawfish was out of sight he came back into the forest. He started to run between two large trees only to discover that they were Crawfish's pinchers. Crawfish pinched Grizzly Bear hard and said, "I thought I told you to stay out of the forest. Go to the high mountains and live there." Bear howled in pain and said he would leave the forest. He walked a short way out of the forest and came back when he thought

Crawfish was not looking. Once again Crawfish pinched Grizzly Bear and chased him out of the forest.

Finally, Grizzly Bear walked a long way toward the high mountains, then leaned against a tree and said to himself. "That Crawfish cannot chase me out of the forest. It is my forest and I will stay there as long as I like." The tree on which he was leaning suddenly moved. Grizzly Bear quickly discovered that he was leaning on one of Crawfish's pinchers. Crawfish pinched Grizzly Bear extra hard and Grizzly Bear tried to tear himself loose from Crawfish's grasp. By now Grizzly Bear was in very great pain and ran off as soon as Crawfish released him. Grizzly Bear left the forest for good and went to live in the high mountains.

Since then grizzly bears have lived in the mountains and people are able to hunt for food in the forest.

Another instructional legend originates with the Creek First Nation, explaining why the possum's tail is flat and bare (Hamlyn, 1967: 146f).

> It seems that Possum once had a beautiful bushy tail and he liked to show it off. He was quite certain that it was the most beautiful tail in the forest, that is, until he met the trickster who was disguised as Racoon. The trickster's tail was clearly more attractive than Possum's tail. The trickster's tail, like that of any racoon, was big and bushy, and had several beautiful dark rings around it.

> Possum was particularly impressed with the rings on Trickster's tail and asked him how he got such a beautiful tail. Trickster decided to have some fun with Possum and told him that he could have the exact same tail if he would put some rings of birch bark on his tail and stick it in the fire. In fact," he said, "the longer you keep your tail in the fire, the brighter the rings will become." The Possum looked so sincere that Trickster had to hide his face and try to keep from laughing.

> The trickster soon disappeared into the forest and Possum went off to find some birch bark rings. Once he had placed them around his tail he made a huge fire and stuck his tail into it. Almost immediately he felt pain, but he decided to act brave and try to ignore it. The pain grew immense, but to Possum's good fortune, the fire eventually went out.

> When Possum looked at his tail he was greatly disappointed. All the hairs on his tail had been burned off and they never grew back. Possum's tail has remained that way to this day. Possum was so ashamed that he had fallen for the trickster's deception that he grew very shy. To this day he prefers to live by himself, away from all the other animals in the forest.

Artist's conception of the Creek First Nation "Possum Tail" legend.

Entertainment Legends

Years ago, during a long winter evening, it was story time in Indian country. One storyteller would begin and when weary or temporarily out of story lines, would be followed by another. The event would come to an end only when everyone except the last storyteller had fallen asleep. Many tribes believed that relating legends was principally a winter activity and it would be bad luck to do so in the summer.

Often, Aboriginal stories were purely intended for amusement, simply to help pass the time. Perhaps the women were busy cooking and the men were away on a hunt. It was therefore left to the older people, grandparents, and elders to amuse the children. The children played games, learned songs, and listened to stories (Hungrywolf, 2001: 6). Of course the tricker figured heavily in these tales.

Following are two trickster legends, "Coyote and the Corn," courtesy of the Apache First Nation, and "Raven Plays a Trick," a tale that originated with the Athapaskan people.

> The people of the village were hungry. Game was scarce and a lack of rain had dried up much plant life. No one knew what to do about it so the people began to pray to the Creator for help. One day, Turkey came to the village and announced that he had four kinds of corn seeds with him. Turkey showed the people where to plant the seeds and how to look after the plants when they came up. He said the corn would come up in four days.
>
> A brother and sister, Big Heart and Redbird, took digging sticks and planted the corn. Soon the corn seeds came up, in four days, just as Turkey had said. The corn grew quickly. Turkey then gave Big Heart and Redbird squash seeds and they planted them as well. As soon as the squash plants came up Big Heart and Redbird asked Turkey for more seeds so they could plant more gardens. They wanted to provide corn and squash for all the people of the village. Turkey offered to look after the crops while Big Heart and Redbird were planting more gardens.
>
> When Big Heart and Redbird came back to the garden that Turkey was looking after, they heard him hollering. Large snakes were threatening to steal the corn, so Turkey ran around with one wing on the ground pretending it was broken. The snakes told Turkey they would not hurt the corn. They only wanted pollen from the corn tassels but they promised to leave the plants alone. Turkey agreed and four days later the snakes left the cornfield.
>
> As the days went by the corn continued to grow and the people picked the ears of corn. They cooked it and everyone had plenty to eat. Then Coyote the Trickster, arrived on the scene. He wanted to have some corn too.

Artist's rendition of the "Coyote and Corn" Apache legend.

"This is silly," he said. The people plant and harvest the corn and then cook it to eat. I will cook mine first, then I will plant it."

Coyote got some ears of corn, cooked it, and planted it, but it never came up. Soon he was begging the people for corn. "You have plenty of corn to eat," he said, "Why not share some of it with me?" The people refused. Coyote was too lazy to do the right things with corn. He was not supposed to cook the corn before planting it, but he would not listen. Besides, he was always playing tricks on the people and they did not trust him. Then Coyote began stealing corn and squash from the people so they chased him out of the village.

Coyote had to leave the village without any corn.

The Athapaskan First Nations represented a widely distributed Indian language family and were considered by some authorities to be the most widely scattered linguistic group in North America. This linguistic stock extended from the Arctic coast to northern Mexico, from the Pacific Ocean to Hudson Bay, and from the heartland of the Rio Grande River to the mouth of the Rio Grande in the south. The following story features Raven, their version of the trickster.

There was once a couple who had a daughter named Bluebell and she was very beautiful. Bluebell's parents hoped that one day she would get a good husband who would love her and care for her. They also wanted to find her a husband who was important and rich. The way to tell if a man was rich or important was to count the number of bone beads he wore on his outfit.

Every time a suitor came into their camp, Bluebell's parents would count the number of bone beads he wore to see if he was a suitable husband.

One day, a messenger arrived to inform the couple that a stranger had arrived in the village and he wanted to marry Bluebell. The stranger wore many bone beads on his outfit so Bluebell's parents were very pleased. Her mother went out to meet the stranger and invited him to their teepee for supper. Bluebell's parents did not know that the stranger was Raven the Trickster.

As the meal began, Raven noticed a dog in the teepee and asked that the animal be removed. "I cannot eat when animals are present," he said, so the dog was removed. Bluebell's mother was impressed that the stranger was so fussy, so she thought he would be a good candidate as a husband for Bluebell.

Sure enough, the wedding was arranged, and Bluebell left the village with her husband. They left by canoe with Bluebell sitting behind Raven. Suddenly it began to rain and Bluebell noticed something running down her husband's back. It looked like he had painted his body with lime. Suspicious now, she tied his tail to a crossbar in the canoe and asked to be

put on shore for a bit. As they landed, Bluebell ran back to her village as fast as she could. Raven tried to follow her but since his tail was caught on the canoe he had to change to his regular form. This slowed his pace and Bluebell made it safely back to her home.

Later, Raven flew over the village and sang, "Ha ha, I tricked you!"

Bluebell told her parents that the Trickster had changed his identity by coating himself with lime. She was very sad about the whole thing and resolved to be much more careful in selecting a husband in the future.

Artist's rendition of the Athapascan legend, "Raven Plays a Trick."

Moral Legends

Before the printed word, all children regardless of their cultural background, were taught by modelling and the oral tradition. Grandparents and elders told them stories, reprimanded them, or engaged them in serious talk about right and wrong. This habit was common to many traditional cultures. Some scholars have likened these Indian stories to old Norse myths and suggested that they have a common origin (Hill, 1983: 8). Biblical stories of this genre told by Jesus Christ are called parables and they are not unlike those passed on by Indigenous peoples all over the world (see Matthew chapter 13 in the *New Testament*).

Common moral teachings emphasized in Aboriginal stories include such values as courage, honesty in dealing with others, and truthfulness in speech (Ressler, 1957: ix). Traditionally, Aboriginal peoples believed in such unchanging, eternal values as honesty, respect for others, and family loyalty. These were viewed as universal imperatives (Weeks, 1981: xvi). McFee, (1972: 96f) identifies four specific values still being perpetuated among the Blackfeet First Nation through modeling, ritual, and instruction. These include (i) individualism, (ii) bravery, (iii) wisdom, and (iv) generosity. Although influenced by changes in lifestyle these beliefs still prevail in modified form. Individualism, for example, applies to personal acts of achievement that benefit the community. Bravery, once the cornerstone of Blackfeet society, has been transferred from acts of hunting and war to success in rodeo. The definition of wisdom, at least for some tribal members, has been translated from the traditional notion that wisdom is a spiritual gift to one of appreciation for book learning. The traditional notion of generosity still prevails, namely, that anyone with resources is expected to share those with people in need, particularly members of one's own family or clan.

Some First Nations distinguish between moral and spiritual legends, the latter subject to more stringent regulations. In some tribes, spiritually significant stories were never told to just anyone who asked, nor were they were told *by* just anyone. Sacred legends were often considered property and thus their transmission from generation to generation was carefully safeguarded. Selected individuals learned a legend by careful listening; then, on mastering the story, passing it on to succeeding generations, perhaps changing aspects of the story to suit their own tastes. The amendments would center on a different choice of animals or sites referred to in the story and preferred by the teller.

The following moral legend originates with the Shoshone tribe (Hamlyn, 1967: 99f), and explains why a flock of golden cranes lost their luminous shade and turned white in color. The reason for their loss demonstrates the consequences of displeasing natural laws put in place by the Great Spirit.

There once lived a flock of large golden crane in the far northland. The Great Spirit had given them their golden plumage and said to them, "I have given you this special gift of golden feathers, but to keep them you must never leave the territory in which you live. If you do so, you will lose your illustrious color." The cranes readily nodded in consensus.

As fall approached, the various species of migratory birds held a council in order to decide when it might be appropriate to head south. The gathering included birds of every sort – ducks, geese, robins, and every other kind. Within a few days, most of the birds left for warmer clime, but the golden cranes had to remain behind. They did not feel good about this because they felt left out and missed their friends.

A few days went by and the leader of the golden cranes called the flock together and said, "We always fly south for the winter with our friends and I think we should do so again. Surely the Great Spirit will understand and let us keep our golden feathers." Several cranes were unsure about the suggestion that they fly south; they did not want to displease the Creator. Their leader was insistent, however, and soon the cranes were on their way.

When the Great Spirit saw what the cranes were doing he grew very disappointed and gave orders to the waters to wash the gold off the cranes' feathers. In the meantime the cranes flew over many unknown lands till they came to the land of the Great Lakes. After circling the waters several times, they flew down to land. They splashed down and almost immediately, the turbulent lake waters began to wash the golden color from their feathers. The leader gave the signal to fly up, but it was too late. The cranes were now plain white in color.

The cranes remembered the warning of the Creator and though they soon flew back to their homeland, they remained white in color and do so to this day.

Legends, along with other elements of the oral tradition, comprise the sacred traditions of the First Nations of North America (Tooker, 1979: 31). We do well to remember that, as such, they are comparable in value to the sacred writings of any world religion as well as to western secular scientific accounts. Although often termed "myths," the observations on which the legends are based do not reflect any less intellectual efforts than do the sacred and secular texts of the high civilizations of the old world.

Their manner of telling reflects a unique art form.

Artist's rendition of the Shoshone legend, "Golden Cranes."

References

Abel, Kerry. 1993. *Drum Songs: Glimpses of Dene History*. Montreal, PQ: McGill-Queen's University Press.

Acco, Anne. 2001. Traditional Knowledge and the Land: The Cumberland House Métis and Cree People. *Métis Legacy: A Métis Historiography and Annotated Bibliography*. Lawrence J. Barkwell, Leah Dorion, and Darren Préfontaine, eds. Winnipeg, MB: Pemmican Publications, 127-134.

Adams, Howard. 1975. *Prison of Grass: Canada From the Native Point of View*. Toronto, ON: New Press.

Alfred, Gerald R. 1995. *Heeding the Voices of our Ancestors: Kahnawake Mohawk Politics and the Rise of Native Nationalism*. Toronto, ON: Oxford University Press.

Anderson, Frank. 1974. *Riel's Manitoba Uprising*. Aldergrove, BC: Frontier Publishing.

Anderson, Margaret Seguin. 1995a. People of Salmon and Cedar: An Overview of the Northwest Coast. *Native Peoples: The Canadian Experience*. Second edition. R. Bruce Morrison and C. Roderick Wilson, eds. Toronto, ON: McClelland and Stewart, 547-555.

————. 1995b. Understanding Tsimshian Potlatch. *Native Peoples: The Canadian Experience*. Second edition. R. Bruce Morrison and C. Roderick Wilson, eds. Toronto, ON: McClelland and Stewart, 556-585.

Bakker, Peter. 2001. The Michif Language of the Métis. *Métis Legacy: A Métis Historiography and Annotated Bibliography*. Lawrence J. Barkwell, Leah Dorion, and Darren Préfontaine, eds. Winnipeg, MB: Pemmican Publications, 177-180.

Banton, Michael, ed. 1966. *Anthropological Approaches to the Study of Religion*. London, UK: Tavistock.

Barkwell, Lawrence J., Leah Dorion, and Darren R. Préfontaine, eds. 2001. *Métis Legacy: A Métis Historiography: An Annotated Bibliography*. Winnipeg, MB: Pemmican Publications.

Becker, Mary Druke. 1995. Iroquois and Iroquoian in Canada. *Native Peoples: The Canadian Experience*. Second edition. R. Bruce Morrison and C. Roderick Wilson, eds. Toronto, ON: McClelland and Stewart, 317-322.

Benedict, Ruth. 1959. *Patterns of Culture*. New York: Houghton-Mifflin.

Berlo, Janet Catherine. 1992. Introduction: The Formative Years of Native American Art History. *The Early Years of Native American Art History: The Politics and Scholarship and Collecting*. Janet Catherine Berlo, ed. Seattle, WA: University of Washington Press, 1-21.

Berlo, Janet Catherine, and Ruth B. Phillips. 1998. *Native North American Art*. New York: Oxford University Press.

Bernstein, Bruce. 1999. Contexts for the Growth and Development of the Indian Art World in the 1960s and 1970s. *Native American Art in the Twentieth Century: Makers, Meanings, Histories.* W. Jackson, Rushing III, ed. London, UK: Routledge, 57-74.

Bertulli, Margaret. 1994. *Archaeological Field Work in the Northwest Territories in 1993.* Yellowknife, NWT: Prince of Wales Northern Heritage Centre.

Bishop, Charles A. 1994. Northern Algonquians, 1550-1760. *Aboriginal Ontario: Historical Perspectives on the First Nations.* Edward S. Rogers and Donald B. Smith, eds. Toronto, ON: Dundurn Press, 275-288.

Blackstock, Michael D. 2001. *Faces in the Forest: First Nations Art Created on Living Trees.* Montreal, PQ: McGill-Queen's University Press.

Boas, Franz. 1955. *Primitive Art.* New York: Dover Publications.

————. 1967. The Winter Festival. *Indians of the North Pacific Coast.* Tom McFeat, ed. Seattle, WA: University of Washington Press 180-197.

Bolz, Peter. 1999. Northwest Coast. *Native American Art: The Collections of the Ethnological Museum Berlin.* Peter Bolz and Hans-Ulrich Sanner, eds. Seattle, WA: University of Washington Press, 161-190.

Bolz, Peter, and Hans-Ulrich Sanner. 1999. *Native American Art: The Collections of the Ethnological Museum Berlin.* Seattle, WA: University of Washington Press.

Boxberger, Daniel L. 1990. *The Northwest Coast Culture Area. Native North Americans: An Ethnohistorical Approach.* Daniel L. Boxberger, ed. Dubuque, IA: Kendall/Hunt, 387-410.

Bragdon, Kathleen J. 1990. The Northeast Culture Area. *Native North Americans: An Ethnohistorical Approach.* Daniel L. Boxberger, ed. Dubuque, IA: Kendall/Hunt, 91-134.

Brandon, S. G. F. 1975. *Man and God in Art and Ritual: A Study of Iconography, Architecture and Ritual Action as Primary Evidence of Religious and Practice.* New York: Charles Scribner's Sons.

Brown, Dee. 1993. *Dee Brown's Folktales of the Native American: Retold For Our Times.* New York: Henry Holt and Company.

Brown, Joseph Epes. 1992. *The Spiritual Legacy of the American Indian.* New York: Crossroad.

Brush, Edward Hale. 1901. *Iroquois: Past and Present.* New York: AMS Press.

Bryan, Liz. 1991. *The Buffalo People: Prehistoric Archaeology on the Canadian Plains.* Edmonton, AB: The University of Alberta Press.

Cajete, Gregory. 1994. *Look to the Mountain: An Ecology of Indigenous Education.* Durango, CO: Kiva Press.

Campbell, Maria. 1973. *Halfbreed.* Toronto, ON: McClelland and Stewart.

Cardinal, Harold. 1977. *The Rebirth of Canada's Indians.* Edmonton, AB: Hurtig Publishers.

Carlson, Paul H. 1998. *The Plains People.* College Station, TX: Texas A & M University Press.

Carstens, Peter. 1991. *The Queen's People: A Study of Hegemony, Coercion, and Accommodation Among the Okanagan of Canada.* Toronto, ON: University of Toronto Press.

Carter, Sarah. 1995. We Must Farm to Enable Us to Live: The Plains Cree and Agriculture to 1900. *Native Peoples: The Canadian Experience*. R. Bruce Morrison and C. Roderick Wilson, eds. Toronto, ON: McClelland and Stewart, 444-447.

Chalmers, F. Graeme. 1995. European Ways of Talking About the Art of the Northwest Coast First Nations. *The Canadian Journal of Native Studies*, XV:1, 113-127.

Champagne, Duane. 1994. *Native America: Portrait of the Peoples*. Detroit, MI: Visible Ink Press.

Clark, Ella Elizabeth. 1971. *Indian Legends of Canada*. Toronto, ON: McClelland and Stewart.

Clark, Ella E. 1988. *Indian Legends from the Northern Rockies*. Norman, OK: University of Oklahoma Press.

Clements, William M. 1996. *Native American Verbal Art: Texts and Contexts*. Tucson, AZ: University of Arizona Press.

Clutesi, George. 1967. *Son of Raven, Son of Deer*. Sidney, BC: Gray's Publishing.

Codere, Helen. 1956. The Amiable Side of Kwakiutl Life: The Potlatch and the Play Potlatch. *American Anthropologist*, LVIII, 334-351.

————. 1968. The Potlatch in Kwakiutl Life. *The North American Indians: A Sourcebook*. Roger C. Owen, James J. F. Deetz and Anthony D. Fisher, eds. New York: The Macmillan Company, 324-335.

Coffer, William E (Koi Hosh). 1978. *Spirits of the Sacred Mountains: Creation Stories of the American Indian*. New York: Van Nostrand Reinhold Company.

Cohodas, Marvin. 1992. Louisa Keyser and the Cohns: Mythmaking and Basket Making in the American West. *The Early Years of Native American Art History: The Politics and Scholarship and Collecting*. Janet Catherine Berlo, ed. Seattle, WA: University of Washington Press, 88-133.

Cole, Douglas, and Ira Chaikin. 1990. *An Iron Hand Upon the People: The Law Against the Potlatch on the Northwest Coast*. Vancouver, BC: Douglas & McIntyre.

Colombo, John Robert, ed. 1987. *New Canadian Quotations*. Edmonton, AB Hurtig Publishers.

Conrad, Margaret, Alvin Finkel, and Cornelius Jaenen. 1993. *History of the Canadian Peoples*. Toronto, ON: Copp Clark Pitman Ltd.

Crowe, Keith J. 1974. *A History of the Original Peoples of Northern Canada*. Arctic Institute of North America. Montreal: Queen's University Press.

————. 1977. *A History of the Original Peoples of Northern Canada*. Second printing. Arctic Institute of North America. Montreal: Queen's University Press.

Davis, Stephen A. 1991. *Peoples of the Maritime: Micmac*. Tantallon, NS: Four East Publications.

Dempsey, Hugh A. 1988. *Indian Tribes of Alberta*. Reprinted and revised, Calgary, AB: Glenbow Museum.

————. 1995. The Blackfoot Indians. *Native Peoples: The Canadian Experience*. Second edition. R. Bruce Morrison and C. Roderick Wilson, eds. Toronto, ON: McClelland and Stewart, 381-413.

Dene of the N. W. T. 1975. *The Dene: Land and Unity for the Native People of the Mackenzie Valley*. Yellowknife, NWT: Printed by Charters Publishing Co. Ltd. of Brampton, ON.

Desbarats, Peter, ed. 1969. *What They Used to Tell About: Indian Legends From Labrador*. Toronto, ON: McClelland and Stewart.

Dickason, Olive Patricia. 1984. *The Myth of the Savage and the Beginnings of French Colonialism in the Americas*. Edmonton, AB: University of Alberta Press.

———. 1993. *Canada's First Nations: A History of Founding Peoples from Earliest Times*. Toronto, ON: McClelland and Stewart.

Dissanayake, Ellen. 1990. *What is Art For?* Seattle, WA: University of Washington Press.

Doige, Lynda A. Curwen. 2003. A Missing Link Between Traditional Aboriginal Education and the Western System of Education. *Canadian Journal of Native Education*, 27:2, 144-160.

Driver, Harold E. 1961. *Indians of North America*. Chicago, IL: The University of Chicago Press.

Drucker, Philip. 1968. Art of the Northwest Coast Indians. *The North American Indians: A Sourcebook*. Roger C. Owen, James J. F. Deetz, and Anthony D. Fisher, eds. New York: The Macmillan Company, 336-345.

Duff, Wilson. 1974. *Arts of the Raven: Master works by the Northwest Coast Indian*. Vancouver, BC: The Vancouver Art Gallery.

———. 1997. *The Indian History of British Columbia: The Impact of the White Man*. Victoria, BC: Royal British Columbia Museum.

Dumond, Don E. 1978. Alaska and the Northwest Coast. *Ancient Native Americans*. Jesse D. Jennings, ed. San Francisco, CA: W. H. Freeman and Company, 43-94.

Eastman, Charles A (Ohiyesa). 1980. *The Soul of the Indian: An Interpretation*. Lincoln, NE: University of Nebraska Press.

Eddy, John A. 1977. Medicine Wheel and Plains Indian Astronomy. *Native American Astronomy*. Anthony F. Aveni, ed. Austin, TX: University of Texas Press, 147-169.

Edmonds, Margot, and Ella E. Clark. 1989. *Voices of the Winds: Native American Legends*. New York: Facts on File.

Erdoes. Richard, and Alfonso Ortiz, eds. 1984. *American Indian Myths*. New York: Pantheon Books.

Ewers, John Canfield. 1939. *Plains Indian Painting*. Stanford, CA: Stanford University Press.

Ewers, John. 1968. The Horse Complex in Plains Indian History. *The North American Indians: A Sourcebook*. Roger C. Owen, James J. F. Deetz, and Anthony D. Fisher, eds. New York: Collier-Macmillan, 494-503.

Ewers, John C. 1981. Artifacts and Pictures in the History of Indian-White Relations. *Indian-White Relations: A Persistent Paradox*. Jane F. Smith and Robert M. Kvasnicka, eds. Washington, DC: Howard University Press, 101-111.

Ewing, Douglas C. 1982. *Pleasing the Spirits: A Catalogue of a Collection of American Indian Art*. New York: Ghylen Press.

Expressing Our Heritage: Métis Artistic Designs (NA). 2001. Saskatoon, SK: Gabriel Dumont Institute.

Farb, Peter. 1968. *Man's Rise to Civilization as Shown by the Indians of North America from Primeval Times to the Coming of the Industrial States.* New York: E. P. Dutton & Co.

Favrholdt, Ken. 2001. Body Art of the Interior Salish People. [http://www.kamloops guide.com/Pages/aNativebody.Html].

Feder, Norman. 1971. *Two Hundred Years of North American Indian Art.* New York: Praeger.

Feest, Christian F., ed. 2000. *The Cultures of Native North Americans.* Cologne, Germany: Könemann.

Finnie, Richard. 1948. *Canada Moves North.* Toronto, ON: The Macmillan Company of Canada.

Fisher, Robin. 1978. *Contact and Conflict: Indian-European Relations in British Columbia, 1774-1890.* Vancouver, BC: University of British Columbia Press.

Fowler, Don D., ed. 1972. *In a Sacred Manner We Live: Photographs of the North American Indian by Edward S. Curtis.* New York: Weathervane Books.

Francis, Daniel. 1992. *The Imaginary Indian: The Image of the Indian in Canadian Culture.* Vancouver, BC: Arsenal Pulp Press.

Friesen, John W. 1995. *Pick One: A User-Friendly Guide to Religion.* Calgary, AB: Detselig Enterprises.

————. 1999. *First Nations of the Plains: Creative, Adaptable and Enduring.* Calgary, AB: Detselig Enterprises Ltd.

Friesen, John W., ed. 1998. *Sayings of the Elders: An Anthology of First Nations' Wisdom.* Calgary, AB: Detselig Enterprises.

Friesen, John W., and Virginia Lyons Friesen. 2004. *We Are Included: The Métis People of Canada Realize Riel's Vision.* Calgary, AB: Detselig Enterprises.

Furniss, Elizabeth. 1995. The Carrier Indians and the Politics of History. *Native Peoples: The Canadian Experience.* Second edition. R. Bruce Morrison and C. Roderick Wilson, eds. Toronto, ON: McClelland and Stewart, 508-546.

Garfield, Viola E. 1939. *Tsimshian Clan and Society.* Seattle, WA: University of Washington.

Gebhard, David. 1974. *Indian Art of the Northern Plains.* Santa Barbara, CA: University of Santa Barbara.

Getty, Ian A. L., and Antoine Lussier, eds. 1983. *As Long as the Sun Shines and Water Flows: A Reader in Canadian Native Studies.* Nakoda Institute Occasional Paper No. 1. Vancouver, BC: University of British Columbia Press.

Gidmark, David. 1995. *The Indian Crafts of William & Mary Commanda.* Mechanicsburg, PA: Stackpole Books.

Glover, Winifred. 1987. *The Land of the Brave: The North American Indian Collection in the Ulster Museum.* Belfast, IRL: Blackstaff Press.

Goldenweiser, Alexander A. 1968. Iroquois Social Organization. *The North American Indians: A Sourcebook*. Roger C. Owen, James J. F. Deetz, and Anthony D. Fisher, eds. New York: Collier-Macmillan, 565-575.

Goldstein, Robert A. 1969. *French-Iroquois Diplomatic and Military Relations, 1609-1701*. The Hague, Netherlands: Mouton.

Grant, Agnes, ed. 1990. *Our Bit of Truth: An Anthology of Canadian Native Literature*. Winnipeg, MB: Pemmican Press.

Grant, Campbell. 1971. Rock Art in California. *The California Indians: A Sourcebook*. Second edition. Berkeley, CA: University of California Press, 231-243.

Grinnell, George Bird. 1962. *Blackfoot Lodge Tales: The Story of a Prairie People*. Lincoln, NE: University of Nebraska Press.

Grobsmith, Elizabeth S. 1990. The Plains Culture Area. *Native North Americans: An Ethnohistorical Approach*. Daniel L. Boxberger, ed. Dubuque, IA: Kendall/Hunt, 167-214.

Gunther, Erna. 1966. *Art in the Life of the Northwest Coast Indians*. Seattle, WA: Superior Publishing Company.

Haberland, Wolfgang. 1964. *The Art of North America*. New York: Crown Publishers.

Hale, Duane K., ed. 1984. *Turtle Tales: Oral Traditions of the Delaware Tribe of Western Oklahoma*. Anadarko, OK: Delaware Tribe of Western Oklahoma.

Hallendy, Norman. 1996. The Silent Messengers. *Equinox*, January/February 1996, No. 85, 36-45.

Hamlyn, Paul. 1967. *American Indian Tales and Legends*. London: Drury Hose.

Harrod, Howard L. 1995. *Becoming and Remaining a People: Native American Religions on the Northern Plains*. Tucson, AZ: University of Arizona Press.

Hawkes, E. W. 1916. *The Labrador Eskimo*. Ottawa, ON: Government Printing House.

Hawthorn, Audrey. 1967. *Art of the Kwakiutl Indians and Other Northwest Coast Tribes*. Vancouver, BC: University of British Columbia Press.

Hawthorn, H. B. , C. S. Belshaw, and S. M. Jamieson. 1960. *The Indians of British Columbia: A Study of Contemporary Social Adjustment*. Toronto, ON: University of Toronto Press.

Haycock, Ronald Graham. 1971. *The Image of the Indian*. Waterloo, ON: Waterloo Lutheran University Press.

Heidenreich, Conrad. 1971. *Huronia: A History and Geography of the Huron Indians, 1600-1650*. Toronto, ON: McClelland and Stewart.

Heizer, Robert F. 1974. Fishermen and Foragers of the West. *The World of the American Indian*. Jules B. Billard, ed. Washington, DC: National Geographic Society, 101-149.

Hewitt, W. E. , ed. 1993. *The Sociology of Religion: A Canadian Focus*. Toronto, ON: Butterworths.

Highwater, Jamake. 1986. North American Indian Art: A Special Way of Seeing. *Artwest*, 8:5, 13-17.

Hildebrandt, Walter, and Brian Hubner. 1994. *The Cypress Hills: The Land and its People.* Saskatoon, SK: Purich Publishing.

Hill, Kay. 1983. *Glooscap and His Magic: Legends of the Wabanaki.* Toronto, ON: McClelland and Stewart.

Hirschfelder, Arlene, and Paulette Molin. 1992. *The Encyclopedia of Native American Religions.* New York: MJF Books.

Hodgson, John. 1994. Buffalo: Back Home on the Range. *National Geographic*, November 1994, 186:5, 64-89.

Holm, Bill. 1965. *West Coast Art: An Analysis of Form.* Seattle, WA: University of Washington Press.

Houle, Robert. 1991. The Spiritual Legacy of the Ancient Ones. *Land Spirit Power: First Nations at the National Gallery of Canada.* Diana Nemiroff, Robert Houle, and Charlotte Townsend-Gault, eds. Ottawa, ON: National Gallery of Canada, 43-73.

Hudson, Douglas. 1995. The Okanagan Indians. *Native Peoples: The Canadian Experience.* Second edition. R. Bruce Morrison and C. Roderick Wilson, eds. Toronto, ON: McClelland and Stewart, 484-507.

Hudson, Douglas, and Elizabeth Furniss. 1995. The Plateau: A Regional Overview. *Native Peoples: The Canadian Experience.* Second edition. R. Bruce Morrison and C. Roderick Wilson, eds. Toronto, ON: McClelland and Stewart, 471-483.

Hungrywolf, Adolf. 2001. *Legends Told by the Old People of Many Tribes.* Summertown, TN: Native Voices.

Hunn, Eugene S. 1990. The Plateau Culture Area. *Native North Americans: An Ethnohistorical Approach.* Daniel L. Boxberger, ed. Dubuque, IA: Kendall/Hunt, 361-386.

Irwin, Rita, and Ruby Farrell. 1996. The Framing of Aboriginal Art. *Visions of the Heart: Canadian Aboriginal Issues.* David Alan Long and Olive Patricia Dickason, eds. Toronto, ON: Harcourt, Brace, & Company, 57-92.

Irwin, R. Stephen. 1994. *The Indian Hunters.* Surrey, BC: Hancock House.

Ives, John W. 1990. *A Theory of Northern Athapaskan Prehistory.* Boulder, CO: Westview Press.

Jacknis, Ira. 1992. "The Artist Himself": The Salish Basketry Monograph and the Beginnings of a Boasian Paradigm. *The Early Years of Native American Art History: The Politics and Scholarship and Collecting.* Janet Catherine Berlo, ed. Seattle, WA: University of Washington Press, 134-161.

Jenness, Diamond. 1986. *The Indians of Canada.* Seventh edition. Toronto, ON: University of Toronto Press.

Johnston, Basil. 1995. *The Manitous: The Spiritual World of the Ojibway.* Vancouver, BC: Key Porter Books.

Johnston, Charles M., ed. 1964. *The Valley of the Six Nations: A Collection of Documents on the Indian lands of the Grand River.* Toronto, ON: University of Toronto Press.

Jones, David M., and Brian Leigh Molyneaux. 2004. *The Mythology of the Americas*. Dayton, OH: Lorenz Books.

Josephy, Jr. , Alvin M. 1968. *The Indian Heritage of America*. New York:Alfred A. Knopf.

Kaltreider, Kurt. 1998. *American Indian Prophecies: Conversations with Chasing Deer*. Carlsbad, CA: Hay House.

Kammler, Henry. 2000. The Northern Rain Forest. *The Cultures of Native North Americans*. Christian F. Feest, ed. Cologne, Germany: Könemann, 273-313.

Kehoe, Alice B. 1981. *North American Indians: A Comprehensive Account*. Englewood Cliffs, NJ: Prentice-Hall, Inc.

Kennedy, Dorothy I. D. and Randy Bouchard. 1992. *St'átl'imx* (Fraser River Lillooet) Fishing. *A Complex Culture of the British Columbia Plateau*. Brian Hayden, ed. Vancouver, BC: University of British Columbia Press, 266-354.

Keyser, James D., and Michael A. Klassen. 2001. *Plains Indian Rock Art*. Seattle, WA: University of Washington Press

King, J. C. H. 1979. *Portrait Masks from the Northwest Coast of America*. London, UK: Thames and Hudson.

Kirk, Ruth. 1986. *Wisdom of the Elders: Native Traditions on the Northwest coast*. Vancouver, BC: Douglas & McIntyre.

Knight, Rolf. 1978. *Indians at Work: An Informal History of Native Indian Labour in British Columbia, 1858-1930*. Vancouver, BC: New Star Books.

Krause, Aurel. 1971. *The Tlinget Indians: Results of a Trip to the Northwest Coast of America and the Bering Straits*. Seattle, WA: University of Washington Press.

Kroeber, A. L. 1907. *Ethnology of the Gros Ventre*. Vol. 18, New York: Anthropological Papers of the American Museum of Natural History.

Laforget, Andrea. 1993 Tsimshian Basketry. *The Tsimshian: Images of the Past: Views for the Future*. Margaret Seguin, ed. Vancouver, BC: UBC Press, 215-280.

Layton, Robert. 1981. *The Anthropology of Art*. London, UK: Granada Publishing.

Lincoln, Kenneth. 1985. *Native American Renaissance*. Berkeley, CA: University of California Press.

Lowie, Robert H. 1954. *Indians of the Plains*. Garden City, NY: The Natural History Press.

————. 1968. The Culture-Type of the Plains Indians. *The North American Indians: A Sourcebook*. Roger C. Owen, James J. F. Deetz, and Anthony D. Fisher, eds. New York: Collier-Macmillan, 487-493.

Macfarlan, Allan A. 1968. *North American Indian Legends*. Mineola, NY: Dover Publications.

MacEwan, Grant. 1995. *Buffalo: Sacred and Sacrificed*. Edmonton, AB: Alberta Sport, Recreation, Parks & Wildlife Foundation.

Macmillan, Cyrus. 1962. *Glooscap's Country and Other Indian Tales*. Toronto, ON: Oxford University Press.

MacNair, Peter. 1995. From Kwakiutl to Kwakwa ka'wakw. *Native Peoples: The Canadian Experience*. Second edition. R. Bruce Morrison and C. Roderick Wilson, eds. Toronto, ON: McClelland and Stewart, 586-606.

Mails, Thomas E. 1997. *Creators of the Plains*. Tulsa, OK: Council Oak Books.

Maliseet Indian Tribe. 2004. [http://www.native-languages.org/maliseet.htm#tribe].

Marriott, Alice, and Carol K. Rachlin. 1975. *Plains Indian Mythology*. New York: New American Library.

Marsh, E. L. 1923. *Where the Buffalo Roamed: "The Story of the Canadian West."* Toronto, ON: The Macmillan Company of Canada, Ltd.

Marshall, Ingeborg. 1982. *The Red Ochre People*. Vancouver, BC: Douglas & McIntyre.

————. 1991. *The Beothuk of Newfoundland: A Vanished People*. St. John's, NL: Breakwater Books.

Mattes, Catherine. 2001. Perspectives in Contemporary Art. *Métis Legacy: A Métis Historiography and Annotated Bibliography*. Lawrence J. Barkwell, Leah Dorion, and Darren Préfontaine, eds. Winnipeg, MB: Pemmican Publications, 189-192.

Massey, Don and Patricia N. Shields. 1995. *Canada: Its Land and People*. Second edition. Edmonton, AB: Reidmore Books.

Matuz, Roger, ed. 1998. *St. James Guide to Native North American Artists*. Detroit, MI: St. James Press.

McFeat, Tom, ed. 1967. *Indians of the North Pacific Coast*. Seattle, WA: University of Washington Press,

McFee, Malcolm. 1972. *Modern Blackfeet: Montanans on a Reservation*. Prospect Heights, IL: Waveland Press.

McHugh, Tom. 1979. *The Time of the Buffalo*. Lincoln, NE: University of Nebraska Press.

McLean, Don. 1987. *1885: Métis Rebellion or Government Conspiracy?* Winnipeg, MB: Pemmican Publications.

McMaster, Gerald R. 1999. Towards an Aboriginal Art History. *Native American Art in the Twentieth Century: Makers, Meanings, Histories*. W. Jackson, Rushing III, ed. London, UK: Routledge, 81-96.

McMillan, Alan D. 1988. *Native Peoples and Cultures of Canada*. Vancouver, BC: Douglas & McIntyre.

————. 1995. *Native Peoples and Cultures of Canada*. Second edition, revised and enlarged. Vancouver, BC: Douglas & McIntyre.

Métis Fingerweaving: Métis Women's Traditional Arts Series. (2003 Video). Saskatoon, SK: Gabriel Dumont Institute Production.

Métis Hooked Rugs: Métis Women's Traditional Arts Series. (2002 Video). Saskatoon, SK: Gabriel Dumont Institute Production.

Miller, J. R. 2004. *Reflections on Native-Newcomer Relations: Selected Essays*. Toronto, ON: University of Toronto Press.

Miller, Virginia. 1995. The Micmac: A Maritime Woodland Group. *Native Peoples: The Canadian Experience*. Second edition. R. Bruce Morrison and C. Roderick Wilson, eds. Toronto, ON: McClelland and Stewart, 347-374.

Mills, Antonia, and Richard Slobodin. 1994. *American Rebirth: Reincarnation Among North American Indian and Inuit*. Toronto, ON: University of Toronto Press.

Minor, Marz, and Nona Minor. 1972. *The American Indian Craft Book*. Lincoln, NE: University of Nebraska Press.

Momatiuk, Yva and John Eastcott. 1995. "Nunavut" Means Our Land. *Native Peoples*, 9:1, Fall/Winter, 42-48.

Morning Dove (Humishuma). 1990. *Coyote Stories*. Lincoln. NE: University of Nebraska Press.

Mowat, Farley. 1952. *People of the Deer*. Toronto, ON: McClelland and Stewart.

Muckle, Robert J. 1998. *The First Nations of British Columbia*. Vancouver, BC: UBC Press.

Mullett, G. M. 1979. *Spider Woman Stories: Legends of the Hopi Indians*. Tucson, AZ: The University of Arizona Press.

Neidhardt, John G. 1979. *Black Elk Speaks*. Lincoln, NE: University of Nebraska Press.

Newcomb, William W. Jr. 1974. *North American Indians: An Anthropological Perspective*. Santa Monica, CA: Goodyear Publishing Company.

Norman, Howard, ed. 1990. *Northern Tales: Traditional Stories of Eskimo and Indian Peoples*. New York: Pantheon Books.

O'Toole, Roger. 1984. *Religion: Classic Sociological Approaches*. Toronto, ON: McGraw-Hill Ryerson.

Oberg, Kalervo. 1973. *The Social Economy of the Tlinget Indians*. Seattle, WA: University of Washington Press.

Our Shared Inheritance: A Tradition of Métis Beadwork. (2002 Video). Saskatoon, SK: Gabriel Dumont Institute Production.

Palmer, William R. 1946. *Pahute Indian Legends*. Salt Lake City, UT: Deseret Book Company.

Parsons, Michael J. 1987. *How We Understand Art: A Cognitive Developmental Account of Aesthetic Experience*. New York: Cambridge University Press.

Pasztory, Esther. 1982. Shamanism and North American Indian Art. *Native North American Art History: Selected Readings*. Zena Pearlstone Mathews and Aldona Jonaitis, eds. Palo Alto, CA: Peek Publications, 7-30.

Patterson, E. Palmer II. 1972. *The Canadian Indian: A History Since 1500*. Don Mills, ON: Collier-Macmillan Canada.

Patterson, Nancy-Lou. 1973. *Canadian Native Art: Arts and Crafts of Canadian Indians and Eskimos*. Don Mills, ON: Collier-Macmillan.

Payment, Diane Paulette. 1990. *"The Free People-Otipemisiwak": Batoche Saskatchewan, 1870-1930*. Ottawa, ON: National Parks and Sites, Parks Service.

Penn, W. S. 1993. *The Telling of the World: Native American Stories and Art*. New York: Stewart, Tabori & Chang.

Penney, David W. 2003. *Native Arts of North America*. Paris: Telleri.

————. (2004). *North American Indian Art*. London, UK: Thames & Hudson.

Peterson, Jacqueline, and Jennifer S. H. Brown. 2001. *The New Peoples: Becoming Métis in North America*. Fourth printing. Winnipeg, MB: University of Manitoba Press.

Petitot, Father Emile. 1981. *Among the Chiglit Eskimos*. Translation of "Les Grands Esquimaux" by E. Otto Höhn. Edmonton, AB: Boreal Institute for Northern Studies.

Potter, Kristin K. 1999. James Houston, Armchair Tourism, and the Marketing of Inuit Art. *Native American Art in the Twentieth Century: Makers, Meanings, Histories*. W. Jackson Rushing III, ed. London, UK: Routledge, 39-56.

Price, John A. 1979. *Indians of Canada: Cultural Dynamics*. Scarborough, ON: Prentice Hall of Canada, Ltd.

Purich, Donald. 1988. *The Métis*. Toronto, ON: James Lorimer.

Racette, Sherry Farrell. 2001. Beads, Silk and Quills: The Clothing and Decorative Arts of the Métis. *Métis Legacy: A Métis Historiography and Annotated Bibliography*. Lawrence J. Barkwell, Leah Dorion, and Darren Préfontaine, eds. Winnipeg, MB: Pemmican Publications, 181-188.

Ray, Arthur J. 1974. *Indians in the Fur Trade: Their Role as Trappers, Hunters, and Middlemen in the Lands Southwest of the Hudson Bay, 1660-1870*. Toronto, ON: University of Toronto Press.

Redish, Laura, and Orrin Lewis. 2004. [http:llwww.geocites.com/bigorrin/maliseet_kids.htm].

Reese, Montana Lisle, ed. 1987. *Legends of the Mighty Sioux*. Interior, SD: Badlands History Association.

Ressler. Theodore Whitson. 1957. *Treasury of American Indian Tales*. New York: Bonanza Books.

Richardson, John Adkins. 1984. *Art: The Way It Is*. Englewood Cliffs, NJ: Prentice-Hall.

Roberts, Lance, Susanne von Below, and Mathias Bos. 2001. The Métis in a Multicultural Society: Some Reflections on the Macro Picture. *Métis Legacy: A Métis Historiography and Annotated Bibliography*. Lawrence J. Barkwell, Leah Dorion, and Darren Préfontaine, eds. Winnipeg, MB: Pemmican Publications, 193-198.

Robertson, Marion. 1969. *Red Earth: Tales of the Micmacs*. Halifax, NS: Nimbus Publishing.

Rogers, Edward S. 1994. Northern Algonquians and the Hudson's Bay Company, 1821-1890. *Aboriginal Ontario: Historical Perspectives on the First Nations*. Edward S. Rogers and Donald B. Smith, eds. Toronto, ON: Dundurn Press, 307-343.

Rowe, Frederick W. 1977. *Extinction: The Beothuks of Newfoundland*. Toronto, ON: McGraw-Hill.

Runes, Dagobert D. 1967. *Dictionary of Philosophy*. Totowa, NJ: Littlefield, Adams & Co.

Rushing III, W. Jackson. 1999. Editor's Introduction to Part III. *Native American Art in the Twentieth Century: Makers, Meanings, Histories*. W. Jackson Rushing III, ed. London, UK: Routledge, 169-173.

Ryan, Joan. 1995. *Doing Things the Right Way: Dene Traditional Justice in Lac La Martre, NWT*. Calgary, AB: Arctic Institute of North America.

Savard Rémi. 1969. The Indians of Eastern Canada and Their Art. *Masterpieces of Indian and Eskimo Art*. The National Gallery of Canada. Np.

Savoie. Donat, ed. 1970. *The Amerindians of the Canadian North-West in the nineteenth Century, as seen by Émile Petitot. Volume II: The Loucheux Indians*. Ottawa, ON: Northern Science Group, Department of Indian Affairs and Northern Development.

Schevill, Margot Blum. 1992. Lila Morris O'Neale: Ethnoaesthetics and the Yurok-Karok Basket Weavers of Northwestern California. *The Early Years of Native American Art History: The Politics and Scholarship and Collecting*. Janet Catherine Berlo, ed. Seattle, WA: University of Washington Press, 162-190.

Schultz, James Willard (Apikuni). 1962. *Blackfeet and Buffalo: Memories of Life Among the Indians*. Edited with an Introduction by Keith C. Seele. Norman, OK: University of Oklahoma Press.

Sealey, D. Bruce, and Antoine S. Lussier. 1975. *The Métis: Canada's Forgotten People*. Winnipeg, MB: Manitoba Métis Federation Press.

Seton, Julia M. 1962. *American Indian Arts: A Way of Life*. New York: The Ronald Press.

Sedgewick, John P., Jr. 1959. *Art Appreciation Made Simple*. New York: Garden City Books.

Shaw, Anna Moore. 1992. *Pima Indian Legends*. Tucson, AZ: University of Arizona Press.

Sprenger, G. Herrman. 1978. The Métis Nation: Buffalo Hunting vs. Agriculture in the Red River Settlement. *The Other Natives: the-les Métis, Volume One, 1700-1885*. Antoine Lussier and D. Bruce Sealey, eds. Winnipeg, MB: Manitoba Métis Federation Press, 115-130.

Steckley, John L., and Bryan D. Cummins. 2001. *Full Circle: Canada's First Nations*. Toronto, ON: Pearson Education Canada.

Steinmetz, Paul B. 1990. Shamanic Images in Peyote Visions. *Religion in Native North America*. Christopher Vecsey, ed. Moscow, ID: University of Idaho Press, 104-116.

Stewart, Hilary. 1979. *Looking at Indian Art of the Northwest Coast*. Vancouver, BC: Douglas & MacIntyre.

————. 1993. *Looking at Totem Poles*. Vancouver, BC: Douglas & McIntyre.

Stiffarm, Preston L. 1983. *Assiniboine Memories: Legends of the Nakota People*. Harlem, MT: Fort Belknap Community Council.

Such, Peter. 1978. *Vanished People: The Archaic Dorset & Beothuk People of Newfoundland*. Toronto, ON: NC Press.

Surtees, R. J. 1985. The Iroquois in Canada. *The History and Culture of the Iroquois Diplomacy: An Interdisciplinary Guide to the Treaties of the Six Nations and Their League*. Francis Jennings, ed. Syracuse, NY: Syracuse University Press, 67-84.

Swinton, George. 1972. *Sculpture of the Eskimo*. Toronto, ON: McClelland and Stewart.

Tate, Agnes Carne. 1975. *Tales from the Longhouse by Indian Children of British Columbia*. Sidney, BC: Gray's Publishing Ltd.

Terrell, John Upton. 1994. *American Indian Almanac*. New York: Barnes & Noble.

The National Gallery of Canada. 1969. *Masterpieces of Indian and Eskimo Art*. Paris: Société des Amis du Musé de l'Homme.

Thom, Laine, ed. 1992. *Becoming Brave: The Path to Native American Manhood*. Vancouver, BC: Raincoast Books.

Tooker, Elizabeth. 1994. The Five (later Six) Nations Confederacy, 1550-1784. *Aboriginal Ontario: Historical Perspectives on the First Nations*. Edward S. Rogers and Donald B. Smith, eds. Toronto, ON: Dundurn Press, 79-91.

Tooker, Elizabeth, ed. 1979. *Native North American Spirituality of the Eastern Woodlands: Sacred Myths, Dreams, Visions, Speeches, Healing Formulas, Rituals and Ceremonies*. New York: Paulist Press.

Trigger, Bruce G. 1994. The Original Iroquois: Hurons, Petun, and Neutral. *Aboriginal Ontario: Historical Perspectives on the First Nations*. Edward S. Rogers and Donald B. Smith, eds. Toronto, ON: Dundurn Press, 41-64.

Underhill, Ruth M. 1963. *Red Man's Religion: Beliefs and Practices of the Indians North of Mexico*. Chicago, IL: The University of Chicago Press.

Valliant, George C. 1973. *Indian Arts in North America*. New York: Cooper Square Publishers.

Vastokas, Joan M. 1982. The Relation of Form to Iconography in Eskimo Masks. *Native North American Art History: Selected Readings*. Zena Pearlstone Mathews and Aldona Jonaitis, eds. Palo Alto, CA: Peek Publications, 61-72.

Vincent, Gilbert T. 1975. *American Indian Art: From the Eugene and Clare Thaw Collection*. New York: Harry N. Abrams, Inc., publishers.

Wallas, James, and Pamela Whitaker. 1989. *Kwakiutl Legends*. Surrey, BC: Hancock House Publishers.

Walters, Anna Lee. 1989. *The Spirit of Native American Beauty and Mysticism in American Indian Art*. San Francisco, CA: Chronicle Books.

Weatherford, Jack. 1991. *Native Roots: How the Indians Enriched America*. New York: Fawcett Columbine.

Wedel, Waldo R. 1978. *The Prehistoric Plains. Ancient Native Americans*. Jesse D. Jennings, ed. San Francisco, CA: W. F. Freeman and Company, 183-219.

Weeks, Rupert. 1981. *Pachee Goyo: History and Legends from the Shoshone*. Laramie, WY: Jelm Mountain Press.

Whidden, Lynn. 2001. Métis Music. *Métis Legacy: A Métis Historiography and Annotated Bibliography*. Lawrence J. Barkwell, Leah Dorion, and Darren Préfontaine, eds. Winnipeg, MB: Pemmican Publications, 169-176.

White, John Manchip. 1979. *Everyday Life of the North American Indians*. New York: Dorset Press.

Whitehead, Ruth Holmes, and Harold McGee. 1983. *The Micmac: How Their Ancestors Lived Five Hundred Years Ago*. Halifax, NS: Nimbus Publishing Company.

Wiley, Gordon R. 1968. History and Evolution of American Indian Cultures. *The North American Indians: A Sourcebook*. Roger C. Owen, James J. F. Deetz, and Anthony D. Fisher, eds. New York: Collier-Macmillan, 7-27.

Wilson, C. Roderick, and Carl Urion. 1995. First Nations Prehistory and Canadian History. *Native Peoples: The Canadian Experience*. Second edition. R. Bruce Morrison and C. Roderick Wilson, eds. Toronto, ON: McClelland and Stewart, 22-66.

Wilson, Roger, ed. 1976. *The Land That Never Melts: Auyuittuq National Park*. Ottawa, ON: Minister of Supply and Services.

Wissler, Clark. 1927. *North American Indians of the Plains*. New York: American Museum of Natural History Handbook Series.

———. 1966. *Indians of the United States*. Revised edition. Garden City, NY: Doubleday & Company.

Wissler, Clark, and D. C. Duvall. 1995. *Mythology of the Blackfoot Indians*. Lincoln. NE: University of Nebraska Press.

Wolforth, John. 1968. *The Northland: Studies of the Yukon and the Northwest Territories*. Toronto, ON: McClelland and Stewart.

Wyatt, Victoria. 1991. The Northwest Coast. *The Native Americans: The Indigenous People of North America*. Colin F. Taylor, ed. London: Salamander Books, 154-181.

Young Man, Alfred. 1992. îndîgena. *Contemporary Native Perspectives*. Gerald McMaster and Lee-Ann Martin, eds. Vancouver, BC: Douglas & McIntyre and Hull, PQ: Canadian Museum of Civilization, 81-99.

Zimmerman, Larry J., and Brian Leigh Molyneaux. 1996. *Native North America*. Norman, OK: University of Oklahoma Press.

Zitkala-Sa. (1985). *Old Indian Legends*. Lincoln, NE: University of Nebraska Press.

About the Authors

John W. Friesen, Ph.D., D.Min., D.R.S., is a Professor in the Graduate Division of Educational Research Education at the University of Calgary where he teaches courses in Aboriginal history and education. An ordained minister with the All Native Circle Conference of the United Church of Canada, he is the recipient of three eagle feathers, and author of more than 40 books including:

Rose of the North (a novel), (Borealis, 1987);

Introduction to Teaching: A Socio-Cultural Approach (co-author), (Kendall/Hunt, 1990);

You Can't Get There From Here: The Mystique of North American Plains Indians Culture & Philosophy (Kendall/Hunt, 1995);

The Real/Riel Story: An Interpretive History of the Métis People of Canada (Borealis, 1996);

Perceptions of the Amish Way (with Bruce K. Friesen) Kendall/Hunt, 1996;

Rediscovering the First Nations of Canada (Detselig, 1997);

Sayings of the Elders: An Anthology of First Nations' Wisdom (Detselig, 1998);

First Nations of the Plains: Creative, Adaptable and Enduring (Detselig, 1999);

Legends of the Elders (Detselig, 2000);

Aboriginal Spirituality and Biblical Theology: Closer Than You Think (Detselig, 2000);

Canada in the Twenty-First Century: A Historical Sociological Approach (with Trevor W. Harrison), (Pearson Canada, 2004);

The Palgrave Companion to Utopian Communities in North America (with Virginia Lyons Friesen), (Macmillan, 2004); and,

Sayings of a Philosopher (Detselig, 2005).

Virginia Lyons Friesen, Ph.D., is a Sessional Instructor in the Faculty of Communication and Culture at the University of Calgary and is a frequent instructor at Weekend University, The University of Calgary's Gifted Centre, and Old Sun College on the Blackfoot Indian Reserve at Siksika, Alberta. An Early Childhood Education Specialist, she holds a Certificate in Counselling from the Institute of Pastoral Counselling in Akron, Ohio. She has co-presented a number of papers at academic conferences and is co-author of: *Grade Expectations: A Multicultural Handbook for Teachers*, (Alberta Teachers' Association 1995), and *The Palgrave Companion to Utopian Communities in North America* (Macmillan, 2004). She served as Director of Christian Education with the Morley United Church on the Stoney (Nakoda Sioux) Indian Reserve from 1988 to 2001.

John W. Friesen and Virginia Lyons Friesen have co-authored the following Detselig Titles:

In Defense of Public Schools in North America, 2001;

Aboriginal Education in Canada: A Plea for Integration, 2002;

We Are Included: The Métis People of Canada Realize Riel's Vision, 2004;

More Legends of the Elders, 2004;

First Nations in the Twenty-First Century: Contemporary Educational Frontiers, 2005;

Still More Legends of the Elders, 2005;

Even More Legends of the Elders 2005; and

Legends of the Elders Handbook for Teachers, Homeschoolers and Parents, 2005.

About the Artist

An apprenticed blacksmith, **David J Friesen** studied design at the Alberta College of Art and obtained a Bachelor of Education degree in early childhood education from the University of Calgary. As well as illustrating several books, he has taught elementary and art education in both public and private schools in Alberta, British Columbia, Ohio, Korea, and Japan. His hobbies include skateboarding, snowboarding, and web and graphic design. Some of his recent works may be found at aviwebsolutions.com.

Index